P9-DHE-229

Manhattan-Elwood Public Library
240 Whitson Street, P.O. Box 53
Manhattan, IL 60442

SEP 3 0 2015

THE NORTH
AMERICAN
INDIAN

The photographs are taken from the 20 portfolios and 20 encyclopedic volumes of the work entitled "The North American Indian" by Edward Sheriff Curtis, published between 1907 and 1930. The rare portfolios with their 721 large-format photogravures have been reproduced here in full, complemented by a selection of photographs from the encyclopedia. The publisher would like to thank the Niedersächsische Staats- und Universitätsbibliothek Göttingen and Dr. Helmut Rohlfing for their kind cooperation.

EACH AND EVERY TASCHEN BOOK PLANTS A SEED!
TASCHEN is a carbon neutral publisher. Each year, we offset our annual carbon emissions with carbon credits at the Instituto Terra, a reforestation program in Minas Gerais, Brazil, founded by Lélia and Sebastião Salgado. To find out more about this ecological partnership, please check: www.taschen.com/zerocarbon
Inspiration: unlimited. Carbon footprint: zero.

To stay informed about TASCHEN and our upcoming titles, please subscribe to our free magazine at www.taschen.com/magazine, download our magazine app for iPad, follow us on Twitter and Facebook, or e-mail your questions to contact@taschen.com.

© 2015 TASCHEN GmbH
Hohenzollernring 53, D–50672 Köln
www.taschen.com

Original edition: © 1997 Benedikt Taschen Verlag GmbH

Editing and layout: Simone Philippi, Ute Kieseyer, Cologne
English translation: Rolf Fricke, Sheestown
Cover design: Birgit Eichwede, Cologne

Printed in China
ISBN 978–3–8365–5056–7

3 8001 00122 3837

EDWARD S. CURTIS

THE NORTH AMERICAN
INDIAN

THE COMPLETE PORTFOLIOS

TASCHEN

Bibliotheca Universalis

**Manhattan-Elwood Public Library
240 Whitson Street, P.O. Box 53
Manhattan, IL 60442**

CONTENTS

EDWARD S. CURTIS
AND THE NORTH AMERICAN INDIANS
Hans Christian Adam

The extraordinary photographs in this book stem from the estate
of approximately 2,200 photogravures made by photographer and
ethnographer Edward Sheriff Curtis (1868–1952). Shortly before the
turn of the century, he began his quest to record the last living tra-
ditions of North American Indian tribes in words and pictures. It
was to take him more than 30 years. The result of these many years
of work was to be published as a massive 20-volume encyclopedia
entitled "The North American Indian." It is not known how many
of the 500 numbered sets originally planned were actually printed.
We do know, however, that only 272 copies were sold, at an issue
price of $3,000, due to insufficient demand. The full title of the
work reads "The North American Indian, being a series of volumes
picturing and describing the Indians of the United States and Alaska,
written, illustrated, and published by Edward S. Curtis, edited by
Frederick Webb Hodge, foreword by Theodore Roosevelt, field
research conducted under the patronage of J. Pierpont Morgan,
in twenty volumes."

The encyclopedia was published between 1907 and 1930 by the
University Press of Cambridge, Massachusetts (from Volume 6/1911
by the Plimpton Press in Norwood, Massachusetts). Starting with
Volume 10/1915, the suffix "and the Dominion of Canada" was added.
This now covered the entire American continent north of the Mexican
border and west of the Mississippi. Each of the 20 self-contained vol-
umes of text was illustrated with approximately 75 14 x 19 cm
(5 x 7 in.) plates, and was devoted to a single or a number of related or
topographically adjacent North American Indian tribes. In addition
to the photographs, artwork and maps were also sometimes included.

The result of this immense investment in time and money
culminated in the book version as an exceedingly lavish and costly

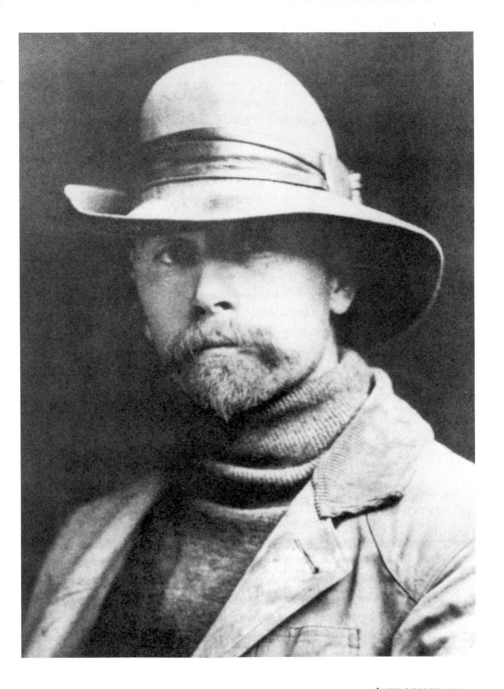

production, an exquisite work printed on heavy stock, with leather binding and gilt edging. Together, the twenty volumes occupied nearly one and a half meters (almost five feet) of shelf space. Their luxurious confection and the small print run, however, prevented the wide dissemination of their content to which the author had aspired.

Each of the 20 volumes was accompanied by a picture portfolio in folio format with around 35 large photogravures of mostly related subjects on 30 x 40 cm (12 x 16 in.) plates. The photogravures were also sold separately in the form of reprints. Curtis's reputation as a photographer, which probably reached its peak between 1903 and 1913, stems mostly from the first few portfolios of these reprints. By the time the last volume was published in 1930, Curtis's name was unknown to all but a very few informed people. When he passed away in 1952, the *New York Times* printed a brief obituary totaling a mere 76 words; it cited his life's work "The North American Indian" and ended tersely with the words "Mr. Curtis was also known as a photographer." Only with the general revival of interest in the medium of photography in the seventies did his pictures and consequently the interest in his person experience a revival.

Chiefs, warriors and medicine men

Curtis's significance as an author and historian who researched individual Indian tribes has only recently been granted a measure of recognition. For years his work as a tireless researcher, author and organizer was largely ignored. And yet he worked in a methodical and systematic fashion, right from the start. The content of each volume follows a fundamental pattern: it starts with a list of the spoken alphabet of Indian expressions, and is followed by an index of illustrations and an introduction to the particular ethnology that is being featured. Although the articles about individual Indian tribes have differing titles, their contents conform to a similar pattern, for instance: "Homeland and life," "Home and general customs," "Home life, arts and beliefs." Most of the descriptions of the different tribes include a chapter on "Mythology," and many of them also contain an additional chapter on related subjects such as "Medicine and medicine men" and "Ceremonies." Curtis was particularly interested in legends and myths

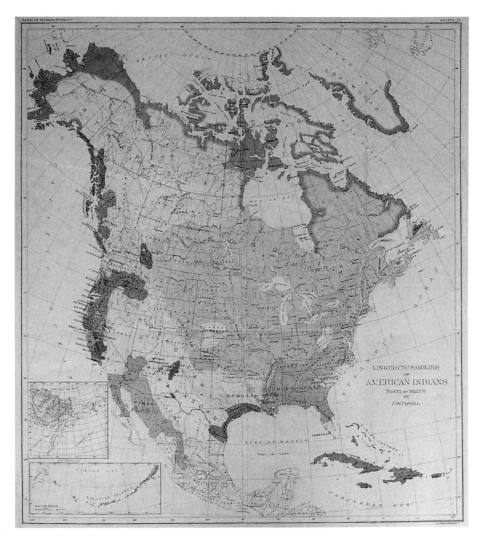

Map from "The North American Indian," Volume I, 1907

Page 7: Edward S. Curtis, 1899

that were passed on by word of mouth and which formed the basis for a tribe's religion. He also dedicated himself intensively to penning the biographies of important chiefs, warriors, medicine men and priests. Further, he was a collector of the texts and melodies of Indian songs and dances.

From the Hopi
to the Alaskan
Eskimos of the
Bering Strait

Between 1895 and 1928 he visited an assortment of diverse Indian tribes, including the Kwakiutl on the Pacific Coast; the Comanches, Apaches and Crees in their characteristic tipis on the expanse of the prairies and at the foot of the Rocky Mountains; and the Hopi and other adobe inhabitants in the dry and dusty Southwest. He would have liked to photograph igloos and other snow shelters too, but by the time the last volume appeared – which was devoted to the Alaskan Eskimos in the Bering Strait – Curtis had turned 59 and lamented that his failing health did not allow him to spend the winter in the Far North. Curtis concluded his work with the remark "Great is the satisfaction the writer enjoys when he can at last say to all those whose faith has been unbounded, 'It is finished!'"

The sequence of the published volumes generally corresponds to the chronological sequence of Curtis's travels. But the photographer also regularly availed himself of the photographs in his archives, which were produced shortly before and after the turn of the century. On the subject of dates, it is important to emphasize that the photographer specifically states in his book that the years cited under his photographs refer to the copyright dates, and not to the dates when the photographs were actually taken.

An illustrated
encyclopedia

The selection of photographs reproduced here combines all the large-format photogravures of the portfolios with an additional selection of smaller photographs from the text volumes. An individual chapter of this book is dedicated to each volume of Curtis's encyclopedia. For editorial reasons, the sequence of pictures within a chapter does not follow that of the original; instead it strives to present a selection of photographs that is as representative and as visually powerful as possible. The artwork for this book comes from the Department for Manuscripts and Rare Prints of the State and

University Library of Lower Saxony in Göttingen, which received set No. 8 of "The North American Indian" as a gift from industrial tycoon and financier John Pierpont Morgan (1837–1913) and his son of the same name (1867–1943), both from New York. The Morgans, as co-financiers of Curtis' project, had requested 25 copies of the mammoth work, which they subsequently donated to prominent national and international institutions. One of these was Göttingen, the alma mater of Morgan senior, who had studied mathematics there.

Edward Sheriff Curtis was born in 1869 in the U.S. state of Wisconsin; he grew up in an area where Indians, such as the Chippewas (Ojibwas) and Winnebago, were still very much to be seen. He was 21 years old when the massacre at Wounded Knee signaled the final demise of Indian culture.

Curtis's father was a preacher who visited his widely scattered flock on day-long horseback rides or by canoe. One consequence of this was that his son, who accompanied him on these trips, became familiar with life under the open skies at an early age. Edward Curtis, whose formal education lasted a mere six years in a one-class village school, was already experimenting with a homemade camera as a youth. He acquired his knowledge from the popular textbook "Wilson's Photographics."

After the early death of his father, Edward Curtis became a photographer and moved to Seattle in 1891, where he first worked in a photographic store, a business he eventually took over. He achieved his reputation with studio and landscape photography. One of his first Indian models was "Princess Angeline" (thus christened by the predominantly white population of the area), whom he photographed not far from his home on Puget Sound. She was about 80 years old, the aged daughter of Chief Sealth, the Suquamish Indian after whom Seattle was named. The photographer paid her a fee of one dollar, about which she made the following observation: it was money earned more easily than by digging for clams in the mud of the sound.

The preacher's son Edward Curtis

Curtis knew the wilderness and peaks of nearby Mount Rainier so well that he worked there as a mountain guide. On one of his trips he came across a group of scientists who had lost their way. Curtis helped bring their small expedition to a happy conclusion and the party came to know him as an extremely friendly man with a talent for organization, and a skilled photographer. They helped him get a highly interesting job in the year that followed: in 1899 Curtis became the official photographer of the Harriman Expedition in Alaska, which enabled him to participate in the daily interdisciplinary colloquia on board the chartered ship; it was like taking a crash course in the sciences. Evidently a rudimentary education was no handicap for the highly intelligent young man eager to absorb new knowledge. Alerted by scientists of the various disciplines, he developed an interest in the different ethnologies on the northwest coast and in the Indians in general. His friendly relations with the expedition participants would later help him establish contacts in the eastern United States.

Despite his fascination with the Indians, Curtis knew little about them when he began his work, and initially he shared the prejudices of the whites, for instance, that Indian religion was nothing more than superstition. But his interest in learning more about the Indians had been stimulated. Along with an anthropologist who had been a member of the Alaskan expedition, he spent an instructive summer with the prairie Indians, where he learned a great deal about the people who were to become not just his Indian models but also the objects of his desire for knowledge. He improved his skills in scientific methodology as well. Between the turn of the century and the year 1906, Curtis repeatedly photographed Indians and their tribes in the great western plains, as well as visiting the Indians of the southwestern United States.

The idea of creating an extensive documentation of the traditional life of the Indian tribes that were dying out in North America probably came to him in 1903 or 1904. The history of all the Indian tribes that could be reached, their lifestyle, ceremonies, legends and

myths were to be recorded systematically, both in words and in pictures. The aspects that Curtis wanted to research included language, social and political organization, religious customs, living conditions, the acquisition and preparation of food, geographic environment, games, music, dances, clothes, weights and measures, and the rituals and traditions attendant upon birth, marriage and death. He researched all these aspects with thoroughness and love for detail, but his most significant contribution concerned the subjects of Indian mythology and religion – an area that had previously attracted very little research.

In order to do justice to his self-assigned task, Curtis had to take photographs in hot and cold weather, in drought conditions and in the snow, over many years and right from the very start. As one of his friends remarked: "To accomplish it, Curtis has exchanged ease, comfort, home life, for the hardest kind of work, frequent and long-continued separation from his family, the wearing toil of travel through difficult regions, and finally the heart-breaking struggle of winning over to his purpose primitive men, to whom ambition, time and money mean nothing, but to whom a dream, or a cloud in the sky, or a bird flying across the trail from the wrong direction, means much."

When Curtis began to photograph the Indians, they had already been herded into reservations. Wars, undernourishment, diseases like tuberculosis and chicken pox, and especially the continuing encroachment on their living space, had decimated their numbers to less than half the original tribal population. For example, in just the one winter of 1864, two tribes, the Piegan and the Cheyenne, lost 1,780 members to measles. An Indian agent reported "that the Bloods alone left standing in their plague-stricken camp five hundred death lodges as silent monuments of the winter's devastation." In nearly every one of the volumes that appeared over the years, Curtis told with great sadness how the members of yet another tribe had been reduced to a fraction of their original numbers. The causes he cited were hunger, disease, war, persecution, "and worst of all, the debilitating passage of time." At the beginning of this century, the entire North American

**The Indians'
struggle
to survive**

Indian population numbered a mere 250,000 (today it is approximately two million).

In retrospect it becomes clear that the photographs of Indians that he took up until about 1904 were in fact preliminary studies for the great work whose concept was slowly taking shape. Curtis embarked on an energetic series of travels in which he visited many tribes. Due to a combination of curiosity and ignorance, he unwittingly violated certain unwritten rules and was correspondingly received rather frostily by the Indians. "Three or four times he heard the crack of a rifle shot in some unseen quarter, followed by the whine of a bullet past his ear (...) another time an Indian scooped up handfuls of dirt and threw them at the camera – only to be startled as Edward this time stood his ground, drawing his knife and rushing the offender."

The Indians value Curtis as a chronicler of their traditions

In 1911, Curtis mentioned to a reporter of the *New York Times* that "many of them are not only willing but anxious to help. They have grasped the idea that this is to be a permanent memorial of their race, and it appeals to their imagination. Word passes from tribe to tribe (...). A tribe that I have visited and studied lets another tribe know that after the present generation has passed away men will know from this record what they were like, and what they did, and the second tribe doesn't want to be left out." Towards the end of his endeavors, Curtis reported that tribes he had unsuccessfully attempted to contact for years had now informed him that he would be welcome to visit. They had come to realize that their traditions were entirely oral, and that Curtis was the only person interested in writing them down. The researcher noted down everything they told him – and he even recorded his own and his assistants' observations.

The President supports the project

Curtis had established a good reputation as a landscape and portrait photographer in Seattle. His success in a national competition earned him an invitation to the White House to photograph the President's son. He took this opportunity to show his photographs of the Indians to Theodore Roosevelt and they immediately captured the President's interest. Roosevelt, who thought of himself as one

of the last frontiersmen, was reminded of the days of his youth. He was very keen to see the frontier country of the West, including Indian culture, preserved. Admittedly, 30 years earlier, Roosevelt had written in his book "The Winning of the West" that the Indian was a "lazy, dirty, drunken beggar, whom the (...) frontiersmen despised and yet whom they feared; for the squalid contemptible creature might at any moment be transformed into a foe whose like was not to be found in all the wide world for ferocity, cunning, and bloodthirsty cruelty."

Hence, at Roosevelt's inauguration, the once-feared Apache chief Geronimo rode in the inaugural parade. From the very beginning, the President declared Curtis's photographs of the Indians to be works of art. He promised to contribute a preface to the publication, thus giving his semi-official blessing to the plans for Curtis's magnum opus. From then on, the photographer held numerous lantern-slide lectures, one of which took place in the Waldorf Astoria Hotel in New York City, where the crème de la crème of New York society applauded his work. Numerous newspaper and magazine articles featured his project. These activities were lucrative, but their proceeds were not nearly sufficient to cover anticipated expenses.

In 1906, in order to commence organization and publicity work for his project, Curtis asked the railway tycoon John Pierpont Morgan to sponsor his plans. Between 1898 and 1906, Curtis had drawn on his own limited resources and had already spent $25,000. He estimated that the remaining work would take five years, and Morgan promised to cover the annual expedition costs of $15,000 for this time period. But this $75,000 contribution was treated more like a closely administered loan than a generous philanthropic gesture. And Morgan placed prime importance on quality: "I want to see these photographs in books – the most beautiful set of books ever published."

John Pierpont Morgan – patron and financier

Two types of paper were to be used, both expensive imports: Japanese vellum and Dutch Van Gelder paper. In return, Morgan was to receive 25 sets of the volumes produced by Curtis, along with 300 additional original prints. He also granted a certain amount of

control over the work in progress to his private librarian, who was to become Curtis's contact for all questions related to the publication. With her constructive criticism, Miss Belle da Costa Greene turned out to be very helpful during the production.

Financial problems

After this first monetary blessing, Curtis initially believed his financial problems were over, but he had underestimated the problems of being his own publisher. The field work required far longer than expected, taking a further 22 years to complete. By the time the project was concluded, Curtis must have spent approximately half a million dollars altogether (another source quotes the even higher figure of one and a half million dollars). From the very start, the cost of field work, assistants, travel, production and printing totaled in excess of the annual sum available. Curtis certainly knew how to perform as a society man and entertainer when there was money to be made. But even with the income from picture sales and lantern-slide lectures presented to the accompaniment of Indian music, the proceeds from volumes that were already sold, and the sluggish subscriptions, money was insufficient. The critical state of the American economy also had its effect on book sales. In 1909 Morgan was forced to help out with an additional $60,000. The project was finally incorporated into a Morgan company called "The North American Indian, Inc.," but not a single year went by in which Curtis could dedicate himself to his work with no financial worries.

Essentially, Morgan's contributions turned out to be much too low. The initial payments were like biting the bait, which, once swallowed, could no longer be disgorged. Morgan took advantage of Curtis's dedication to bolster his own reputation as a patron, which he achieved in a relatively cost-effective fashion. It has never been explained why Curtis turned for assistance to Morgan, of all people, a man whose railroads had played a major role in the extermination of the buffalo, thus taking away the basic staple of Indian life.

Morgan died in 1913, and it was not until 1922 that his son decided – more or less compelled by circumstances – to shoulder the costs of printing, following a long interruption in the publication of

the books. In the meantime, because of the long wait for delivery of the volumes, subscribers had begun to complain, not only to Curtis, but directly to the Morgan Bank. All told, the Morgans subsidized the project with approximately $400,000. Even though this princely sum was insufficient to cover the actual costs incurred, it was nonetheless the Morgans who made the publication of "North American Indians" at all possible.

In spite of Roosevelt's political backing, Curtis's project received no state support – neither from the Smithsonian Institution, nor from the American Bureau of Ethnology. Established ethnologists and anthropologists viewed Curtis with suspicion, since he could not claim an academic background, even though both his contacts with influential personalities and his talents as a lecturing artist made him better known than many a professor. Furthermore, scientists took exception to the artistic aspects of his photography. As a result, his writings also found little dissemination, as they did not appear in professional periodicals reporting on current scientific activity, but were to be found in small editions of exceedingly beautiful and extremely expensive books.

Established ethnologists view Curtis with suspicion

Nevertheless, Frederick Hodge, an experienced specialist at the American Bureau of Ethnology, stood by Curtis, albeit in more of a personal than an official capacity. Hodge became active as Curtis's publisher, and his advice and help exerted a positive influence on the project. Hodge, who edited the material, was paid seven dollars per 1,000 words. Several times even he had to wait two years for his invoices to be paid.

Curtis ended up working for 30 years on his self-assigned project, in which he regarded himself as both an artist and a scientist. He visited 80 tribes, exposed a total of approximately 40,000 negatives, conducted countless interviews on manners and customs, wrote down the tribal histories that had been handed down orally, and concerned himself with stories, legends and myths. He conducted linguistic studies, and with the help of an assistant used an early Edison wax cylinder recording instrument to record music, songs and chants,

40,000 negatives and 10,000 songs

which were later transcribed into musical notation. The entire material was then prepared for publication. As an example, the basic concepts of 75 languages and dialects were preserved in this manner, and more than 10,000 songs were recorded.

But that wasn't all: Curtis was also the first person to make motion pictures of the Indians, filming, among other things, the Snake Dance of the Hopi Indians. The Snake Dance, best known of Hopi ceremonies and one of the most spectacular of all primitive performances, is a biannual, sixteen-day rite conducted by the Snake and Antelope fraternities as a dramatized prayer for rain. Not only did Curtis record this most spectacular of Indian dances on motion picture film and in still photographs, but he also earned the trust of the Indians to such an extent that they allowed him to participate in the dances. This required him to fast for several days and then move around and dance to the drum beat wearing a loin cloth and body paint, clenching a live rattlesnake between his teeth.

"Land of the Head Hunters"

Between 1910 and 1914 Curtis made a silent movie entitled "Land of the Head Hunters," which dealt with the life of the Indians on the northwest coast of the United States. Though the script was based on legends and oral descriptions, he staged the film taking major liberties with the truth, and used the proven movie approach of enriching it with doses of violence and romance. The director himself dressed the Indians. Later on he incorporated stills from the making of the movie into his book publications without identifying them as such. Afterwards, this was to lead to criticism from the scientific community. The movie was not a success with the public, but it influenced later ethnographically oriented moviemakers like Robert Flaherty ("Nanook of the North," 1921).

A team of 17 assistants

Even before embarking on his project, Curtis had decided to record the entire history of all native American populations, especially since no one else had dared tackle such a project up until then. Even with a superhuman effort, such an endeavor could inevitably accomplish only a mere fragment of its ambitious objective, thus leaving it open to criticism. Furthermore, Curtis was occupied with

a number of different interests, not concentrating on any one in particular, which led to citicism from scientists with a less universal vision.

Curtis did not conduct all his research by himself, but distributed key subject areas among his team members. He himself performed the original photography, organization and coordination as well as writing and partly editing the texts. Curtis was often portrayed as a lone individual attempting to perform the work of an entire institution. This is contradicted by the fact that he employed up to 17 assistants at any one time. The latter included not just seasonal field workers, but also those involved in the project at different locations scattered throughout the United States: in the photographic center, in the studio in Seattle, as book sales persons in New York City, and at the publisher's in Washington. The employees cost him up to $4,500 per month – it is no wonder that the balance of income and expenditure was one of Curtis's greatest worries. Planner, organizer and coordinator, he traveled tirelessly in the service of his project, crisscrossing the United States at least 125 times. And it is not at all clear whether Curtis had to invest more time in raising money for his project than he did in performing his actual research.

His assistant William E. Myers, "a master of shorthand, an expert in spelling, gifted as a phonetist, sat at my left and the interpreter at my right. I led in asking questions and Myers and the interpreter prompted me if I overlooked any important points (…). By writing all information in shorthand, we speeded the work to the utmost. I hazard the statement that our trio could do more work in a year than a lone investigator, writing in longhand and lacking phonetic skill could do in five years. Also, we knew nothing of labor union hours. Myers neatly typed his day's collection before going to bed. In that way field notes were kept to the minute. Our average working time for a six months' season would exceed 16 hours a day." Myers worked independently for a large part of the time. He prepared trips, organized future field work, gathered information from libraries and often conducted completely independent on-site research. He wrote the

16 hours a day spent working in the field

final versions of the texts in cooperation with Curtis and Hodge. He was far more than a secretary: he was also a scientist, whose contribution to the "North American Indian," though difficult to assess, was certainly very substantial.

Curtis neglects family and studio

In the meantime, another employee, Adolph F. Muhr, ran Curtis's famous photographic studio in Seattle. Muhr, who had an outstanding reputation according to the trade press, also worked on Curtis's Indian negatives. As a result, he could only devote a limited amount of time to the studio, which caused its income to decline. The studio income was supposed to provide a living for the Curtis family. This constant shortage of money and Curtis's near-permanent absence from home led to the break-up of his marriage. The project came to a standstill between 1916 and 1922, as Curtis was neither physically nor financially able to continue his life work after both Muhr's death in 1915 and his divorce with its resulting additional financial drain.

New start in Los Angeles

In 1919 Curtis moved to Los Angeles, where he began to take on photographic assignment work. In addition he worked as a cameraman for Hollywood Studios and took the still photographs for movies such as Cecil B. DeMille's silent epic "The Ten Commandments." His financial situation improved, allowing him to resume his life work with volume 12 of the "North American Indian." At this point in time there was barely any public or scientific interest in the continuation of Curtis's work. Such was the financial and mental stress associated with completing the project that Curtis exhausted himself both physically and emotionally. Charles Lauriat, a Boston book dealer, took over the not very successful distribution of the remaining volumes and photogravures. Curtis died in Whittier, California, in 1952 at the age of 84, after spending his last years working on a manuscript with the working title "The Lure of Gold," which was never published.

Picturesque impressionistic images

It is extremely difficult to assess with fairness such an extensive work as Curtis's with its so many diverse qualities. The author's pictorial approach to his subject in particular evidenced such changes over the 30 years he worked on the project that it cannot be ascribed

to progress in photographic technology alone. Curtis belonged to the pictorial tradition of photography. He initially strove to produce pictures with an impressionistic, picturesque atmosphere that could be interpreted universally, in contrast to documentary photography which is bound to time and place. For instance, when Curtis took a portrait, this seldom occurred spontaneously, as he met with his model on a particular day, at a particular time, in a particular place. Rather, he sought to compose his photographs as though there had been no previous contact between the model and the photographer. Nevertheless there are also numerous examples in Curtis's photographic estate that depict detailed scenes considered to be of a typical everyday nature, and these have been accepted to this day as valuable source material deserving of high respect. The only portion of Curtis's work, however, that has remained in people's memories is that classified as art photography.

Are these photographs with their magical quality really an echo of a time when humanity and nature were still in harmony? This is certainly questionable. Even before the influence of the whites began, the Indians in no way behaved in a manner that today's back-to-nature idealists and friend of shamans would consider politically correct. Rather, many tribes fought each other in the cruelest fashion and they certainly did not always utilize their rich resources with purposeful conservation in mind. When a chief ordered his tribe to leave camp, this did not necessarily mean that they were setting off on new heroic ventures; it merely meant that the surroundings had been so polluted by their own excrement that they could no longer tolerate it there.

However, the Indians possessed an entirely different concept of nature: they saw themselves as being in harmony with nature in the way described by Chief Standing Bear: "We do not think of the great open plains, the beautiful rolling hills and winding streams with tangled growth as wild (…). Only to the white man was nature a wilderness, and only to him was the land infested with wild animals and savage people. To us it was tame. Earth was bountiful and we were

People in harmony with nature?

surrounded with the blessings of the Great Mystery. Not until the hairy men from the east came and with brutal frenzy heaped injustices upon us and the families we loved was it wild for us. When the very animals of the forest began fleeing from his approach, then it was for us that the Wild West began" (Chief Standing Bear of the Poncas).

As unanimously reported by contemporary observers, Curtis was able to adapt himself to the Indians in an entirely natural manner. He respected his opposites, without being arrogant or over-friendly. He gradually learned to integrate himself completely into the daily life of the Indians, and because he came to value and accept them, they came to accept him also. "An Indian is like an animal or a small child (…). They instinctively know whether you like them, or if you are patronizing them. They knew I liked them and was trying to do something for them." As Curtis's participation in the Snake Dance demonstrates, he must also have been able to adapt spiritually to the myths of the Indians. The belief spread among Indian tribes that Curtis was one of only a very few whites capable of sharing "Manitou," the "Great Mystery," with them.

The Indians and Curtis respect and value each other

Curtis sympathized with their lost values, and that is why his photographs show an Indian world that at first glance seems untouched by white civilization. Many an Indian tribe had its own particular tribal culture that was very different from the others' and of which only fragments were known. Only when Curtis started out on his project did he become aware of the extent to which the traditional values of the Indian tribes had been eroded.

Lost values of the Indian world

The Indians had been unable to offer any lasting resistance to the ever accelerating encroachment of civilization, especially during the 19th century. Restricted to their reservations, they were subject to the will of their white overlords. It was Curtis's objective to write down what could still be documented at the end of the 19th century. There are, however, significant discrepancies between his texts and commentaries on the one side, and many of his famous pictures on the other. Curtis produced scientific descriptions of ongoing and

of remembered traditions, as well as of the frugal everyday life of Indian societies in the reservations. In contrast, he took fascinating photographs exaggerating Indian mythology that were frequently regarded as typical of Curtis's work: intriguing, romanticized images of Indians in feathered headdress, silhouetted against fluffy clouds in waning sunlight. These pictures represent only a portion of Curtis's visual heritage. But they have nonetheless resulted in Curtis's mystical Indian being placed side by side with the lonesome cowboy, who since Hollywood's earliest days has ridden off into the sunset at the end of a movie; an unsatisfactory comparison in which both figures are represented as symbols of a bygone era that only seemed to be better and that was heroically aggrandized by whichever medium was being used.

Many critics were disturbed by this basic discrepancy. Though we may not agree with some of Curtis's methods, actions and perceptions, fundamentally he was way ahead of his contemporaries with regard to his acceptance of the Indians. "Though we can find fault with many of his statements and actions, Curtis was really far ahead of most of his contemporaries in his sensitivity to the people who were the subject of his words and photographs (...) it is unfair (...) to Curtis (...) to judge (his) actions according to rules that were not part of their world." It filled him with rage to see the white men of his day continue to treat the Indians with injustice, something which had virtually become standard behavior. With reference to an actual disregard of treaties that the whites had concluded with the Indians and the great hardship that resulted, Curtis made the following statement in his books: "The conditions are still so acute that, after spending many months among these scattered groups of Indians, the author finds it difficult even to mention the subject with calmness."

Curtis' critics

The territorially confined reservation Indians were but a shadow of their former greatness. And yet, retrospectively, the image of their lives was to undergo a metamorphosis in Europe, just as was the existence of the cowboys in America. They were judged according to

The whites want to get rid of the Indians

controversial "white" concepts, be they "noble savages" or "redskins." The settlers who streamed westward across Indian territory would have liked to see the Indians eradicated. Even those who remained in the comfort of their own homes had little sympathy for the Indians. Newspaper articles of the 19th century described the "bloodcurdling gruesome deeds" of the Indians in cleverly contrived, journalistic horror stories fleshed out with gory details. These contributed to the general belief of the American public that the only good Indian is a dead one. Three million buffaloes, the principal food source of the prairie Indians, had been slaughtered by the whites in the early seventies – though not for the sheer fun of it, as has often been implied. The only sinister purpose behind this was the attempt to starve the Indians to death in order "to allow civilization to advance," as civil war hero General Phillip Sheridan phrased it.

Sitting Bull leads the Indians to their final victory

Alongside their conflicts with the white settlers, skirmishes among the Indians themselves offered further welcome justification for "pacification" by the various Washington governments and the U.S. army. The eviction of the Indians from their ancestral lands ended with the battle at Wounded Knee in 1890. Fifty years later Curtis compiled a written record of the Indian version of the war stories, which up to then had only passed down by word of mouth. "Little less than a massacre" was the way he described the bloody events at Wounded Knee, during which U.S. troops slaughtered women and children.

Even the last great victory of the Indians could not have prevented this massacre. Under the leadership of Sitting Bull, an alliance of several tribes in 1876 was the last to succeed in defeating "that implacable foe of encroaching civilization." The battle at the Little Bighorn River cost the lives of General George Armstrong Custer and 200 soldiers. Curtis got the Indians to show him the battle site. He interviewed eyewitnesses and he questioned the military. With his concern for objectivity, he offered a fresh analysis of Custer's military mistakes in describing the battle as "the most unfortunate day experienced by United States troops in Indian Warfare."

It would be wrong to judge Curtis's work as a photographer solely by the carefully staged, now very expensive photographs that have long since become icons. Feather-decorated Indians on horseback, peaceful scenes of Indian squaws carrying water, frame-filling images of expressive, often wrinkled Indian faces actually remind us more of the romantic aspects of the 19th century than of Curtis's own era, in which the first automobiles came off the assembly line.

Ethnologists have criticized Curtis's pictures for being much too artistic for a proper ethnological portrayal. Perhaps Curtis's depiction of the Indians as belligerent yet peaceful, living in harmony with family, tribe and nature, was intended to make up for the injustices that members of his own race had perpetrated upon the "redskins." In any case, he did not want his photography to corroborate the prevailing public perception that Indians were living in "painful poverty," that they were vegetating in "sorry weaknesses" of their own making or that they were to be regarded as "debauched vagabonds." Instead he showed the Indian "in the normal, noble life" a people of proud stature and noble heritage. In contrast to the moral convictions that many others still held from the 19th century, Curtis commented: "As an alien race, we should hardly presume to judge them (in this instance, the Apsaroke; in general, the Indians) wholly by our standards and not give them credit for their own customs and codes. They on their part consider some of our customs highly objectionable and immoral."

His contemporaries could certainly read a political message into the project's photographs, but this was not necessarily the one the photographer had intended to convey. Wasn't Curtis seeking to conjure images of erstwhile greatness in his depictions? Had white America not succeeded in vanquishing these people whom he described as proud, brave and warlike? Was the legendary greatness of these former enemies not further enhanced by Curtis's photographs? Could the victorious white majority that had defeated this once mighty foe not bask all the more in the glorious myth of its own deeds? In his letter of recommendation for Curtis, Roosevelt

wrote that "The Indian, as an Indian, is on the point of perishing, and when he has become a United States citizen, though it will be a much better thing for him and for the rest of the country, he will completely lose his value as a living historical document." Curtis did not share Roosevelt's views.

Information new to science

Much that Curtis has recorded contradicts what anthropology long considered to be true, even up to the present day. For instance he describes the history of the Mandan tribe of the prairies, whose origin is regarded as uncertain. Curtis's notations, however, describe a remarkable mythological origin of this tribe, which points to the Gulf Coast of the United States. The tribe's ranking elder describes a migration along the Missouri River, "from the place where the river flows into the great water" and talks of a "land to the south where the green of the trees never faded and the birds were always singing." There are many such passages in Curtis's volumes that contain information that was unknown to science and that was no longer known to the descendants of the tribes that Curtis visited.

Snake Dance of the Hopi as tourist attraction

Curtis strove passionately to assemble, in words and pictures, a testimonial to a culture that had already nearly vanished and that he was convinced would soon cease to exist altogether. "And above all, none of these pictures would admit anything which betokened civilization, whether in an article or dress or landscape or objects on the ground." A second intensive scrutiny of Curtis's photographs, however, makes it clear that this aspiration was no longer realizable. The photographer had long been aware of the influence of civilization upon the Indians and had come to accept this with sadness. Some of the portrait photographs, for example, show the safety pins that held together the blanket with which Curtis liked to drape his models, and from which the weathered and photogenic faces of the person portrayed would often peer out. Some women are no longer robed in their traditional dress, but are wearing colorfully printed cotton dresses.

Certain photographs are also known to have had objects of civilization subsequently removed by retouching. Curtis was only able

to take photographs of some traditional dances after he had persuaded his hosts to stage them especially for him. A few photographs even show tourists in the background, transported there along the Atcheson, Topeka & Santa Fe Railroad which had long been promoting visits to the Indians of the Southwest in a poster campaign. Travelers thought of the Hopi Snake Dance as a "good show," never as a religious ritual. Would any of them have noticed that an initiated white man was among the dancers? The Hopis eventually got weary of the tourists – beginning as early as 1911, photographers were no longer allowed to record the Snake Dance.

A substantial segment of Curtis's work consists of powerful, large-format portraits. During his travels, the photographer took along a tent in which he posed his models in front of the camera: "the usual photo tent, in which he posed his subjects, adjusting the light by moving a flap in the top." These portraits, produced with relatively simple means, offer further evidence of Curtis's training as a commercial portrait photographer who was able to achieve the best results in studio situations. While Curtis earned his money in the studios, he often had to pay his Indian models. Some dances and ceremonies were staged especially for his camera. He even bribed a corruptible priest with $500 in order to photograph the figures of the "Sacred Turtles" without the knowledge of the other members of the tribe. He paid the Zunis 50 cents per pose, which corresponded to about half a day's wages at the time.

500 dollars for the "Sacred Turtles"

The extraordinary quality of Curtis's portraits elicits the impression that conclusions can be drawn about the character of the sitter – and this appears to have been precisely what Curtis had in mind. Don't we get the impression that the Indian is about to start telling you the story of his or her life at any moment? Don't we want to ascribe certain characteristics, assume certain experiences, to these people with their weathered faces? Critics have succumbed to the fascination of these photographs ever since they were produced. They have attempted to make them speak and have described them from a background of many different prejudices.

A woman critic, a contemporary of Curtis, described a portrait of an Indian in the following manner: "One of the most remarkable portraits (...) there is a strange mingling of unconquerable dignity and cynicism in the face, a fine sarcasm hovers above the thin lips, all the wiliness and immobility of the typical Red Man are there, together with a certain eagle-like grandeur. And yet, with that sternly patrician nose and ironical mouth it might also be the face of a Roman Cynic. It is indeed a face of a man who, though he belongs to a vanquished race, would die without surrendering the secret of his inner self."

Such interpretations of the photographs are in keeping with the tradition of the "personality study," which was a very popular experimental science during the first half of the 19th century. So-called phrenology drew conclusions about a person's mental characteristics from his or her physiognomy, i.e. from the shape of the head, the distance between the eyes and the size of the temporal lobes. This type of procedure allowed researchers to draw the most diverse of conclusions and was not immune from the continuing influence of prejudices.

Curtis distanced himself completely from the anthropometry that was so popular at that time; it sought to quantify ethnology in a manner that was allegedly neutral and positivistic by using a ruler to measure body sizes, ear lengths and the distances between nostrils in inches or in centimeters, but this was nonetheless biased by the arrogance of the white man. Curtis's intentions were artistic and he adopted a humanistic approach. He was concerned with depicting the spiritual, and in order to bring this out in his pictures, he employed an arsenal of pictorial devices including the distribution of light and shadow, sharp and blurred focus, and especially cropping to heighten dramatic impact.

Needle-sharp portraits

Curtis was an extremely dedicated photographer, but time and circumstances did not always allow him to achieve technically perfect, optimal results. His numerous portraits could be needle-sharp or slightly blurred. Even though it might be slightly out of focus or not

formally perfect, if Curtis considered a photograph to be sufficiently important due to the expressiveness of the subject, he would also include it as "a lively snapshot" in his publication. Basically, however, he placed the greatest importance on picture quality, even before starting on his project: "I made one resolve, that the pictures should be made according to the best of modern methods and of a size that the face might be studied as the Indian's own flesh (…)."

Curtis had the great good fortune of being able to have his photographic work reproduced by the best possible technique available at the time: photogravure. Being practically screenless and silver-free, this intaglio process was essentially stable and permitted individual retouching of the photographic originals by highly qualified retouchers and printers. It was possible, for example, to enhance a cloudy sky, to lighten shadows, and to subsequently tone down details in the image that were deemed to be superfluous. The process even made it possible to improve slightly out-of-focus parts of a picture by means of manual intervention.

Curtis's print process: the photogravure

Of course it was impossible to correct all the image defects completely. Photogravure is a process that can be individually manipulated by the printer, but it is also a very time-consuming reproduction method, permitting only one print at a time to be made in a gravure press.

With so much manual work, it is not surprising that the volumes and portfolios 1 to 11, produced by the reputable firm of "John Andrew and Son" in Boston, exhibit nuances that are distinctly different from those in volumes 12 to 20. The latter were also produced in Boston, but by a slightly less perfectionist company of the name "Suffolk Engineering and Electrotyping Co." The reproductions in these volumes differ in quality, for instance in the color of the printing ink: from volume 12 onward the color brown is slightly paler. Color saturation also seems to be less intense, i.e. the blacks are less solid. These differences in quality must be taken into account when viewing the modern reproductions in this book, which were themselves produced in such a different manner.

Indians radiating power and dignity

Curtis's books contain a great deal of information that is available nowhere else and that had certainly never been published before. Today this photographer and researcher's life's work is preserved in manuscript departments, museums and library stockrooms. It did not reach such a wide public as Curtis had hoped for. His pictures of Indians embodying strength and dignity remain engraved in our minds, pictures that document a wide cultural diversity and that express the universal values of the family, the tribe and the nation. In Curtis's encyclopedia the Indian tribes are finally united in peace and brotherhood. The photogravures show the heritage of the Indian and make it part of American history. The photographs may be posed, idealistic and romantic, but they do represent an American dream, the call for a better world, a dream of pride and freedom.

Theodore Roosevelt
October 1, 1906

In Mr. Curtis we have both an artist and a trained observer, whose pictures are pictures, not merely photographs; whose work has far more than mere accuracy, because it is truthful. All serious students are to be congratulated because he is putting his work in permanent form; for our generation offers the last chance for doing what Mr. Curtis has done. The Indian as he has hitherto been is on the point of passing away. His life has been lived under conditions through which our own race passed so many ages ago that not a vestige of their memory remains. It would be a veritable calamity if a vivid and truthful record of these conditions were not kept. No one man alone could preserve such a record in complete form. Others have worked in the past, and are working in the present, to preserve parts of the record; but Mr. Curtis, because of the singular combination of qualities with which he has been blest, and because of his extraordinary success in making and using his opportunities, has been able to do what no other man has ever done; what, as far as we can see, no other man could do. He is an artist who works out of doors and not in the closet. He is a close observer, whose qualities of mind and body fit him to make his observations out in the field, surrounded by the wild life he commemorates. He has lived on intimate terms with many different tribes of the mountains and the plains. He knows them as they hunt, as they travel, as they go about their various avocations on the march and in the camp. He knows their medicine men and sorcerers, their chiefs and warriors, their young men and maidens. He has not only seen their vigorous outward existence, but has caught glimpses, such as few white men ever catch, into that strange spiritual and mental life of theirs; from whose innermost recesses all white men are forever barred. Mr. Curtis in publishing this book is rendering a real and great service; a service not only to our own people, but to the world of scholarship everywhere.

THE
NORTH AMERICAN
INDIAN

BEING A SERIES OF VOLUMES PICTURING
AND DESCRIBING

THE INDIANS OF THE UNITED STATES
AND ALASKA

WRITTEN, ILLUSTRATED, AND
PUBLISHED BY
EDWARD S. CURTIS

EDITED BY
FREDERICK WEBB HODGE

FOREWORD BY
THEODORE ROOSEVELT

FIELD RESEARCH CONDUCTED UNDER THE
PATRONAGE OF
J. PIERPONT MORGAN

IN TWENTY VOLUMES
THIS, THE FIRST VOLUME, PUBLISHED IN THE YEAR
NINETEEN HUNDRED AND SEVEN

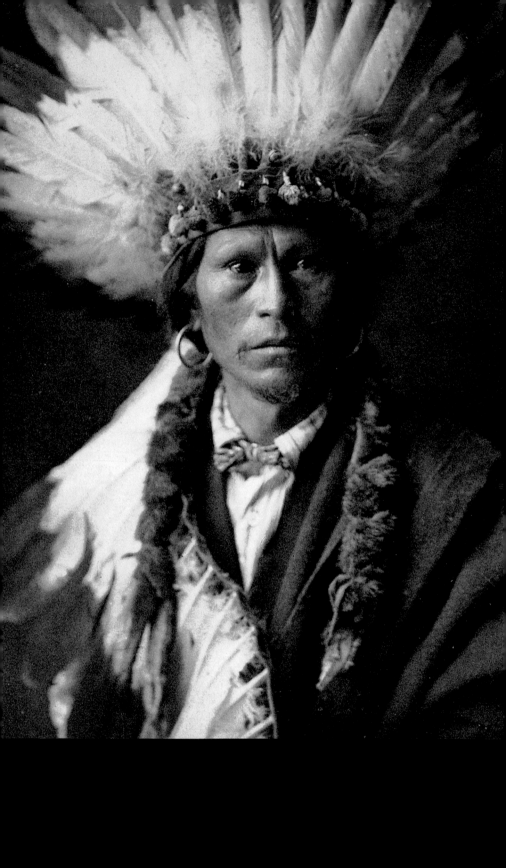

Apache

Jicarillas

Navaho

Volume I

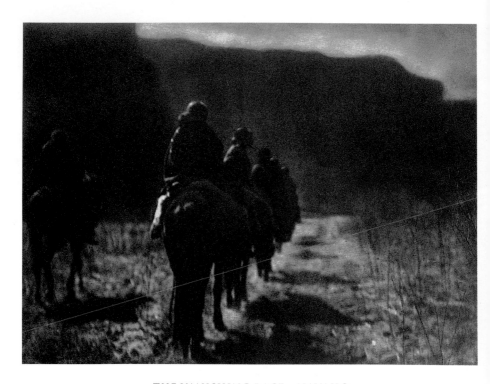

THE VANISHING RACE – NAVAHO

The thought which this picture is meant to convey is that the
Indians as a race, already shorn of their tribal strength and stripped of
their primitive dress, are passing into the darkness of an unknown future.
Feeling that the picture expresses so much of the thought that inspired
the entire work, the author has chosen it as the first of the series.

PAGE 34
CHIEF GARFIELD – JICARILLA

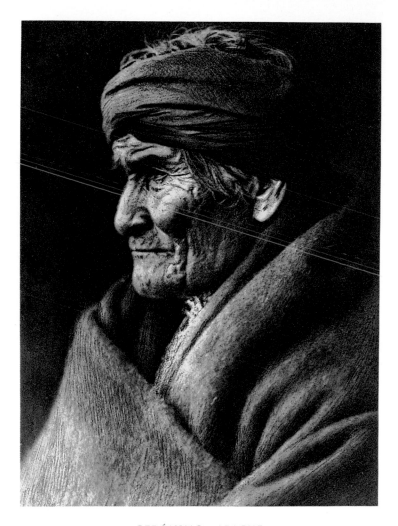

GERÓNIMO – APACHE

This portrait of the historical old Apache was made in March,
1905. According to Gerónimo's calculation, he was at that time
seventy-six years of age, thus making the year of his birth 1829.
The picture was taken at Carlisle, Pennsylvania, the day before
the inauguration of President Roosevelt, Gerónimo being one
of the warriors who took part in the inaugural parade at
Washington. He appreciated the honor of being one of
those chosen for this occasion.

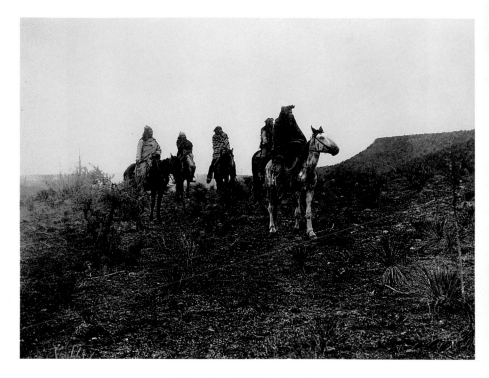

DESERT ROVERS – APACHE

The White Mountain Apache and the desert portion of
their country. The picture was made on a gray day of early
spring, when the Apache wear blankets as a protection against
the keen air of their mountain home.

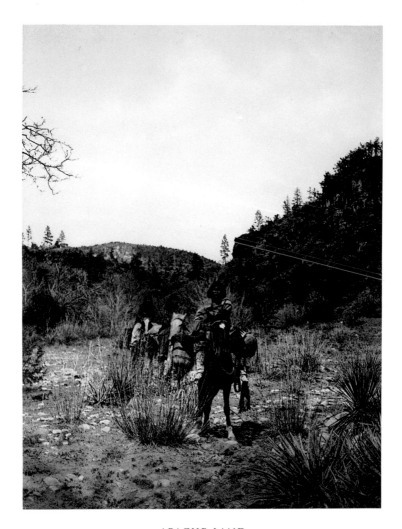

APACHE-LAND

Apache horsewomen in a small valley of the White Mountain
region. The horses are laden with the complete camp equipage,
on top of which the women have taken their seats.

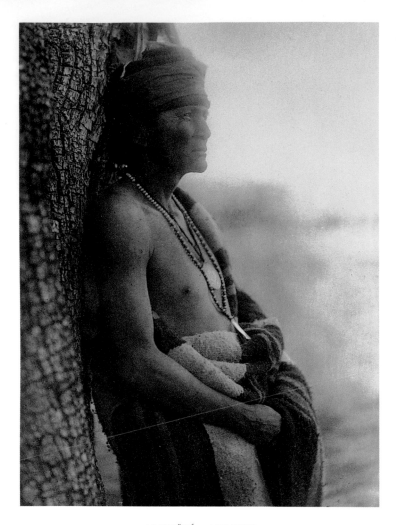

ALCHĪSÉ – APACHE

Chief of the White Mountain Apache. A well-known character,
having been a scout with General Crook. Colonel Cooley, who
was chief of scouts under Crook, says a braver man than Alchīsé
never lived. He was about twenty-two years of age when Fort
Apache, then Camp Ord, was established in 1870, making the
year of his birth about 1848. This portrait was made at Alchīsé's
camp on White River in the spring of 1903.

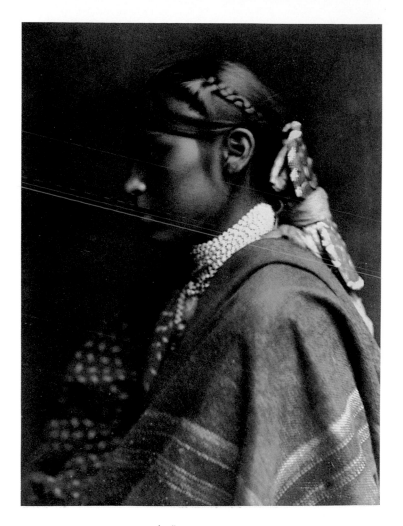

SÍGĒSH – APACHE

This illustrates the girls' method of tying the hair previous
to marriage. The ornament fastened to the hair in the back
is made of leather, broad and round at the ends and narrow
in the middle.

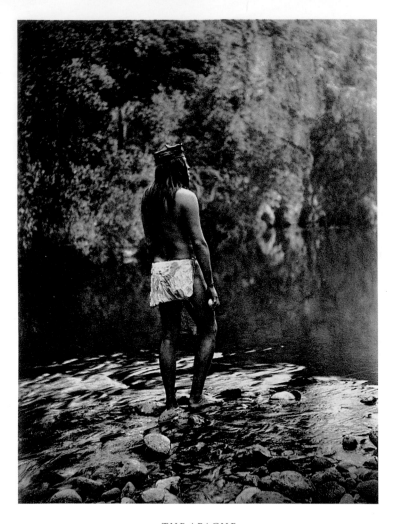

THE APACHE

This picture might be titled "Life Primeval." It is the Apache
as we would mentally picture him in the time of the Stone Age.
It was made at a spot on Black River, Arizona, where the dark,
still pool breaks into the laugh of a rapids.

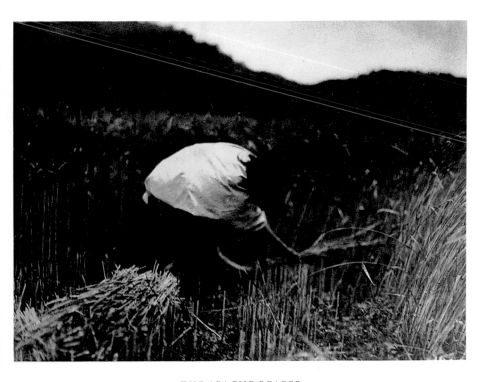

THE APACHE REAPER

Here the Apache woman is seen in her small wheatfield
harvesting the grain with a hand sickle, the method now
common to all Indians of the Southwest.

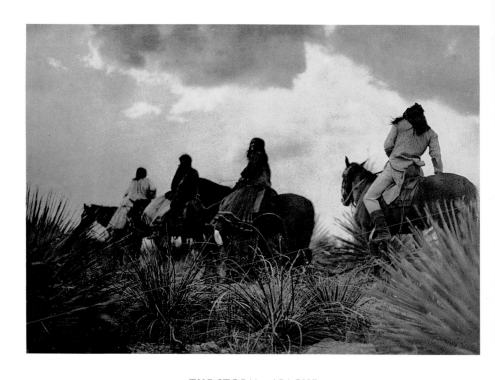

THE STORM – APACHE

A scene in the high mountain of Apache-land just
before the breaking of a rainstorm.

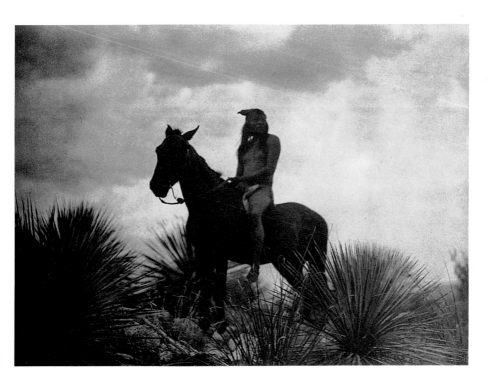

THE SCOUT – APACHE

The primitive Apache in his mountain home.

GETTING WATER – APACHE

A picture made in early spring on the banks of White River,
Arizona. The water bottle is the typical Apache one of
basketry covered with piñon gum.

STORY-TELLING – APACHE

A story-telling group, particularly typical of these people.
The Apache often sit about and exchange stories of the
past or of today.

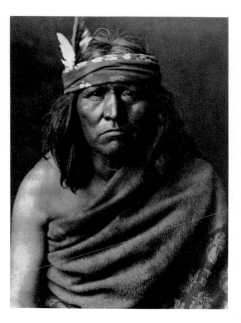

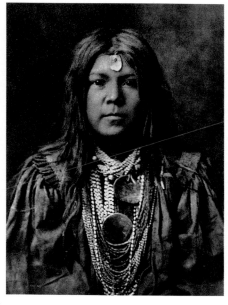

RENEGADE TYPE – APACHE

No picture could better show the old renegade type of the Apache than this one of Genitoa. It is the type of Indian who has yielded to the inevitable and lives in peace – not because he prefers it, but because he must.

APACHE NALÍN

An Apache girl about fourteen years of age.

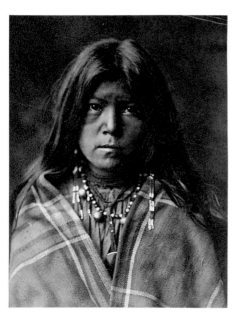

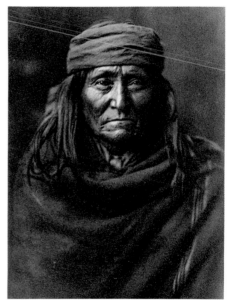

CHIDĚH – APACHE

ÉSKADI – APACHE

A headman of one of the bands, and
a particularly fine Apache type.

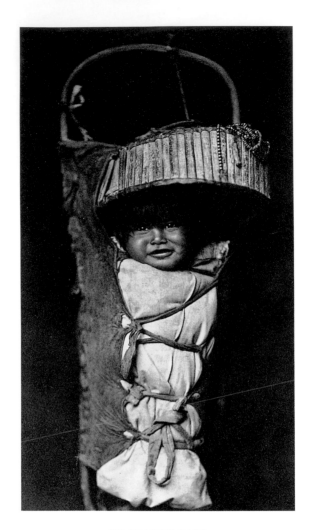

AN APACHE BABE

A fortunate child picture, giving a good idea of the happy
disposition of Indian children, and at the same time
showing the baby carrier or holder.

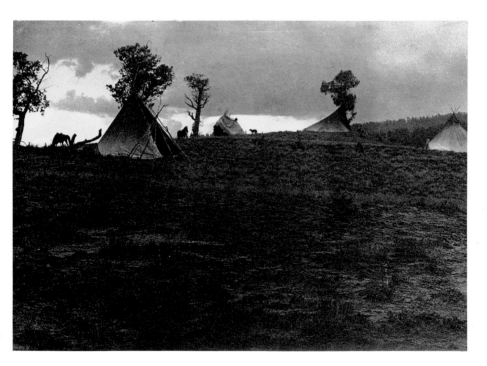

A HILLTOP CAMP – JICARILLA

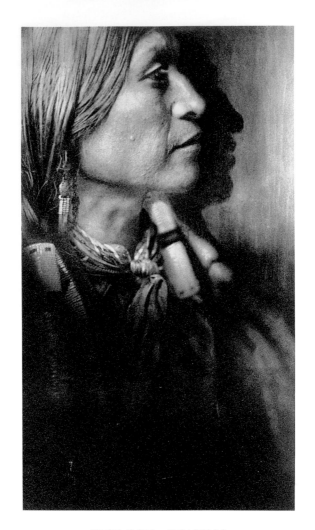

VASH GON – JICARILLA

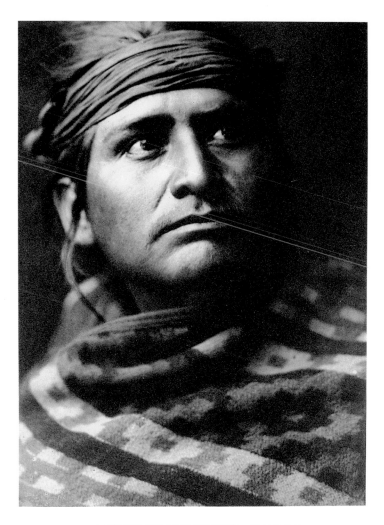

A CHIEF OF THE DESERT – NAVAHO

Picturing not only the individual but a characteristic member
of the tribe – disdainful, energetic, self-reliant.

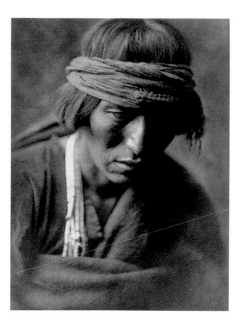

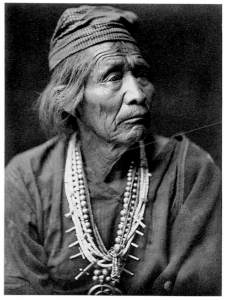

HASTOBÍGA –
NAVAHO MEDICINE-MAN

NĚSJÁJA HATÁLĬ –
NAVAHO

A well-known Navaho medicine-man. While in
the Cañon de Chelly the writer witnessed a very
interesting four-day ceremony given by the Wind
Doctor. Něsjája Hatálĭ was also assistant medicine-
man in two nine-day ceremonies studied – one
in Cañon del Muerto and the other at the
mouth of Cañon de Chelly.

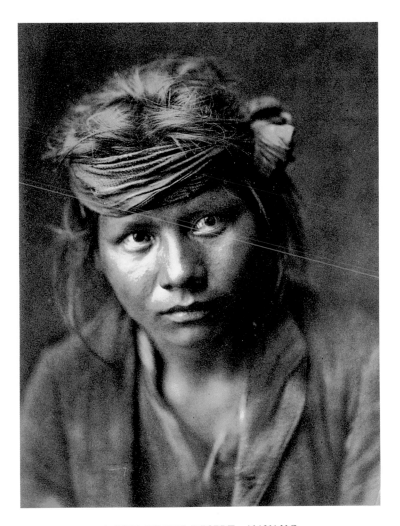

A SON OF THE DESERT – NAVAHO

In the early morning this boy, as if springing from the earth
itself, came to the author's desert camp. Indeed, he seemed a
part of the very desert. His eyes bespeak all the curiosity, all
the wonders of his primitive mind striving to grasp the
meaning of the strange things about him.

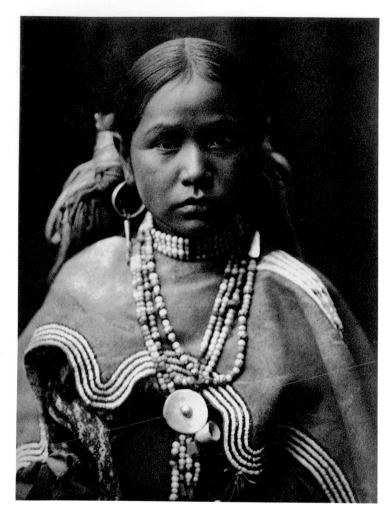

JICARILLA MAIDEN

This pictures exceedingly well the typical Jicarilla women's dress: a cape of deerskin, beaded, a broad belt of black leather, a deerskin skirt, and the hair fastened at each side of the head with a large knot of yarn or cloth.

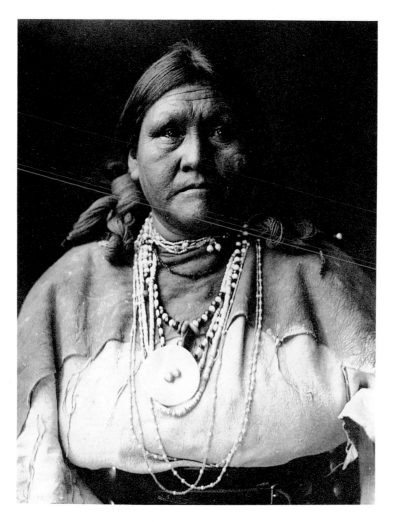

JICARILLA MATRON

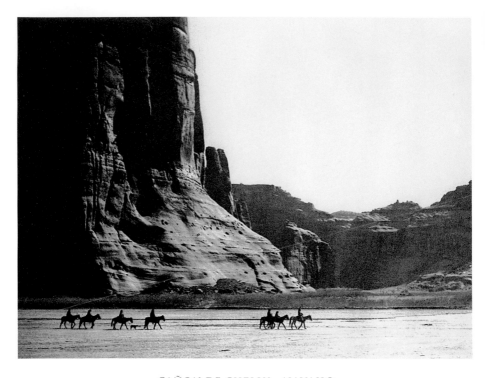

CAÑON DE CHELLY – NAVAHO

A wonderfully scenic spot is this in northeastern Arizona, in the
heart of the Navaho country – one of their strongholds, in fact.
Cañon de Chelly exhibits evidence of having been occupied by a
considerable number of people in former times, as in every niche
at every side are seen the cliff-perched ruins of former villages.

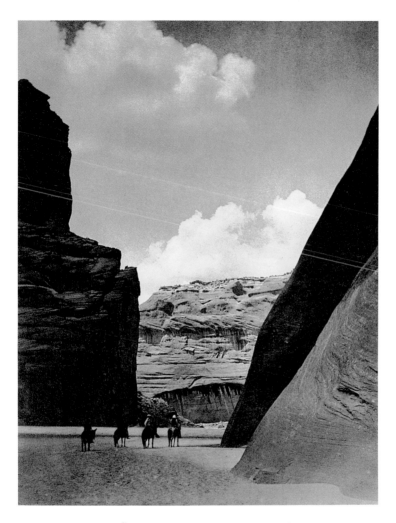

CAÑON DEL MUERTO – NAVAHO

This "Cañon of the Dead" is a branch of Cañon de Chelly,
deriving its name from having been the scene of the massacre
of a band of Navaho by a troop of Mexican soldiers.

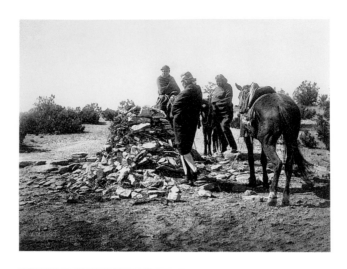

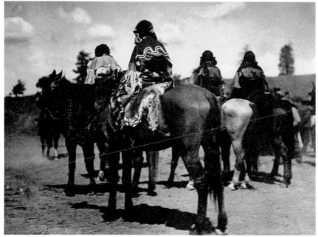

AT THE SHRINE – NAVAHO

Scattered about the Navaho reservation are many cairn
shrines. The Navaho, when alone or in parties, on approach-
ing one of these gathers a few twigs of piñon or cedar, places
them on the shrine, scatters a pinch of sacred meal upon it,
and makes supplication for that which he may habitually
need or which the moment demands.

JICARILLA WOMEN

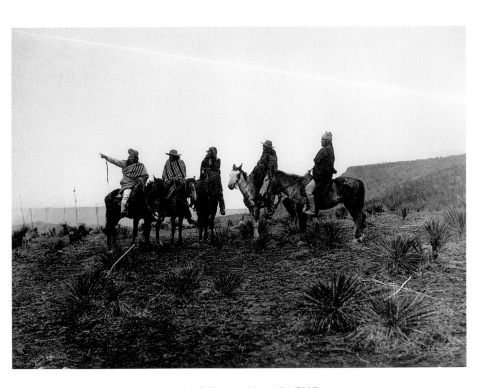

THE LOST TRAIL – APACHE

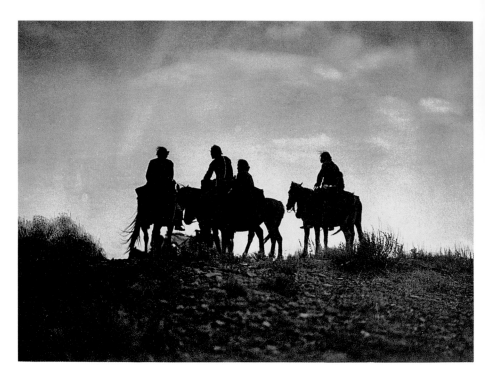

SUNSET IN NAVAHO-LAND

WOMEN OF THE DESERT - NAVAHO

The Navaho women are, for the greater part, the owners of the
flocks and invariably, with the children, the herders. They are so
thoroughly at home on their scrubby ponies that they seem a part
of them and probably excel all other Indians as horsewomen.

A DRINK IN THE DESERT ~ NAVAHO

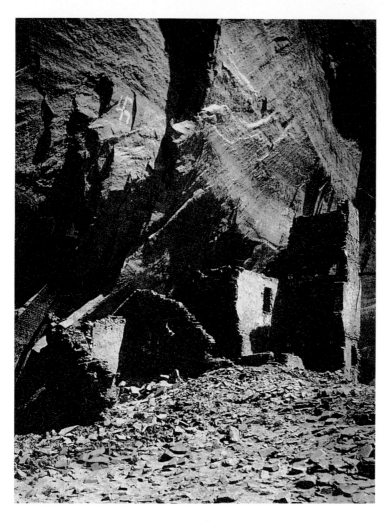

ANTELOPE RUIN – CAÑON DEL MUERTO

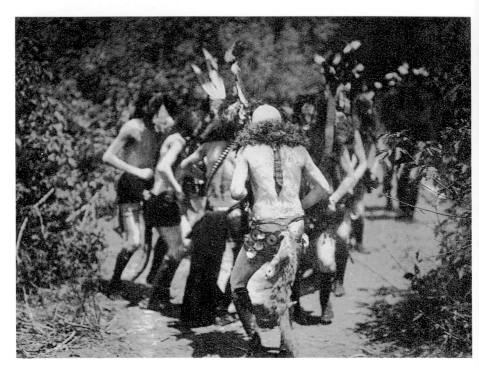

YÉBĬCHAI DANCERS − NAVAHO

MESCAL HARVEST – APACHE

CUTTING MESCAL – APACHE

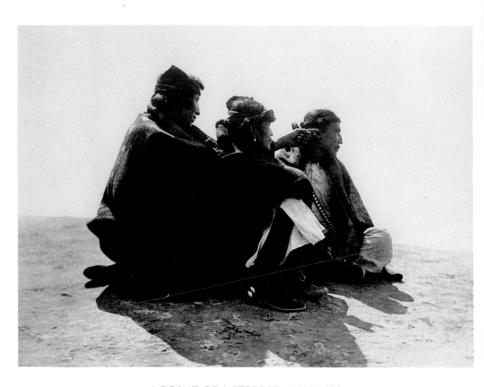

A POINT OF INTEREST – NAVAHO

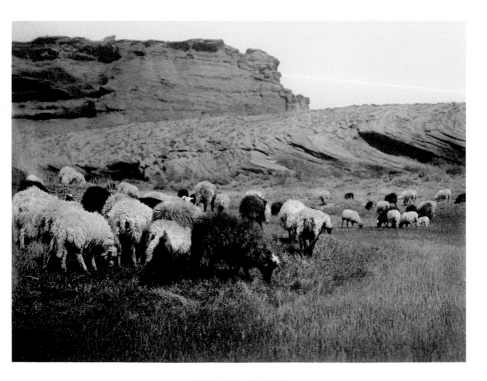

NAVAHO FLOCKS

The Navaho might well be called the "Keepers of Flocks."
Their sheep are of the greatest importance to their existence,
and in the care and management of their flocks they exhibit
a thrift not to be found in the average tribe.

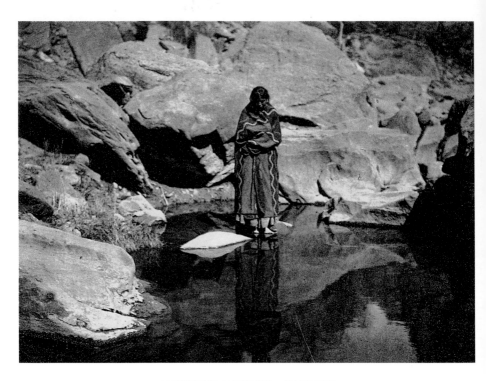

NATURE'S MIRROR – NAVAHO

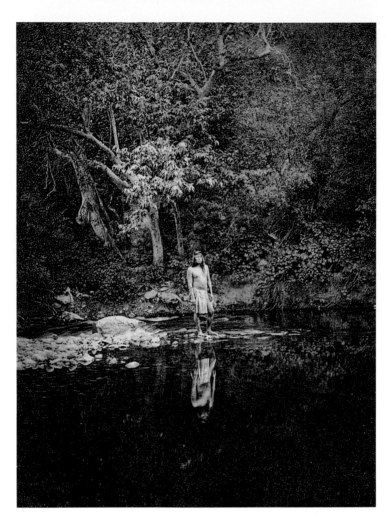

THE POOL – APACHE

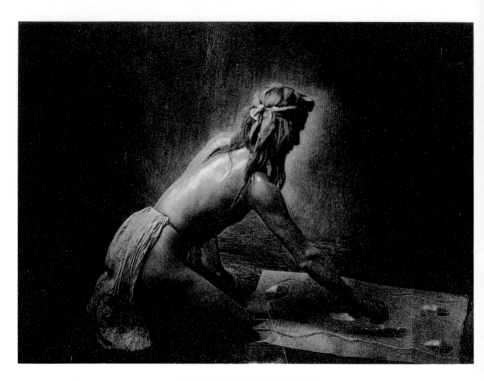

APACHE MEDICINE-MAN

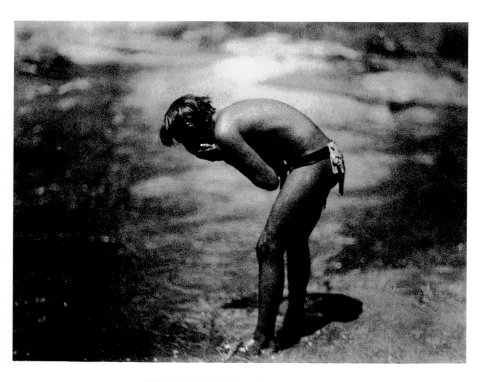

THE MORNING BATH – APACHE

The Apache, old and young alike, are particularly fond of bathing,
and make the most of every opportunity to have a swim. They call
it "a swim" regardless of how shallow the water may be, just so
long as they can wash their bodies.

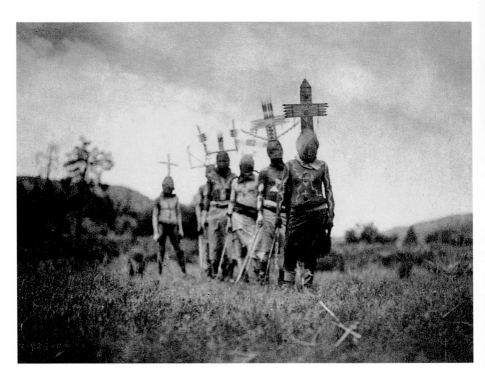

APACHE GÁÚN

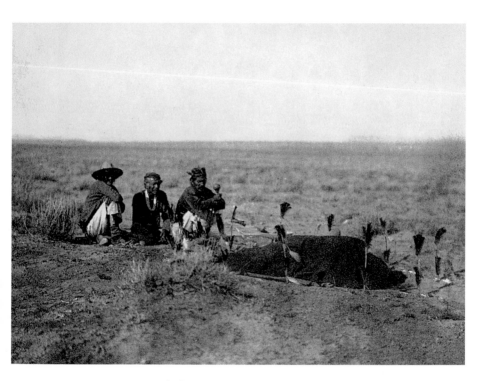

YÉBĬCHAI SWEAT – NAVAHO

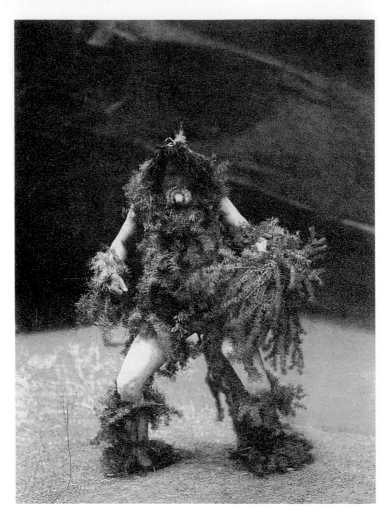

TÓNENĬLĬ – NAVAHO

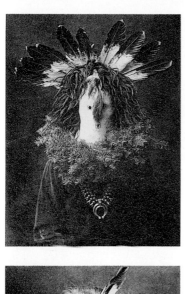

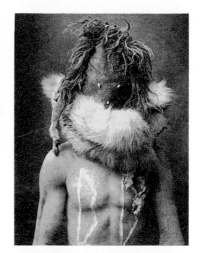

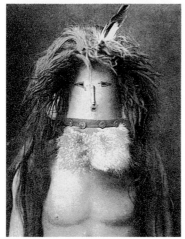

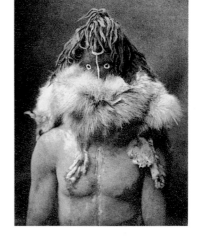

HASCHÓGAN – NAVAHO

NAYÉNÈZGANÌ – NAVAHO

HASCHĔBAÁD – NAVAHO

HASCHÉZHÌNÌ – NAVAHO

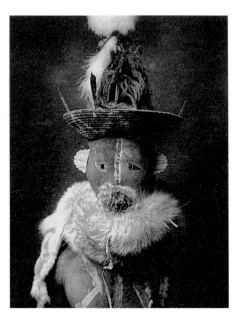 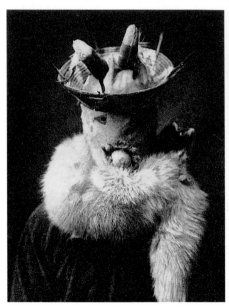

ZAHADOLZHÁ – NAVAHO GÁⁿASKĬDĬ – NAVAHO

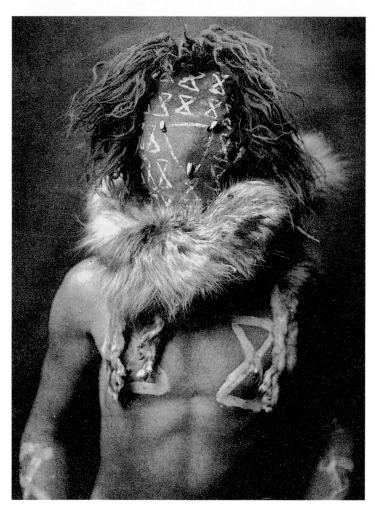

TOBADZĬSCHÍNĬ – NAVAHO

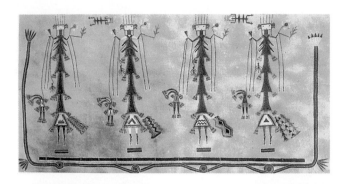

ALHKĪDÓKĪHĪ – NAVAHO

One of the four elaborate dry-paintings or sand altars
employed in the rites of the Mountain Chant, a Navaho
medicine ceremony of nine days' duration.

APACHE CAMP

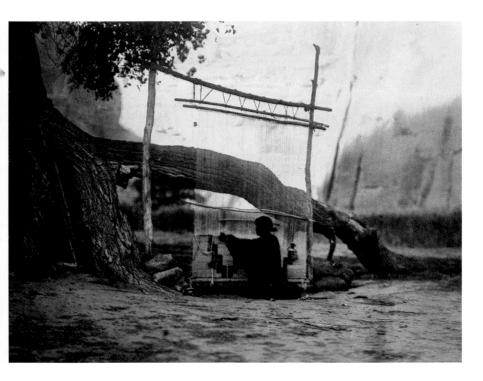

THE BLANKET WEAVER – NAVAHO

In Navaho-land blanket looms are in evidence everywhere.
In the winter months they are set up in the *hogáns*, but during
the summer they are erected outdoors under an improvised
shelter, or, as in this case, beneath a tree. The simplicity of the
loom and its product are here clearly shown, pictured in the
early morning light under a large cottonwood.

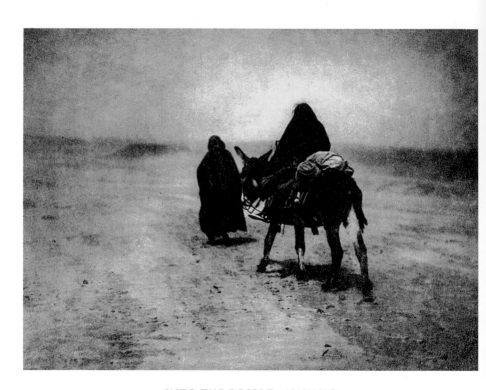

INTO THE DESERT – NAVAHO

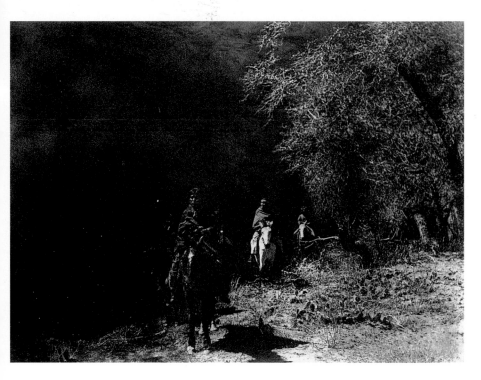

OUT OF THE DARKNESS – NAVAHO

In Tésakod Cañon, a small branch of Cañon de Chelly. At the
point where this picture was made the gorge is very narrow.

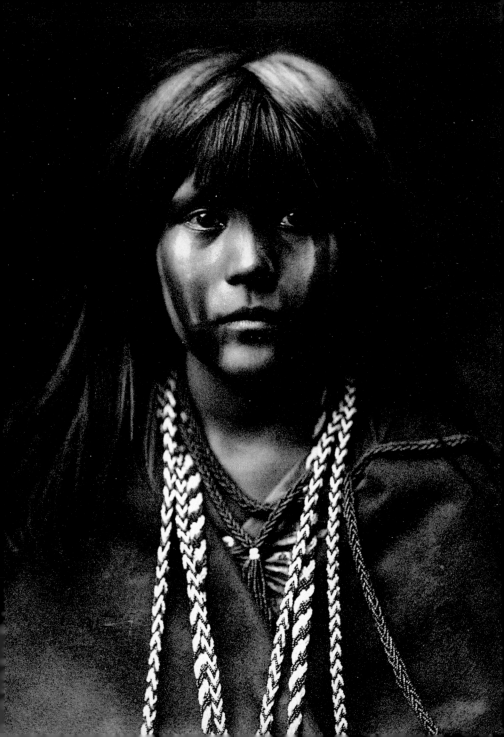

PIMA

PAPAGO

QÁHATĬKA

MOHAVE

YUMA

MARICOPA

WALAPEI

HAVASUPAI

APACHE-MOHAVE

YAVAPAI

VOLUME II

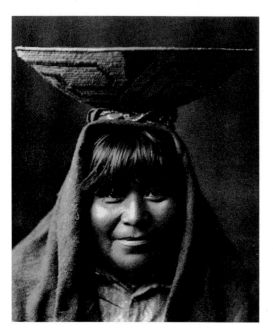

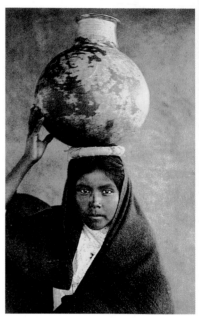

PIMA MATRON

QAHÁTĬKA WATER GIRL

A representative Pima woman of middle age.

PAGE 84
MÓSA – MOHAVE

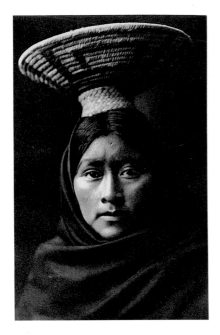

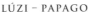

LÚZI – PAPAGO

The Papago women always carry their burdens
on, or supported from, their heads. When the
burden – be it basket, pottery, or a box – has
a flat or a rounded bottom, the ring of woven
yucca is placed on the head in order to give
the load a firm position for carrying, and to
relieve the bearer of the pressure.

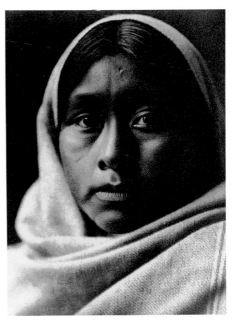

PAPAGO GIRL

A particularly fine-looking Papago girl of as
nearly pure blood as can be found in the region.
The northern Piman tribes have been in direct
contact with Spanish people for more than two
centuries. Much of the early foreign blood, how-
ever, has become so blended that its physical
influence is no longer apparent.

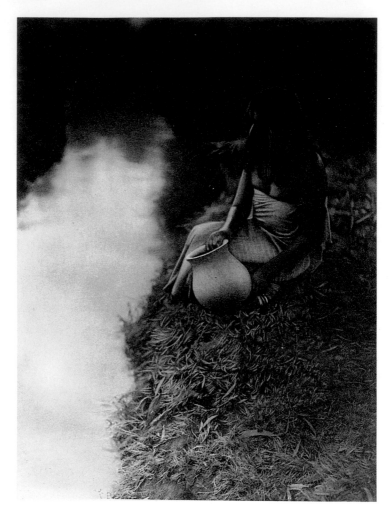

BY THE CANAL – MARICOPA

Earthen utensils of native manufacture are in general use among
the Maricopa. Large jars are kept in the houses to be filled with a
day's supply of water; smaller ones are used for conveying water,
and as cooking utensils.

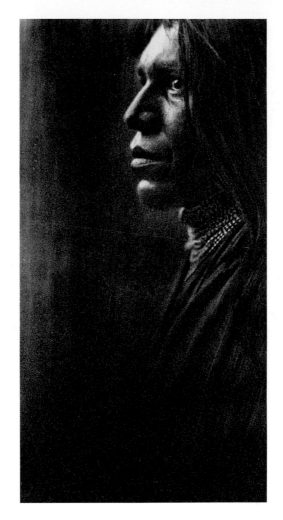

THE YUMA

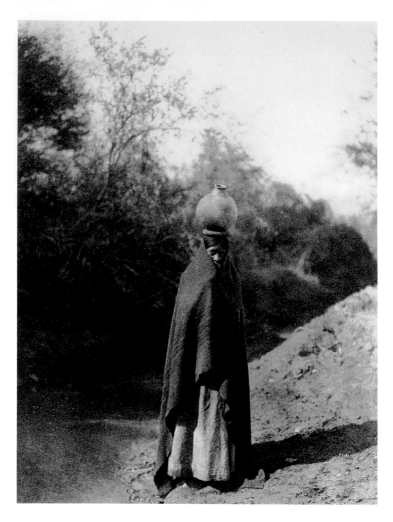

MARICOPA GIRL

The young Maricopa women affect the Mexican more
than the Indian dress; but they are by no means unpicturesque
in their garb of many colors as they gracefully bear their
burdens on their heads.

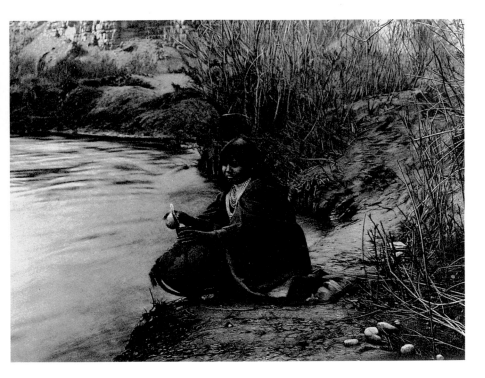

GETTING WATER – HAVASUPAI

The beautiful limpid Havasu flows the entire length of
Cataract Cañon, furnishing the Havasupai with ample water
for irrigation and for domestic use. They carry the household
supply of water in gummed wicker bottles held in place on
the back by a burden strap passing across the forehead,
in a manner similar to that of the Hopi.

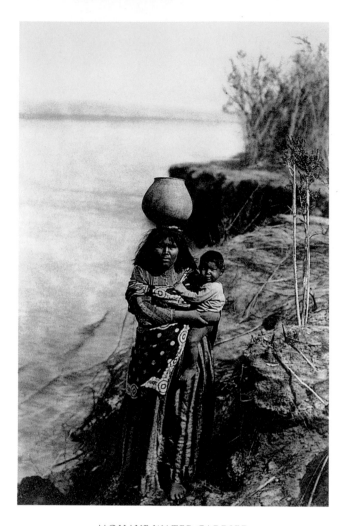

MOHAVE WATER CARRIER

A Mohave mother on the bank of the Colorado River. The
Mohave carry practically all burdens on their heads. Being
unusually large and strongly built, the women thus bear immense
loads with apparent ease. A woman has been seen to balance on
her head a railroad tie of such weight that a strong man could
do no more than to pick it up, and in addition a heavy load
in each hand.

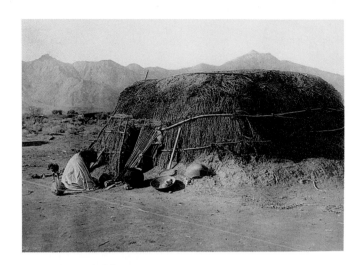

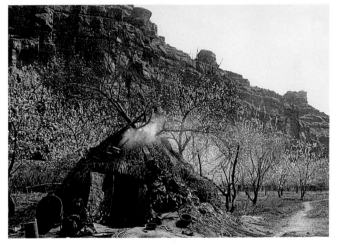

PIMA KI

The old-time round dwelling of the Piman tribes. The *ki*
was usually about 15 feet in diameter. As the winter climate of
southern Arizona is very mild, only a small fire was needed
to keep the *ki* warm in even the coldest weather.

HOME OF THE HAVASUPAI

The Havasupai dwelling is a dome-shaped framework of poles.

STONE MAZE

PIMA BURIAL GROUNDS

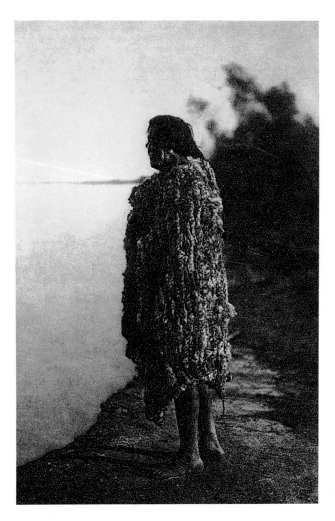

MOHAVE MAN

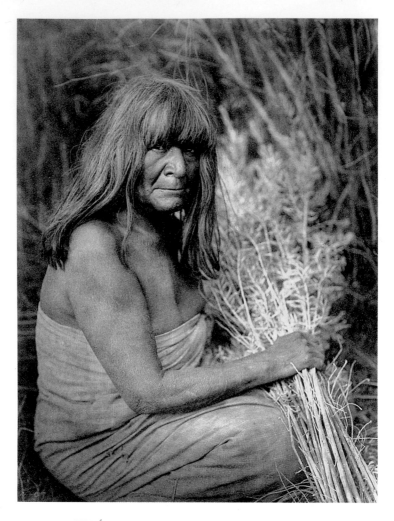

HIPÁH WITH ARROW-BRUSH – MARICOPA

Arrow-brush is extensively used by the tribes of this region as
a covering for their houses. In earlier time they lived in circular
houses constructed of a framework of heavy poles covered with
arrow-brush and coated with mud. In many of the modern
rectangular houses, also, the arrow-brush is used, bound together
closely with withes, and plastered on the outside with adobe.

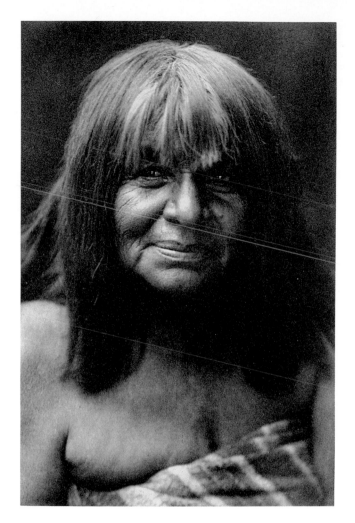

HAVACHÁCH – MARICOPA

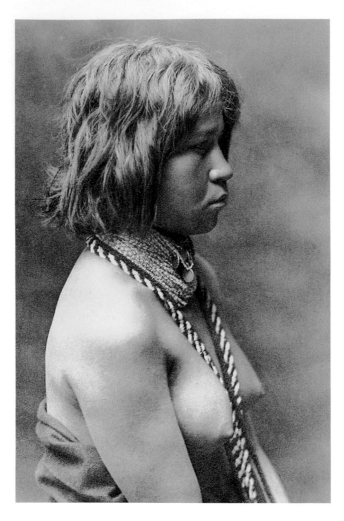

JUDITH – MOHAVE

A young Mohave woman eighteen years of age.

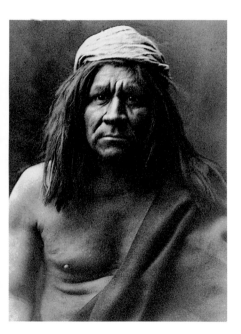

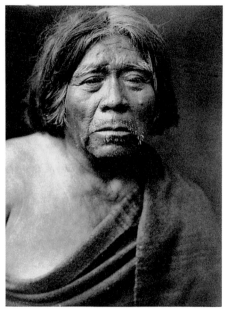

MOHAVE CHIEF

A representative type of the Mohave men.

MAT STAMS – MARICOPA

This individual exhibits strongly the characteristics
of the Yuman stock to which he belongs.

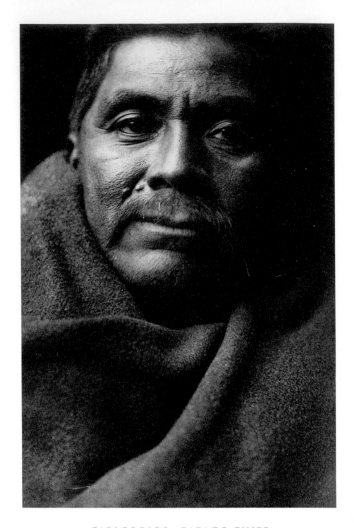

CARLOS RIOS – PAPAGO CHIEF

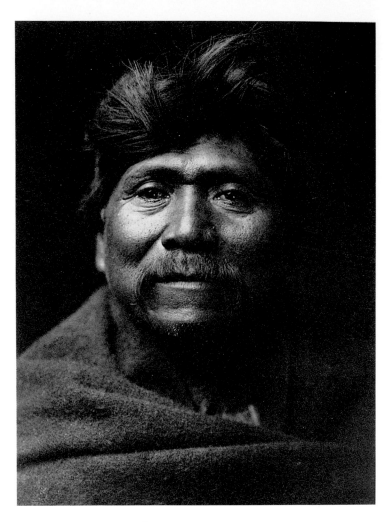

PACHÍLAWA – WALAPAI CHIEF

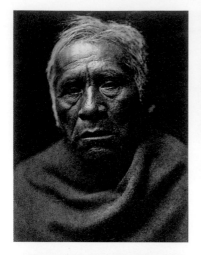

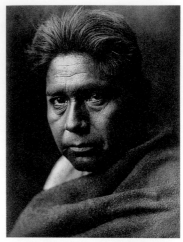

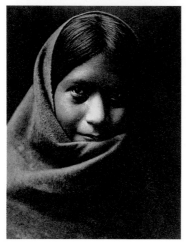

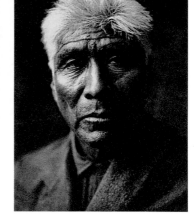

CAPTAIN CHARLEY – MARICOPA

This portrait shows clearly the strongly Yuman cast of features retained by this branch of the stock.

PAKÍT – MARICOPA

CHIJÁKO – PIMA

A representative Pima man of middle age.

KÁVIU – PIMA

The Pima are bright, active, and progressive Indians, as the portrait of this typical man of the tribe attests.

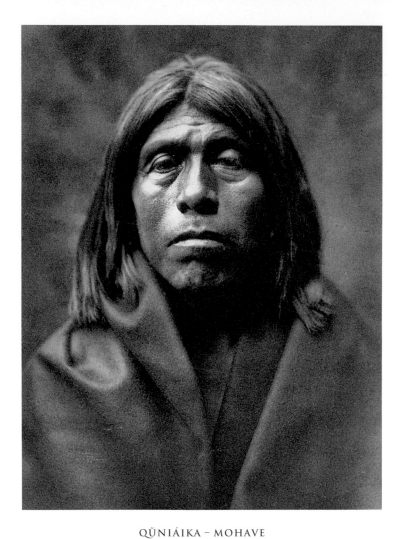

QŬNIÁIKA – MOHAVE

Although this pictures one of the best of his tribe, it serves
as well to illustrate a man of the Age of Stone.

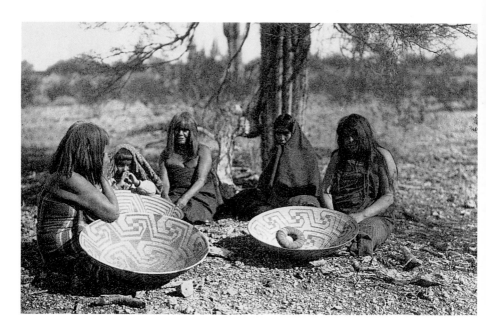

MARICOPA GROUP

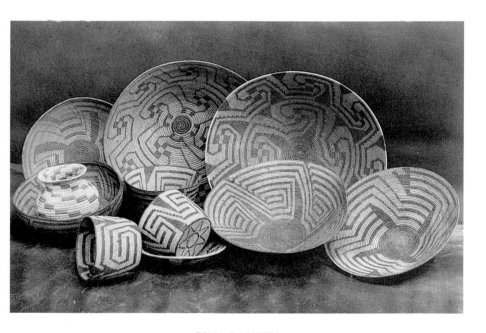

PIMA BASKETS

The baskets made by the Pima, Papago, and Qahátika, as well
as by their Maricopa neighbors, are practically identical in form
and design, but the Maricopa basketry is of somewhat superior
workmanship. The four-armed cross, a form of the swastika, appears
as a central feature in the decoration of a majority of the Piman and
Maricopa baskets of to-day, and while the true signification here is
not known with certainty, it is not impossible that it was designed
originally to represent the winds of the four cardinal directions.

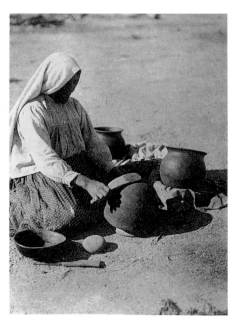

PAPAGO POTTER

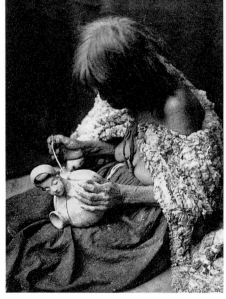

MOHAVE POTTER

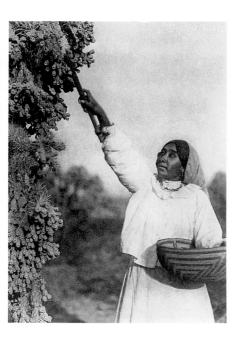

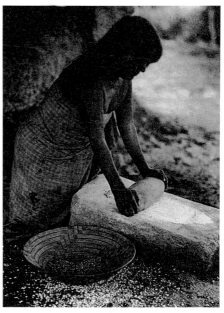

GATHERING HÁNAMH – PAPAGO

Hánamh is the Piman name for the cholla cactus
and its fruit. The natives gather the fruit of this spiny
plant in large quantities, and it forms a food of mate-
rial importance. In gathering it they use rude tongs
made from a split stick. After a basket is filled, the
fruit is spread on the ground and brushed about with a
small, stiff besom until the spines are worn off, or the
spines are burned off in an open fire.

MARICOPA WOMAN MEALING

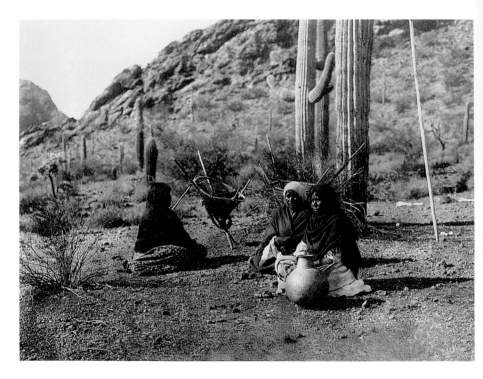

RESTING IN THE HARVEST FIELD –
QAHÁTĬKA

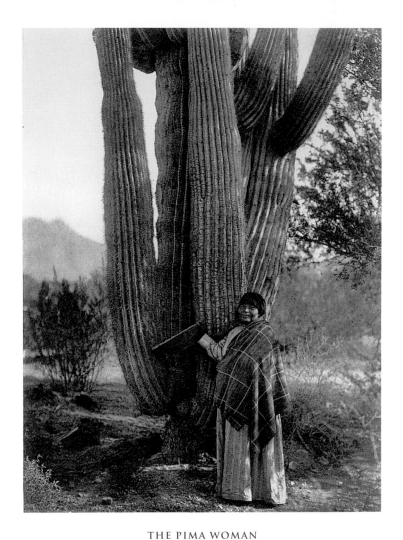

THE PIMA WOMAN

This picture gives also an idea of the size attained
by the giant cactus, or saguaro.

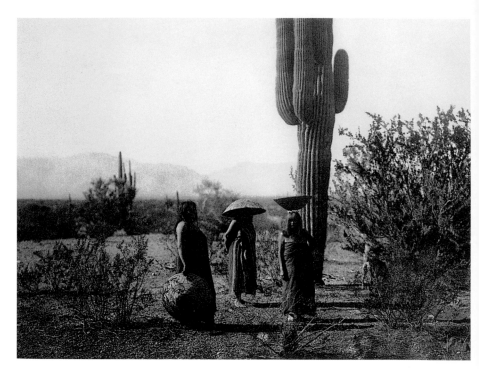

SAGUARO FRUIT GATHERERS – MARICOPA

Like their Piman neighbors, the Maricopa gather large quantities
of the fruit of the saguaro, or giant cactus, which they relish in
its natural state as well as in the form of wine or preserve.

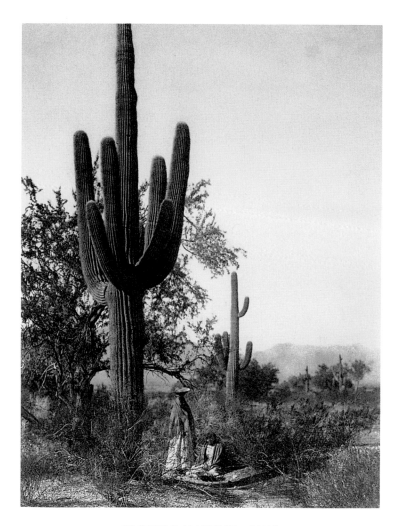

SAGUARO HARVEST – PIMA

The fruit of the saguaro, or giant cactus, called *hásĕn* by the Pima, forms a very important source of the food supply of the tribes of southern Arizona. This fruit is of about the size of a small pear, and is very sweet. It is eaten fresh, dried, or in the form of syrup, and a sort of wine is made from its juice. In gathering it the natives use a long pole with a wooden blade at the end.

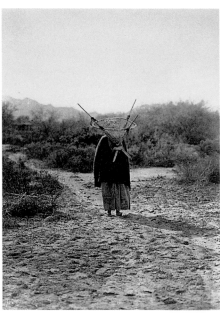

HAVASUPAI CLIFF DWELLING

THE BURDEN BEARER – PIMA

This illustration shows the typical burden basket of
the several Piman tribes of southern Arizona, called
kího in the Piman language. Their mythology relates
that once the *kího* was an animate being, but owing to
disobedience of divine laws when the people emerged
from the under-world, it became inanimate, and has
since been carried on the backs of women.

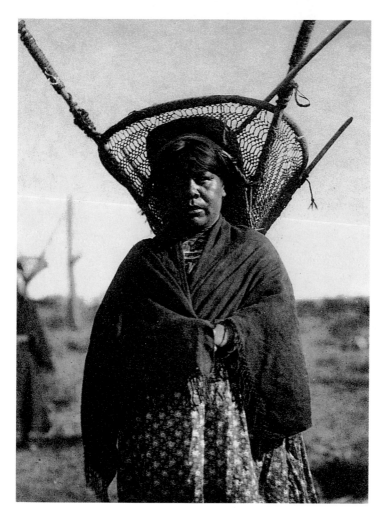

KÍHO CARRIER – QAHÁTĬKA

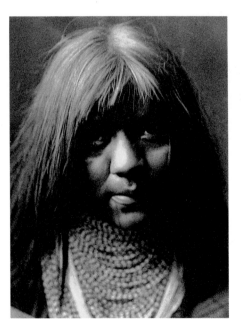

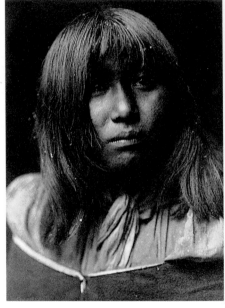

HWÁLYA – YUMA

A Yuma girl, characteristic of southern
Yuman maidenhood.

TONOVÍGĚ – HAVASUPAI

This portrait was made in winter while a party of
Havasupai were encamped in the high country above
their cañon home. As a snowstorm was raging at the
time, the woman's hair became dotted with flakes,
as the picture reveals.

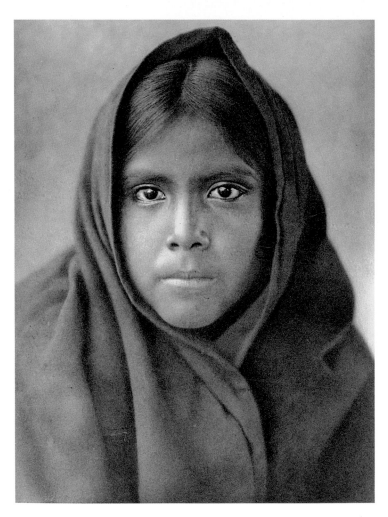

QAHÁTĬKA GIRL

AUTHOR'S CAMP, WALAPAI-LAND

WALAPAI WINTER CAMP

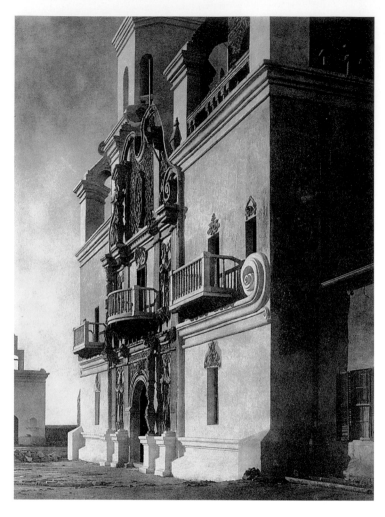

FAÇADE – SAN XAVIER DEL BAC MISSION

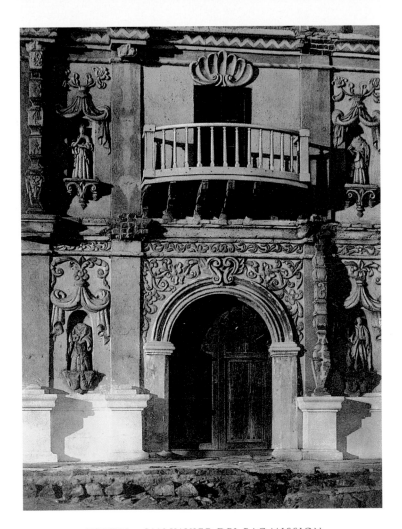

PORTAL – SAN XAVIER DEL BAC MISSION

San Xavier del Bac is one of the most beautiful of the old
Southwestern mission churches. The mission was founded
in 1692; the construction of the present church was commenced
in 1783 and finished fourteen years later. It has recently been
repaired, and is in a good state of preservation.

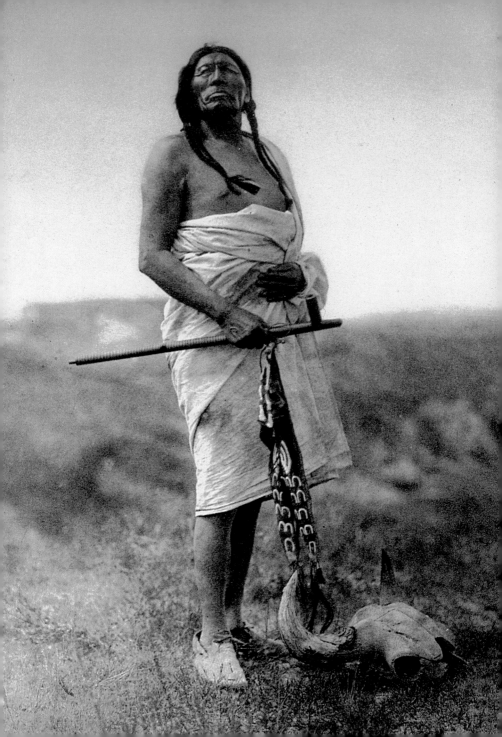

Teton Sioux

Yanktonai

Assiniboin

Volume III

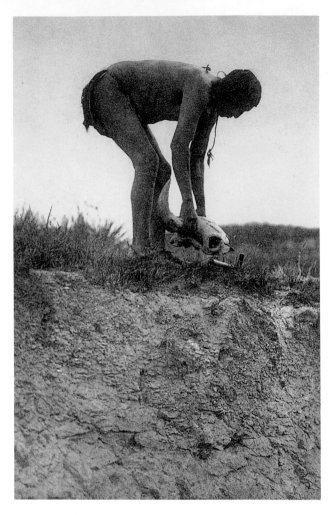

HUᴺKÁ-LOWAᴺPI – FIRE-CARRIER BRINGING
THE SKULL

PAGE 120
THE MEDICINE-MAN

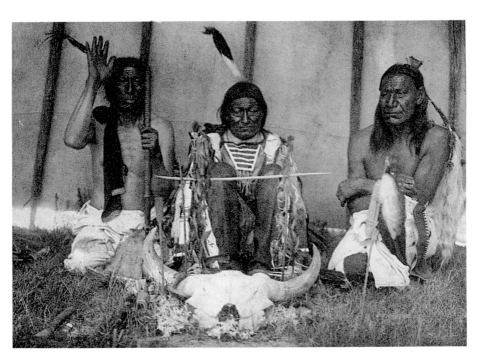

HUNKÁ-LOWANPI – THE ALTAR COMPLETE

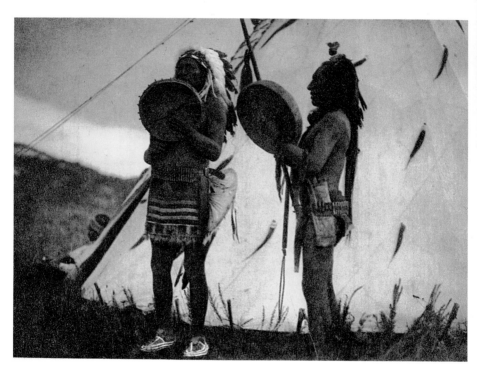

SINGING DEEDS OF VALOR

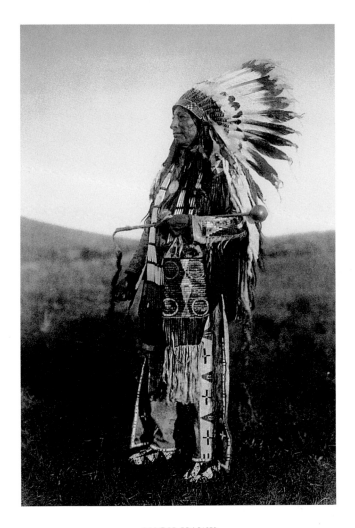

HIGH HAWK

The subject is shown in all the finery of a warrior dressed for
a gala occasion – scalp-shirt, leggings, moccasins, pipe-bag, all
embroidered with porcupine-quills; eagle-feather war-bonnet, and
stone-headed war-club from the handle of which dangles a scalp.
High Hawk is prominent among the Brulés mainly because he is
now their leading historical authority, being much in demand to
determine the dates of events important to his fellow tribesmen.

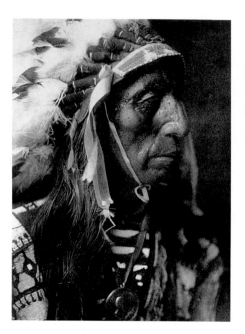

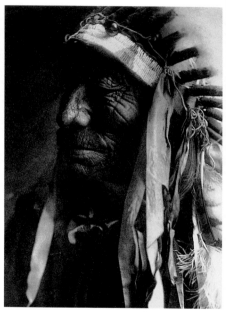

JACK RED CLOUD

The subject of this portrait is the son of
the Oglala chief Red Cloud.

FAST ELK

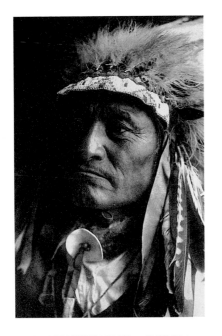

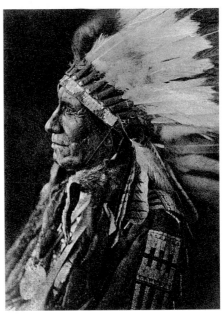

CRAZY THUNDER – OGLALA

A splendid specimen of the Teton Sioux.

AMERICAN HORSE – OGLALA

This subject is one of the four chiefs
who died in December, 1908.

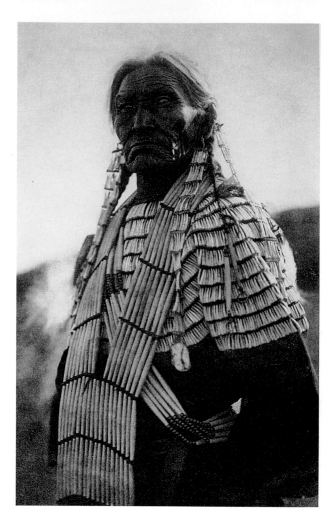

SLOW BULL'S WIFE

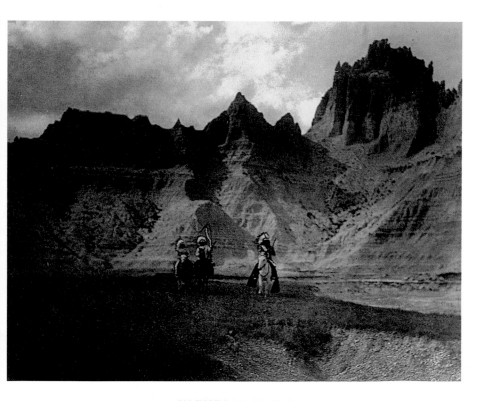

IN THE BAD LANDS

This striking picture was made at Sheep Mountain in the
Bad Lands of Pine Ridge reservation, South Dakota.

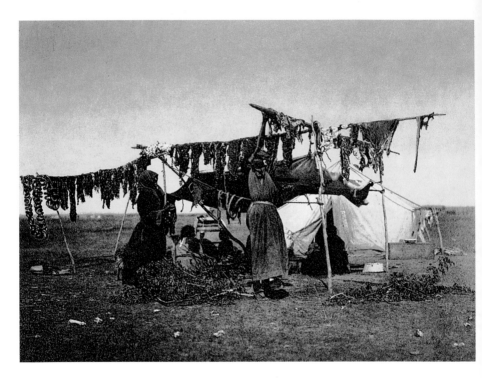

DRYING MEAT

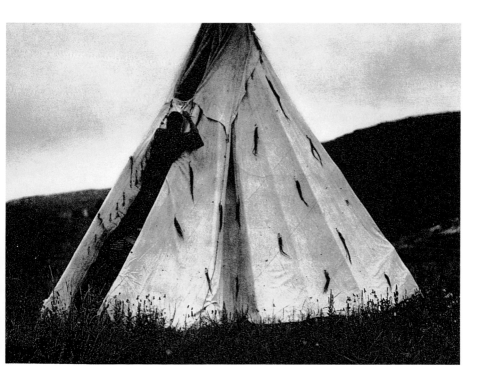

TIPI CONSTRUCTION

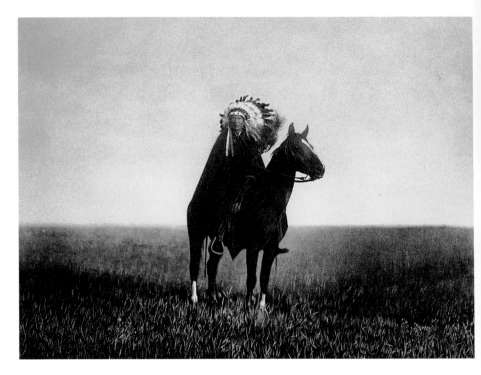

THE PRAIRIE CHIEF

This picture was made on the Pine Ridge reservation in
South Dakota at a time when the Indians were assembled
in a large encampment, reliving the days of old.

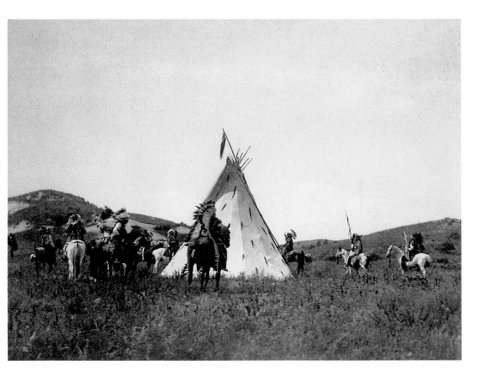

SIOUX CAMP

It was customary for a war-party to ride in circles
about the tipi of their chief before starting on a raid
into the country of the enemy.

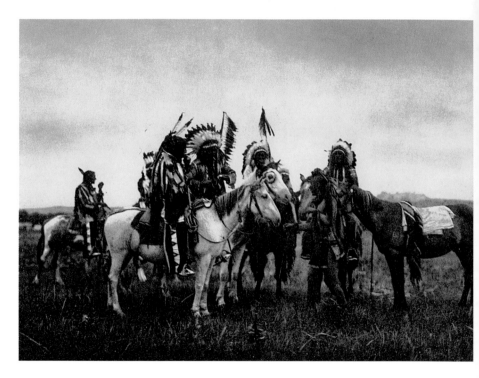

THE PARLEY

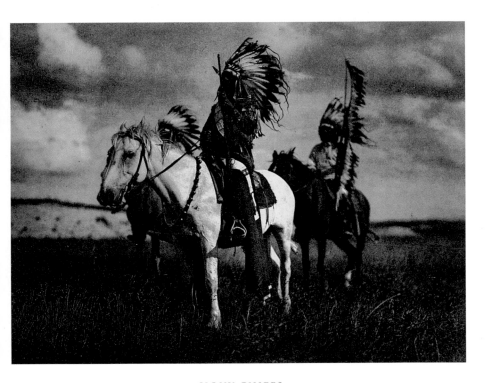

SIOUX CHIEFS

Very often two or three men would form themselves into a war-
party and ride away to be gone weeks or months. Sometimes they
returned with scalps, or horses, or women; and again the war-
party, whether large or small, met defeat and none survived to
bring back to anxious wives and children the story of the disaster.

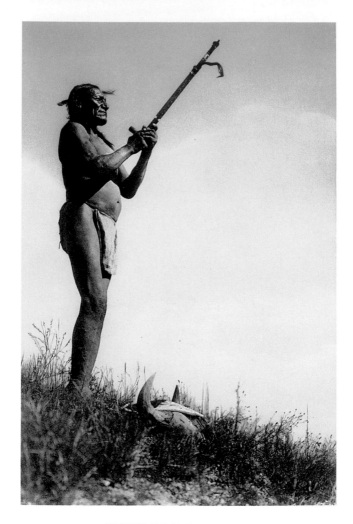

PRAYER TO THE MYSTERY

In supplication the pipe was always offered to the Mystery
by holding it aloft. At the feet of the worshipper lies a buffalo-
skull, symbolic of the spirit of the animal upon which the Indians
were so dependent. The subject of the picture is Picket Pin,
an Oglala Sioux.

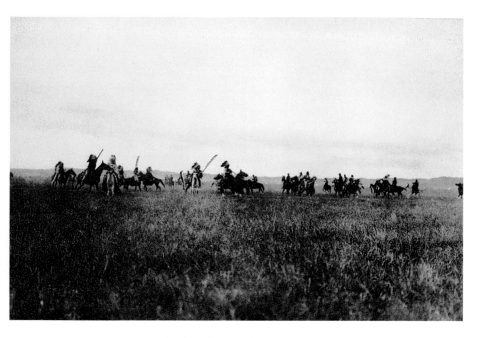

THE MORNING ATTACK

The favorite moment for attack was just at dawn, when the
enemy was presumably unprepared to offer quick resistance.

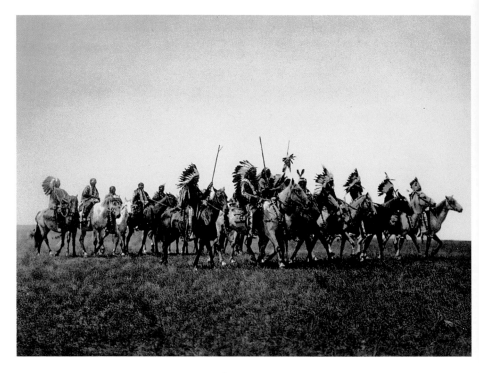

BRULÉ WAR-PARTY

This rhythmic picture shows a party of Brulé Sioux
reenacting a raid against the enemy.

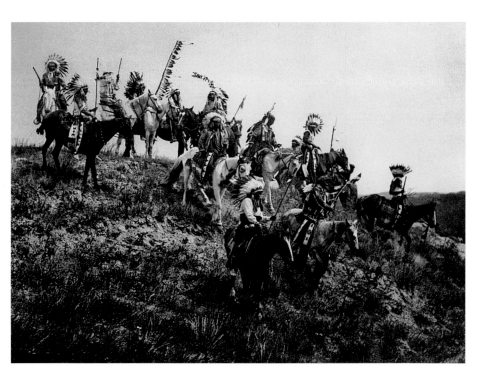

OGLALA WAR-PARTY

Here is depicted a group of Sioux warriors as they appeared
in the days of intertribal warfare, carefully making their way
down a hillside in the vicinity of the enemy's camp. Many hold
in their hands, instead of weapons, mere sticks adorned with
eagle-feathers or scalps – the so-called coup-sticks – desiring
to win honor by striking a harmless blow therewith as well
as to inflict injury with arrow or bullet.

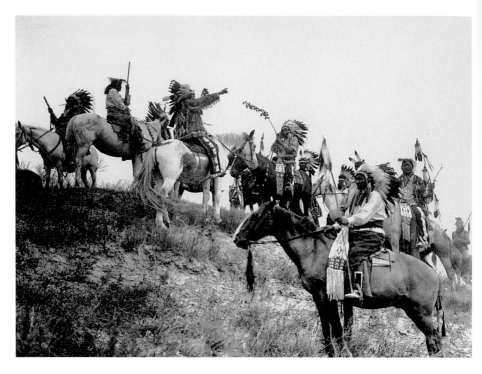

PLANNING A RAID

The Indians, in their striking and characteristic costumes,
unconsciously form themselves into most picturesque groups.
This shows a party of Oglala Sioux on a hill overlooking
the valley of Wounded Knee Creek, on the Pine Ridge
reservation in South Dakota.

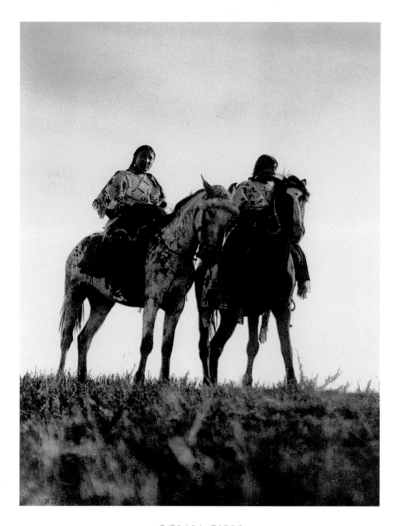

OGLALA GIRLS

As a rule the women of the plains tribes are natural horsewomen,
and their skill in riding is scarcely exceeded by that of the men.
As mere infants they are tied upon the backs of trusty animals, and
thus become accustomed to the long days of journeying.

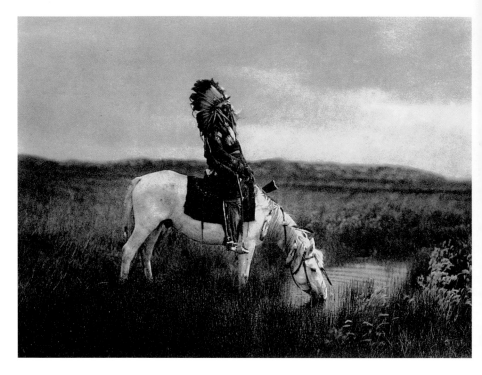

AN OASIS IN THE BAD LANDS

This picture was made in the heart of the Bad Lands of
South Dakota. The subject is the sub-chief Red Hawk.

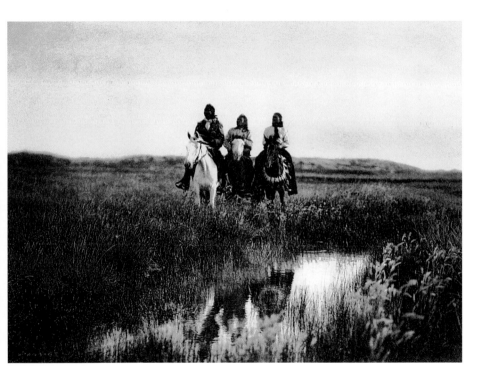

IN THE LAND OF THE SIOUX

This picture illustrates the general character of the Sioux
country. The broad, rolling prairie is broken by low hills,
while here and there lie pools of stagnant water in old buffalo-
wallows. The subjects of the picture are Red Hawk, Crazy
Thunder, and Holy Skin, three Oglala who accompanied
the author on a trip into the Bad Lands.

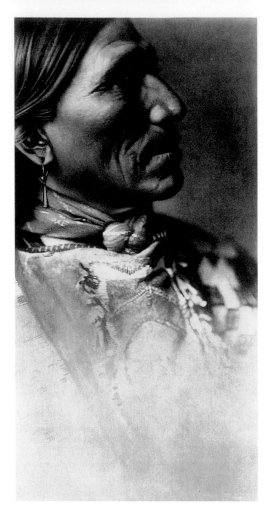

LITTLE HAWK

This portrait exhibits the typical Brulé physiognomy.

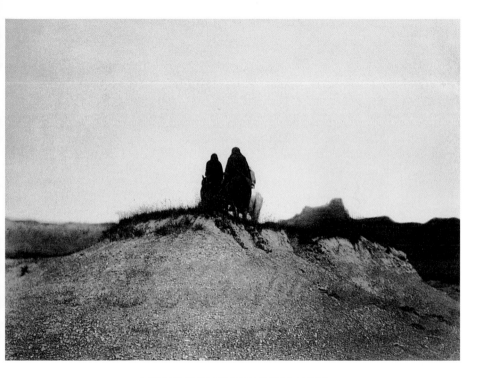

A GRAY DAY IN THE BAD LANDS

A cold, cheerless day, when the party of Sioux, wrapped
closely in their blankets, rode on in stolid silence.

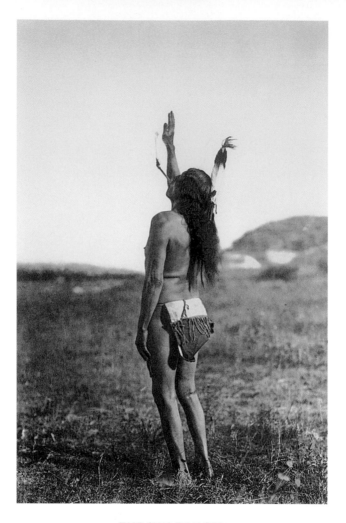

THE SUN DANCER

As they dance, the performers never leave the spot on which
they stand, the movement consisting in a slight upward spring
from the toes and ball of the foot; legs and body are rigid. Always
the right palm is extended to the yellow glaring sun, and their
eyes are fixed on its lower rim. The dancer concentrates his mind,
his very self, upon the one thing that he desires, whether it be
the acquirement of powerful medicine or only success in the
next conflict with the enemy.

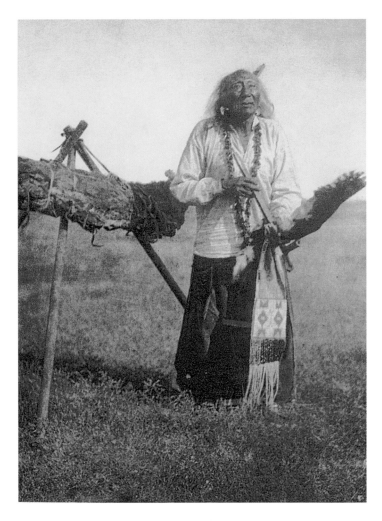

ELK HEAD, AND THE SACRED PIPE BUNDLE

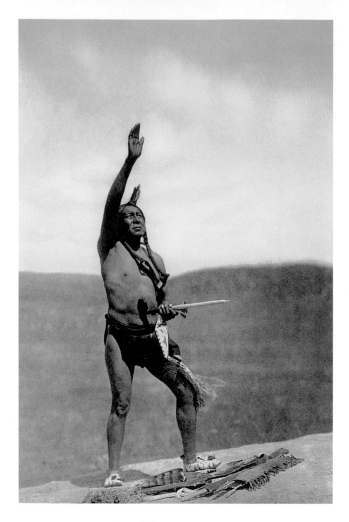

INVOCATION-SIOUX

Shrines are often bowlders or other rocks which through some
chance have been invested with mythic significance, and to them
priests and war-leaders repair to invoke the aid of the supernatural
powers. The half-buried bowlder is accredited with the power of
revealing to the warrior the foreordained result of his projected
raid. Its surface bears what the Indians call the imprint of human
feet, and it is owing to this peculiarity that it became a shrine.

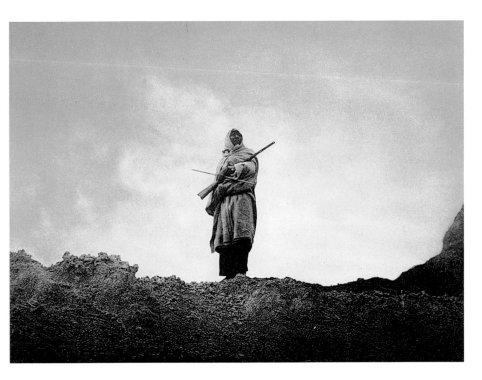

THE MOUNTAIN-SHEEP HUNTER – SIOUX

Mountain-sheep, grazing in the most inaccessible parts of the
Bad Lands, were sought only by the more ambitious hunters.

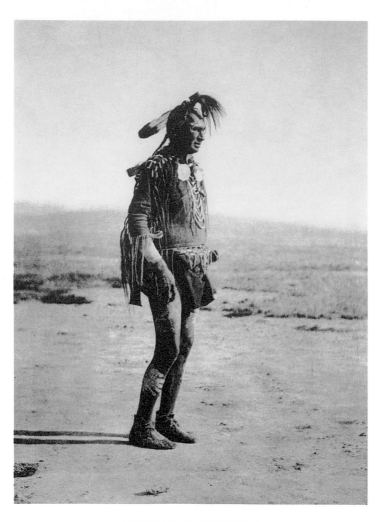

WHITE MAN RUNS HIM

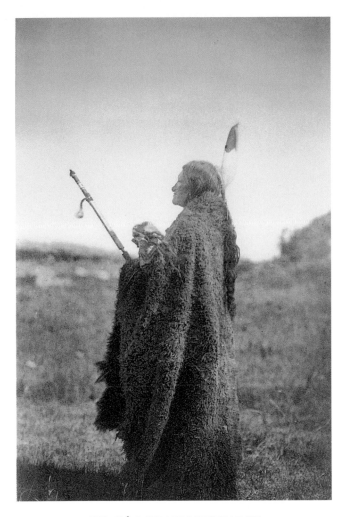

HUᴺKÁ-LOWAᴺPI CEREMONY

The subject of this picture is Saliva, an Oglala Sioux,
a priest of the *Huᴺká-lowaᴺpi* ceremony.

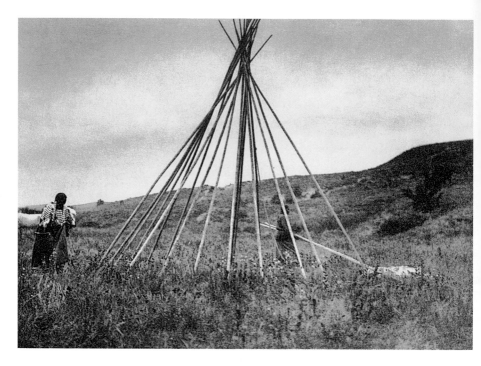

TIPI CONSTRUCTION

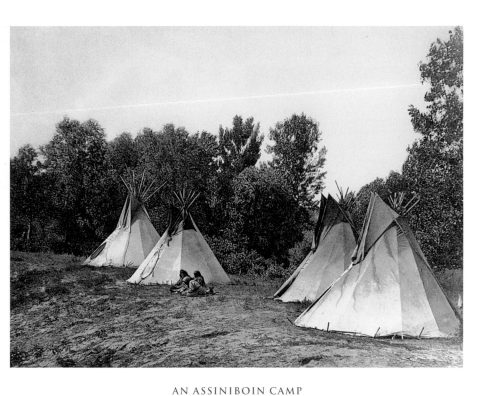

AN ASSINIBOIN CAMP

In making their camps the Indians often choose
most picturesque spots.

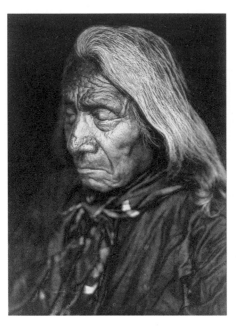 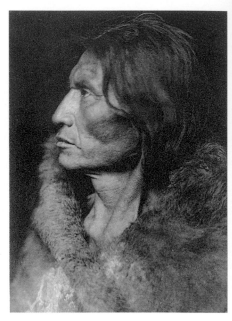

RED CLOUD – OGLALA

MOSQUITO HAWK – ASSINIBOIN

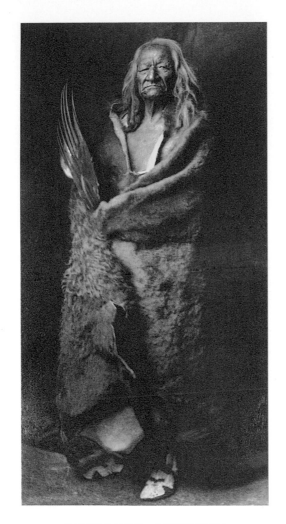

BLACK EAGLE – ASSINIBOIN

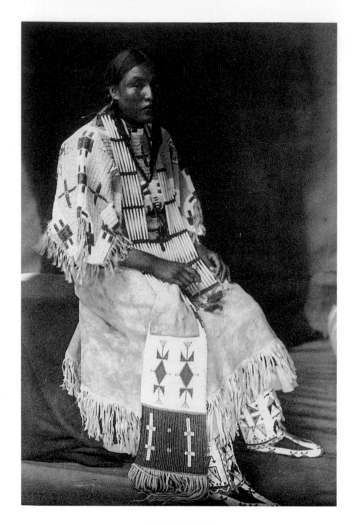

SIOUX GIRL

A young Sioux woman in a dress made entirely of deerskin,
embroidered with beads and porcupine-quills.

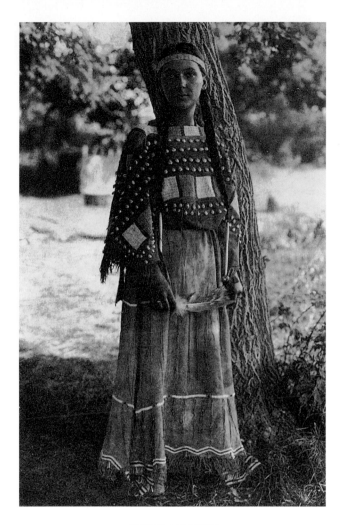

SIOUX MAIDEN

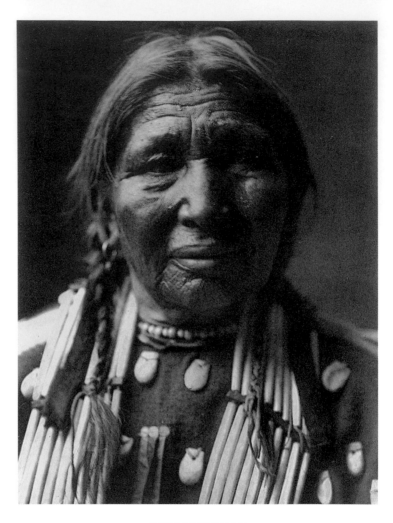

OGLALA WOMAN

A face so strong that it is almost masculine, showing strikingly
how slight may be the difference between male and female
physiognomy in some primitive people.

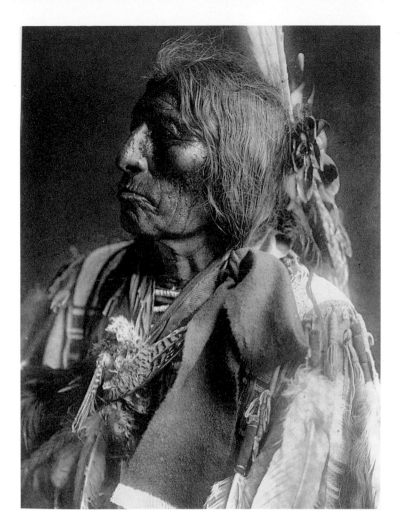

SLOW BULL – OGLALA

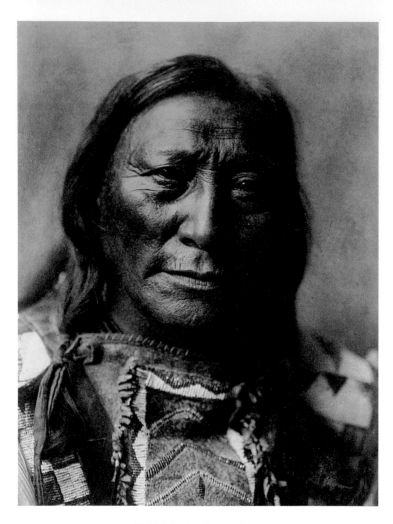

HOLLOW HORN BEAR

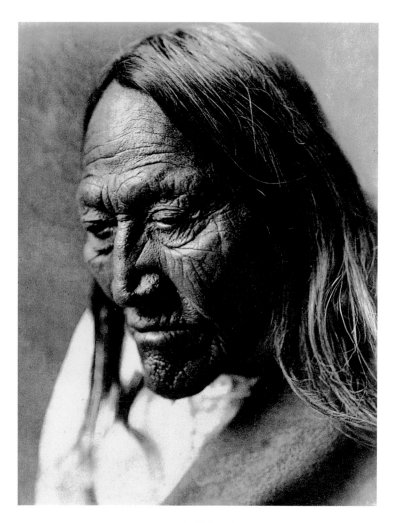

TWO STRIKE

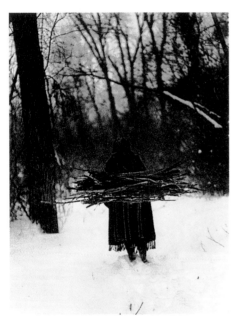

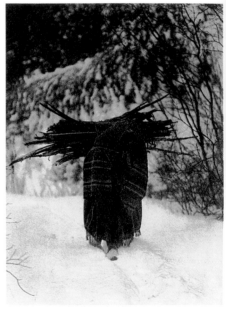

THE WOOD GATHERER – SIOUX

Fuel for cooking and for warming the tipi was gathered and carried in by the women, as a part of their domestic work.

A HEAVY LOAD – SIOUX

Summer and winter the Sioux woman performed the heavy work of the camp, and what was seemingly drudgery was to her a part of the pleasure of life.

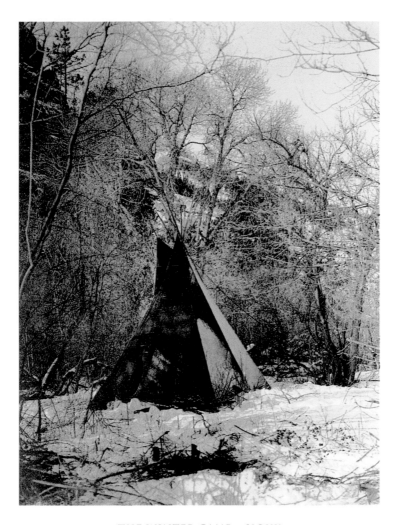

THE WINTER CAMP – SIOUX

With the coming of winter the plains tribes pitched their
camps in forested valleys, where they not only were protected
from the fierce winds of the plains, but had an ample supply
of fuel at hand.

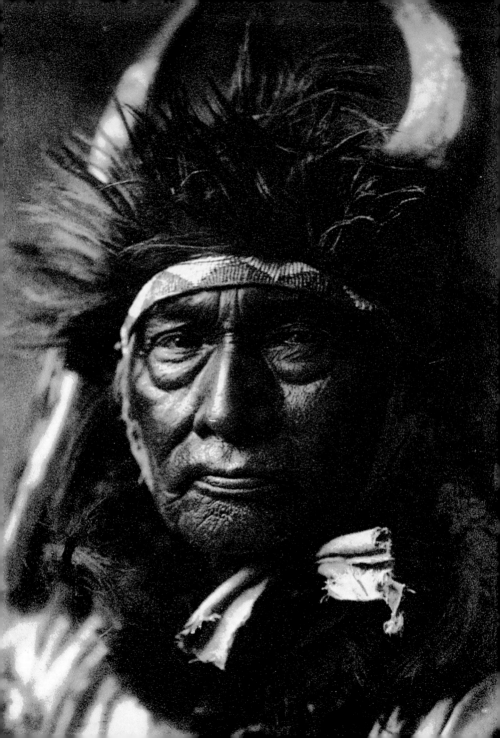

Apsaroke (Crows)

Hidatsa

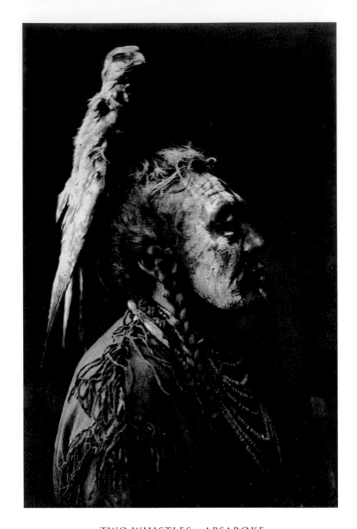

TWO WHISTLES – APSAROKE

PAGE 164
BÚLL CHIEF – APSAROKE

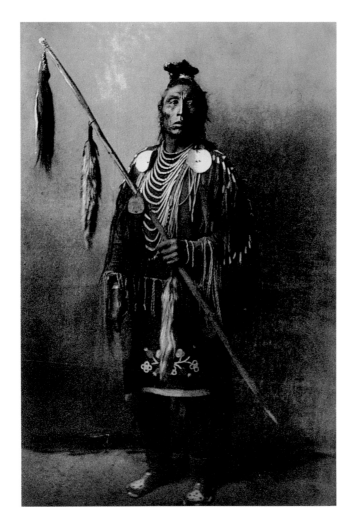

APSAROKE WAR-CHIEF

The three fox-tails hanging from the coup-stick show the subject
– Medicine Crow – to be the possessor of three first coups, that
is, in three encounters he was the first to strike one of the enemy's
force. The necklace consists of beads, and the large ornaments
at the shoulders are abalone shells.

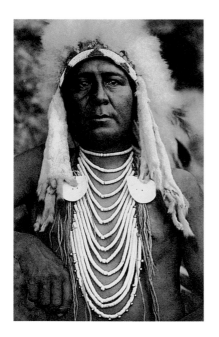

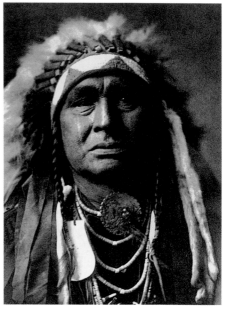

UPSHAW – APSAROKE

WHITE MAN RUNS HIM – APSAROKE

An educated Apsaroke, son of Crazy Pend
d'Oreille. Upshaw has assisted the author in his
field-work, collecting material treating of the
northern plains tribes.

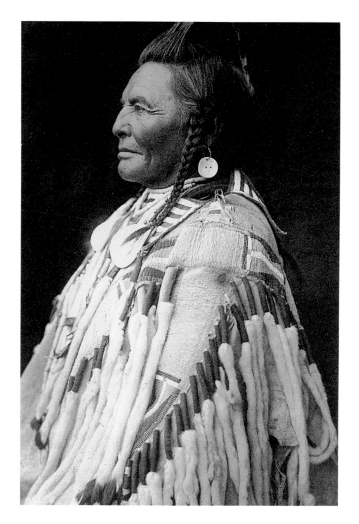

SHOT IN THE HAND – APSAROKE

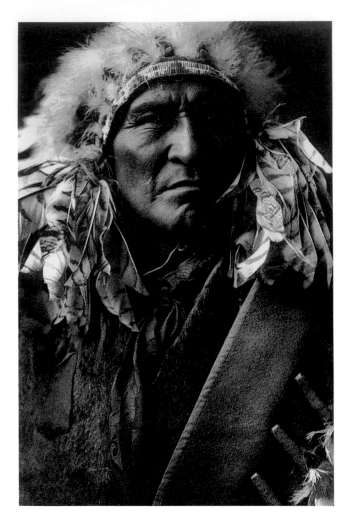

BREAD – APSAROKE

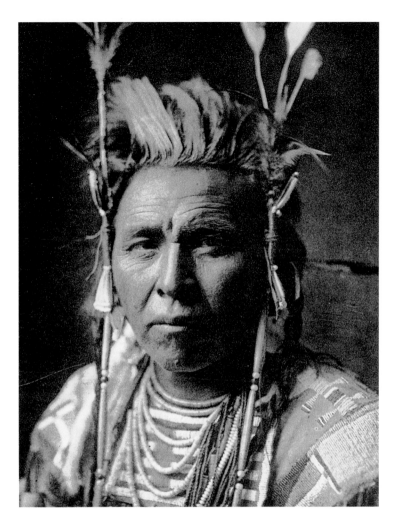

SPOTTED JACK-RABBIT – APSAROKE

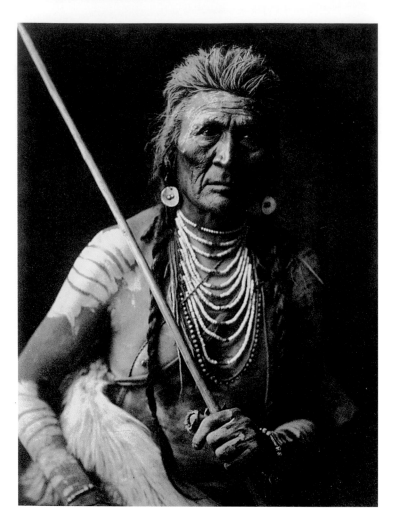

WOLF – APSAROKE

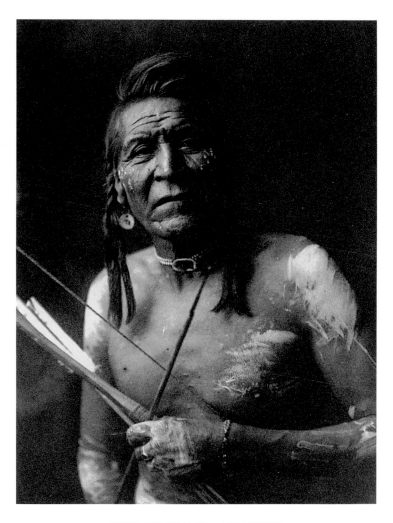

TWO LEGGINGS – APSAROKE

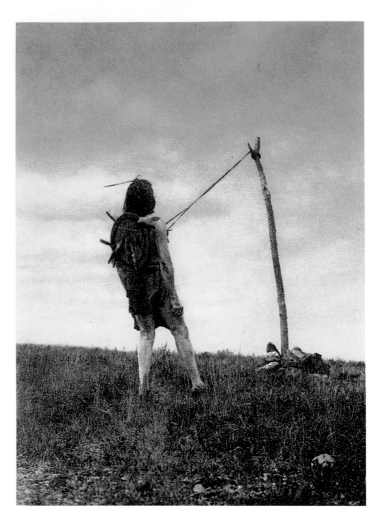

FOR STRENGTH AND VISIONS

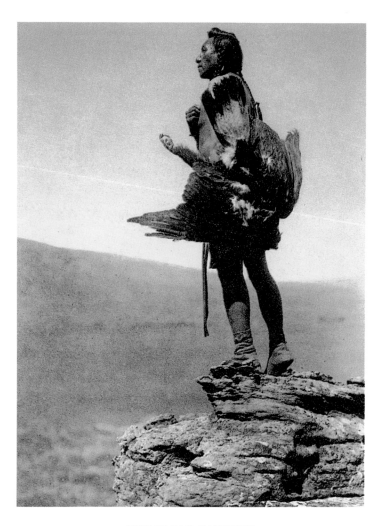

THE EAGLE-CATCHER

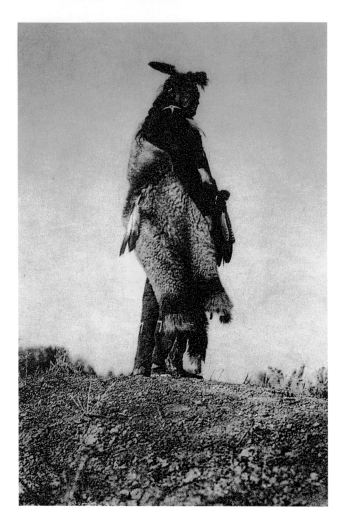

THE SCOUT – APSAROKE

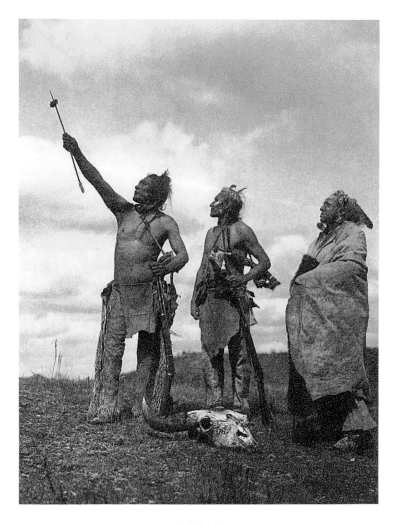

THE OATH

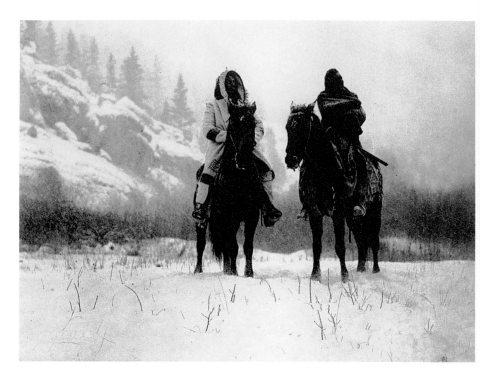

FOR A WINTER CAMPAIGN - APSAROKE

It was not uncommon for Apsaroke war-parties, mounted or
afoot, to move against the enemy in the depth of winter. The
warrior at the left wears the hooded overcoat of heavy blanket
material that was generally adopted by the Apsaroke after
the arrival of traders among them. The picture was made in
a narrow valley among the Pryor mountains, Montana.

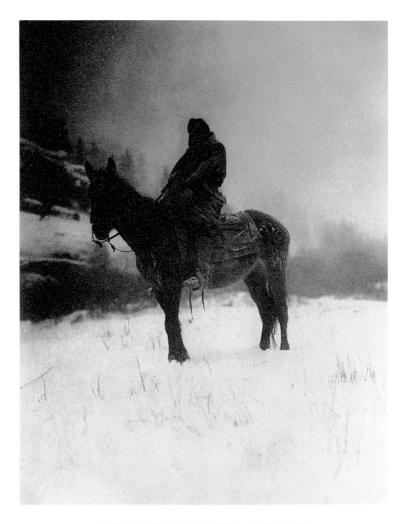

THE SCOUT IN WINTER – APSAROKE

The accounts of scouting and hunting parties during the severest
winter weather furnish many thrilling stories and show a manly
indifference to bodily discomfort.

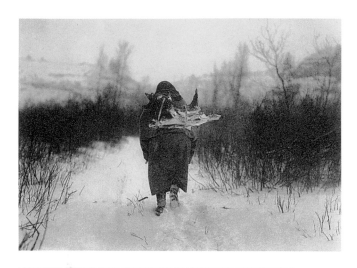

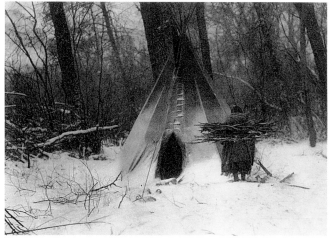

GOING TO CAMP – APSAROKE

This picture was made at a small winter camp on Pryor Creek
in the Pryor Mountains, Montana.

WINTER – APSAROKE

In the thick forests along the banks of mountain streams
the Apsaroke made their winter camps.

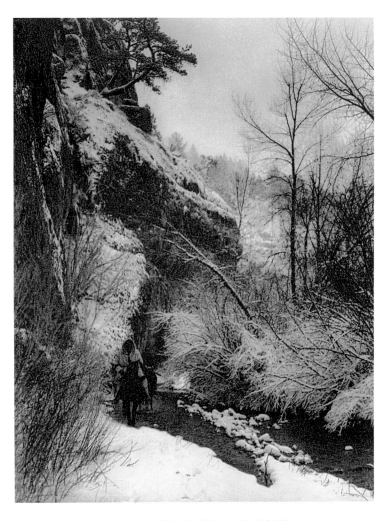

PASSING THE CLIFF – APSAROKE

A winter scene on Pryor Creek, Montana.

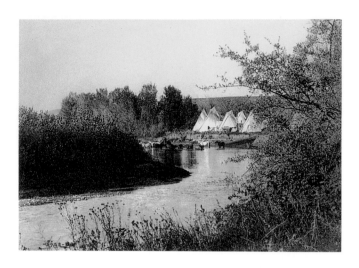

ON THE LITTLE BIGHORN – APSAROKE

This picturesque camp of the Apsaroke was on the Little
Bighorn River, Montana, a short distance below where
the Custer fight occurred.

AUTUMN – APSAROKE

An autumn scene in the valley of the Little Bighorn.

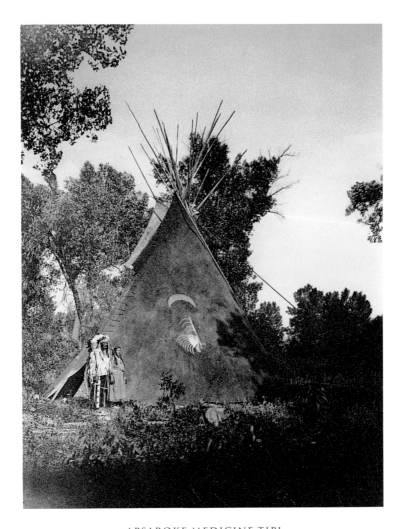

APSAROKE MEDICINE TIPI

The Apsaroke medicine-men usually painted their lodges
according to the visions received while fasting and supplicating
their spirits. This tipi was painted dark red, with various symbols
on the covering. No man would dare so to decorate a tipi without
having received his instructions in revelation from the spirits.

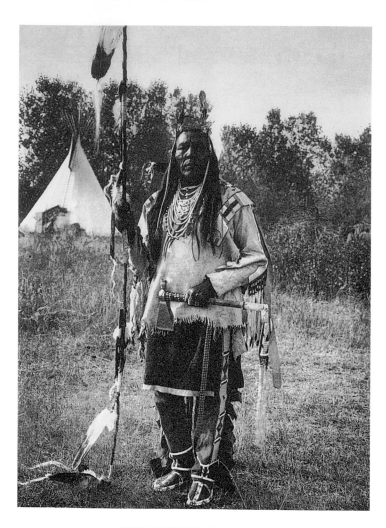

BIRD ON THE GROUND –
APSAROKE

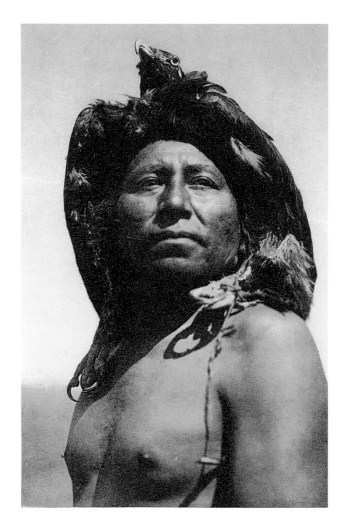

THE EAGLE MEDICINE-MAN –
APSAROKE

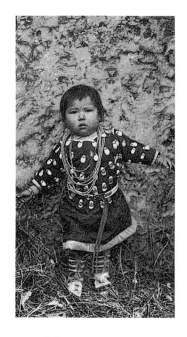

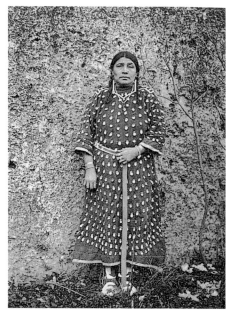

A BABY APSAROKE APSAROKE WOMAN

PLAYMATES – AP'SAROKE

THE CHIEF HAD A BEAUTIFUL
DAUGHTER

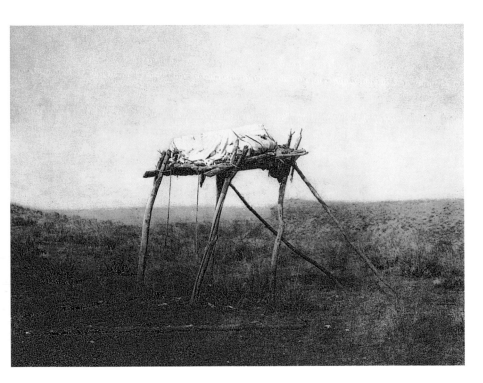

A BURIAL PLATFORM –
APSAROKE

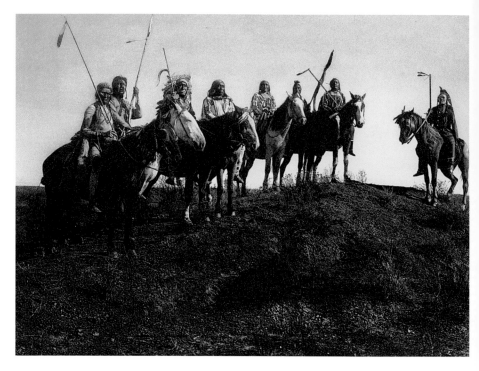

WATCHING FOR THE SIGNAL –
APSAROKE

When there were indications that the war-party was near
the enemy, a halt was made while the scouts reconnoitered
the position of the hostile party. Their appearance on a distant
hilltop was awaited by the main body with great anxiety, for
if they were seen running in zigzag lines it meant that the
enemy had been actually discovered.

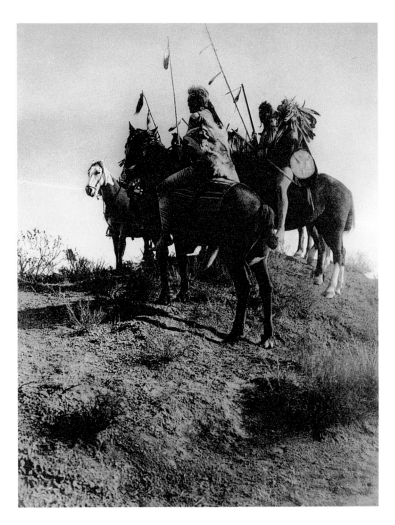

THE SPIRIT OF THE PAST –
APSAROKE

A particularly striking group of old-time warriors, conveying
so much of the feeling of the early days of the chase and the
war-path that the picture seems to reflect in an unusual
degree "the spirit of the past."

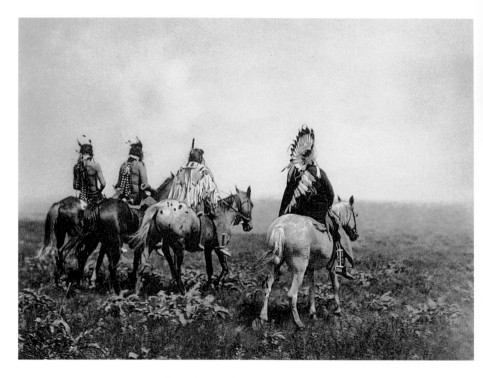

THE CHIEF AND HIS STAFF –
APSAROKE

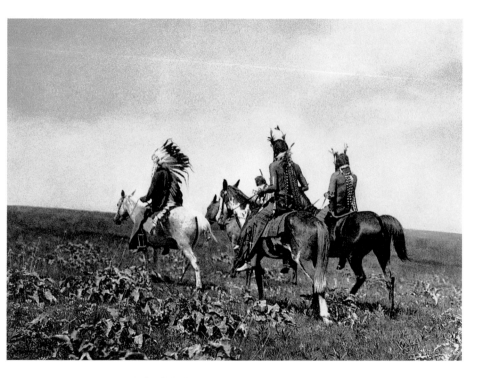

A SUCCESSFUL RAID FOR HORSES –
APSAROKE

The Apsaroke were one of the most fearless tribes, and their stories
of raiding parties, large and small, are almost numberless.

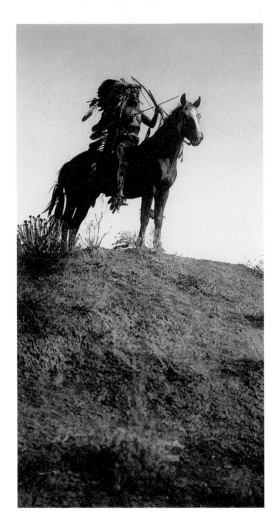

READY FOR THE CHARGE – APSAROKE

The picture shows well the old-time warrior with bow and
arrow in position, two extra shafts in his bow-hand, and
a fourth between his teeth ready for instant use.

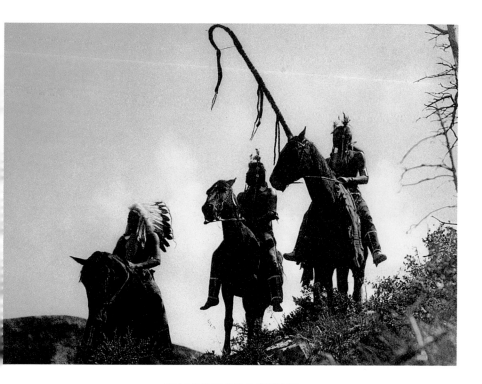

APSAROKE WAR GROUP

The warrior at the right holds the curved staff of one of the
tribal military organizations, which, at the crisis of a fight,
was planted in the ground as a standard behind which the
bearer was pledged not to retreat.

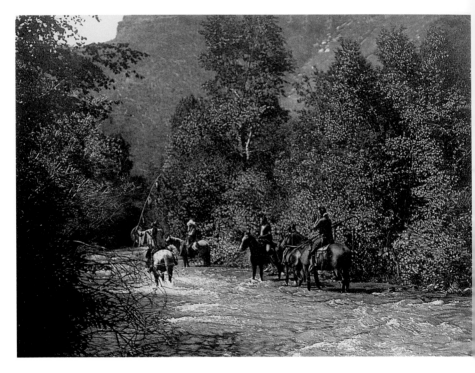

A MOUNTAIN FASTNESS – APSAROKE

The Apsaroke lived much among the mountains, and
nowhere do they seem more at home than on the streams
and in the cañons of their forested ranges.

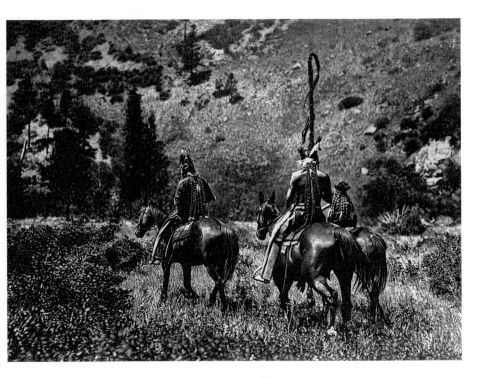

IN BLACK CAÑON

The Apsaroke, although not exclusively mountain dwellers,
were ever fond of the hills, preferring the forest shade and the clear
mountain streams to the hot, ill-watered, monotonous prairies.
The picture illustrates the Apsaroke custom of wearing
at the back of the head a band from which fall numerous strands
of false hair ornamented at regular intervals with pellets of bright-
colored gum. Black Cañon is in the northern portions of the
Bighorn Mountains, Montana.

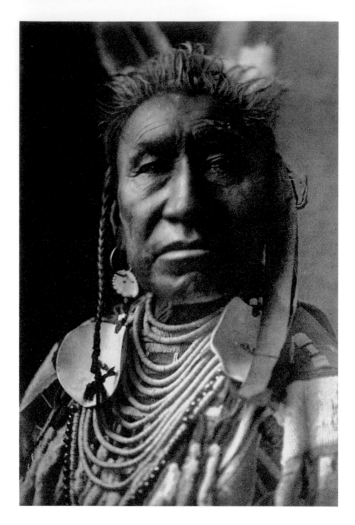

FISH SHOWS – APSAROKE

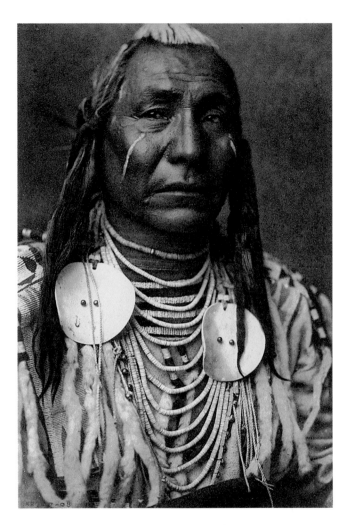

RED WING – APSAROKE

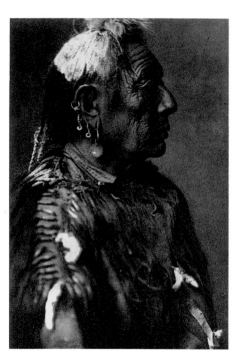

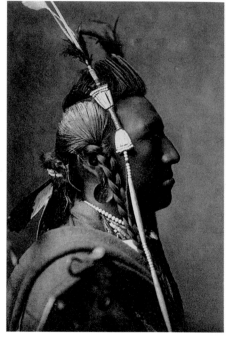

WOLF LIES DOWN – APSAROKE

SWALLOW BIRD – APSAROKE

This picture illustrates the characteristic Apsaroke
manner of arranging the hair.

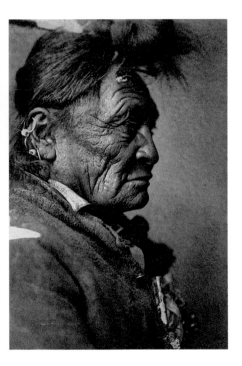

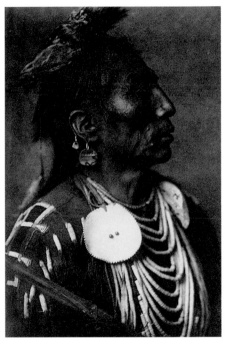

HOOP ON THE FOREHEAD –
APSAROKE

MEDICINE CROW –
APSAROKE

The hawk fastened on the head is illustrative
of the manner of wearing the symbol of one's
tutelary spirit.

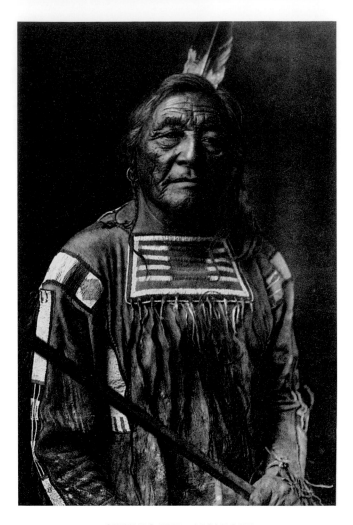

SITTING ELK - APSAROKE

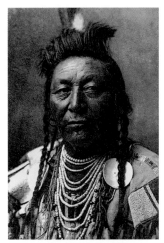

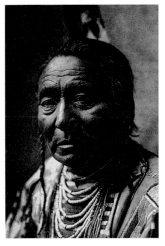

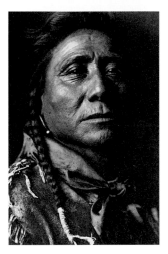

LONE TREE –
APSAROKE

PLENTY COUPS –
APSAROKE

WET – APSAROKE

COUPS WELL-KNOWN –
APSAROKE

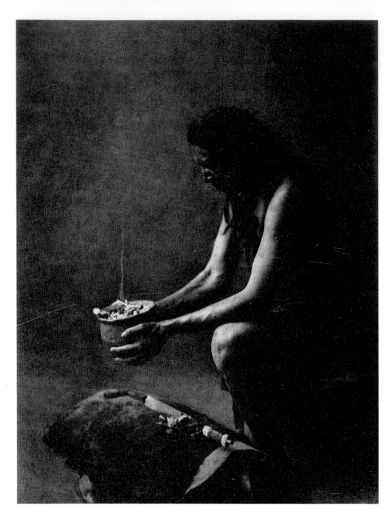

INCENSE OVER A MEDICINE BUNDLE –
HIDATSA

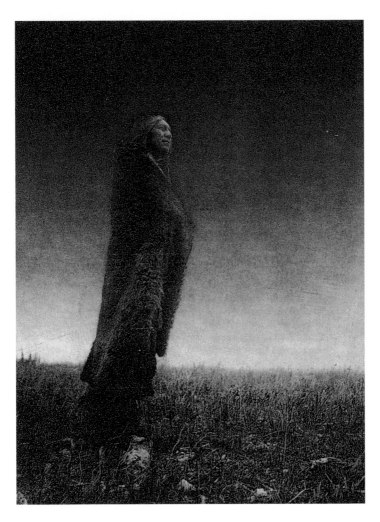

CRYING TO THE SPIRITS

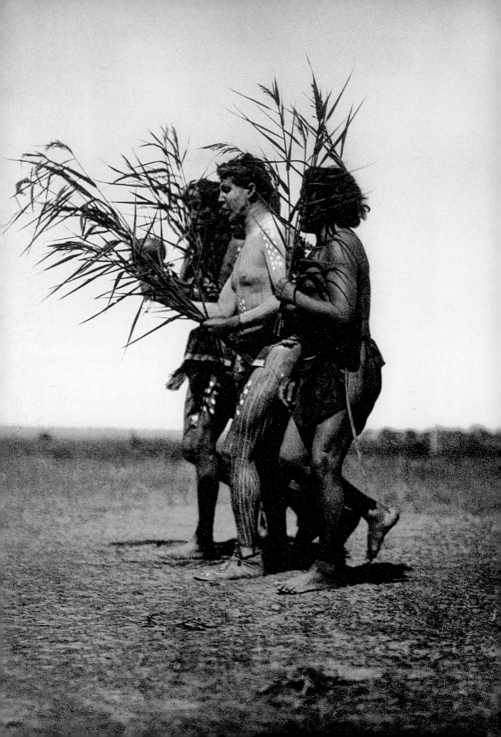

Mandan

Arikara

Atsina

Volume V

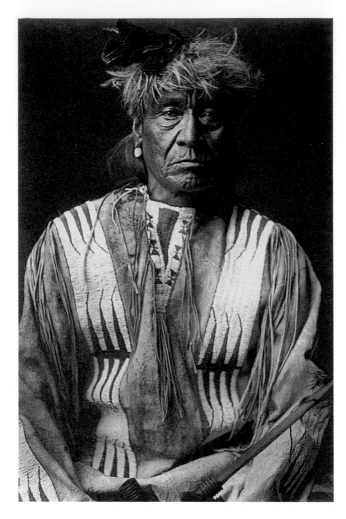

RED WHIP – ATSINA

PAGE 206
ARIKARA MEDICINE CEREMONY –
THE DUCKS

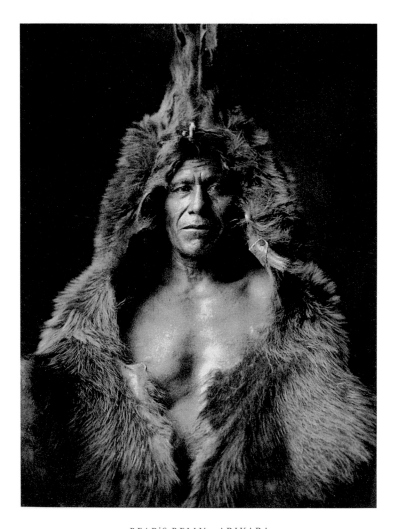

BEAR'S BELLY – ARIKARA

A member of the medicine fraternity, wrapped
in his sacred bear-skin.

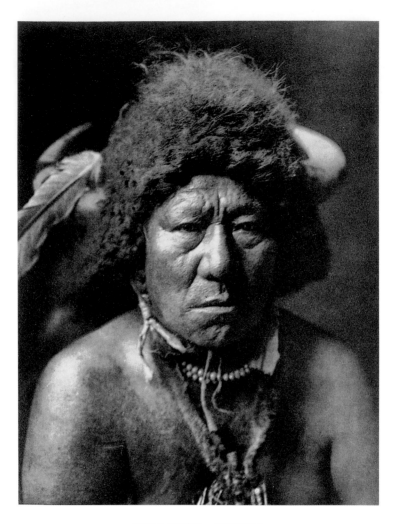

BULL NECK – ARIKARA

A member of the Buffalo order of the medicine fraternity.
Bull Neck is portrayed wearing his head-dress of buffalo
horns and hide.

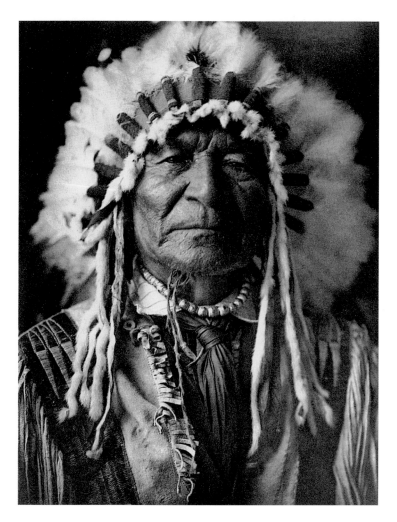

SITTING BEAR – ARIKARA

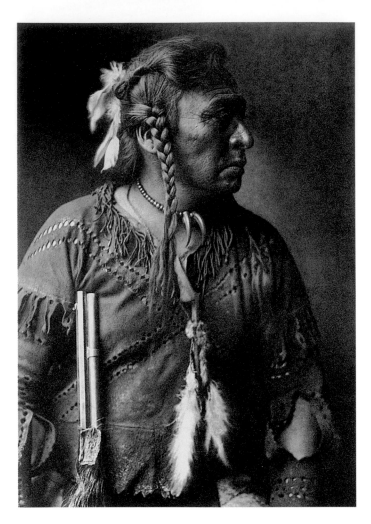

HORSE CAPTURE – ATSINA

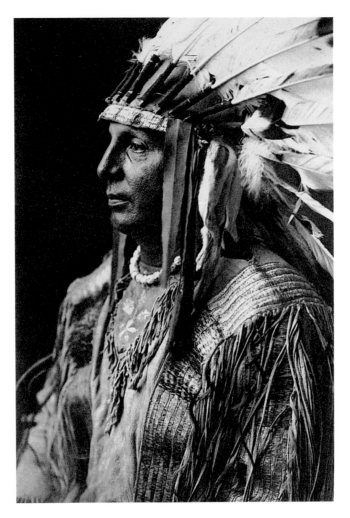

WHITE SHIELD – ARIKARA

A mixed-blood member of the medicine fraternity.

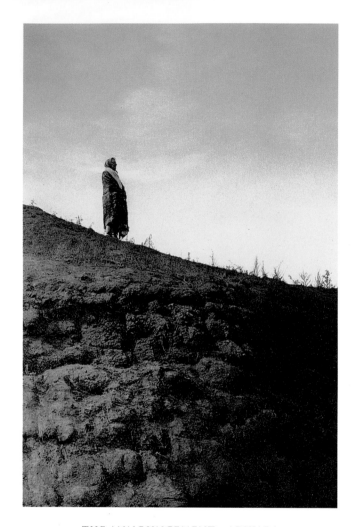

THE ANNOUNCEMENT – ARIKARA

Among the Missouri River Indians of the earthen lodges –
the Mandan, Hidatsa, and Arikara – the chiefs and priests
made their announcements from the housetops. This picture
is of Bear's Teeth standing on the roof of the ceremonial
lodge in which occurred the medicine ceremony.

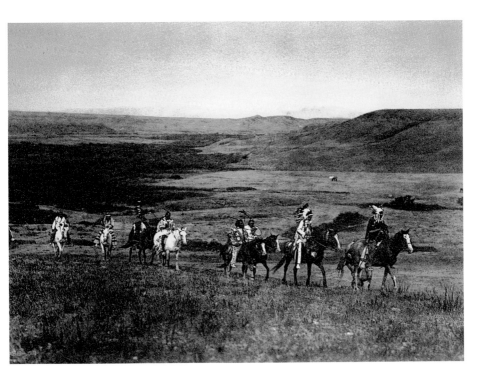

THE LAND OF THE ATSINA

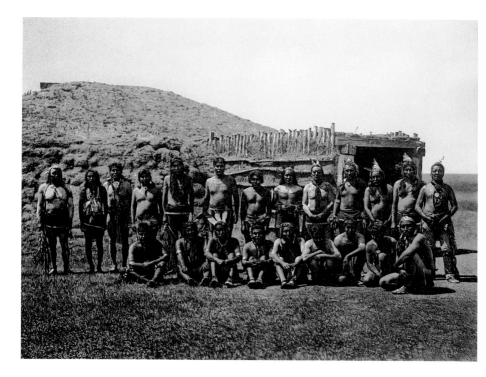

ARIKARA MEDICINE FRATERNITY

In this group are shown the principal participants in the
reenactment of the Arikara medicine ceremony, which was
given for the author's observation and study in July, 1908.

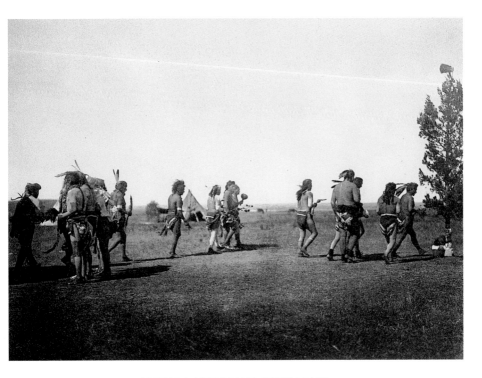

ARIKARA MEDICINE CEREMONY –
DANCE OF THE FRATERNITY

After each order has performed its dance about the sacred
cedar, the entire fraternity, group by group, emerges
from the lodge and dances.

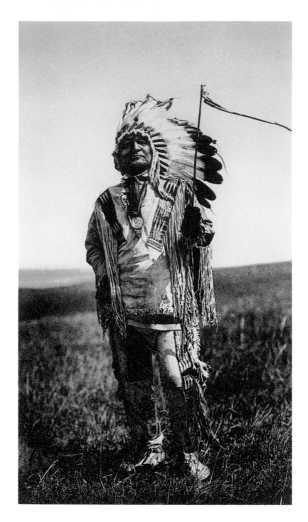

ARIKARA CHIEF

The tribal chief, Sitting Bear, is portrayed in full costume
of scalp-shirt, leggings, and moccasins, all of deerskin, and
eagle-feather war-bonnet and coup-stick.

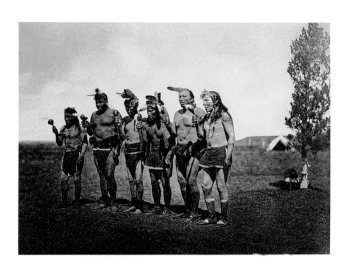

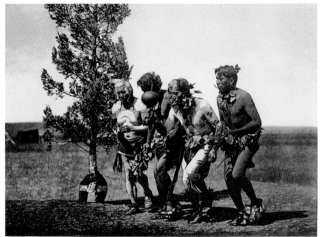

ARIKARA MEDICINE CEREMONY –
THE BEARS

After dancing around the sacred cedar, the members
of the Bear order halt and complete their songs before
reentering the medicine-lodge.

ARIKARA MEDICINE CEREMONY –
DANCE OF THE BLACK-TAIL DEER

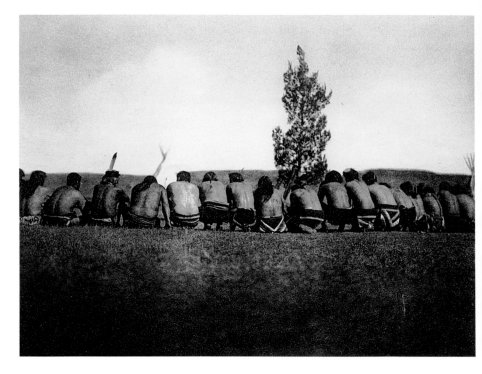

ARIKARA MEDICINE FRATERNITY –
THE PRAYER

This impressive picture from the Arikara medicine ceremony
shows the priests in a semicircle about the sacred cedar.

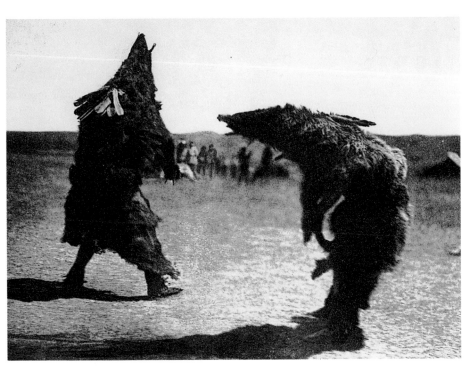

ARIKARA MEDICINE CEREMONY –
THE BEARS

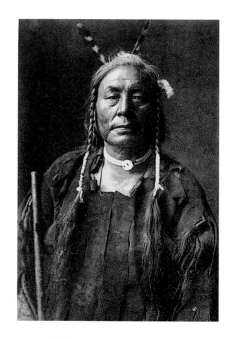

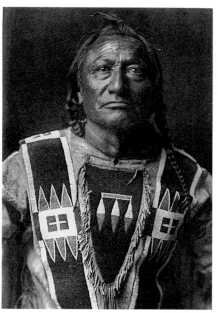

EAGLE CHILD – ATSINA OTTER ROBE – ATSINA

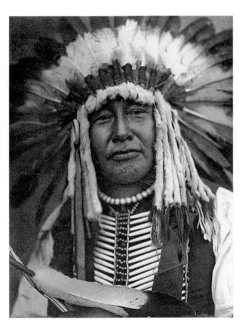

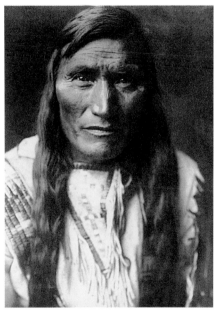

YELLOW OWL – MANDAN

A face approaching the type of the pure Mandan.
The neck ornament consists of beads and cylindrical
bones, and from the eagle-feather war-bonnet hang
numerous weasel-tails.

HEAD-DRESS – ATSINA

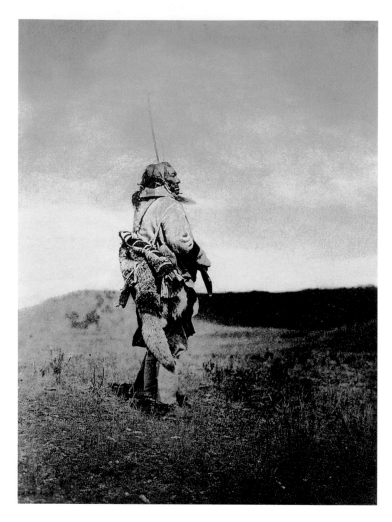

THE SCOUT – ATSINA

The scouts of many tribes, among which were the Atsina,
carried a wolf-skin which they used in waving signals to their
chief. That which is apparently hair-ornamentation, standing high
above the head of the subject, is in reality coarse stalks
of grass, indicating that the wearer is a scout. The origin of the
custom was in the practice of scouts to wear on their heads
thick masses of grass, which enabled them to peer over hill-
tops without being discovered by the enemy.

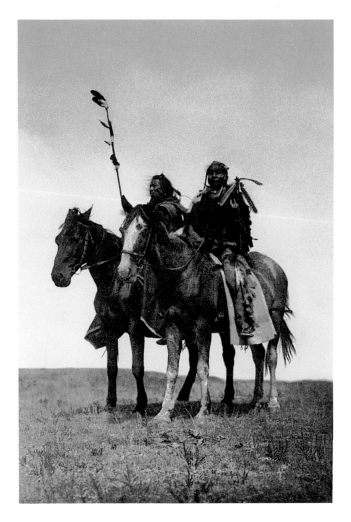

ASSINIBOIN BOY – ATSINA

The head-band, so commonly used by many tribes of the
Southwest, notably the Apache and Navaho, is not often
worn in the Northwest.

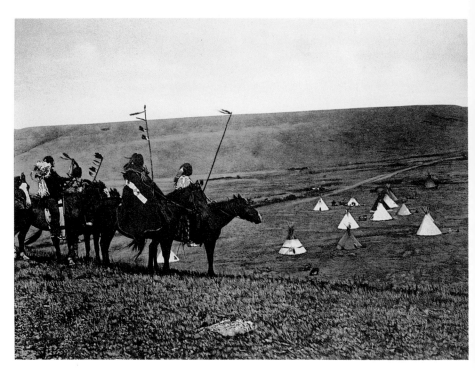

WAR-PARTY'S FAREWELL – ATSINA

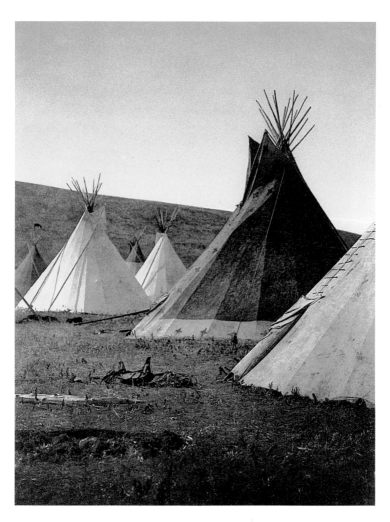

ATSINA CAMP

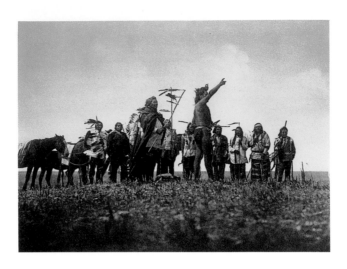

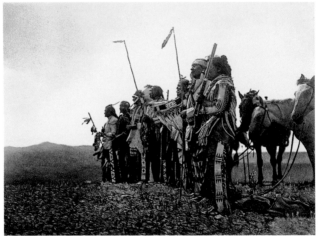

THE SCOUT'S REPORT – ATSINA

The chief of the scouts, returning to the main party, tells
what he has seen and experienced. While he speaks, the war-leader
stands slightly in advance of his men, and carefully listening to
the words of the scout, quickly forms his plan of action.

AWAITING THE SCOUT'S RETURN – ATSINA

The war-party sent scouts, who kept a lookout for the enemy.

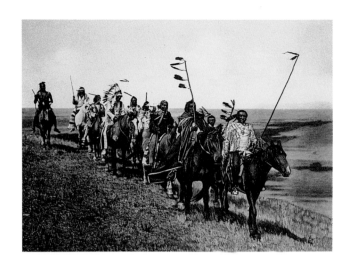

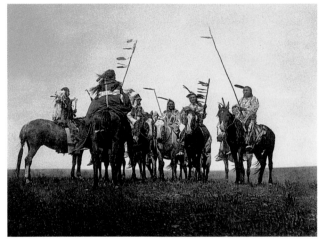

ON THE WAR-PATH – ATSINA

These grim-visaged old warriors made a thrilling picture as
they rode along, breaking out now and then into a wild song
of the chase or the raid.

ATSINA WARRIORS

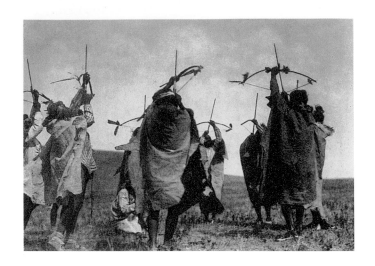

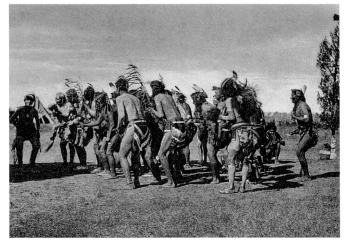

ATSINA CRAZY DANCE –
THE FLIGHT OF ARROWS

DANCING INTO THE MEDICINE
LODGE – ARIKARA

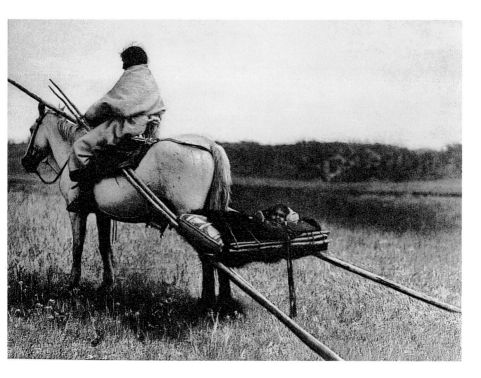

TRAVELLING – ATSINA

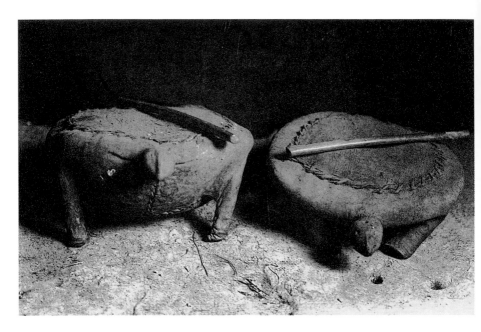

THE SACRED TURTLES – MANDAN

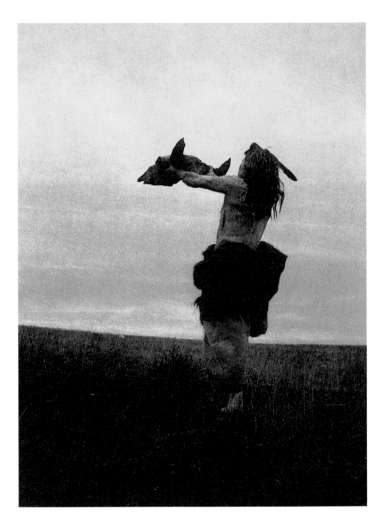

OFFERING THE BUFFALO-SKULL – MANDAN

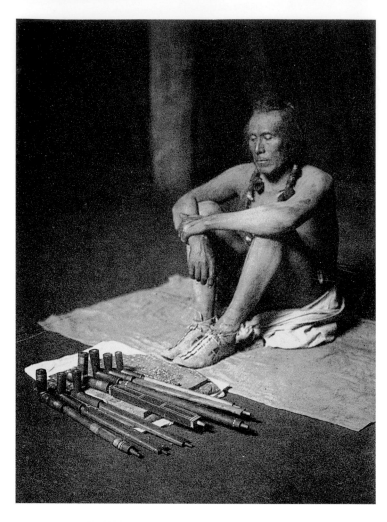

IN THE MEDICINE-LODGE – ARIKARA

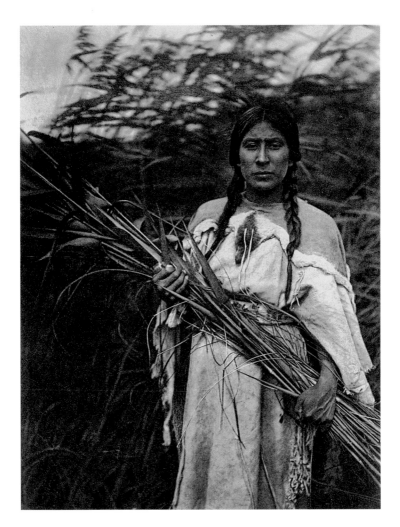

THE RUSH GATHERER – ARIKARA

The Arikara, as well as their close neighbors, the Mandan
and Hidatsa, made many mats of rushes. These were
used largely as floor coverings.

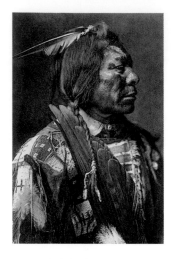

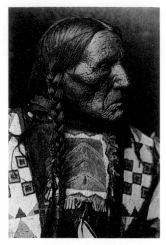

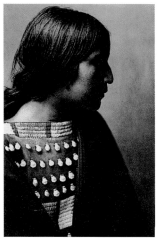

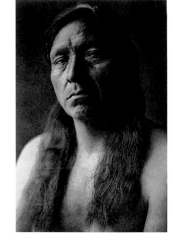

LONE FLAG – ATSINA

NO BEAR – ATSINA

ARIKARA GIRL

FOUR HORNS – ARIKARA

The subject is considered by her
tribesmen to be a pure Arikara, but
her features point unmistakably to
a white ancestor, and there is little
doubt that the blood of other
tribes flows in her veins.

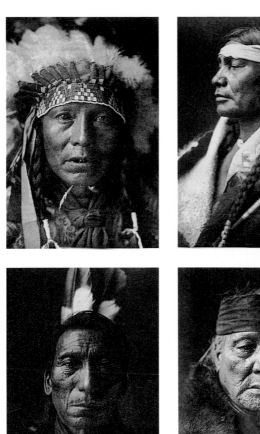

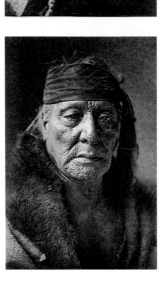

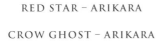

RED STAR – ARIKARA

CROW GHOST – ARIKARA

ATSINA CHIEFS

BEAR'S TEETH – ARIKARA

A member of the Night order of
the medicine fraternity.

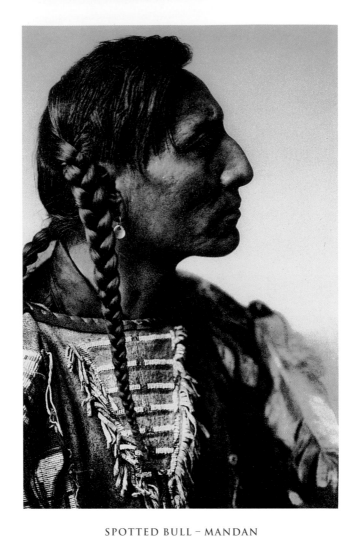

SPOTTED BULL – MANDAN

Not a true Mandan type. The face shows evidence of
alien blood, possibly Dakota.

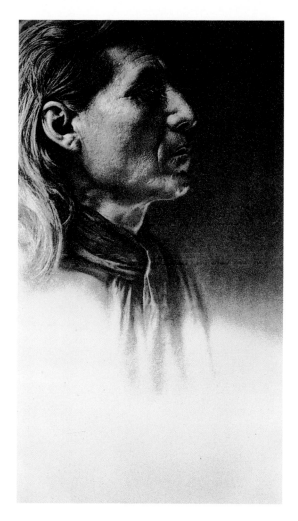

LITTLE SIOUX – ARIKARA

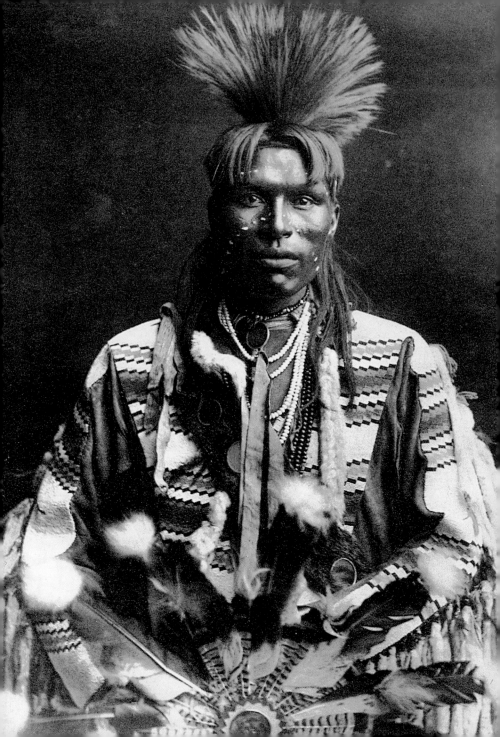

Piegan

(Blackfeet & Bloods)

Cheyenne

Arapaho

Volume VI

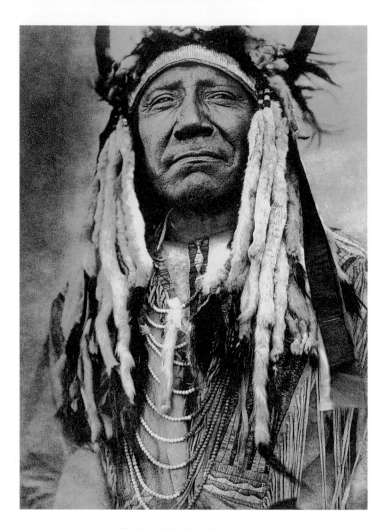

TWO MOONS – CHEYENNE

Two Moons was one of the Cheyenne war chiefs at the battle
of the Little Bighorn in 1876, when Custer's command was
annihilated by a force of Sioux and Cheyenne.

PAGE 240
A PIEGAN DANDY

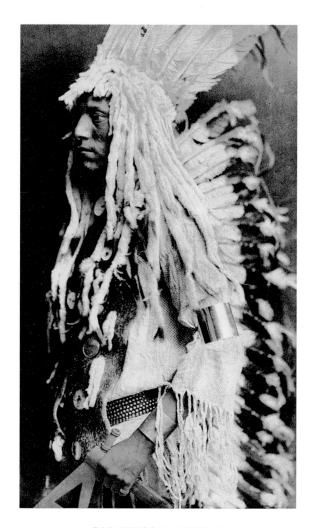

OLD PERSON – PIEGAN

The young men eagerly seize every occasion of public
festivity to don the habiliments of their warrior fathers.

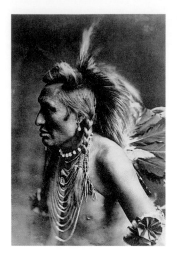

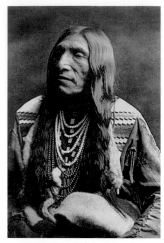

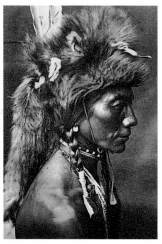

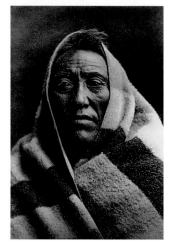

GAMBLER – PIEGAN

YELLOW KIDNEY – PIEGAN

The portrait shows Apuyótoksi (Light-colored Kidney) wearing a wolf-skin war-bonnet.

DOUBLE RUNNER – PIEGAN

Double Runner's is an excellent type of the Piegan physiognomy, as well as of the ideal North American Indian as pictured by the average person. His native name is Aḣkutômaḣka.

MIDDLE CALF – PIEGAN

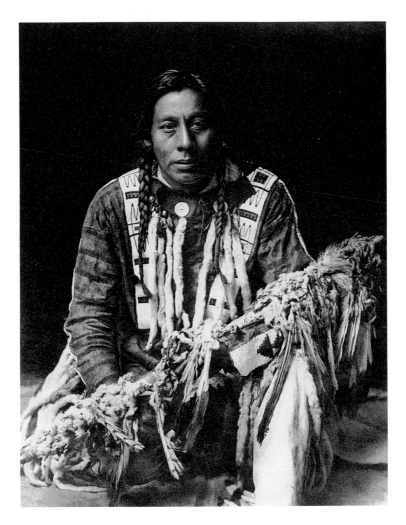

A MEDICINE-PIPE – PIEGAN

Medicine-pipes, of which the Piegan have many, are simply
long pipe-stems variously decorated with beads, paint, feathers,
and fur. Each one is believed to have been obtained long ago in
some supernatural manner, as recounted in a myth. The medicine-
pipe is ordinarily concealed in a bundle of wrappings, which are
removed only when the sacred object is to be employed in healing
sickness, or when it is to be transferred from one custodian to
another in exchange for property.

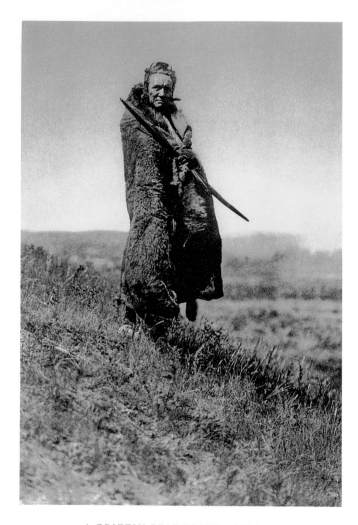

A GRIZZLY-BEAR BRAVE – PIEGAN

At least two of the Piegan warrior societies (the Braves and the
All Brave Dogs) included in their membership two men known
as Grizzly-bear Braves. It was their duty, at the time of the society
dances, to provide their comrades with meat, which they appropri-
ated wherever they could find it. Their expression and demeanor
did justice to their name, and in their official capacity they were
genuinely feared by the people.

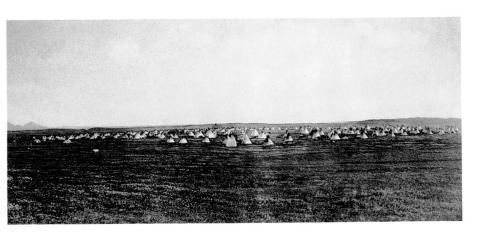

SUN DANCE ENCAMPMENT – PIEGAN

This tribal assembly for the Sun Dance of 1898 comprised
about two hundred and thirty tipis, including a number of visiting
Blackfeet and Bloods from Canada. The scene is on the Piegan
reservation in northern Montana, near Browning.

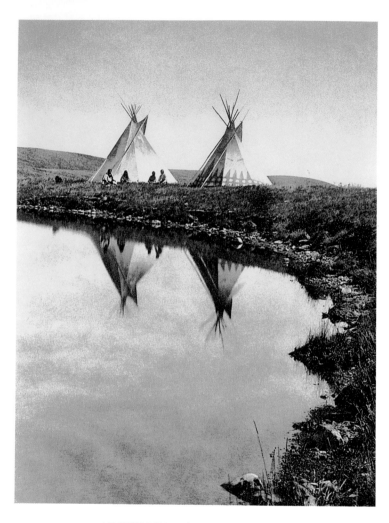

AT THE WATER'S EDGE - PIEGAN

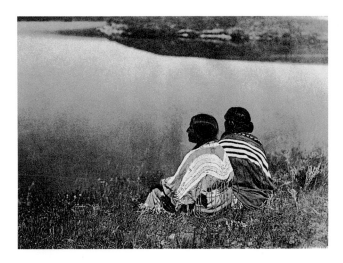

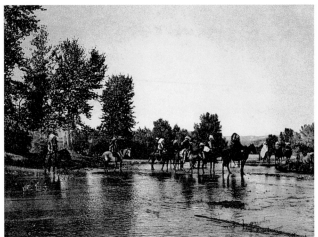

AN IDLE HOUR – PIEGAN

AT THE FORD – CHEYENNE

The picture represents a party of warriors on the march.
The scene is at Tongue River, in Montana.

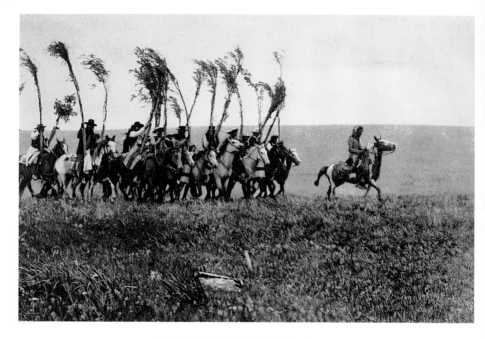

BRINGING THE SWEAT-LODGE
WILLOWS – PIEGAN

Young horsemen are coming toward the Sun Dance
encampment with willows for the faster's sweat-lodge.

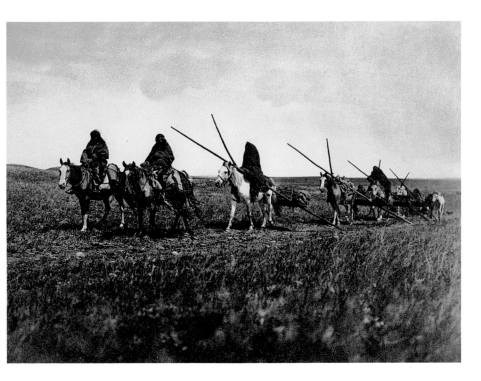

TRAVAUX – PIEGAN

With most of the plains tribes the travois was the universal
vehicle for transporting camp equipment, but is now rarely seen.
In the days before the acquisition of horses a smaller form
of the same device was drawn by dogs. The occasion of this
picture was the bringing of the sacred tongues to the
medicine-lodge ceremony.

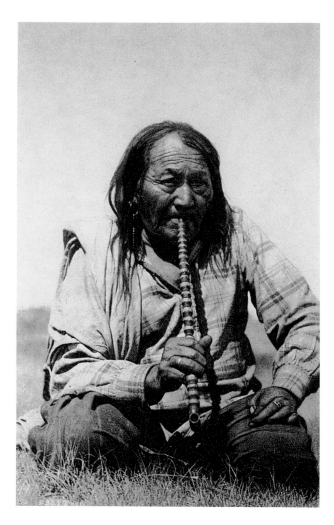

A SMOKE – ARAPAHO

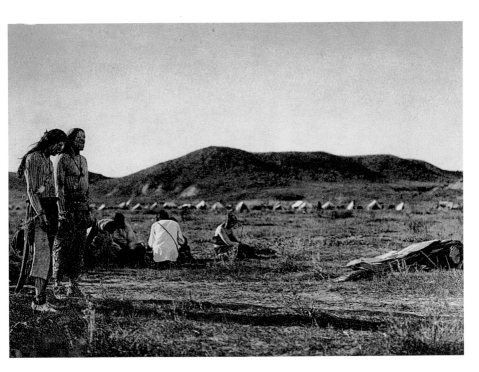

BEFORE THE FINAL JOURNEY – CHEYENNE

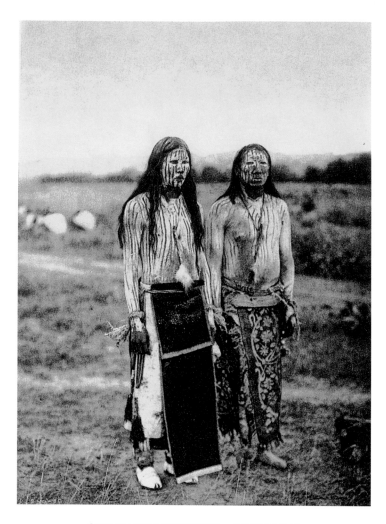

SUN DANCE PLEDGERS – CHEYENNE

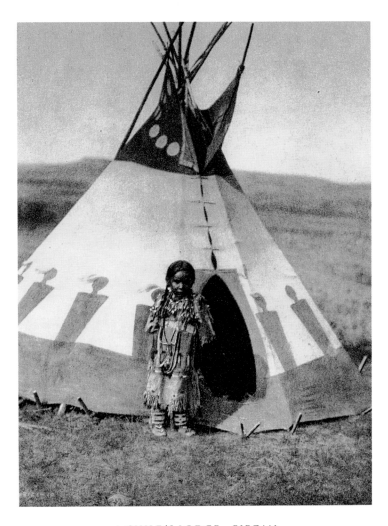

A CHILD'S LODGE – PIEGAN

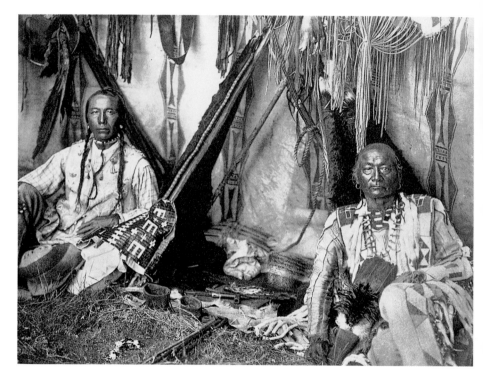

IN A PIEGAN LODGE

Little Plume with his son Yellow Kidney occupies the
position of honor, the space at the rear opposite the entrance.
The picture is full of suggestion of the various Indian activities.
In a prominent place lie the ever-present pipe and its accessories
on the tobacco cutting-board. From the lodge-poles hang the
buffalo-skin shield, the long medicine-bundle, an eagle-wing
fan, and deerskin articles for accoutering the horse.

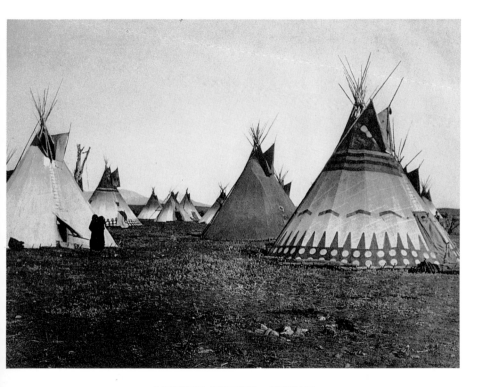

PAINTED LODGES – PIEGAN

Symbolically painted tipis are frequently observed among the
Piegan. Sometimes incidents in the owner's career, especially as
a warrior, are depicted, but more often, as in this picture, the
painting is conventional, and imitative of a tipi seen by
the owner in a vision.

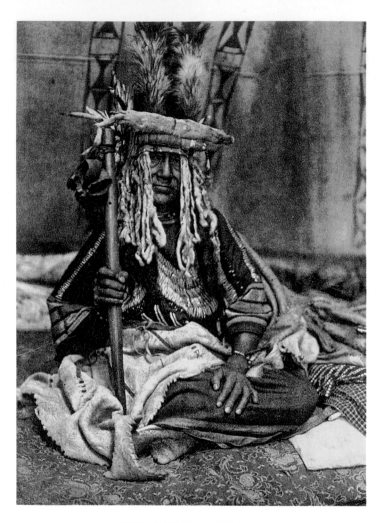

THE PLEDGER – PIEGAN

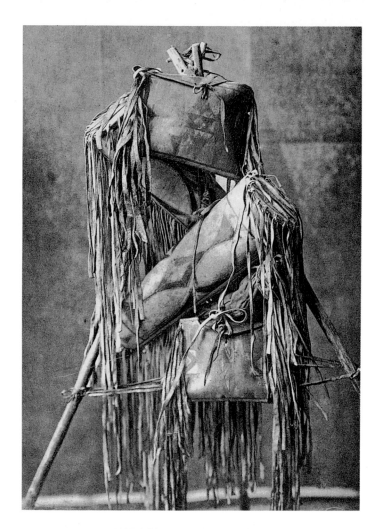

MEDICINE-BAGS – PIEGAN

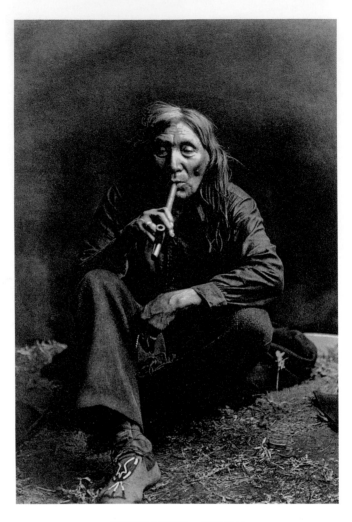

CROW EAGLE – PIEGAN

CAMP IN THE COTTONWOODS –
CHEYENNE

The scene shows a single lodge pitched in one of the cottonwood
groves in the bottoms along Tongue River, in Montana.

CUTTING THE CENTRE-POLE – CHEYENNE

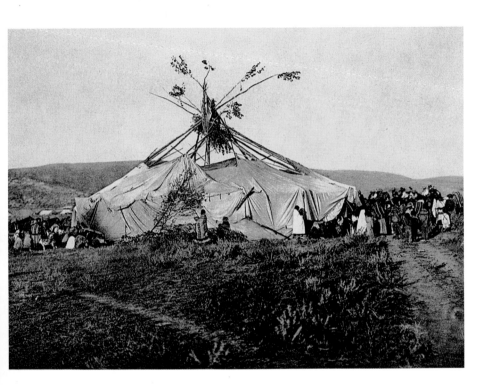

SUN DANCE IN PROGRESS – CHEYENNE

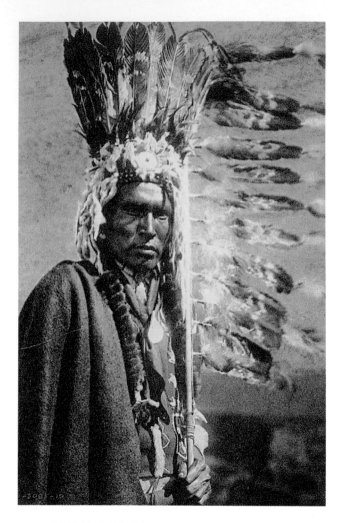

PIEGAN WAR-BONNET AND COUP-STICK

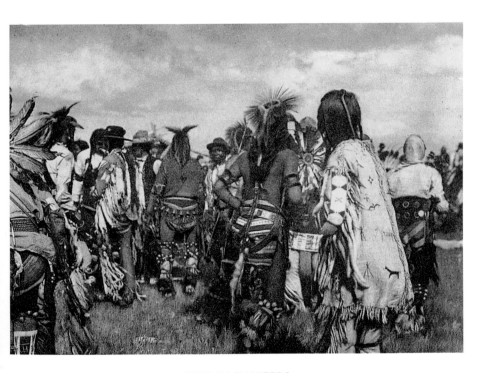

PIEGAN DANCERS

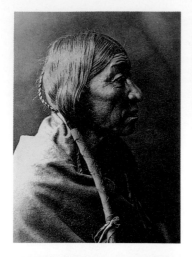

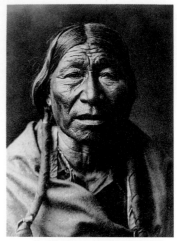

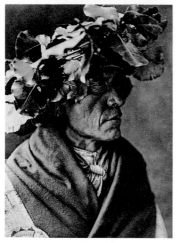

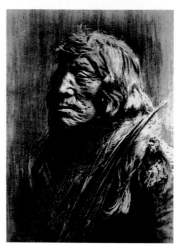

CHEYENNE PROFILE

PORCUPINE – CHEYENNE

At the summer gatherings for such
occasions as the Sun Dance, the
men sometimes protect their heads
from the merciless sun by a thatch of
cottonwood leaves.

CHEYENNE TYPE

WHITE CALF – PIEGAN

Unistaí-poka (White Buffalo-calf) died at
Washington in 1903. He was then almost
eighty years of age, and had been chief of
his tribe for about a generation.

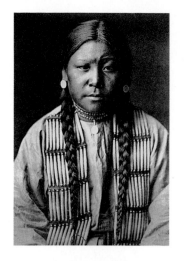

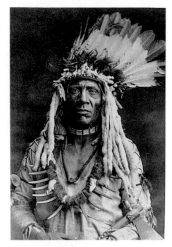

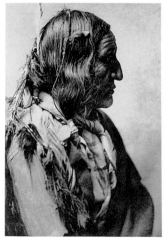

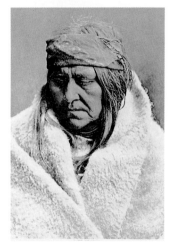

CHEYENNE GIRL

LITTLE WOLF – CHEYENNE

WEASEL TAIL – PIEGAN

The accoutrement of this brave (Ápôĥsuyĭs) comprises the war-bonnet of eagle-feathers and weasel-skins, deer-skin shirt, bone necklace, grizzly-bear claw necklace, and tomahawk-pipe.

TWO BEAR WOMAN – PIEGAN

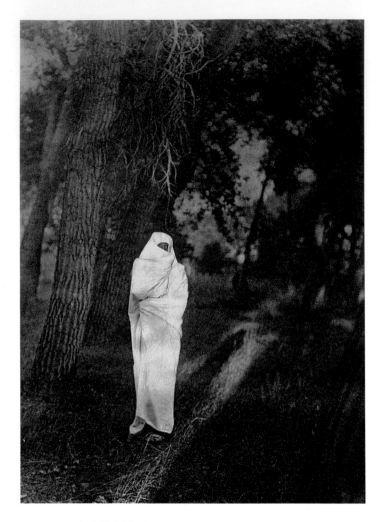

WAITING IN THE FOREST – CHEYENNE

At dusk in the neighborhood of the large encampments young
men, closely wrapped in non-committal blankets or white cotton
sheets, may be seen gliding about the tipis or standing motionless
in the shadow of the trees, each one alert for the opportunity
to steal a meeting with his sweetheart.

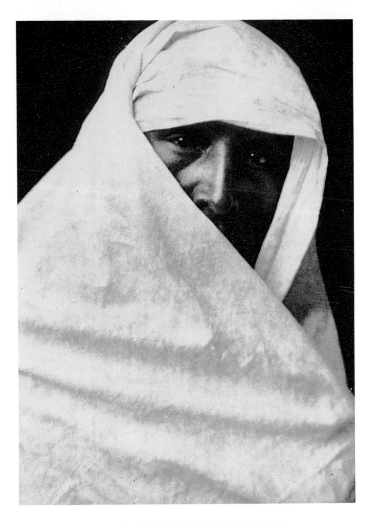

A FAVORITE CHEYENNE COSTUME

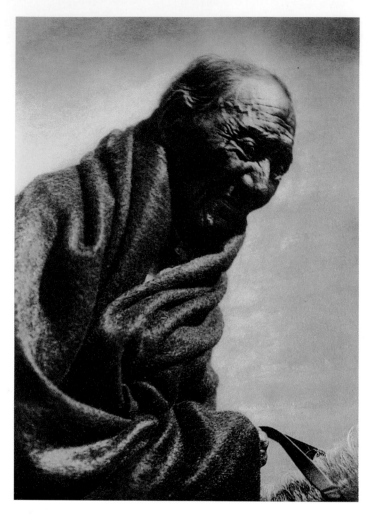

MORNING EAGLE – PIEGAN

At an age of more than ninety, Apinákuipita is still hale
enough to ride his horse to the tribal gatherings.

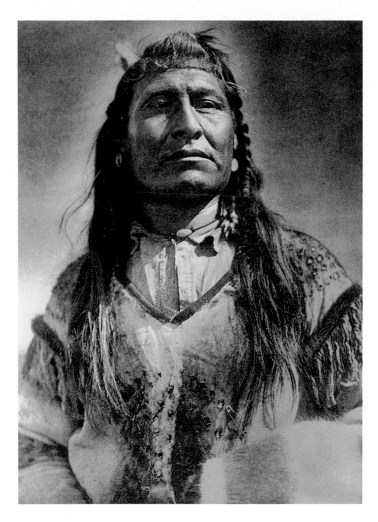

NEW CHEST – PIEGAN

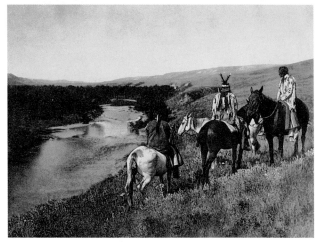

THE THREE CHIEFS – PIEGAN

Three proud old leaders of their people. A picture of the
primal upland prairies with their waving grass and limpid streams.

THE PIEGAN

This scene on Two Medicine River near the eastern foot-hills
of the Rocky Mountains is typical of the western portion of the
Piegan country.

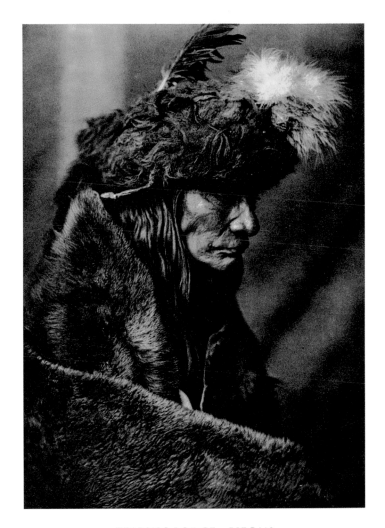

TEARING LODGE – PIEGAN

Pínokiminŭkŝh is one of the few Piegan of advanced years
and retentive memory. He was born about 1835 on Judith River
in what is now northern Montana, and was found to be a valuable
informant on many topics. The buffalo-skin cap is a part of his
war costume, and was made and worn at the command of a
spirit in a vision.

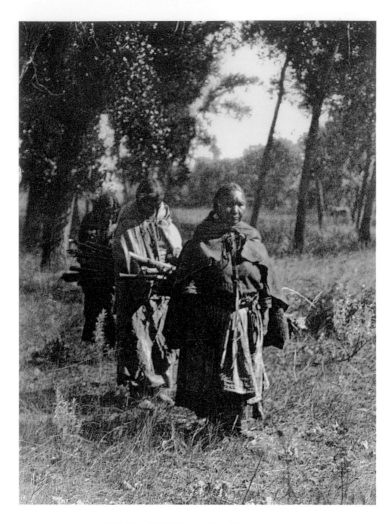

WOOD GATHERERS – CHEYENNE

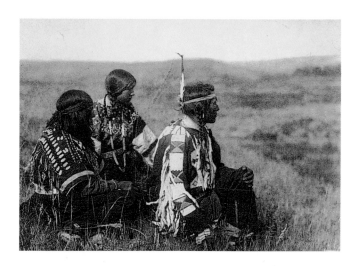

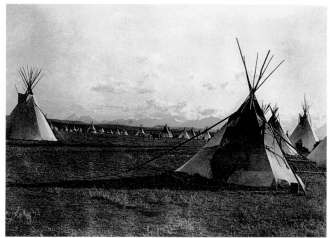

OVERLOOKING THE CAMP – PIEGAN

PIEGAN ENCAMPMENT

The picture not only presents a characteristic view of an
Indian camp on an uneventful day, but also emphasizes the grand
picturesqueness of the environment of the Piegan, living as they
do almost under the shadow of the towering Rocky Mountains.

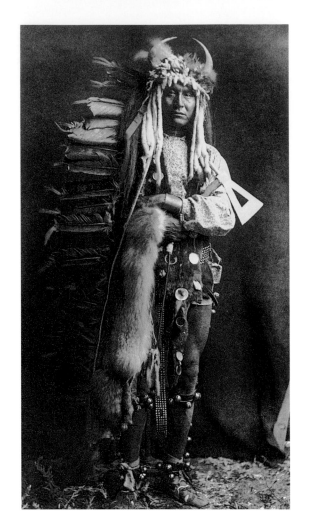

IRON BREAST – PIEGAN

The picture illustrates the costume of a member of the Bulls,
an age society for many years obsolete.

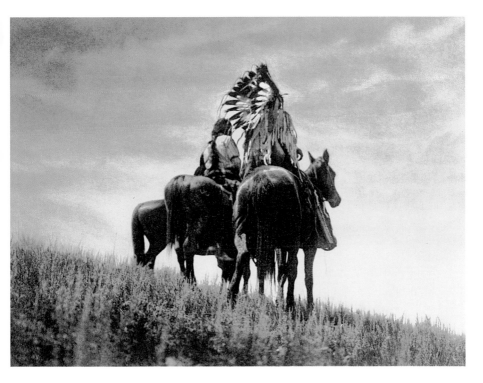

CHEYENNE WARRIORS

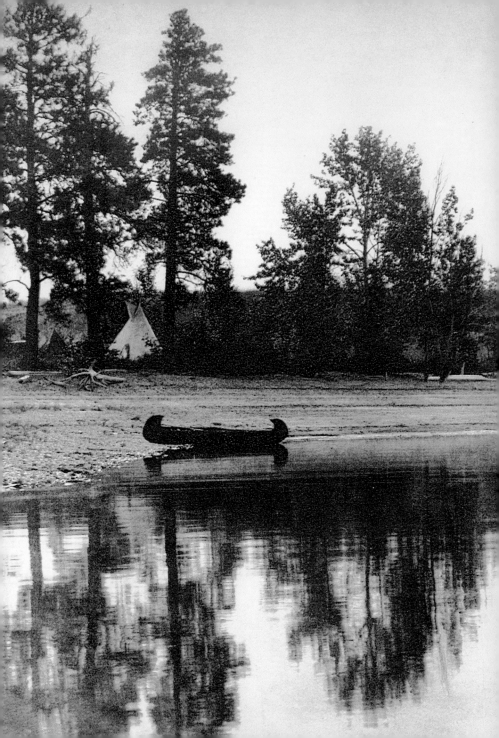

Yakima

Klickitat

Interior Salish

Kutenai

Volume VII

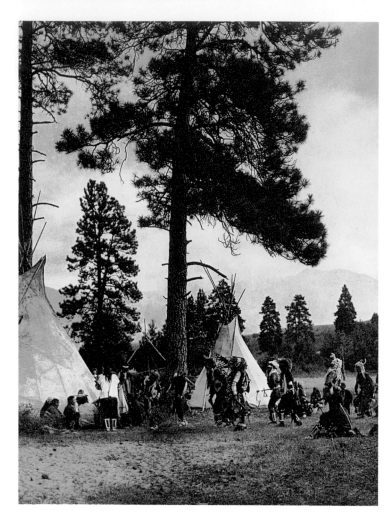

A FLATHEAD DANCE

Eliminating the environment, one would suppose that a party
of plains Indians were performing. The costumes, the step, the
gesture, the character of the songs, all evidence the derivation
of the Flathead war-dance.

PAGE 278
KUTENAI CAMP

THE RUSH GATHERER – KUTENAI

Rushes gathered in the swamps and in the shallows of the lakes
were dried and strung together into mats, which primitively were
used for lodge-covers, mattresses, canoe cushion, and for a variety
of domestic purposes.

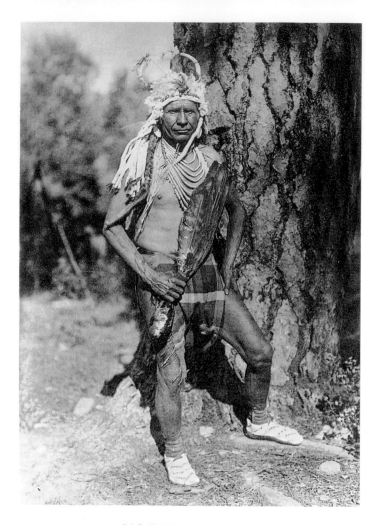

BIG KNIFE – FLATHEAD

Big Knife's ancestry includes an Iroquois (perhaps a halfbreed),
one of a number who came into the Northwest as employees of
the Hudson's Bay Company. The head-dress of buffalo horns
and scalp is not characteristic of the Salish tribes, but of
the plains Indians.

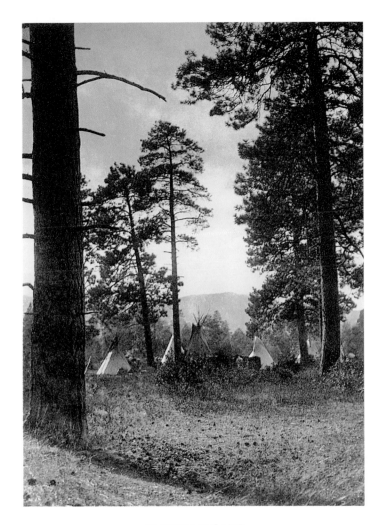

FLATHEAD CAMP

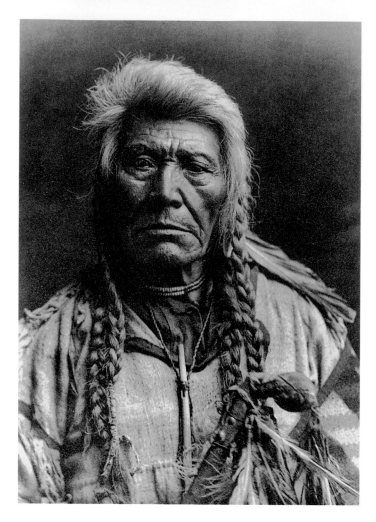

A FLATHEAD CHIEF

Through the medium of their annual incursions into the buffalo
plains east of the Rocky Mountains, the Flatheads adopted much
of the plains culture. Not only their domicile (the tipi), their
garments, weapons, and articles of adornment, came from this
source, but many of their dances were in imitation of similar
ceremonies practised by the prairie tribes. Prominent features of
the accoutrement of this Flathead chief are his war-club of the
plains type, and an eagle-bone whistle.

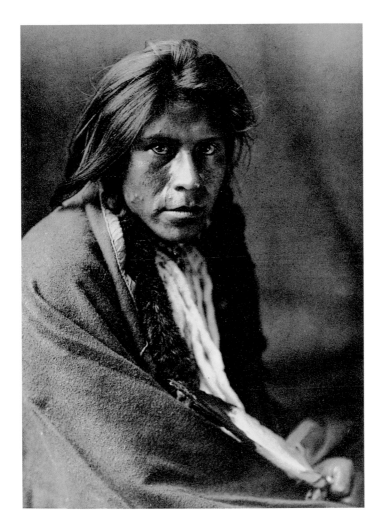

KALISPEL TYPE

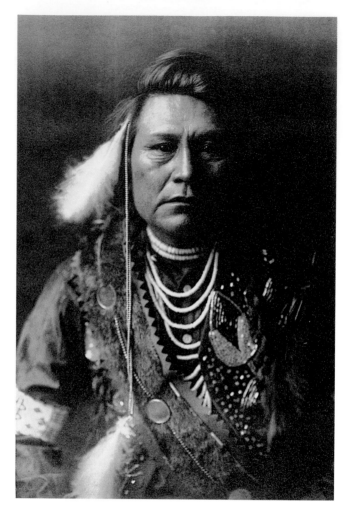

ÍNAS͡HAH͘-YAKIMA

Many of the elderly and middle-aged Yakima, especially
those of what was formerly the ruling class, feel the same dislike
and suspicion of the white man that moved their fathers, in the
uprising of 1855, to attempt to expel the newcomers from their
territory. The brooding expression of dissatisfaction on the face
of this man seemingly represents inherent tribal antipathy to
the white race, engendered by their aggression and greed.

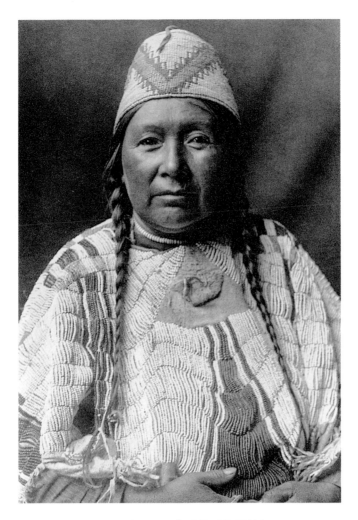

WIFE OF MNAÍNAK – YAKIMA

Mnaínak, son of the former chief of the Columbia River
village Skĭn at the north side of Celilo falls, is probably the man
of greatest influence among the remnant of the cognate bands
that constitute the Yakima.

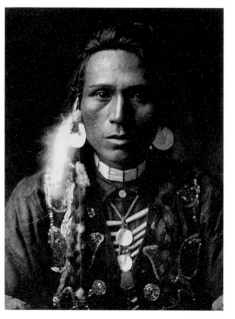

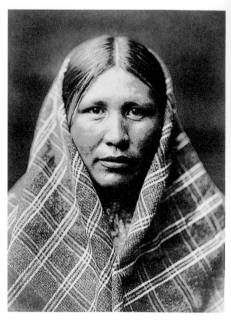

A YOUNG YAKIMA

NESPILIM WOMAN

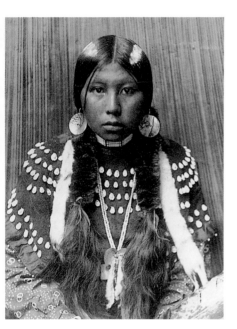

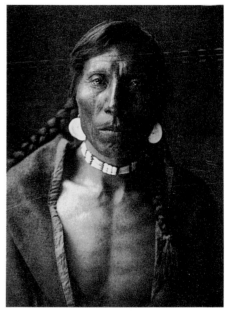

DUSTY DRESS – KALISPEL

THE PEACE-OFFICER – KALISPEL

This Kalispel young woman, Skoﬁlpá, is garbed in
a dress ornamented with shells that imitate elk-tusks.
The braids of hair are wound with strips of otter fur,
and a weasel-skin dangles from each. The bands of
white on the hair are effected with white clay.

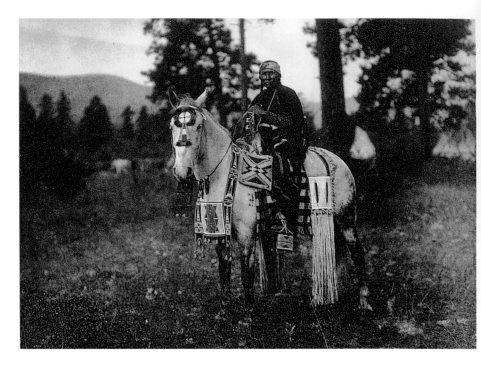

FLATHEAD HORSE TRAPPINGS

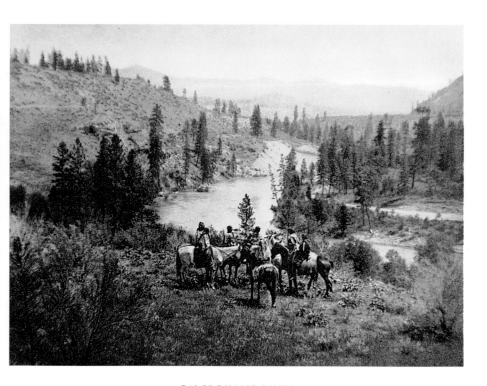

ON SPOKANE RIVER

Spokane River, from a short distance below its head in Cœur
d'Alêne Lake to its confluence with the Columbia, flows through
the midst of what was the territory of the Spokan Indians. The
character of the country through which the stream passes for some
miles above its mouth is well shown in the picture. Northward
from the stream lie the mountains among which the three Spokan
tribes hunted deer and gathered berries, and southward stretch the
undulating plains where they obtained their supplies of roots.

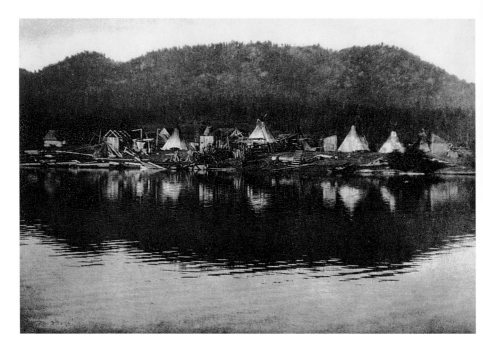

KALISPEL VILLAGE

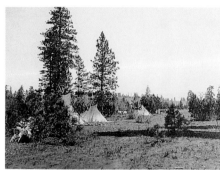

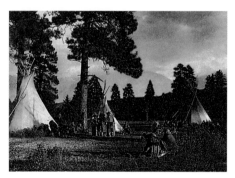

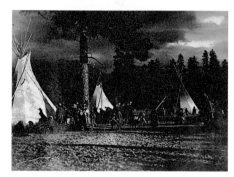

A MOUNTAIN CAMP – YAKIMA

A CAMP OF THE YAKIMA

FLATHEAD CAMP ON JOCKO RIVER

A STORMY DAY – FLATHEAD

The scene depicts a small camp among the pines on
the reservation of the Flatheads in western Montana,
the majestic Rocky Mountains rising abruptly in
the background.

The day was a succession of sudden squalls descending
from the near-by mountains. Just a moment before
sunset the sun broke through the clouds for an
instant, and this striking picture was obtained.

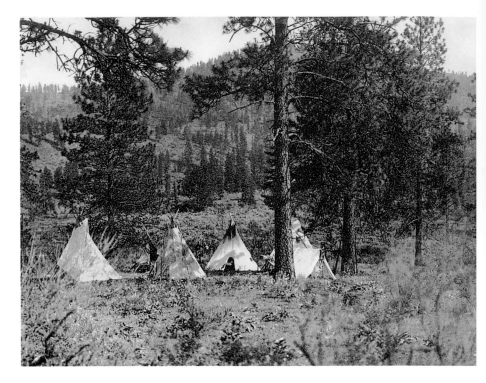

SPOKAN CAMP

The scene is the narrow bench some hundreds of feet above
the level of Spokane River, on its northern bank and a few miles
above its confluence with the Columbia.

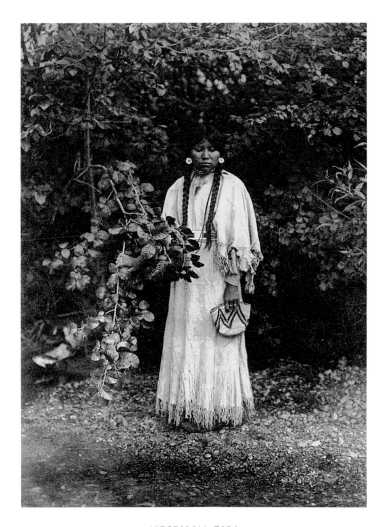

NESPILIM GIRL

In the early years of the nineteenth century various explorers noted
that the bands dwelling along the upper course of the Columbia,
among which the Nespilim were included, wore practically no
clothing, excepting as the cold made some protection necessary. The
hair of the women was arranged in two knots at the sides of the face.
Prior to the middle of the century the use of deerskin garments had
become common, and gradually other customs were borrowed from
the tribes east of the Rocky Mountains.

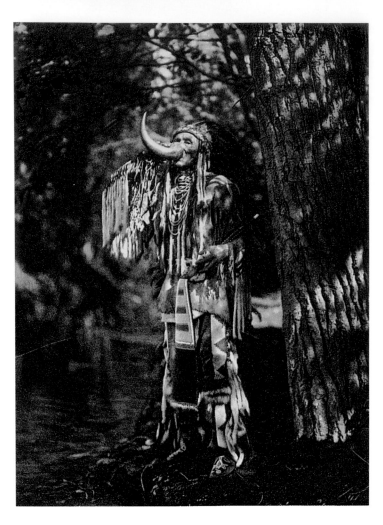

FLATHEAD WARRIOR

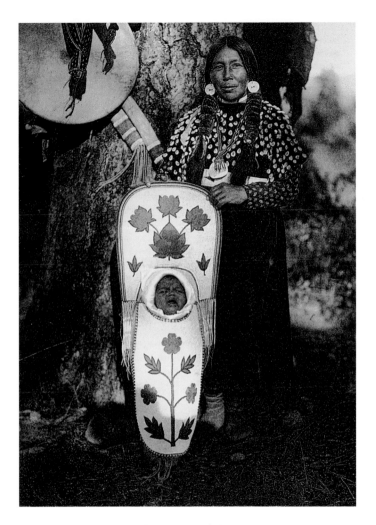

FLATHEAD MOTHER

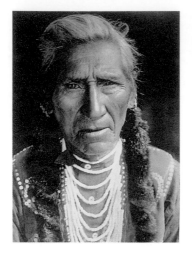

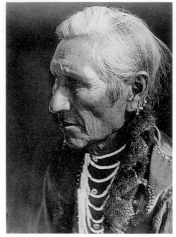

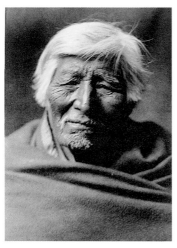

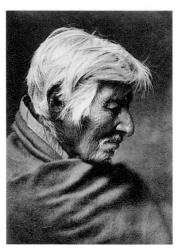

FLATHEAD TYPE

FLATHEAD PROFILE

KLICKITAT PROFILE

The Flatheads are unusually compos-
ite, and the original of the portrait here
presented, while as good a type as can
be found, no doubt is of a very different
mould from that of three or four
generations ago.

KLICKITAT TYPE

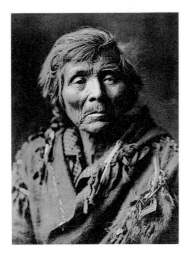

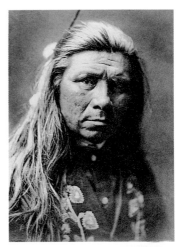

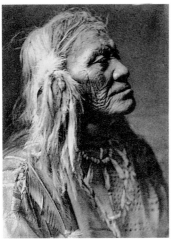

SPOKAN MAN

LUQAÍÔT - KITTITAS

This is a son of Owhi (Óĥai), who as chief
of the Salishan band inhabiting Kittitas
valley, Washington, at first appeared to
favor the Stevens treaty of 1855, but a few
months later was drawn into the Indian
uprising by killing some prospectors.

NESPILIM MAN

The Nespilim were a small Salishan band
living north of the Columbia in the valley
of Nespilim River. Few representatives of
the tribe survive.

WÍSHNAI - YAKIMA

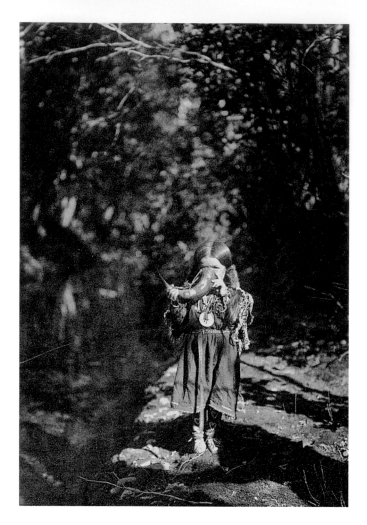

A DRINK – FLATHEAD

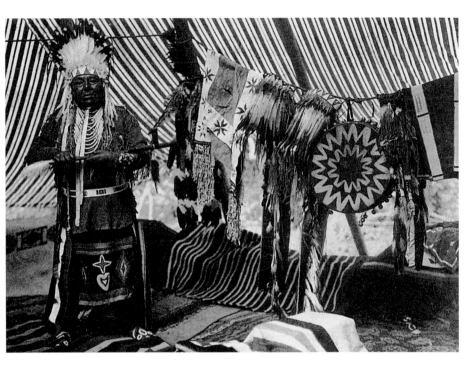

MNAÍNAK, A YAKIMA CHIEF

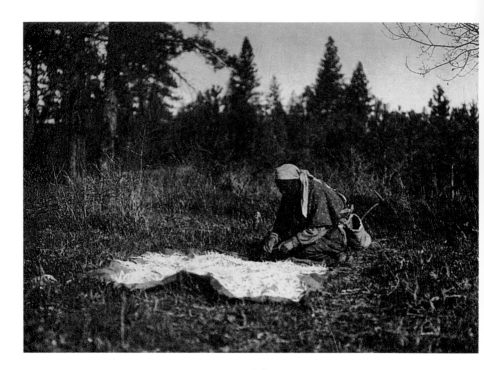

DRYING PIAHÉ – YAKIMA

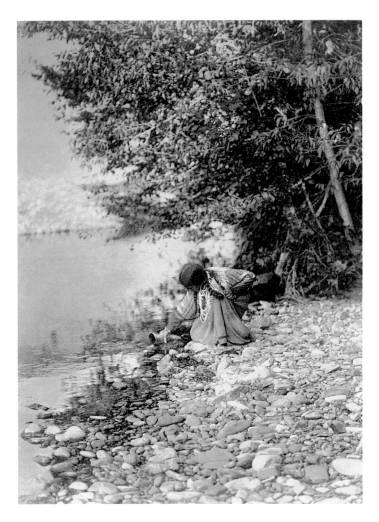

BY THE RIVER – FLATHEAD

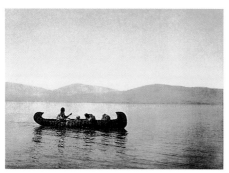

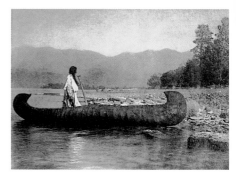

KUTENAI GIRLS

CROSSING THE LAKE – KUTENAI

KUTENAI DUCK HUNTER

COUNTRY OF THE KUTENAI

The Kutenai occupied portions of southeastern British Columbia, northern Idaho, and northwestern Montana. In this region of blue, mountain-girt lakes and majestic rivers they very naturally made use of canoes.

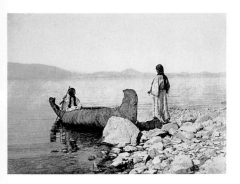

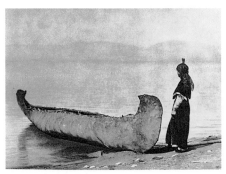

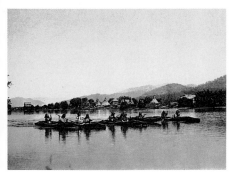

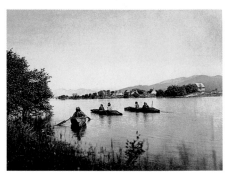

EMBARKING –
KUTENAI

ON THE SHORE OF THE
LAKE – KUTENAI

KALISPEL SCENE

From time out of mind the Kalispel have been boat-
men, and they are one of the few inland tribes that
still possess and use craft of native manufacture. Their
canoes are made of pine-bark on a framework of
cedar strips.

VILLAGE OF THE KALISPEL

The Kalispel, who now number about a hundred,
are scattered along the eastern side of Pend d'Oreille
River in eastern Washington. In the summer they
assemble in their picturesque village at the edge
of a camas meadow opposite the town of Cusick.

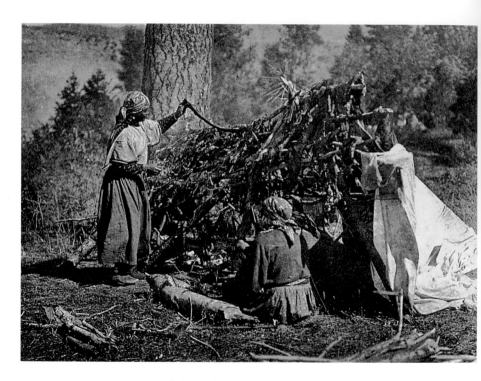

DRYING MEAT – FLATHEAD

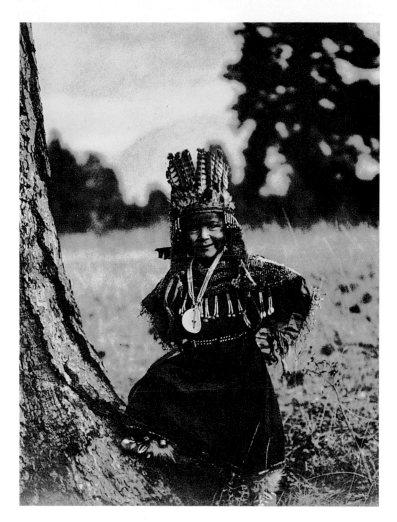

FLATHEAD CHILDHOOD

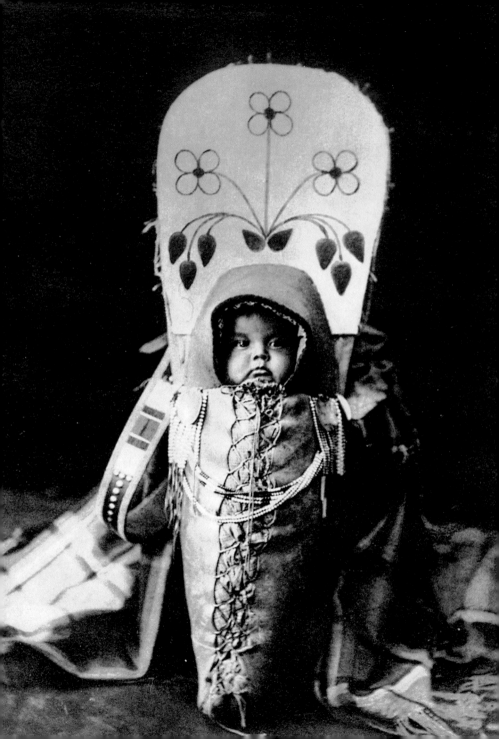

Nez Percés

Wallawalla

Umatilla

Cayuse

Chinookan Tribes

Volume VIII

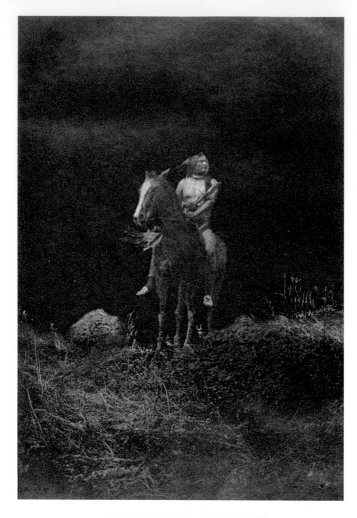

NIGHT SCOUT – NEZ PERCÉ

PAGE 308
NEZ PERCÉ BABE

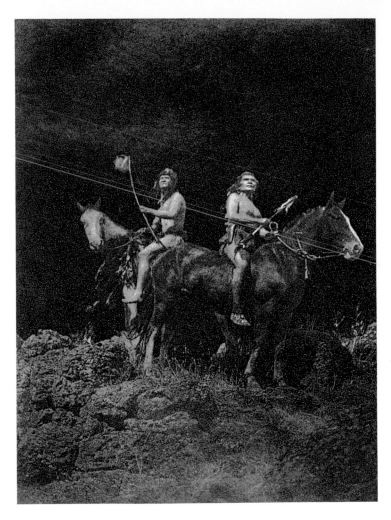

WATCHING FOR THE SIGNAL –
NEZ PERCÉ

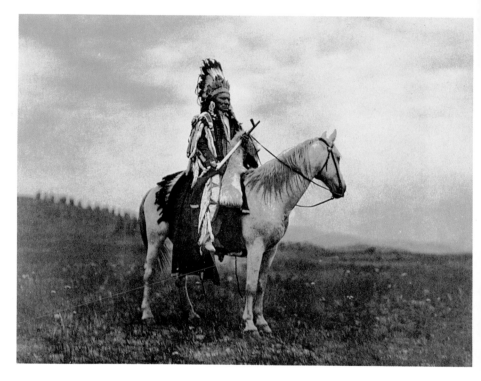

A WAR CHIEF – NEZ PERCÉ

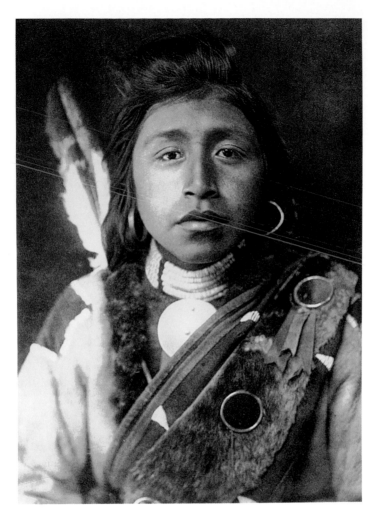

KÁSH͡HILA – WISHHAM

This sturdy young fellow has little of the appearance of the
Chinookan. In feature and in costume he recalls the plains Indian.

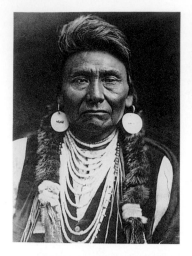

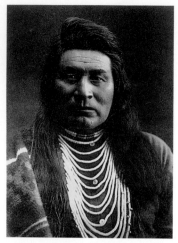

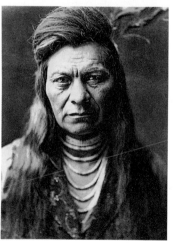

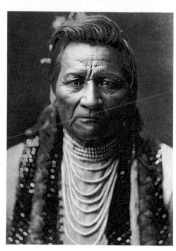

CHIEF JOSEPH – NEZ PERCÉ

Chief Joseph is better known than any other Northwestern Indian. To him popular opinion has given the credit of conducting a remarkable movement from Idaho to northern Montana in the flight of the Nez Percés in 1877.

BLACK EAGLE – NEZ PERCÉ

TYPICAL NEZ PERCÉ

PIÓPIO-MAKSMAKS – WALLAWALLA

The son of that principal chief of the Wallawalla who negotiated a treaty with Governor Isaac I. Stevens in the Walla Walla valley in 1855. The father was killed while a captive of the Oregon volunteers.

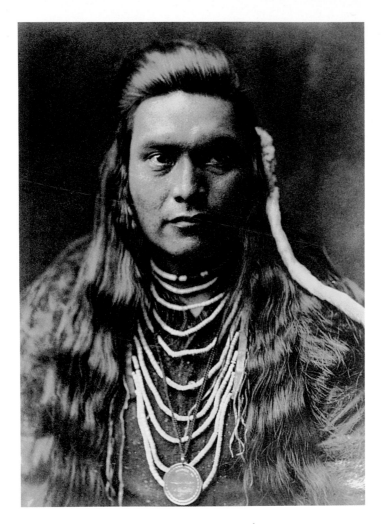

LAWYER – NEZ PERCÉ

The original of this portrait is a member of the family of that
Lawyer who played a prominent part in Nez Percé affairs in the
years following the treaty of 1855.

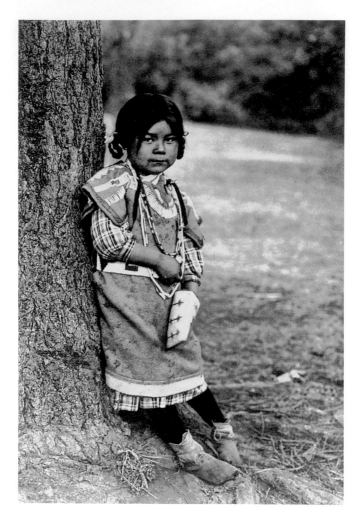

INNOCENCE - UMATILLA

Few aspects of Indian life are more interesting to the casual
visitor than the demeanor of the children, with their coy bash-
fulness, their mischievous, sparkling eyes, their doubtful
hesitation just the other side of friendliness.

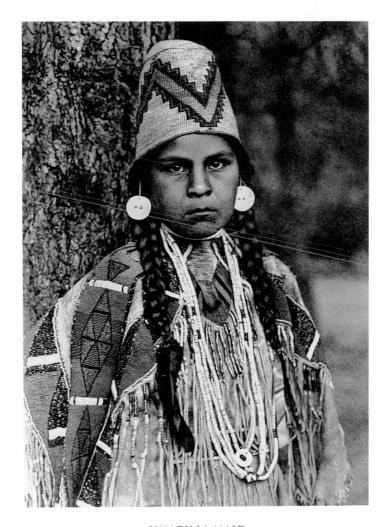

UMATILLA MAID

Two distinct cultural areas are represented in the costume
of this damsel. The familiar beadworked, deerskin dress is an
acquisition from the plains culture, while the basketry hat and
the shell-bead necklace hail from the Pacific slope. Note the
skin of the deer's tail fastened in front at the collar, as an aid
in removing the garment.

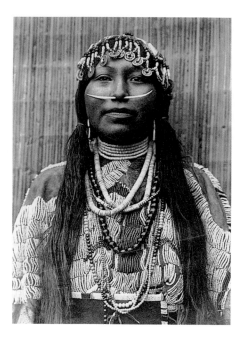

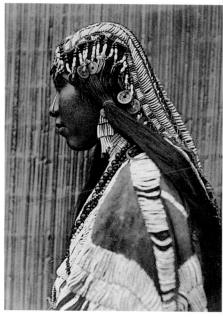

WISHHAM GIRL

WISHHAM GIRL, PROFILE

The subject is clothed in a heavily beaded deerskin dress. An indispensable ornament of the well-born person was the dentalium shell thrust through a perforation in the nasal septum. The head-dress consists of shells, shell beads, commercial beads, and Chinese coins. This form of head-dress was worn on special occasions by girls between the age of puberty and their marriage.

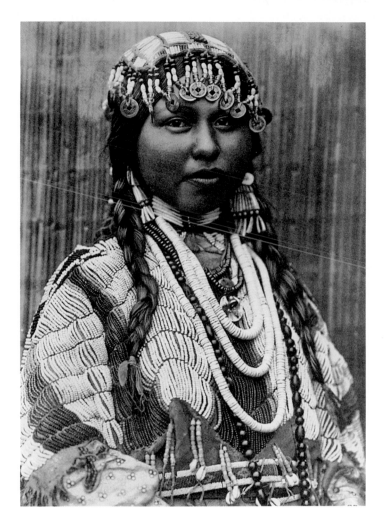

WISHHAM BRIDE

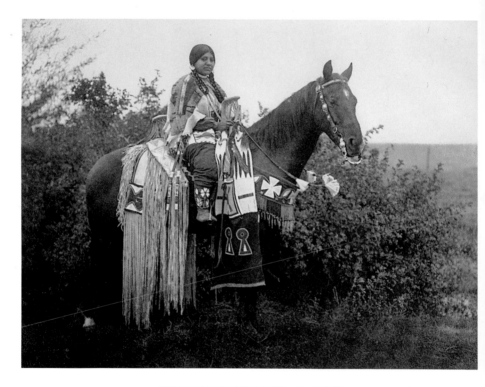

HOLIDAY TRAPPINGS – CAYUSE

Wealthy members of the tribes living on the Umatilla reservation
in Oregon spare no expense in bedecking themselves and their
mounts on gala occasions. The articles of adornment are usually of
deerskin, or of commercial blankets on which designs
are worked in beads.

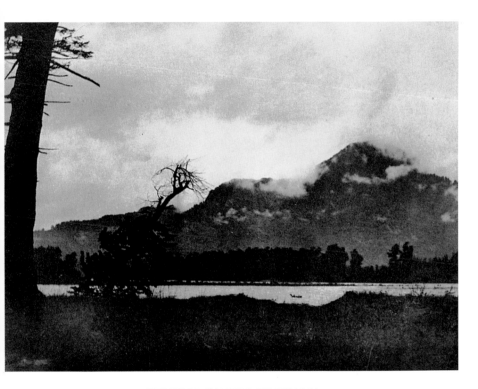

EVENING ON THE COLUMBIA

A spur of the Cascade Mountains occupies the background.

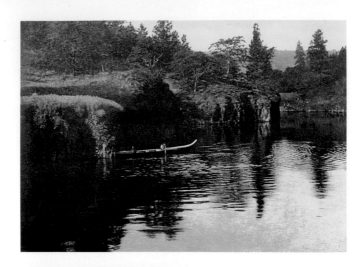

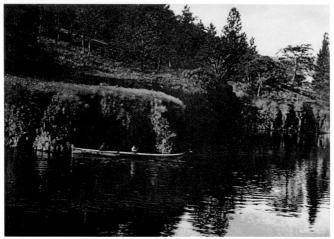

ON KLICKITAT RIVER

ON KLICKITAT RIVER

ON KLICKITAT RIVER

Klickitat River flows through what was the territory of the
Klickitat, a bold, roving, gypsy-like group of Shahaptian bands.
The picture shows one of a succession of beautiful scenes near the
mouth of this stream. The land at its junction with the Columbia
was formerly Chinookan territory, and in fact it was never
altogether given up to the Klickitat.

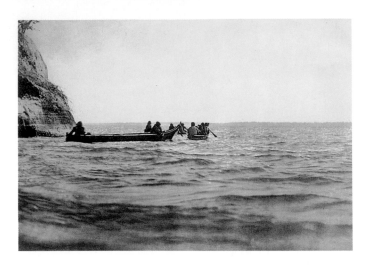

THE LOWER COLUMBIA

The Columbia near its mouth spreads in a broad estuary between
shores now low and flat, and again bold and wooded. The conflict
between winds, tides, and current sometimes raises seas that
threaten even power-driven craft, and the natives who formerly
swarmed in this region were necessarily clever canoemen.

THE COLUMBIA NEAR WIND RIVER

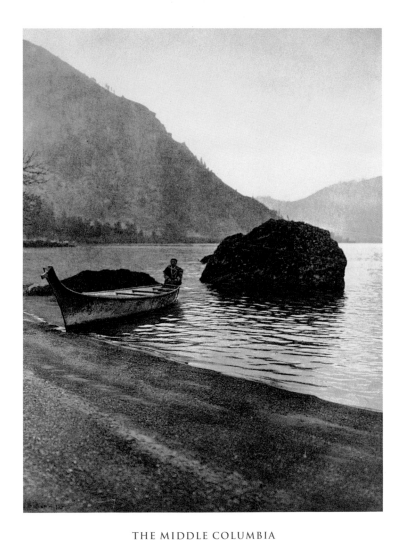

THE MIDDLE COLUMBIA

This picture was made a few miles above the Cascades
of the Columbia.

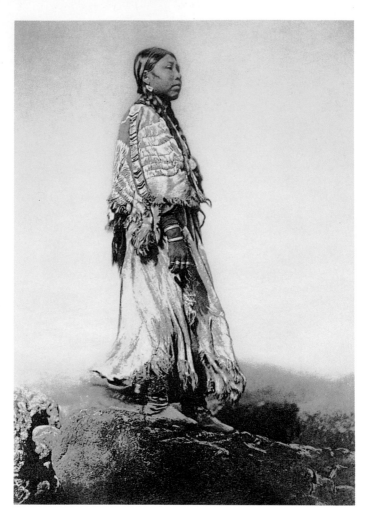

WISHHAM WOMAN

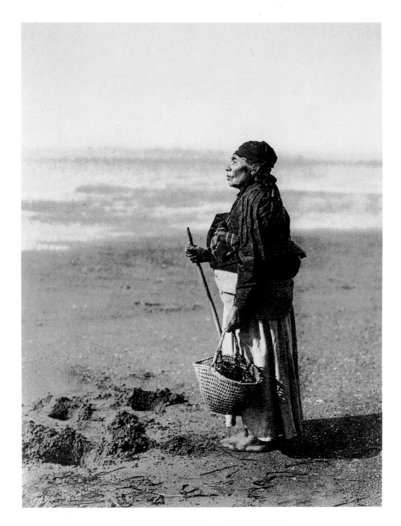

ON THE BEACH – CHINOOK

An old Chinook woman with staff and clam-basket makes her
way slowly over the mud flats of the southern end of Shoalwater
bay, in Washington. Chíiś, Burden-basket (Catherine Hawks),
was a member of the populous tribe that formerly occupied that
part of the state of Washington lying between the middle of
Shoalwater Bay and the Columbia.

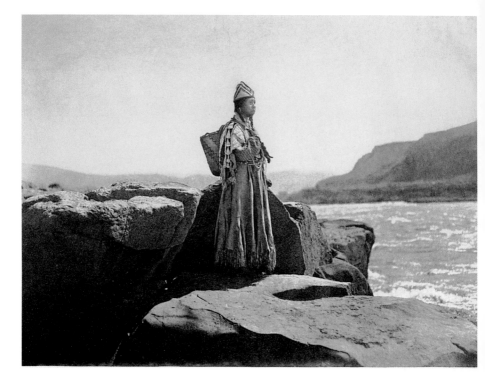

WISHHAM MAID

Clad in her deerskin dress of the plains and her basketry hat of
the coast, the girl pauses on the grim lava rocks above the Dalles,
looking out across the thundering rapids, perhaps observing
the activities of her friends in the village Wásko.

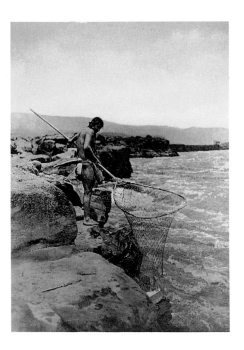

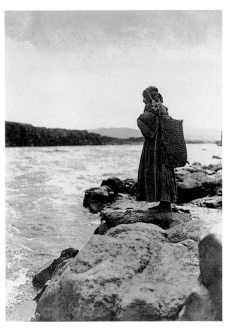

DIP-NETTING IN POOLS –
WISHHAM

In the quiet pools along the rocky shore the
salmon sometimes lie resting from their long journey
up-stream. The experienced fisherman knows these
spots, and by a deft movement of his net he takes
toll from each one.

THE FISH CARRIER –
WISHHAM

From the fishing station the salmon are carried
to the house, distant perhaps a quarter of a mile
or more, in an open-mesh bag (*ihḷḳábēnīh*) borne
on the back and supported by means of a tump-
line passing across the forehead.

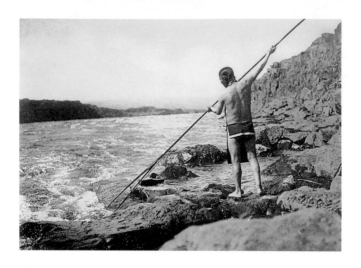

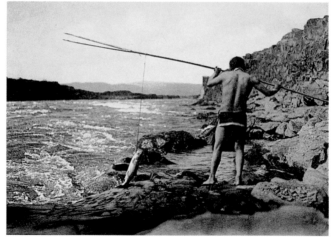

SPEARING SALMON – WISHHAM

The nature of the shore and the height of the water level
sometimes combine to make dip-netting impossible. Recourse
is then had to the double-pointed spear, the socketed barbs of
which are connected to the shaft by strong cords, so that when
a fish is struck and in its struggles the barbs detach from the
prongs, it is held as by a hook and line.

SALMON FISHING – WISHHAM

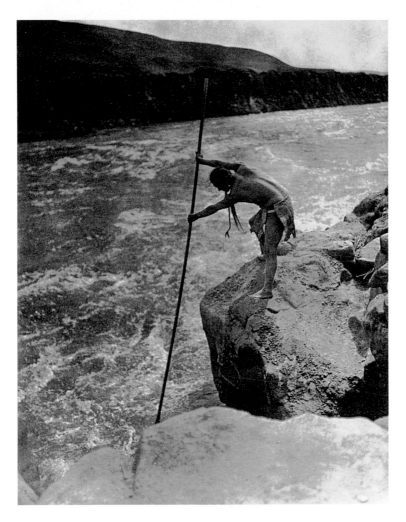

THE FISHERMAN – WISHHAM

Along the middle course of the Columbia at places where the
abruptness of the shore and the up-stream set of an eddy make
such a method possible, salmon were taken, and still are taken, by
means of a long-handled dip-net. At favorable seasons a man will,
in a few hours, secure several hundred salmon – as many as the
matrons and girls of his household can care for in a day.

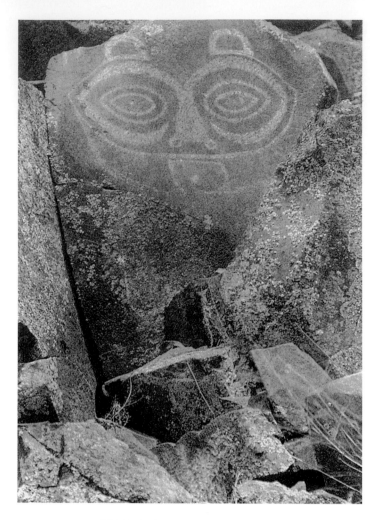

TSAGIGLÁLAL, THE GUARDIAN
OF NIH͡HLÚIDIḢ

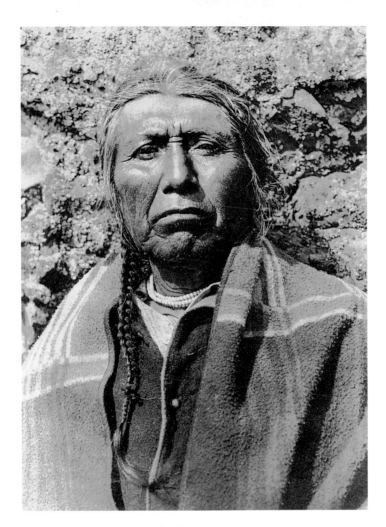

HLALÁKŬM – WISHHAM

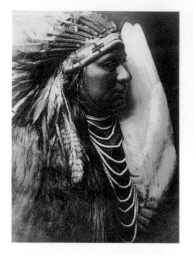

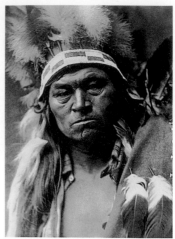

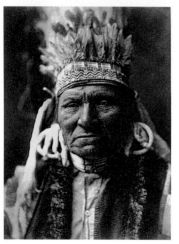

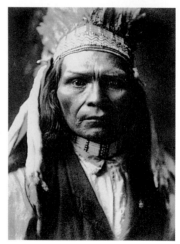

NEZ PERCÉ BRAVE

CAYUSE WARRIOR

YELLOW BULL – NEZ PERCÉ

NEZ PERCÉ WARRIOR

As a member of a family which was
responsible for precipitating the Nez
Percé outbreak of 1877, he proved a
source of valuable information. His son
was one of the men who murdered the
first white settlers in this conflict.

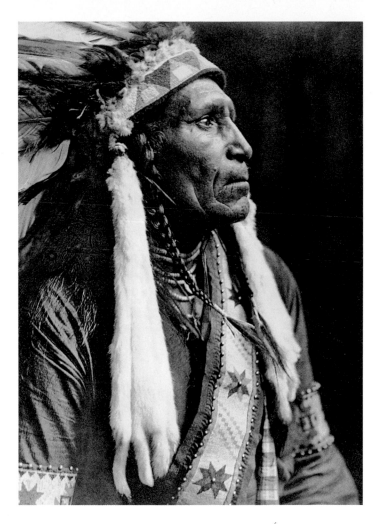

RAVEN BLANKET – NEZ PERCÉ

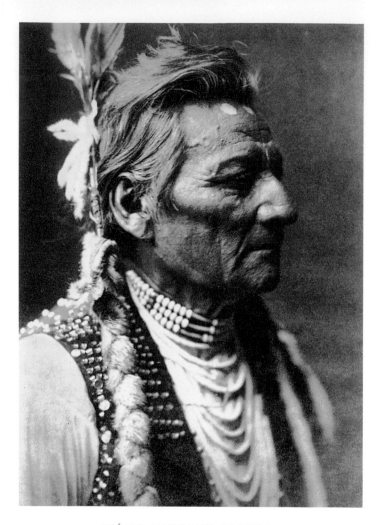

PIÓPIO-MAKSMAKS, PROFILE –
WALLAWALLA

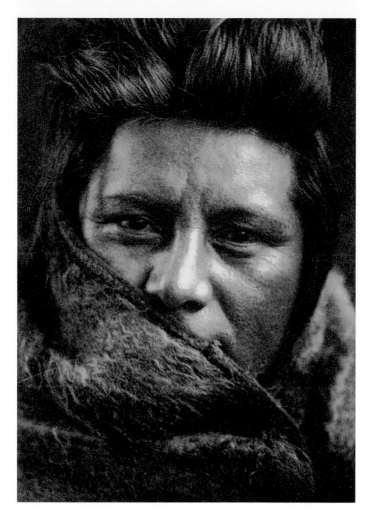

A YOUNG UMATILLA

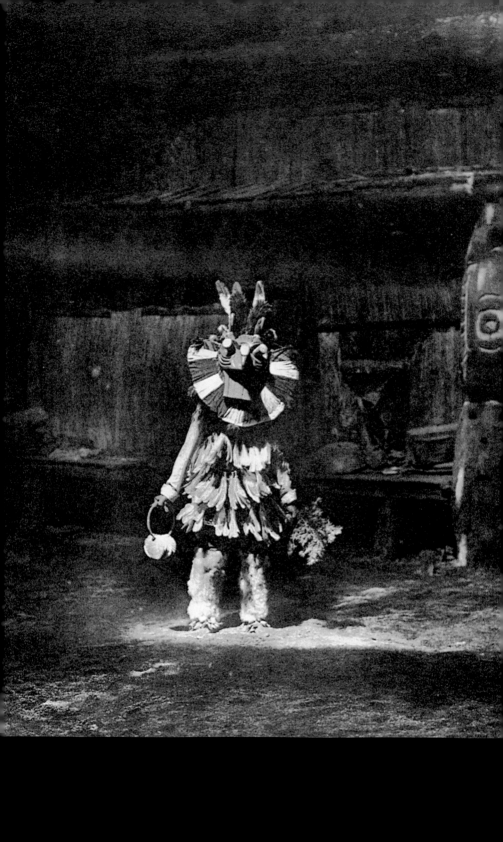

Salishan Tribes of the Coast

of the Coast

Chimakum

Quilliute

Willapa

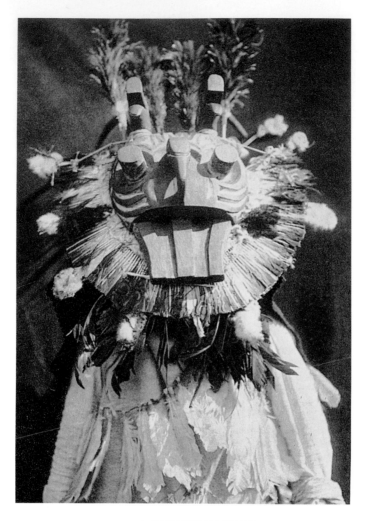

A COWICHAN MASK

PAGE 338
MASKED DANCER – COWICHAN

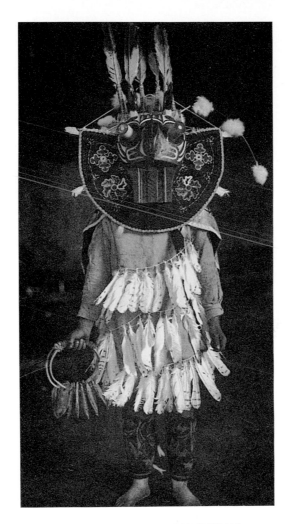

MASKED DANCER – COWICHAN

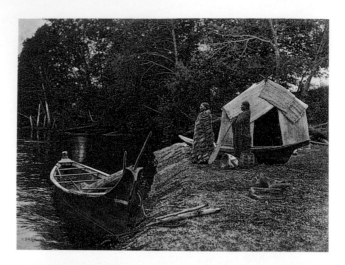

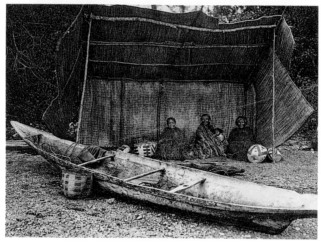

ON SKOKOMISH RIVER

PUGET SOUND CAMP

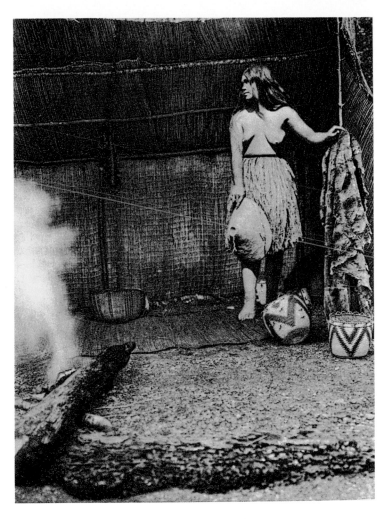

A PRIMITIVE CAMP

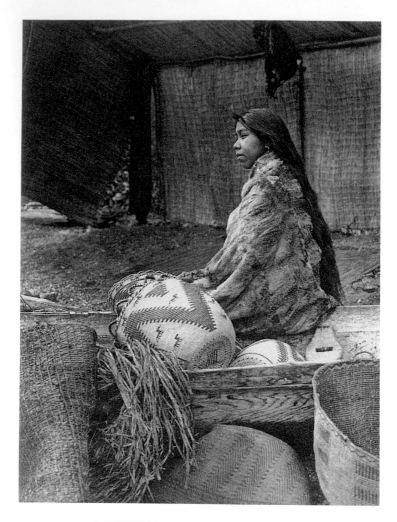

A CHIEF'S DAUGHTER - SKOKOMISH

Pride of birth played a prominent role in the life of the
Pacific Coast Indians. Society was rigidly divided into nobility,
common people, and slaves taken in war. No woman of common
birth could afford the luxury of the fur robe worn by the
subject of this picture.

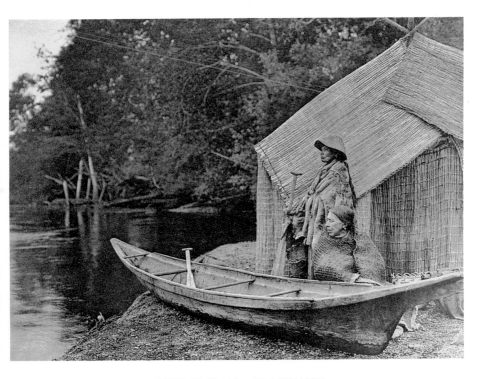

FISHING CAMP – SKOKOMISH

The picture shows a typical summer house at a picturesque
spot on Skokomish River.

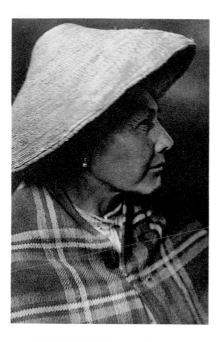 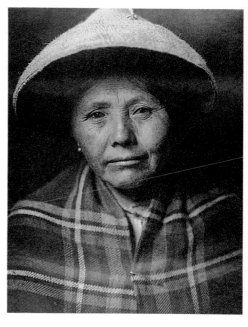

QUINAULT FEMALE PROFILE QUINAULT FEMALE TYPE

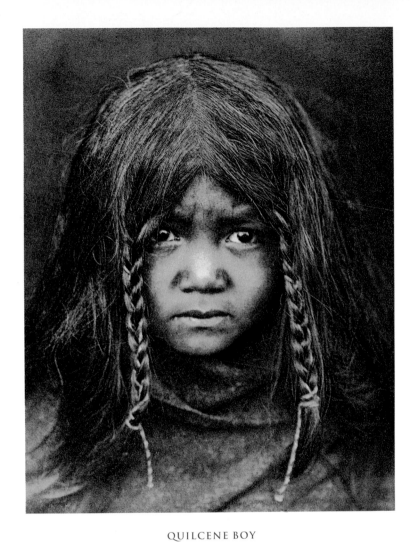

QUILCENE BOY

The Quilcene, like the Skokomish, are a band of Twana
living on Hoods Canal, Washington.

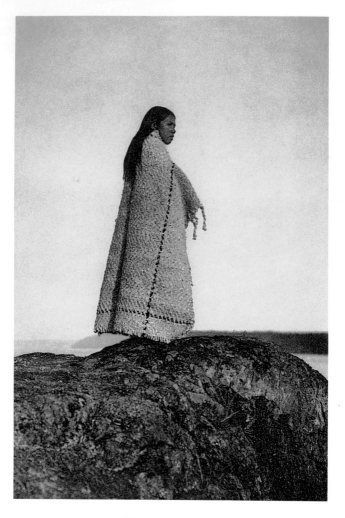

COWICHAN GIRL

A maiden of noble birth clad in a goat-hair robe.

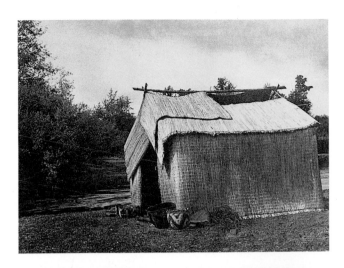

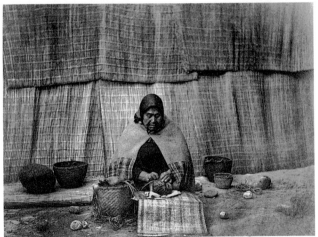

A MAT HOUSE – SKOKOMISH

A summer house of tule mats on a framework of poles is very
quickly completed. As rolls of matting are included in the
equipment of every party of travellers, the means of providing
shelter are never lacking. The picture affords a glimpse of
Skokomish River, a scenic stream flowing into the head
of Hoods Canal.

BASKET MAKER

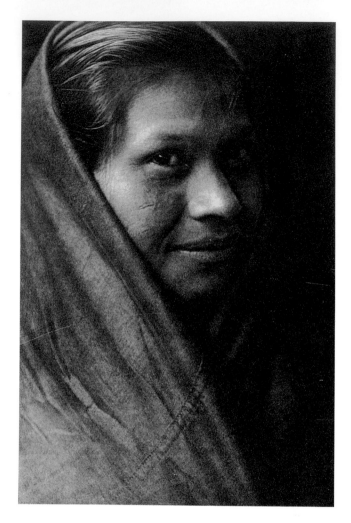

QUILLIUTE GIRL

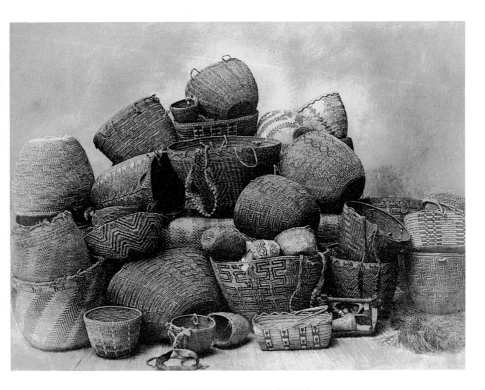

PUGET SOUND BASKETS

Basketry continues to be an important industry of many
Puget Sound tribes, the bulk of the product passing into the hands
of dealers. Women of the Skokomish band of Twana
are especially skilful in weaving soft, flexible baskets.

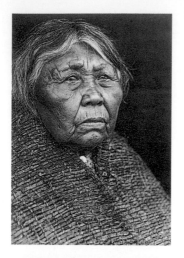

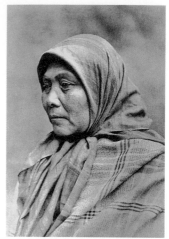

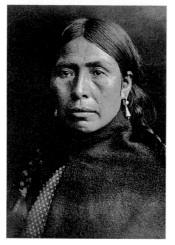

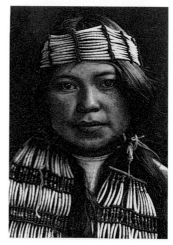

HLEÁSTŬNŬH –
SKOKOMISH

PUGET SOUND
TYPE

LUMMI TYPE

The Lummi held considerable
territory in the vicinity of Lummi
Bay, Washington, as well as many
of the San Juan Islands.

SHELL ORNAMENTS –
QUINAULT

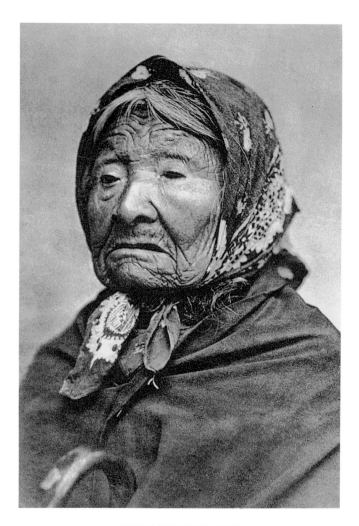

PRINCESS ANGELINE

This aged woman, daughter of the chief Síaɫ (Seattle), was
for many years a familiar figure in the streets of Seattle.

COWICHAN RIVER

ON QUINAULT RIVER

COWICHAN CANOES

The scene looks out from the mouth of Cowichan River
upon Cowichan harbor.

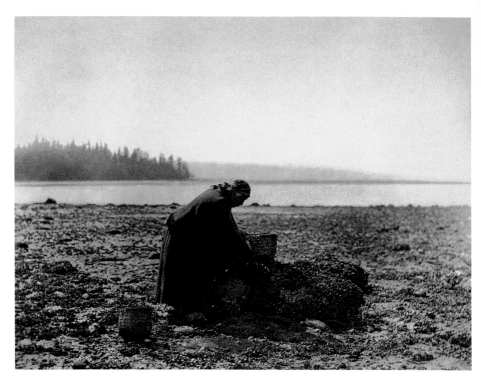

THE MUSSEL GATHERER

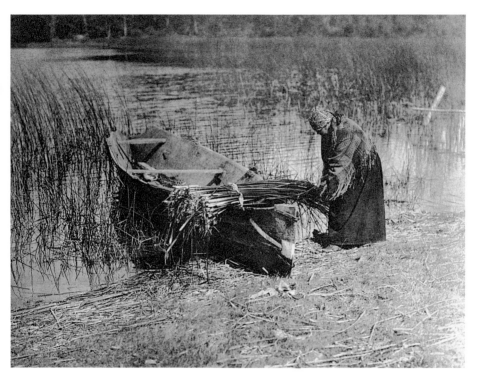

THE TULE GATHERER – COWICHAN

The manufacture of tule mats for use as carpets, house-walls,
mattresses, capes, and sails is still in many localities an
important duty of women.

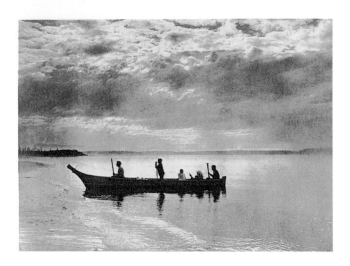

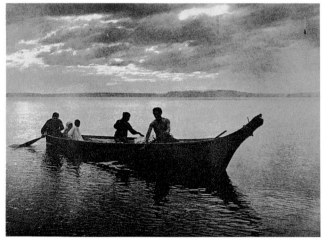

SUNSET ON PUGET SOUND

HOMEWARD

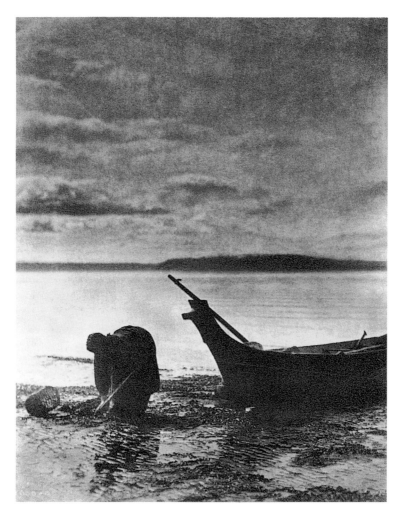

THE CLAM DIGGER

Clams are an important food to those who live in the vicinity
of the clam beds; to others they are a comparative luxury obtained
by barter. The implement of the digger is a wooden dibble.

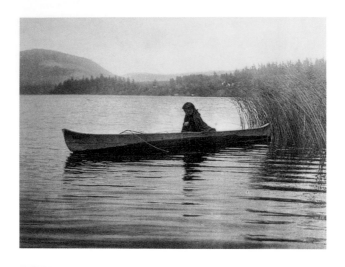

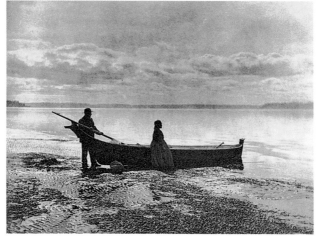

QUAMICHAN LAKE

On the shores of this beautiful lake, which is near Duncans,
British Columbia, the Cowichan of Vancouver Island
obtain their supplies of tules.

EVENING ON PUGET SOUND

The photograph was made near the city of Seattle.

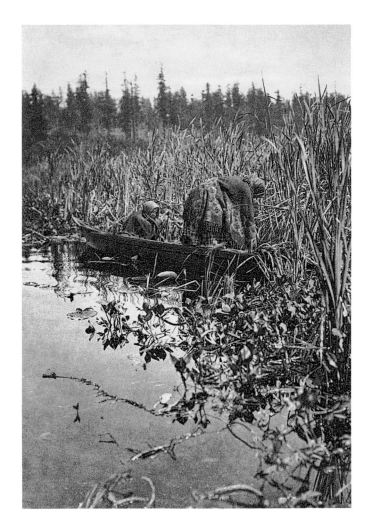

TULE GATHERERS – PUGET SOUND

HOP PICKERS – PUGET SOUND

A PRIMITIVE QUINAULT

Among all the Coast Salish the aboriginal dress of women
was a knee-length kilt of thick, cedar-bark fringe. No other
garment was worn except when cold or rain made goat-hair
or vegetal-fiber blankets or capes desirable.

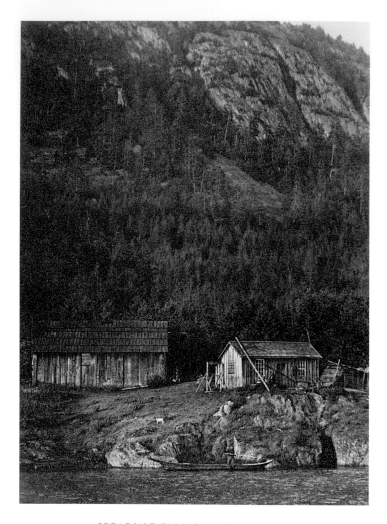

SPEARING SALMON - COWICHAN

The view includes the deep slope of Tsoḥélĭm Mountain
and a portion of the village Hénĭpsŭm at the mouth of
Cowichan River, Vancouver Island.

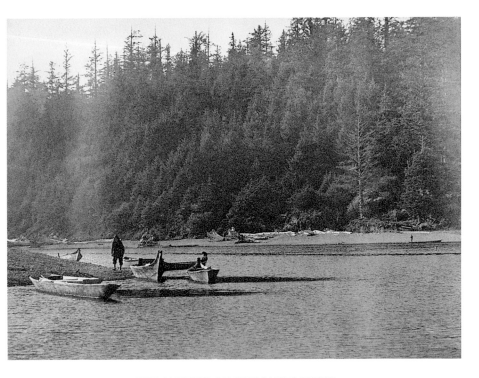

THE MOUTH OF QUINAULT RIVER

The village of the Quinault stands at the mouth of this stream,
a few hundred yards from the ocean. From the river they gain their
livelihood in salmon fishing.

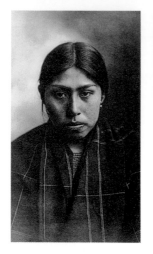
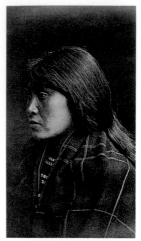
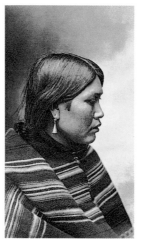
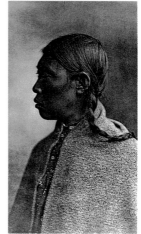

SUQUAMISH WOMAN

The Suquamish were one of
numerous Puget Sound tribes.

SUQUAMISH GIRL

LUMMI WOMAN

SQUAXON MATRON

The Squaxon were a small
tribe at the very head of Puget
Sound.

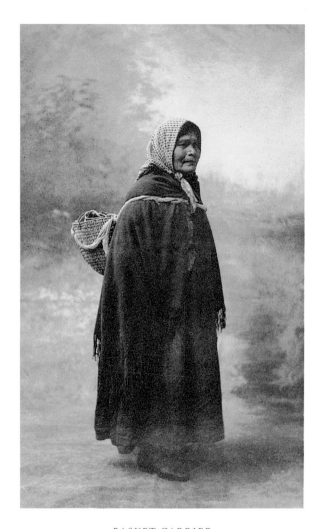

BASKET CARRIER

When a heavy burden is to be borne, the tump-line crosses
the forehead and the bearer walks stooping.

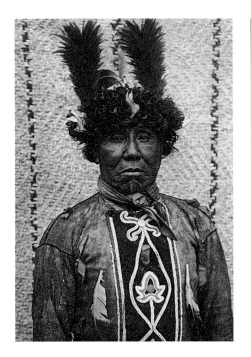

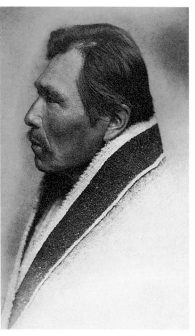

COWICHAN WARRIOR

SNOQUALMU TYPE

The Snoqualmu were a vigorous tribe
inhabiting the watershed of Snoqualmie
River, Washington.

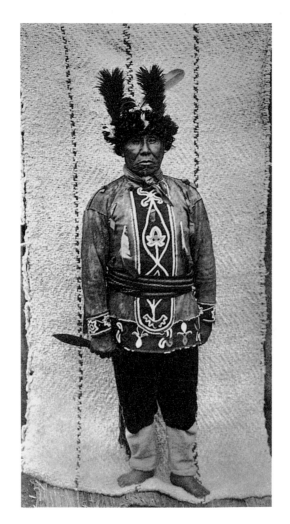

COWICHAN WARRIOR

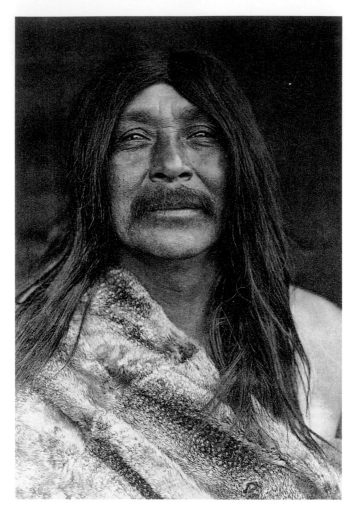

LÉLEḢALT – QUILCENE

Among the Pacific Coast tribes the moustache does not necessarily
indicate white ancestry. The earliest travellers noted that many of
the men had considerable hair on the face.

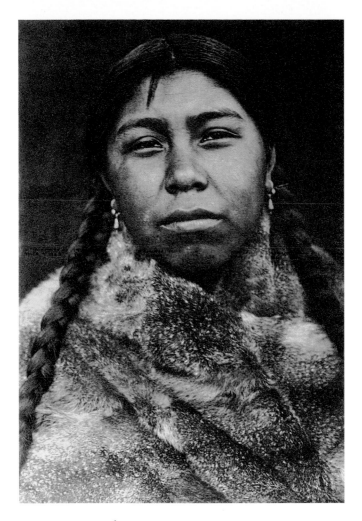

TSÁTSALATKSA – SKOKOMISH

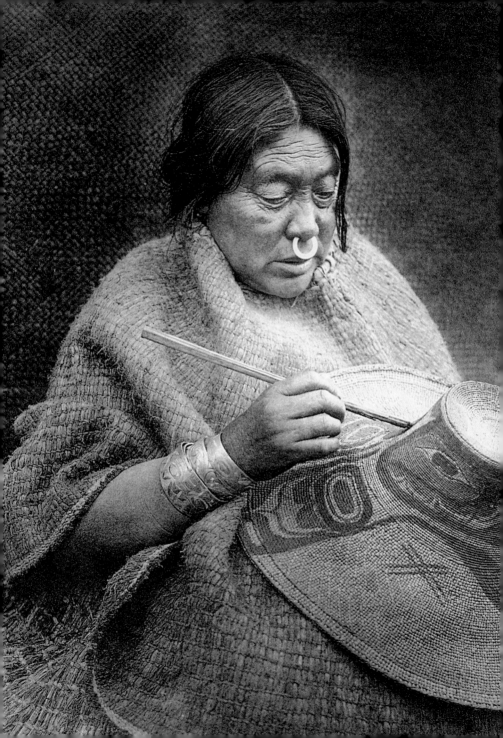

KWAKIUTL

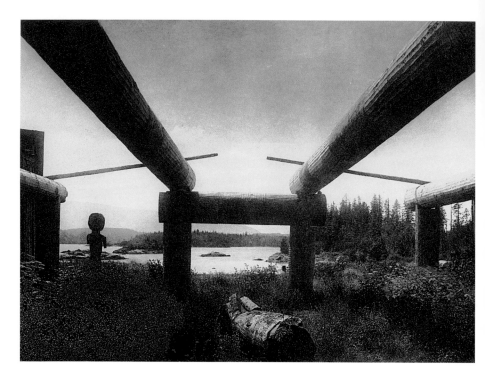

KWAKIUTL HOUSE-FRAME

The two long beams in the middle are twin ridge-
timbers. At the extreme right and left are the eaves-timbers.
The longitudinal and circular flutes of the columns are
laboriously produced by means of a small hand-adze
of primitive form.

PAGE 372
PAINTING A HAT – NAKOAKTOK

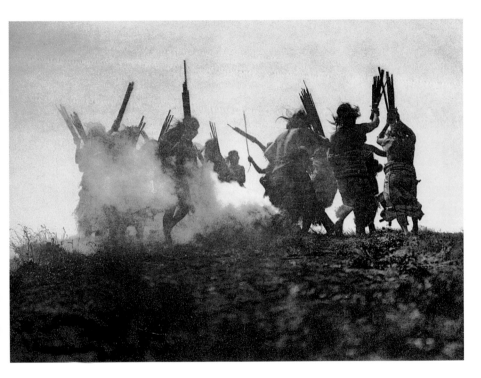

DANCING TO RESTORE AN ECLIPSED
MOON – QÁGYUHL

It is thought that an eclipse is the result of an attempt of
some creature in the sky to swallow the luminary. In order to
compel the monster to disgorge it, the people dance round a
smouldering fire of old clothing and hair, the stench of which,
rising to his nostrils, is expected to cause him to sneeze
and disgorge the moon.

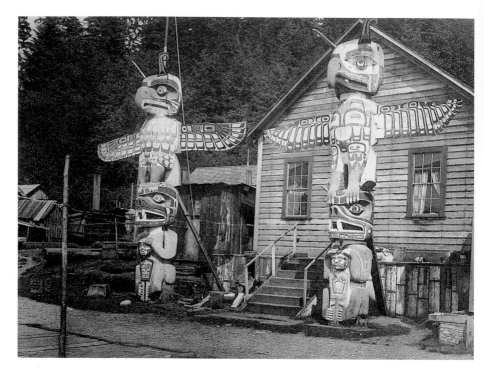

CARVED POSTS AT ALERT BAY

These two heraldic columns at the Nimkish village Yílís, on
Cormorant Island, represent the owner's paternal crest, an eagle,
and his maternal crest, a grizzly-bear crushing the head of
a rival chief.

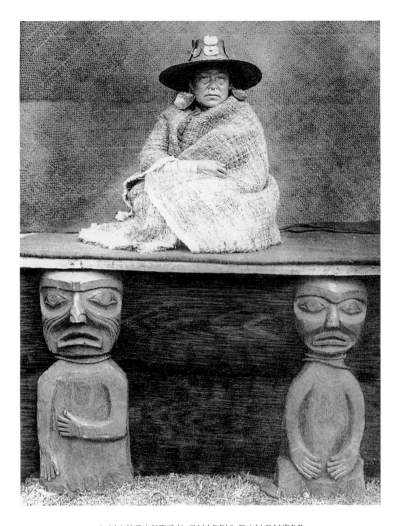

A NAKOAKTOK CHIEF'S DAUGHTER

When the head chief of the Nakoaktok holds a potlatch
(a ceremonial distribution of property to all the people), his eldest
daughter is thus enthroned, symbolically supported on the
heads of her slaves.

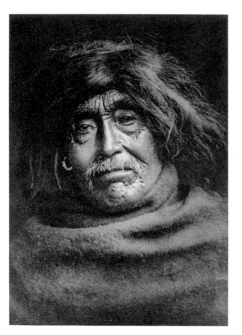

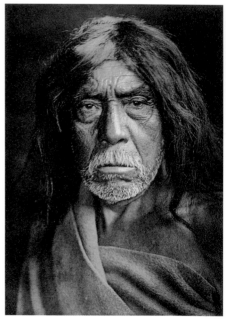

MÓWAKIU – TSAWATENOK

SÍWĬT – AWAITLALA

The Tsawatenok are an inland and river tribe,
depending on the sea for their sustenance much less
than do most Kwakiutl tribes, and to an equal degree
devoting more time to hunting and trapping in the
mountains. Their territory lies along Kingcome River,
at the head of the long, mainland indentation
known as Kingcome inlet.

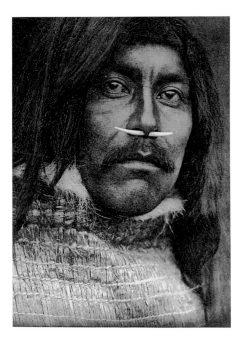

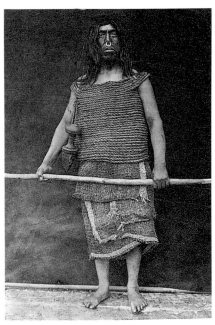

QU'HÍLA – KOPRINO

This young chief of an almost extinct tribe
resident on Quatsino Sound, near the northwestern
end of Vancouver Island, is wearing one of the nose-
ornaments formerly common among Kwakiutl nobil-
ity. The dentalium shells of which they consisted
were obtained in vast numbers in certain
waters of the sound.

NAKOAKTOK WARRIOR

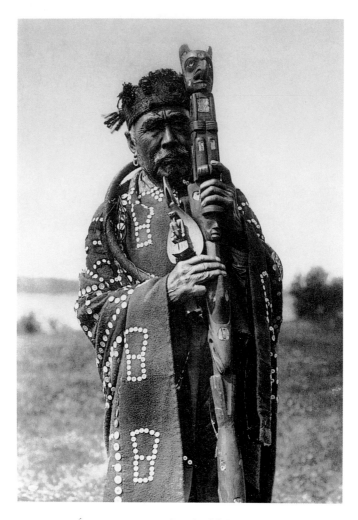

HÁMASAKA IN TLÙ'WŬLÁHŬ COSTUME
WITH SPEAKER'S STAFF – QÁGYUHL

The principal chief of the Qágyuḥl is depicted in a "button
blanket" (which is simply a woollen blanket ornamented with
hundreds of large mother-of-pearl buttons), cedar-bark neck-ring,
and cedar-bark head-band. His right hand grasps a shaman's rattle,
and his left the carved staff which, as a kind of emblem of office,
a man always holds when making a speech. The button designs
along the edge of the blanket represent "coppers."

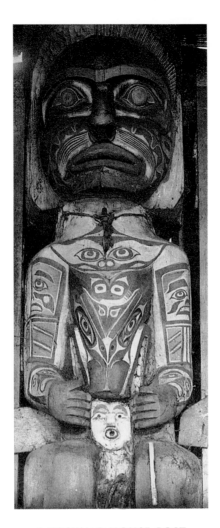

A KOSKIMO HOUSE-POST

The huge, grotesquely carved, interior supporting columns are the
most striking feature of Kwakiutl houses. The figures perpetuate
the memory of incidents in the legendary history of the family,
frequently representing a tutelary spirit of the founder.

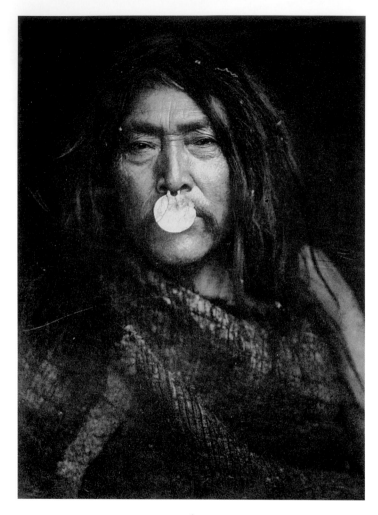

NAÉMAH̓L P̮ŬNKŬMA – HAHUAMIS

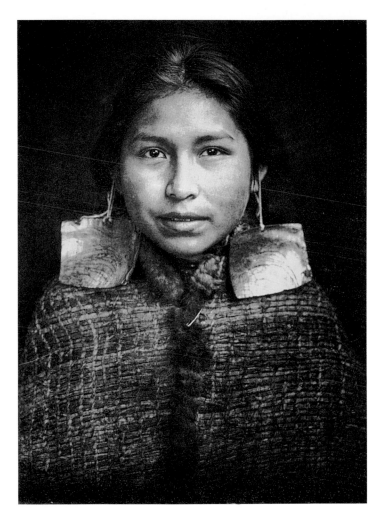

TSAWATENOK GIRL

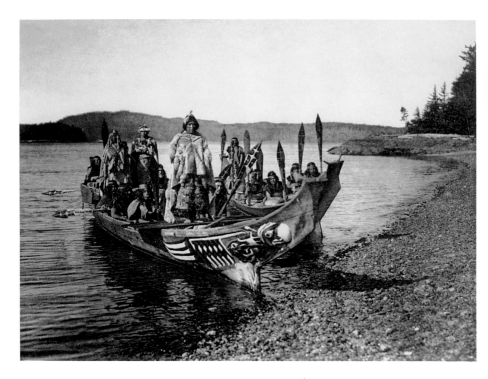

THE WEDDING PARTY – QÁGYUHL

After the wedding ceremony at the bride's village the party
returns to the husband's home. The newly married pair stand on
a painted "bride's seat" in the stern of the canoe, and the
bridegroom's sister, or other relative, dances on a platform in the
bow, while the men sing and rhythmically thump the canoes with
the handles of their paddles.

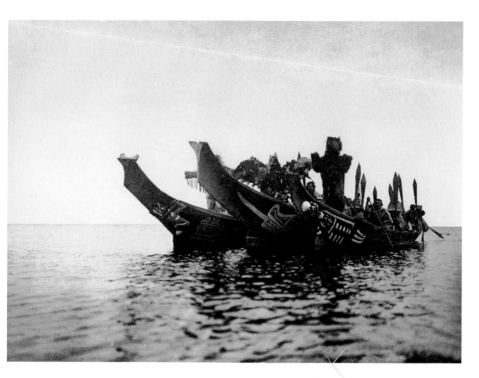

MASKED DANCERS IN CANOES – QÁGYUHL

Visitors approaching a village where the winter dance is
in progress sometimes array themselves in their ceremonial
costumes, and dance while the canoes slowly move shoreward.
From left to right the dancers represent respectively Wasp,
Thunderbird, and Grizzly-bear.

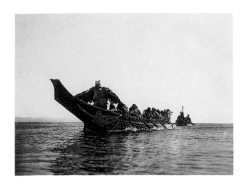

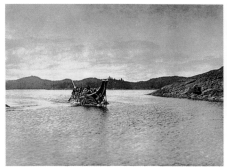

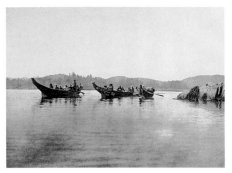

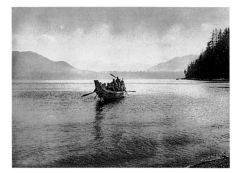

WEDDING GUESTS

IN KWAKIUTL WATERS

In a characteristic setting is shown a fleet of the
beautifully modelled Kwakiutl canoes, manned
by crews in aboriginal dress.

AN INLAND WATERWAY

A CHIEF'S PARTY – QÁGYUHL

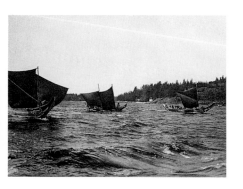

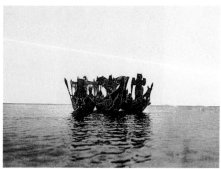

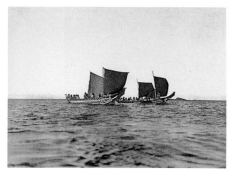

ROUNDING INTO PORT –
QÁGYUHL

The primitive Kwakiutl sail for canoes was a sheet of
cedar-bark matting, and on catamarans a large, square
section of thin boards was propped up against the
wind. Canvas is now used. The painting on the canoe
at the left represents *sísiutl*, the mythical serpent.

SAILING – QÁGYUHL

MASKED DANCERS IN CANOES –
QÁGYUHL

SAILING – QÁGYUHL

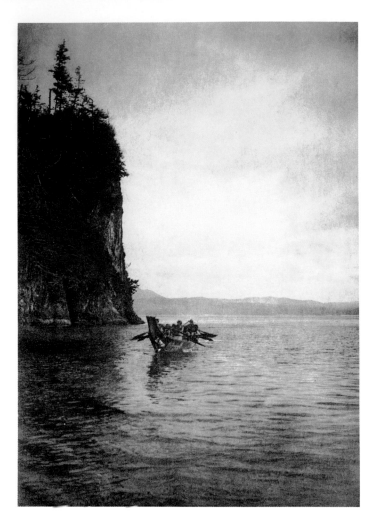

PASSING A DREADED POINT

Precipitous cliffs such as this are especially feared in rough
weather, and the steersman usually supplicates the *geniús loci*
under the title of Númas ("old man").

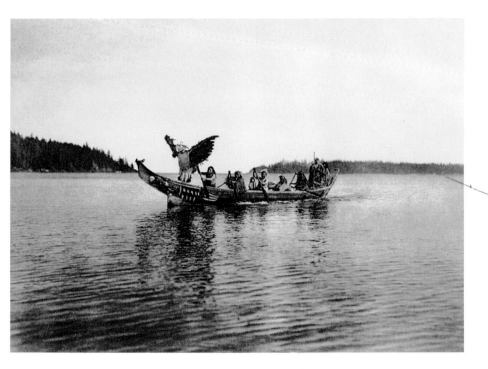

COMING FOR THE BRIDE – QÁGYUHL

In the bow Qúnḥiulaḥl, a masked man personating the
thunderbird, dances with characteristic gestures as the canoe
approaches the bride's village.

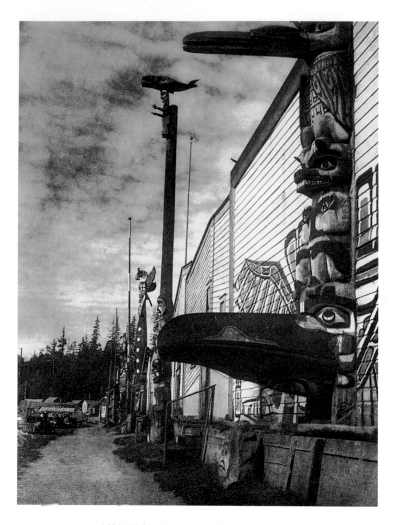

NIMKISH VILLAGE AT ALERT BAY

The figure at the bottom of the column in the foreground,
with the painting on the front of the house, represents a raven.
When a feast or a dance is to be held in this house, the guests enter
through the raven's beak, the lower mandible of which swings up
and down on a pivot. When a guest steps beyond the pivot, his
weight causes the beak to clap shut, and thus the mythic raven
symbolically "swallows" the tribesmen one by one.

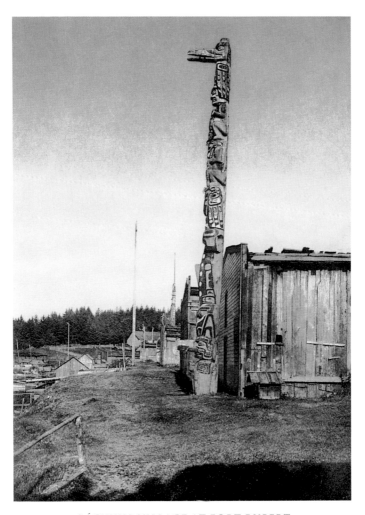

QÁGYUHL VILLAGE AT FORT RUPERT

This village of Tsáhes was founded in 1849, when the tribe
abandoned Kalokwis, on Turnour Island, in order to be near the
Hudson's Bay Company post which was then being established
at Fort Rupert, on Vancouver Island. The heraldic column in
the foreground commemorates the legendary history of a
Tsimshian family.

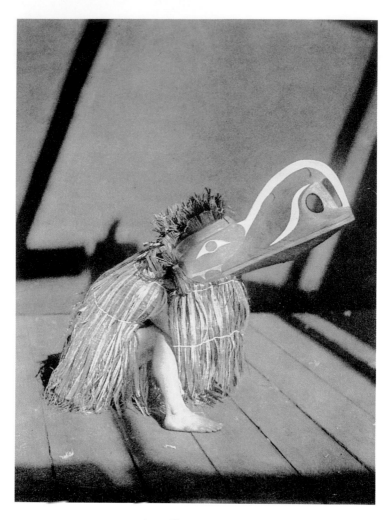

KALÓQŮTSUIS – QÁGYUHL

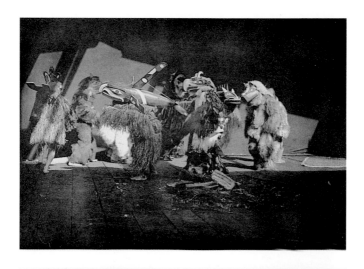

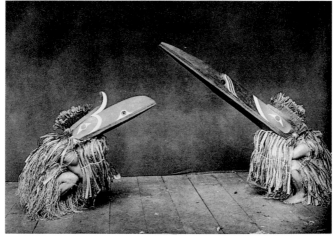

GROUP OF WINTER DANCERS – QÁGYUHL

K̓ÓTSUIS AND HÓḢHUQ

These two masked performers in the winter dance represent huge,
mythical birds. K̓ótsuis (the Nakoaktok equivalent of the Qágyuhl
Kalóqǔt̓suis) and Hóḣhuq are servitors in the house of the
man-eating monster P̓áḣpaqalanóḣsiwi. The mandibles of these
tremendous wooden masks are controlled by strings.

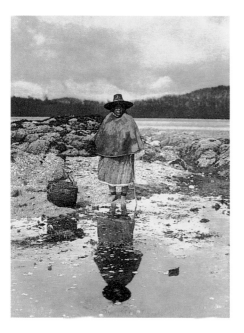

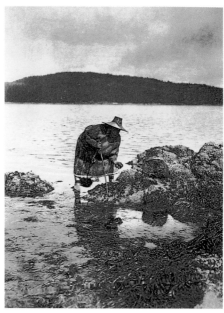

ON THE BEACH – NAKOAKTOK

This high-born clam-digger is wearing the aboriginal costume consisting of a cedar-bark blanket used as a robe, a cedar-bark rain-cape, a spruce-root "chief's hat," and woollen ankle-bands.

GATHERING ABALONES – NAKOAKTOK

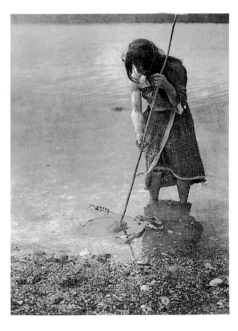

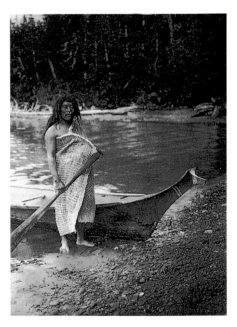

THE OCTOPUS CATCHER – QÁGYUHL

QUATSINO SOUND

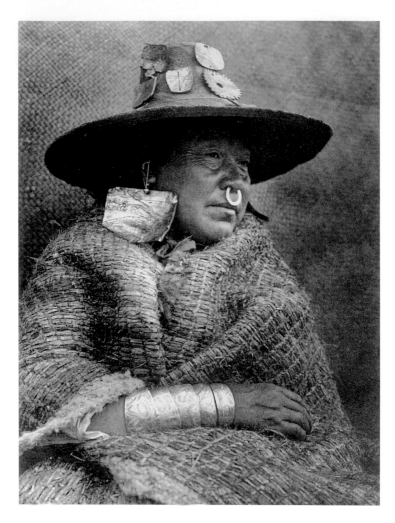

A CHIEF'S DAUGHTER – NAKOAKTOK

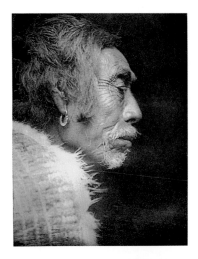

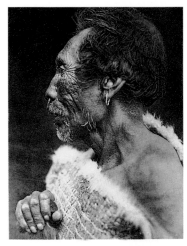

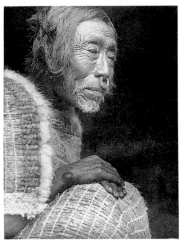

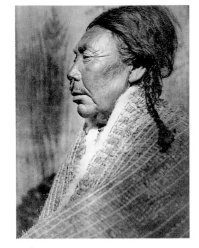

YÁKOTLÜS – QUATSINO
(PROFILE)

In physique and intelligence the Quatsino
seem inferior to the other Kwakiutl
tribes. This plate illustrates the artificial
deformation of the head, which formerly
was quite general on the North Pacific coast.

YÁKOTLÜS – QUATSINO

TSÚLNITI – KOSKIMO

KOSKIMO WOMAN

The head is a good illustration of the
extremes to which the Quatsino Sound
tribes carried the practice of artificially
lengthening the skulls of their infants.

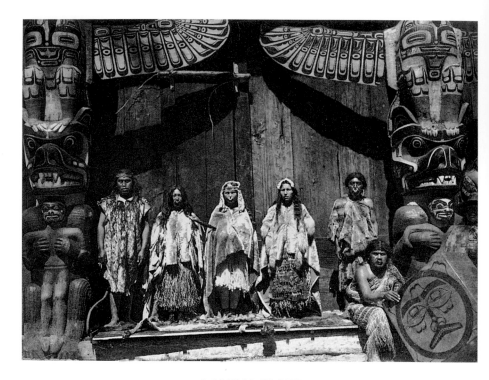

A BRIDAL GROUP

The bride stands in the middle between two dancers hired for
the occasion. Her father is at the left, and the bridegroom's father
at the right behind a man who presides over the box-drum.

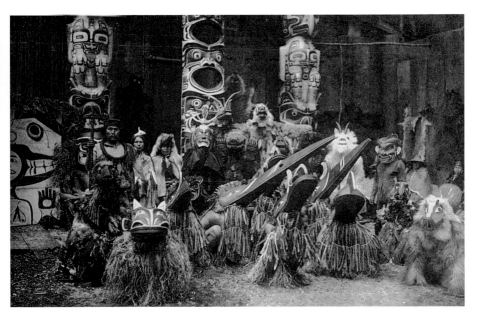

MASKED DANCERS – QÁGYUHL

The plate shows a group of masked and costumed performers
in the winter ceremony. The chief stands at the left, grasping
a speaker's staff. A few of the spectators are visible at the right.
At the extreme left is seen a part of the painted *máwihl* through
which the dancers emerge from the secret room; and in the
centre, between the carved house-posts, is the Awaitlala *háms'pĕk*,
showing three of the five mouths through which the *hamatsa*
wriggles from the top to the bottom of the column.

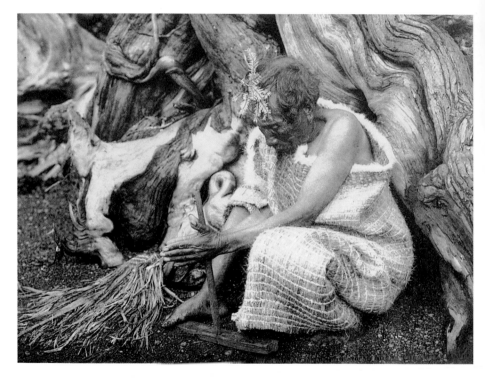

THE FIRE-DRILL – KOSKIMO

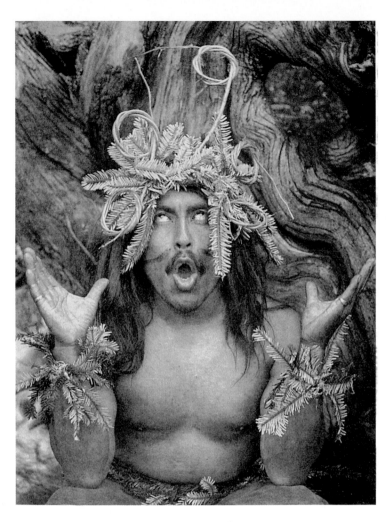

HAMATSA EMERGING FROM THE WOODS –
KOSKIMO

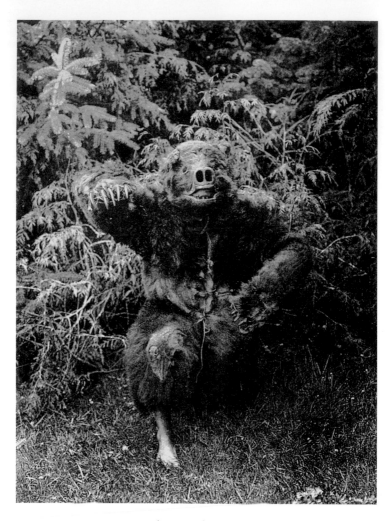

NÁNE – QÁGYUHL

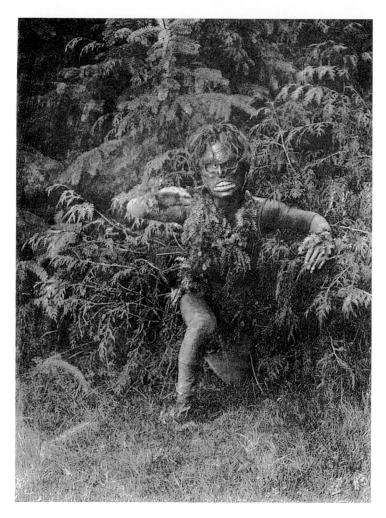

PÁQ̓ŪSĨLAH̓L EMERGING FROM THE
WOODS – Q̓ÁGYUHL

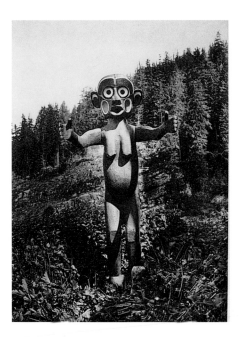

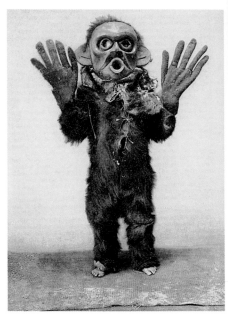

A TSÚNUK̇WA AT KWAUSTUMS HAMÍ – KOSKIMO

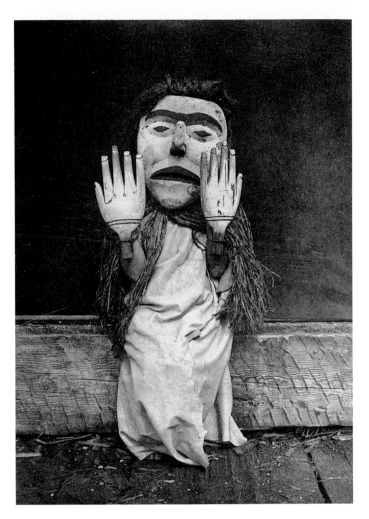

NÚH̄LĪMḴILAKA – KOSKIMO

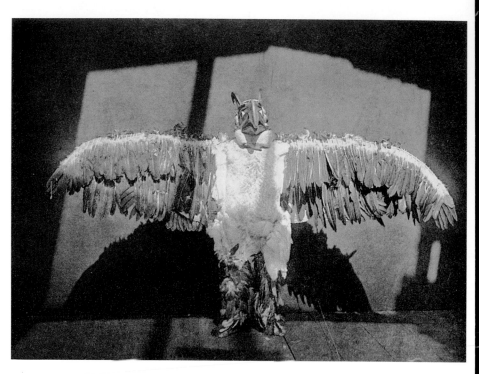

QÚNḤULAH̄L – QÁGYUHL

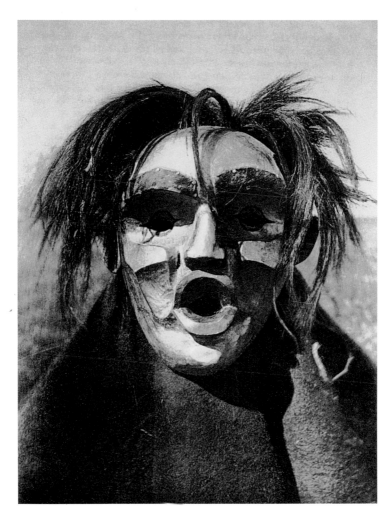

TSÚNUK̓WALAH̄L - Q̓ÁGYUHL

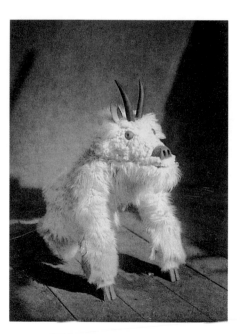 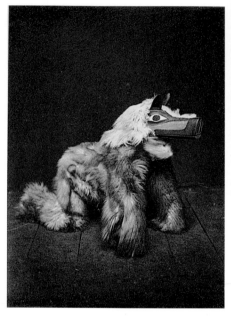

TÁWIḦYILAH̄L - QÁGYUHL WÁSWASLIKYI - QÁGYUHL

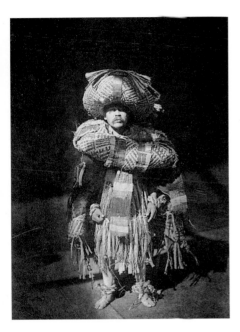

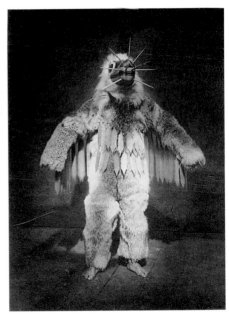

HAMATSA – QÁGYUHL HÁMASÏLAH̄L – QÁGYUHL

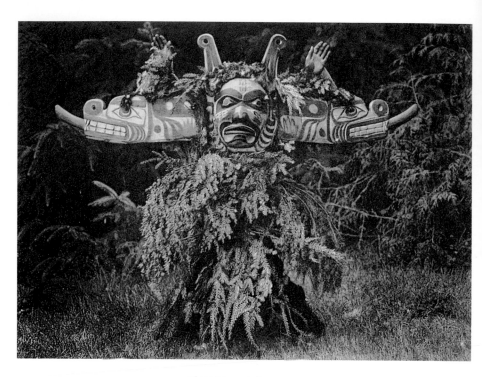

SÍSIUTL – QÁGYUHL

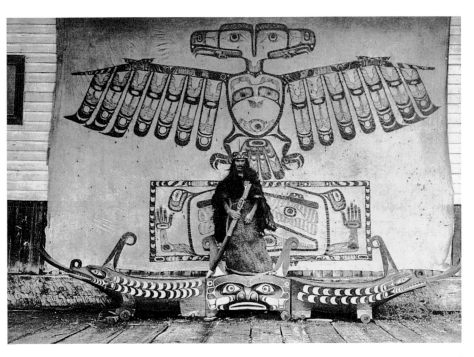

A NAKOAKTOK MÁWIHⱢ

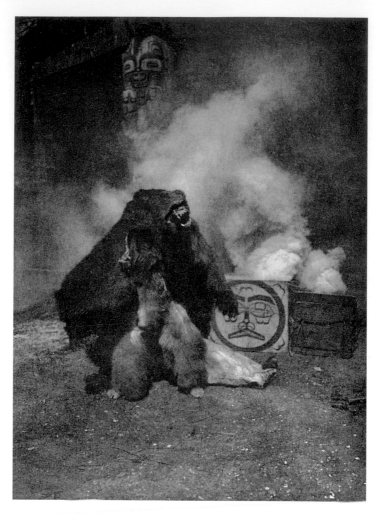

GRIZZLY-BEAR DANCER – QÁGYUHL

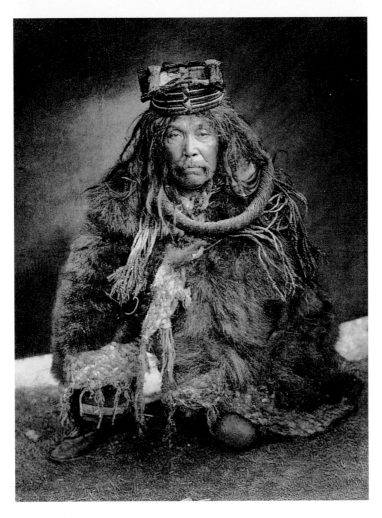

A HAMATSA COSTUME – NAKOAKTOK

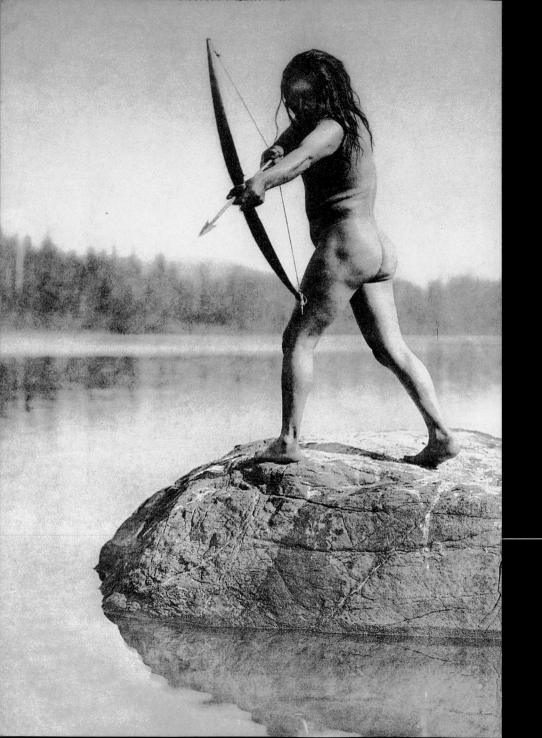

Nootka

Haida

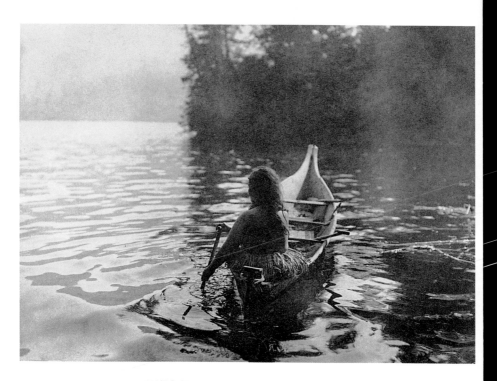

INTO THE SHADOW – CLAYOQUOT

A medicine-woman, alone, is seeking a solitary place in which
to perform her rites of bodily purification. Most of the Indian
women are no less skilful than the men in handling canoes.

PAGE 414
THE BOWMAN

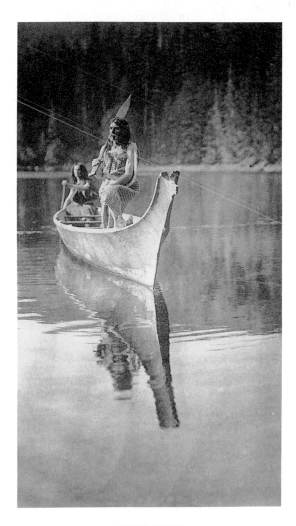

AT NOOTKA

The canoe is floating on the waters of Boston cove, where
in 1803 the trading ship *Boston* was taken and burned by the
Mooachaht Indians, and the entire crew killed except John Jewitt
and John Thompson, who were held as slaves by the chief for three
years. Jewitt's brief account of his captivity is one of our most
interesting records of life among the Indians.

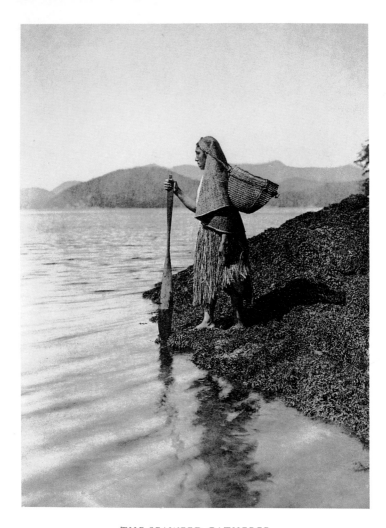

THE SEAWEED GATHERER

Seaweed of the genus *Porphyra* is a favorite food among all the
tribes of the North Pacific coast. The green, membranous fronds
are gathered in the spring from tidal rocks and are pressed into
flat cakes and dried.

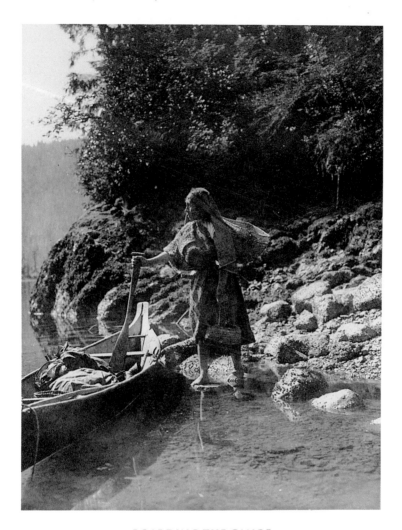

BOARDING THE CANOE

A Hesquiat berry-picker in primitive garb on the bold shores of
Clayoquot Sound. The barefoot natives make their way without
difficulty over barnacle-covered rocks such as these. It will be
noted that the canoe has been fitted with rowlocks.

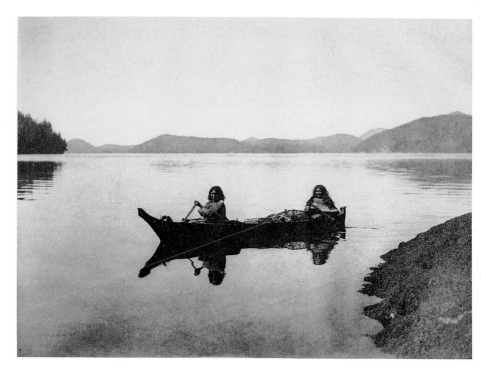

CANOEING ON CLAYOQUOT SOUND

Two Hesquiat women are homeward bound with the product
of their day's labor in gathering food, and cedar-bark to be used
in making mats.

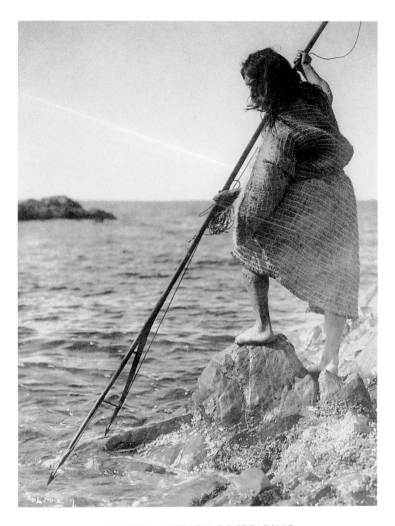

NOOTKA METHOD OF SPEARING

The harpoon for seals, porpoises, and salmon is double-headed,
so that if the point on the main shaft glances off, the other may
perhaps lodge in the hunter's prey.

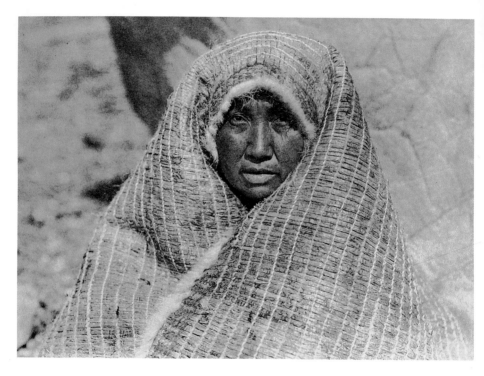

NOOTKA WOMAN WEARING CEDAR-BARK
BLANKET

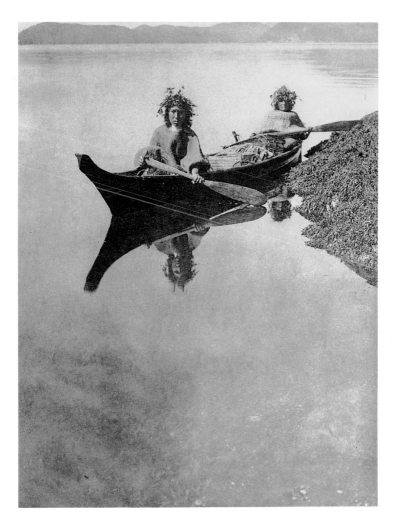

ON THE WEST COAST OF VANCOUVER
ISLAND

Lacking hats to protect their heads from the sun, women some-
times make use of wreaths of foliage.

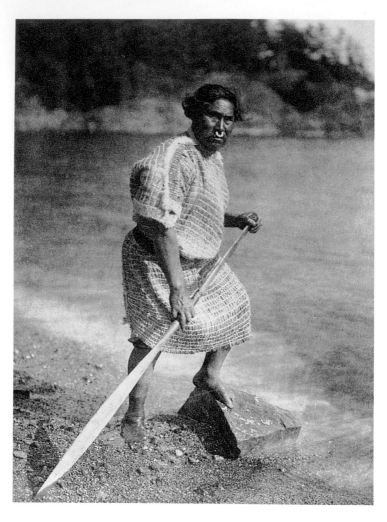

A NOOTKA

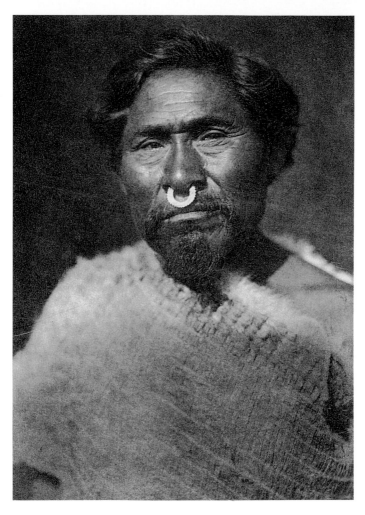

SÚQITLAÁ

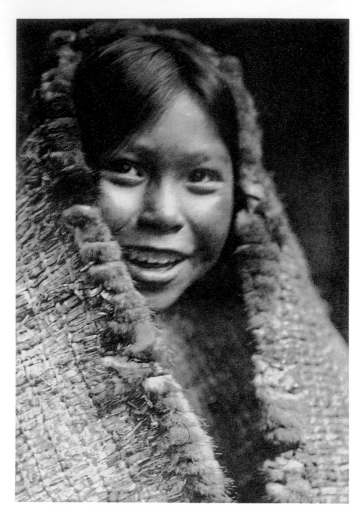

CLAYOQUOT GIRL

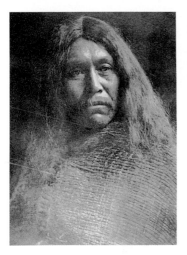

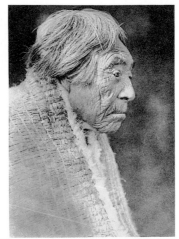

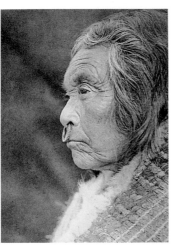

A CLAYOQUOT TYPE

It was men such as the possessor of this
inscrutable face who in 1811 attacked the
Astor trading ship *Tonquin*, so success-
fully that the only recourse of the crew
was to blow up the vessel.

HAIYAHL – NOOTKA

A NOOTKA WOMAN

A NOOTKA MAN

It is commonly believed that the facial
hair of many North Coast natives is proof
of intermingled Caucasian blood.

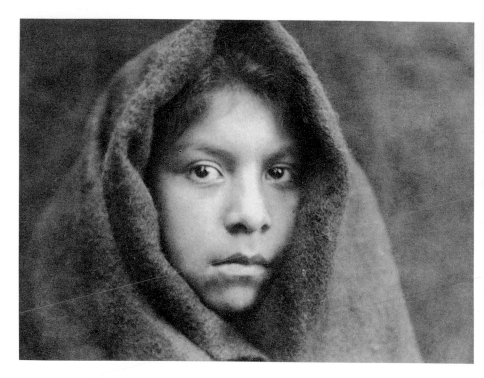

A MAKAH MAIDEN

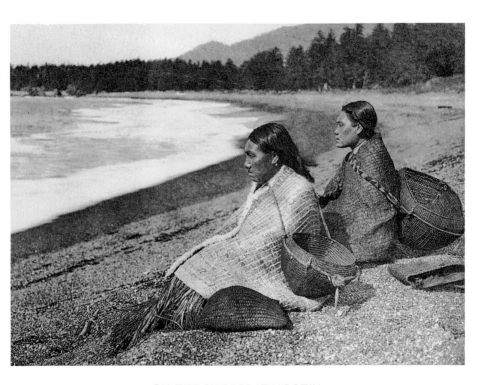

ON THE SHORES AT NOOTKA

Two women wearing the primitive bark blanket and nose-
ornament, and with clam-baskets on their backs, rest on the beach
while waiting for the tide to fall and uncover the clam-beds.

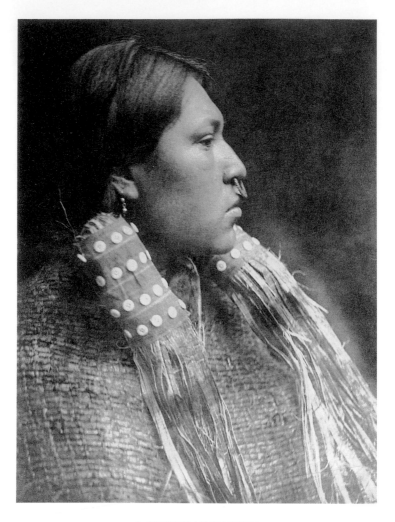

A HESQUIAT MAIDEN

The girl wears the cedar-bark ornaments that are tied to the hair
of virgins on the fifth morning of their puberty ceremony. The
fact that the girl who posed for this picture was the prospective
mother of an illegitimate child caused considerable amusement
to the native onlookers and to herself.

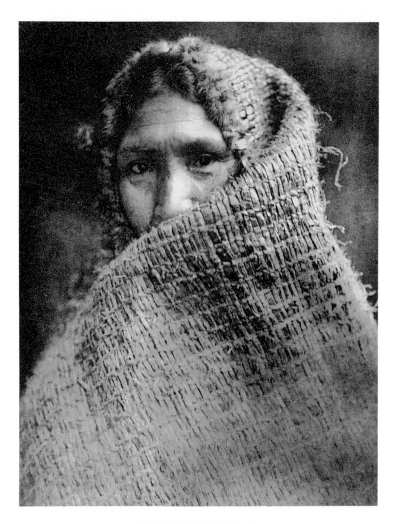

A HESQUIAT WOMAN

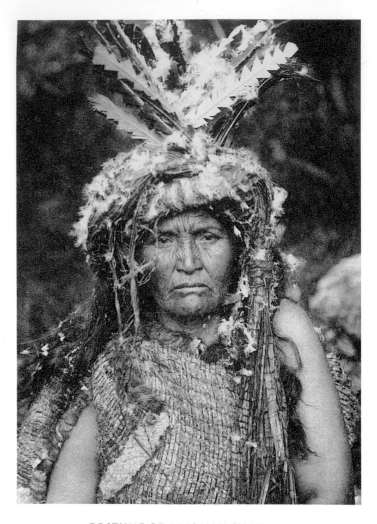

COSTUME OF A WOMAN SHAMAN –
CLAYOQUOT

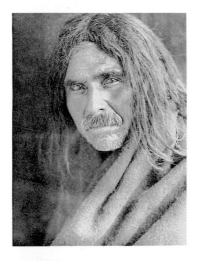

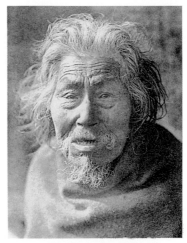

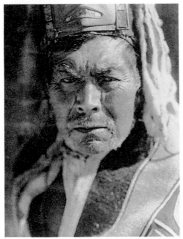

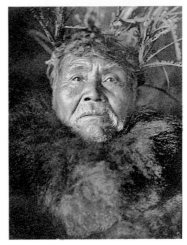

A HAIDA OF KUNG

A HAIDA OF MASSETT

The head-dress is a "dancing hat,"
and consists of a carved wooden mask
surmounted by numerous sea-lion
bristles and with many pendent strips
of ermine-skin.

THE OLDEST MAN OF
NOOTKA

This individual is the most primitive relic
in the modernized village of Nootka. He
lives in thought in the golden age when
the social and ceremonial customs of his
people were what they had always been.

THE WHALER

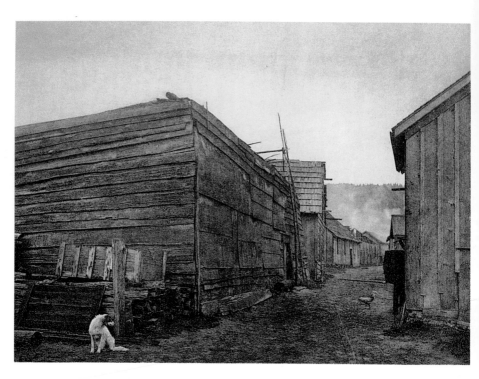

VILLAGE SCENE – NEAH BAY

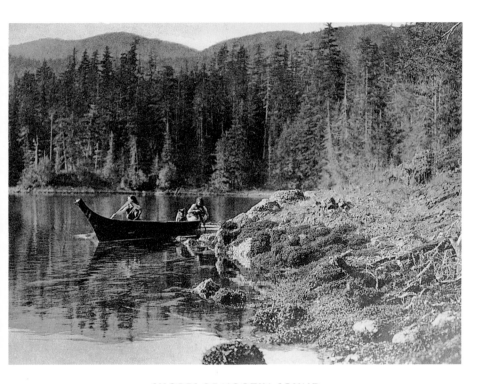

SHORES OF NOOTKA SOUND

This plate conveys an excellent impression of the character
of much of the Vancouver Island coast, with its rugged,
tide-washed rocks, thickly timbered lowland, and
lofty mountains in the distance.

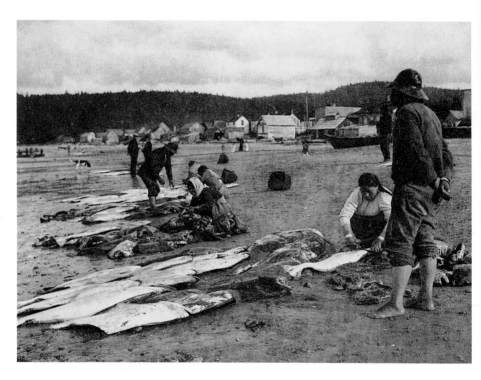

HALIBUT FISHERS – NEAH BAY

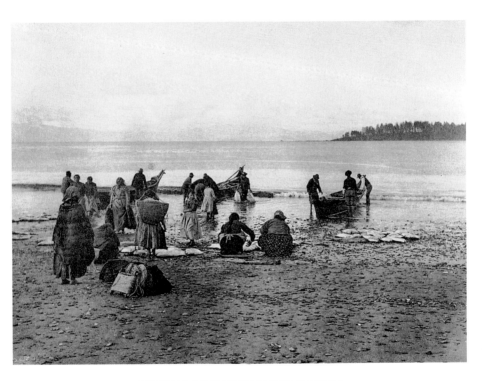

RETURN OF THE HALIBUT FISHERS

Huge quantities of halibut are taken by the Makah at Cape
Flattery, and the flesh is sliced thin and dried for storage.

COOKING WHALE BLUBBER

A PARTIALLY CUT UP WHALE

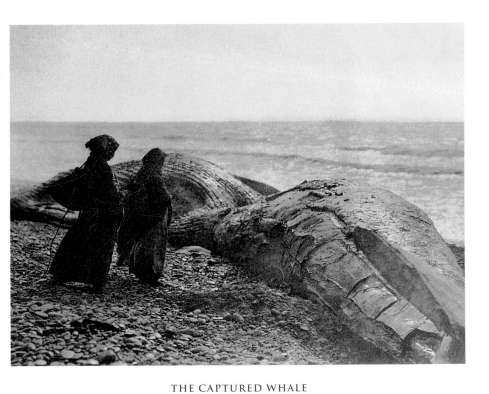

THE CAPTURED WHALE

A small humpback whale (*Megaptera*) lies partially butchered
on the beach at Neah Bay.

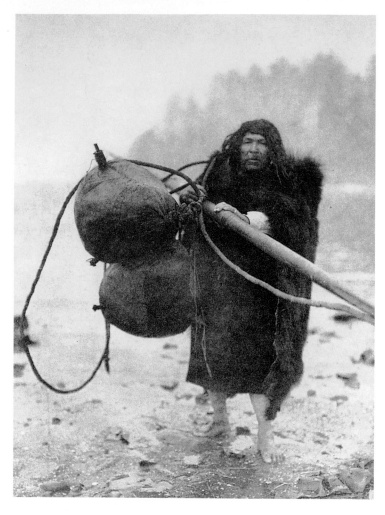

THE WHALER – MAKAH

Note the great size of the harpoon-shaft. Indian whalers implanted
the harpoon-point by thrusting, not by hurling, the weapon.

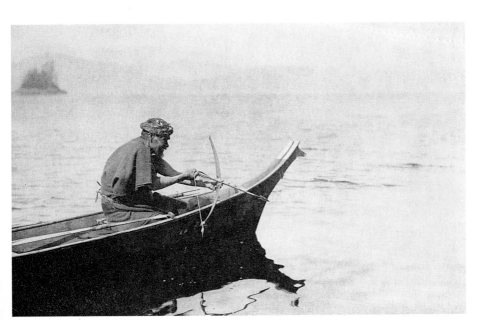

A SEA-OTTER HUNTER

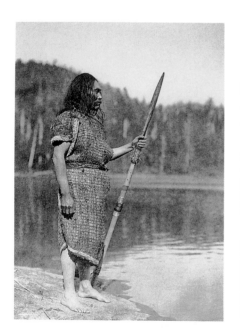

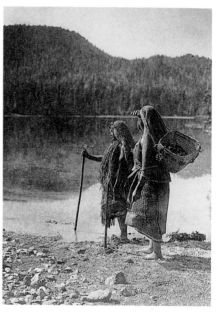

THE WHALER – CLAYOQUOT

The spear in the subject's hand is the weapon
of a warrior, not of a whaler.

WAITING FOR THE CANOE

As evening approaches, two women with
clam-baskets and digging-sticks gaze across
the water, anxiously awaiting the canoe that
is to come and convey them home.

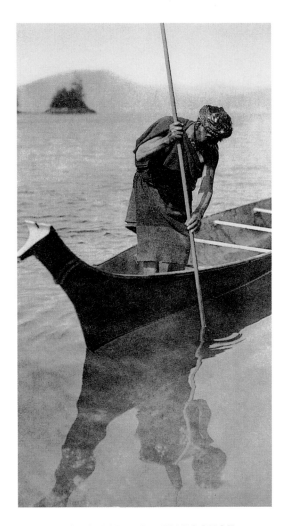

FISH SPEARING – CLAYOQUOT

The fisherman is taking flounders and other flatfish, which lie
half-covered in the sand. At certain seasons, when the water is
not turbid by reason of the presence of excessive marine growth,
objects on the bottom of a quiet bay can be discerned at a sur-
prising depth. It is frequently assumed that the prows of North
Coast canoes are carved in imitation of a dog's head, but the
natives deny any intentional resemblance. The notch in the top
of the prow is simply a rest for the shaft of a spear or harpoon.

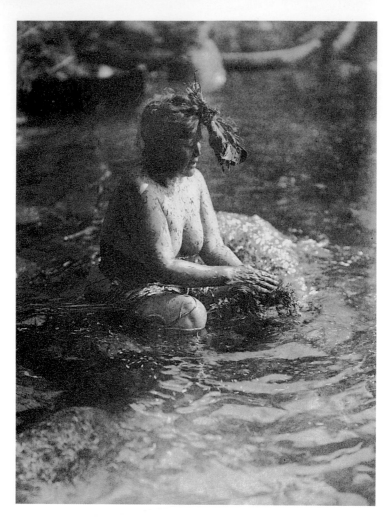

CEREMONIAL BATHING

The subject of this plate is a female shaman of the
Clayoquot tribe. The ceremonial washing of shamans is
much like that of whalers and other hunters, consisting mainly
of sitting or standing in water and rubbing the body with
hemlock sprigs in order to remove all earthly taint,
which would offend the supernatural powers.

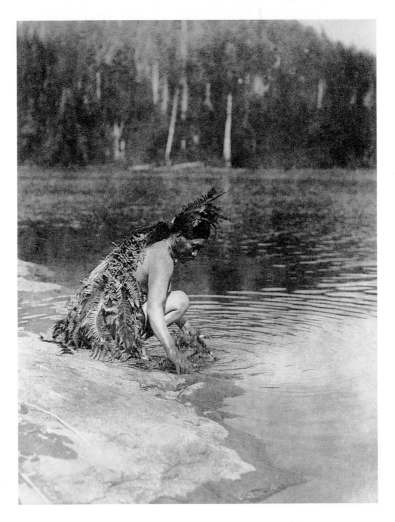

WHALE CEREMONIAL – CLAYOQUOT

Before daring to practise his dangerous art, the whaler subjects
himself to a long and rigorous course of ceremonial purification in
order to render himself pleasing to the spirit whale. He bathes
frequently, rubs his body vigorously with hemlock sprigs, dives,
and imitates the movements of a whale.

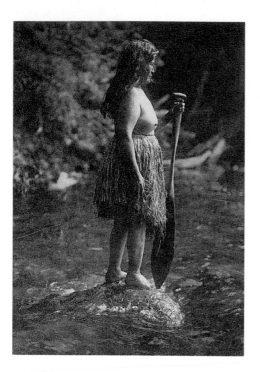

A SHAMAN OR MEDICINE
WOMAN

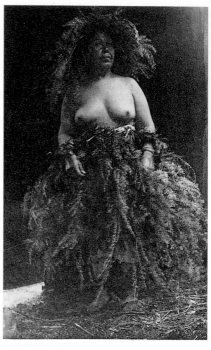

CEREMONIAL COSTUME OF
HEMLOCK BOUGHS

WOMAN SHAMAN LOOKING FOR
CLAIRVOYANT VISIONS – CLAYOQUOT

HAIDA SLATE CARVINGS

Some of the Haida men are remarkably skilled in carving
miniature "totem poles" out of a soft black slate. A column such
as those here reproduced simply recounts a myth.

A HAIDA CHIEF'S TOMB AT YAN

The remains of the chief rest in a niche cut into the top of the
transverse beam. This tomb is of unusual form, and must have
been erected at enormous cost to the dead man's family.

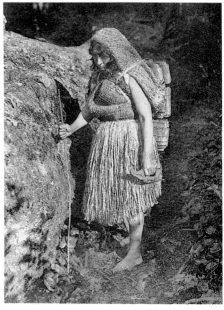

THE BERRY-PICKER – CLAYOQUOT

THE BARK GATHERER

These people still use large quantities of yellow-cedar bark in the manufacture of mats, and formerly this material furnished them their clothing also. The Hesquiat woman in the picture has a bulky pack of bark on her back, and in her hand is a steel-bladed adz of the primitive type.

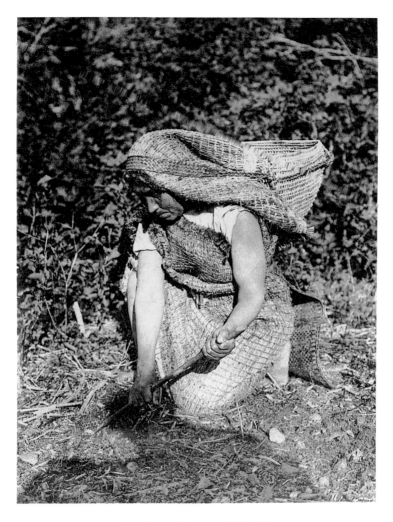

HESQUIAT ROOT DIGGER

Nootka women very commonly wore the bark cape folded
over the head, to protect the forehead from the tump-line, when
carrying the burden-basket. The proper use of the cape was
to shed rain.

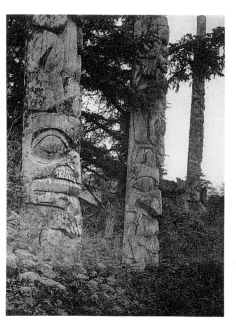

TOTEMS AT KUNG

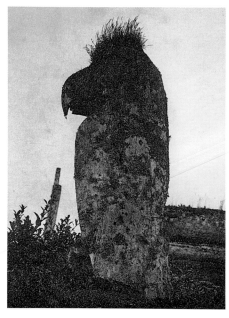

A RAVEN TOTEM AT YAN

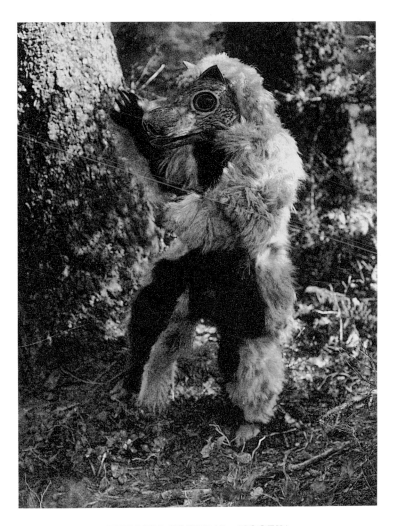

THE BEAR COSTUME – NOOTKA

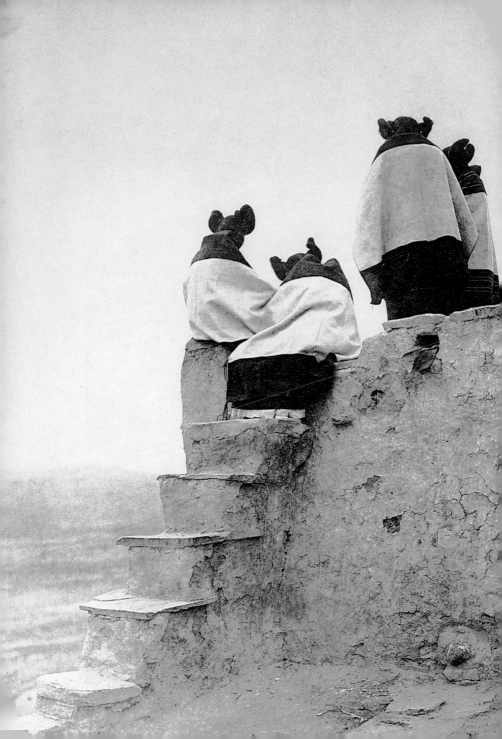

HOPI

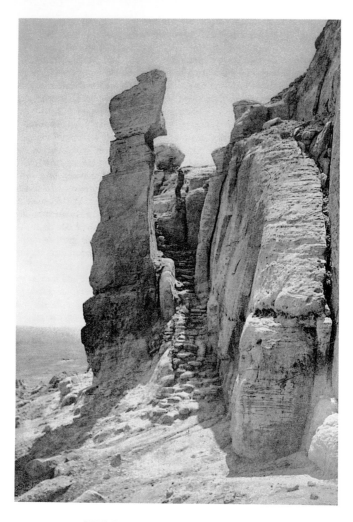

THE STAIRWAY TRAIL AT WALPI

PAGE 454
WATCHING THE DANCERS

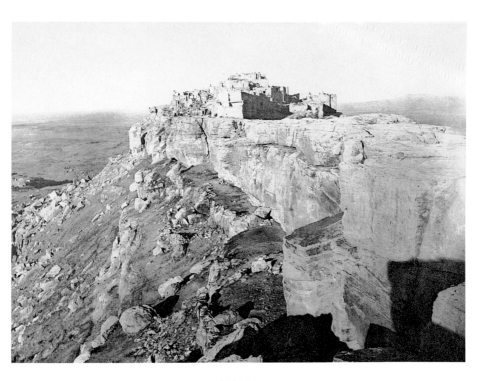

WALPI

Picturesque Walpi, perched on the point of a rocky island in
a sea of sand, is an irregular, rambling community-house, built
without design, added to in haphazard fashion as need arose;
yet it constitutes a perfectly satisfying artistic whole.

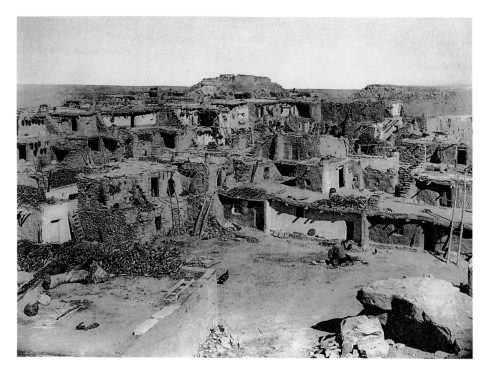

MISHONGNOVI

A comprehensive view of this interesting Middle Mesa pueblo. On
..n eminence in the middle background is Shipaulovi, and at the
right, several miles distant, is Shongopavi, on another
tongue of the Mesa.

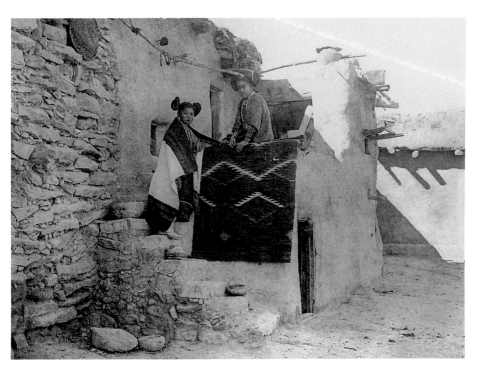

TEWA GIRLS

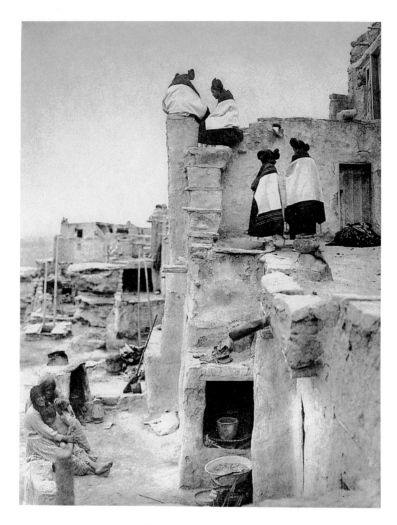

ON THE HOUSETOP

A typical village scene illustrating many features of pueblo
architecture. At the extreme left is the entrance of an under-
ground *kiva*, with the tips of the ladder projecting. In the central
foreground is a baking-room, where *piki* is prepared, and to
the left is an outdoor oven for baking loaf-bread.

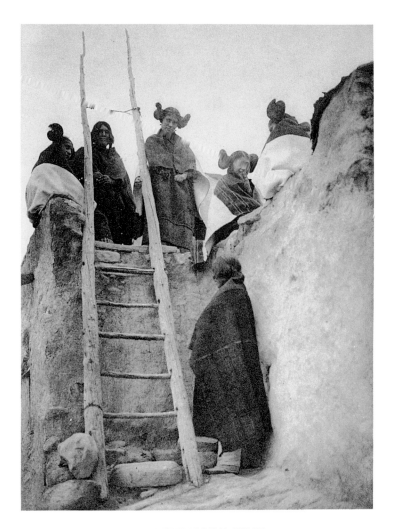

AN AFTERNOON CHAT

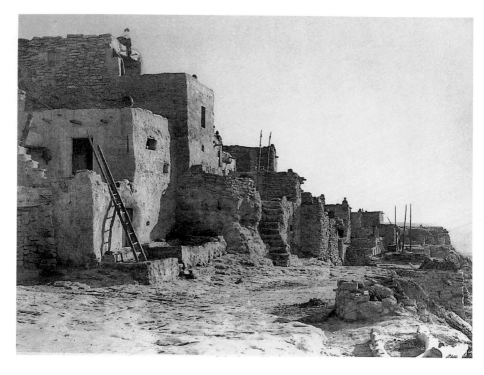

EAST SIDE OF WALPI

Few illustrations of Hopi architecture show as much regularity
as this view of a Walpi street.

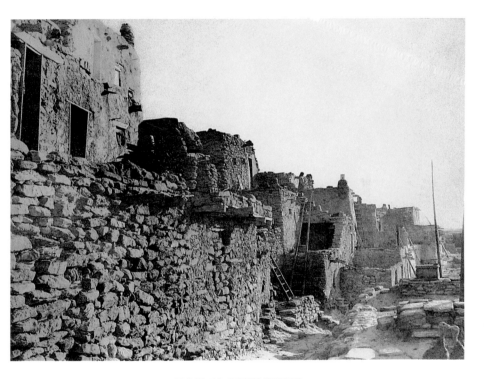

HOPI ARCHITECTURE

The house-walls are about eighteen inches thick, and consist
of fragments of sandstone, shaped by fracture but undressed, and
bound together with mud plaster. The upper levels of the terraced
buildings are reached by ladders and by stone steps.

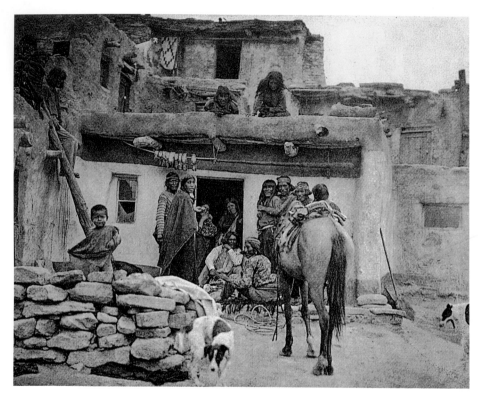

A VISITOR

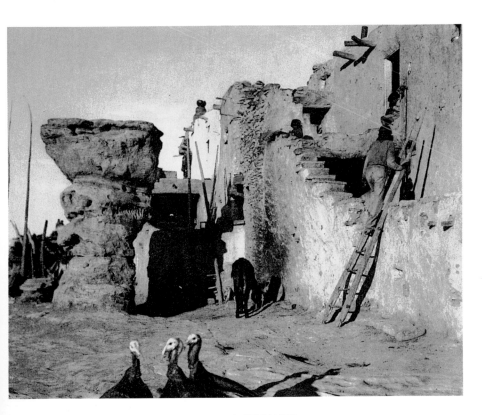

THE PLAZA AT WALPI

HOPI FARMERS, YESTERDAY AND TODAY

COUNTING THE RECORD

A series of marks cut into the rock at Middle Mesa records the
losses inflicted on marauding enemies in a former generation.

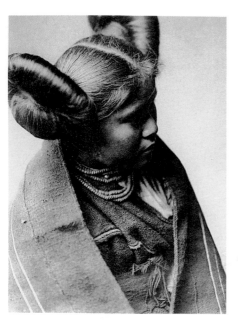 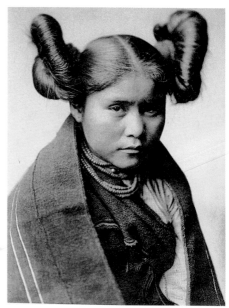

CHAÍWA – TEWA – PROFILE CHAÍWA – TEWA

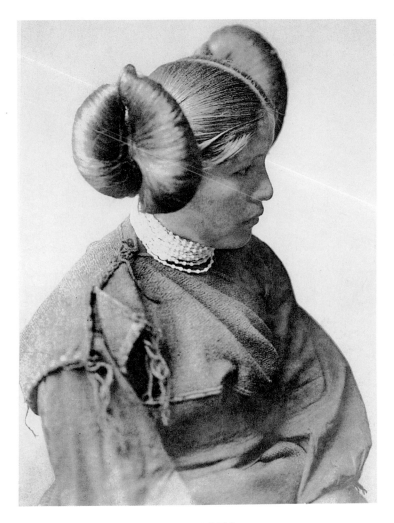

A HOPI GIRL

Soft, regular features are characteristic of Hopi young
women, and no small part of a mother's time used to be devoted to
dressing the hair of her unmarried daughters. The aboriginal style
is rapidly being abandoned, and the native one-piece dress here
illustrated is seldom seen even at the less advanced
stage of the Hopi pueblos.

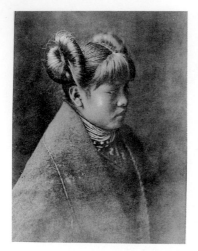

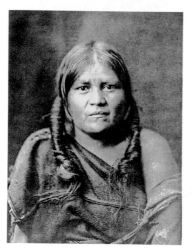

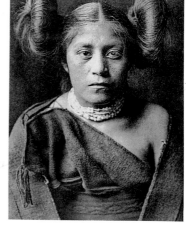

MODIFIED STYLE OF
HAIR-DRESSING

A HOPI WOMAN

THE HOPI
MAIDEN

A TEWA GIRL

An excellent feminine type of these
early immigrants from the Rio Grande. The
arrangement of her hair indicates
that she is unmarried.

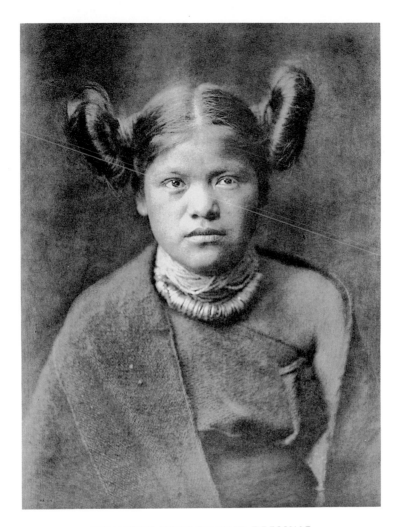

PRIMITIVE STYLE OF HAIR-DRESSING

The arrangement imitates the squash-blossom and indicates
virginity. Within the last decade it has become rare, except on
ceremonial occasions.

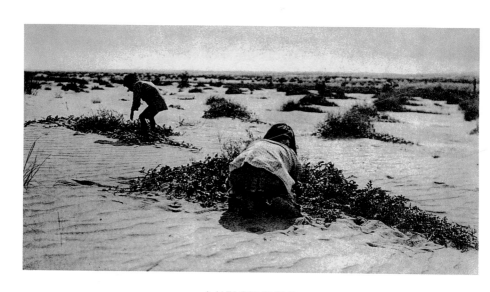

A MELON FIELD

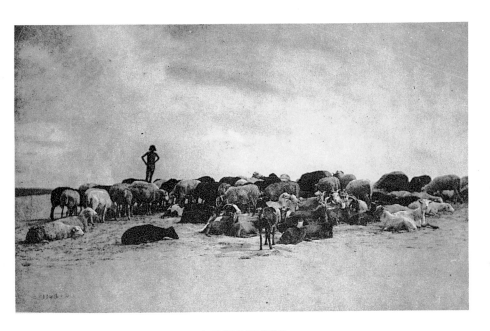

A HOPI FLOCK

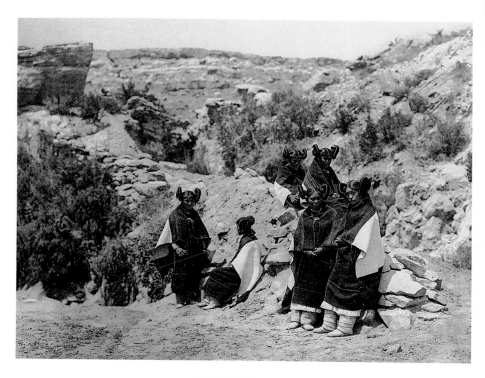

EAST MESA GIRLS

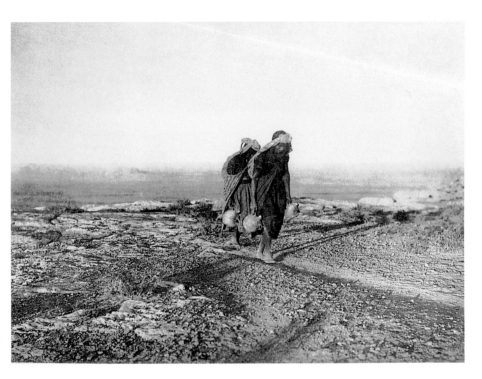

THE WATER CARRIERS

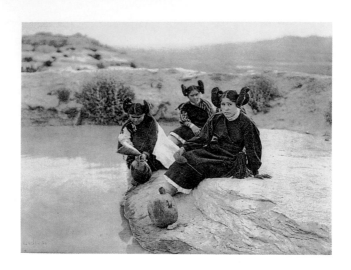

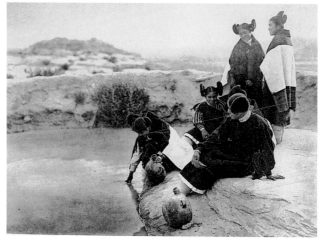

EVENING IN HOPI LAND

LOITERING AT THE SPRING

A group of Walpi and Hano girls in holiday attire. The back-
ground is a typical bit of Southwestern desert.

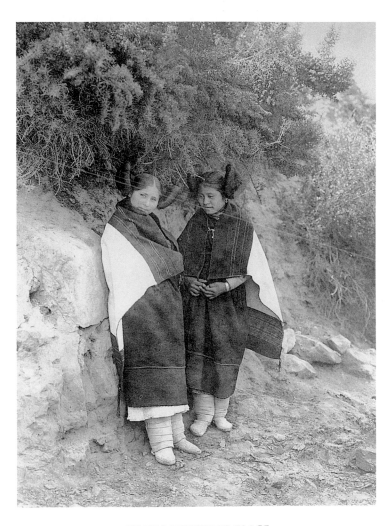

AT THE TRYSTING PLACE

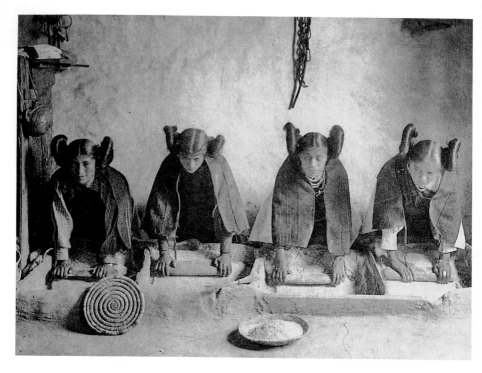

GRINDING MEAL

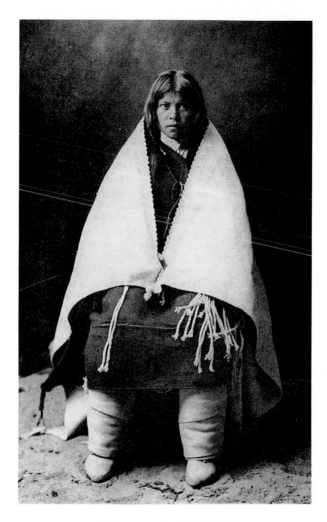

HOPI BRIDAL COSTUME

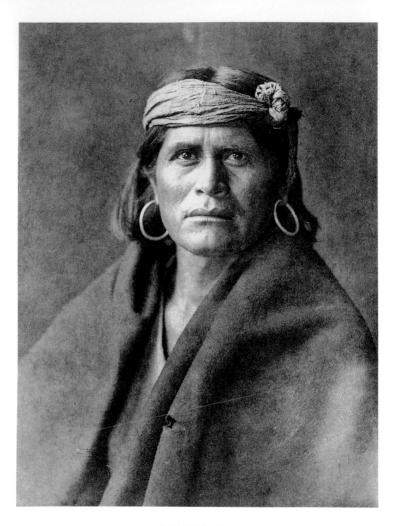

A WALPI MAN

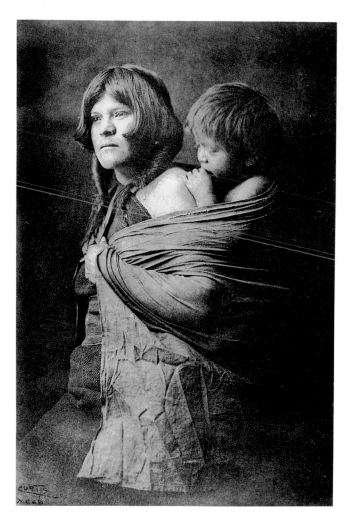

A HOPI MOTHER

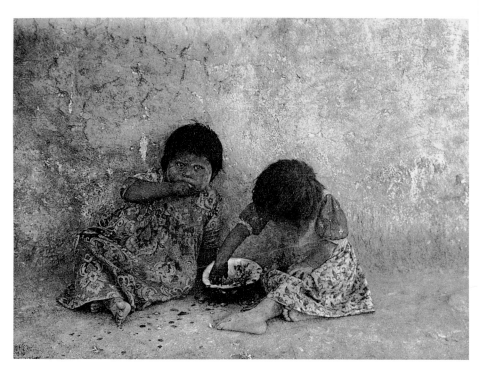

THE DELIGHTS OF CHILDHOOD

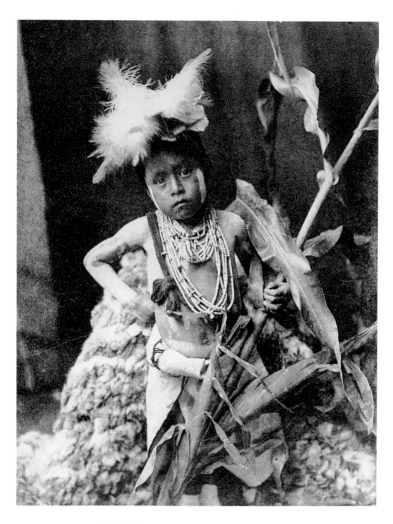

AWAITING THE RETURN OF THE
SNAKE RACERS

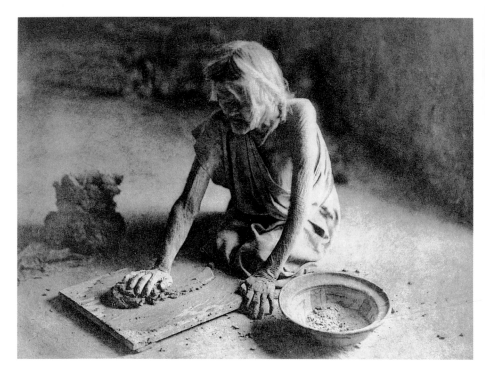

POTTER MIXING CLAY

This woman, so aged that her shrivelled skin hangs in folds, still
finds pleasure in creating artistic and utilitarian pieces of pottery.

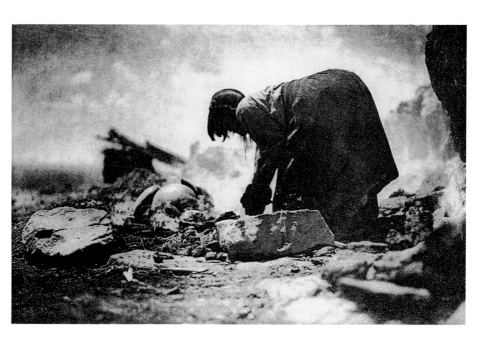

POTTER BUILDING HER KILN

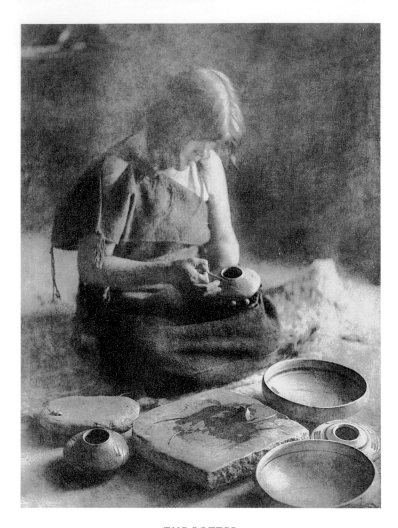

THE POTTER

Every visitor at East Mesa knows Nampeyo, the potter of
Hano, whose creations excel those of any rival. Strangers wander
into her house, welcome though unbidden, but Nampeyo only
works and smiles. In the plate her paint-stone occupies the
central foreground.

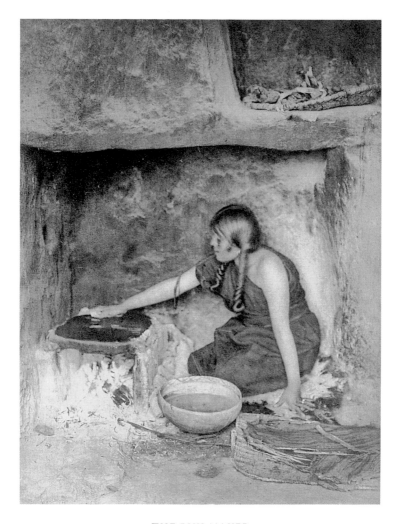

THE PIKI MAKER

Piki is corn-bread baked in colored sheets of paper-like
thinness. The batter is spread on the baking-stone with the
bare hand, and the quickly baked sheet is folded and laid
on the basket at the baker's left.

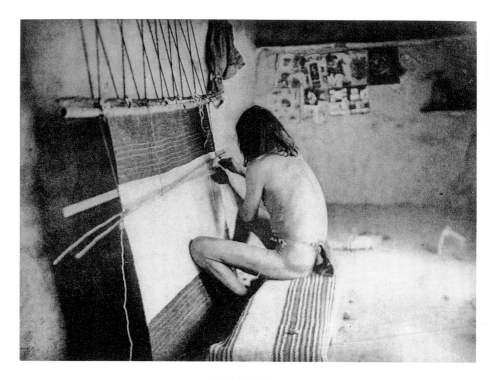

THE WEAVER

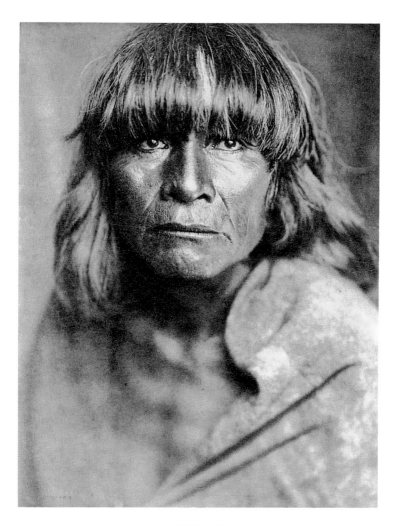

A HOPI MAN

In this physiognomy we read the dominant traits of Hopi
character. The eyes speak of wariness, if not of downright distrust.
The mouth shows great possibilities of unyielding stubbornness.
Yet somewhere in this face lurks an expression of masked
warmheartedness and humanity.

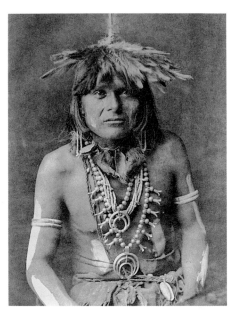

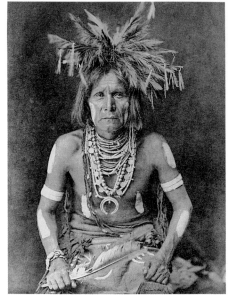

A WALPI SNAKE PRIEST

The subject is Köyáwaima ("gray [dawn] walking"),
who has been chief of the fraternity since 1899.

A SNAKE PRIEST

The white markings, typifying the antelope, indicate
that the subject is accoutred for the semi-final day
of the Snake dance, when the public performance
consists of the dance and the ceremonial race of the
Antelope fraternity.

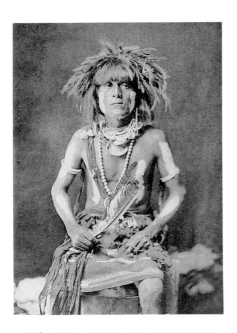

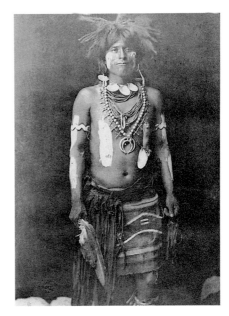

HÓNOVI – WALPI SNAKE PRIEST, WITH TOTÓKYA DAY PAINTING

This plate depicts the accoutrement of a Snake dancer on the day of the Antelope dance. The right hand grasps a pair of eagle-feathers – the "snake whip" – and the left a bag of ceremonial meal. Hóṇovi was one of the author's principal informants.

SNAKE DANCER IN COSTUME

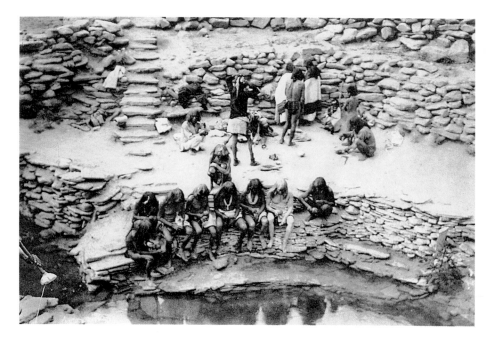

FLUTE DANCERS AT TUREVA SPRING

The Flute dance is a religious ceremony concerned with bringing
rain. It represents the legendary arrival of the Flute people in the
Hopi country, their friendly encounter with the clans already
there, and the rain-making rites subsequently performed by
them for the common good. The episode here represented was
photographed at Middle Mesa. The individual seated near the
right end is an albino, not a white man.

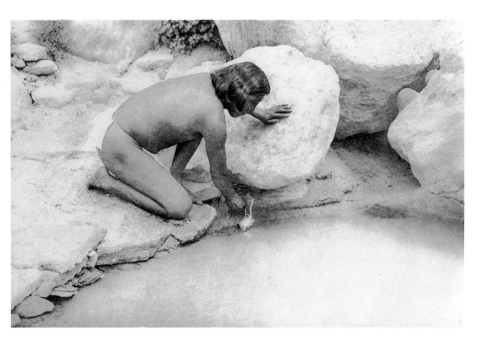

DEPOSITING A PRAYER-STICK

Round, painted sticks with feathers attached by cotton cords are
deposited in various places, particularly in springs and at shrines,
in supplication to the spirits associated with the locality.

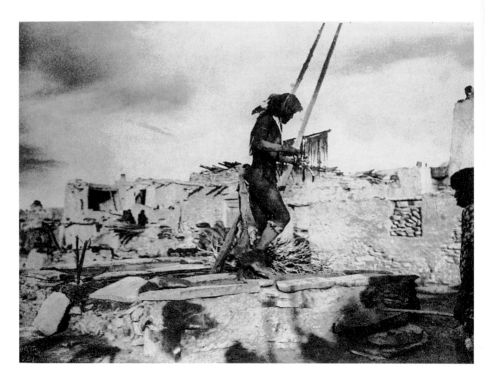

SNAKE PRIEST ENTERING THE KIVA

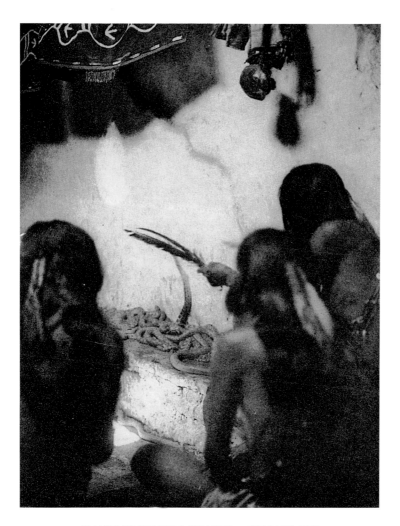

SINGING TO THE SNAKES – SHIPAULOVI

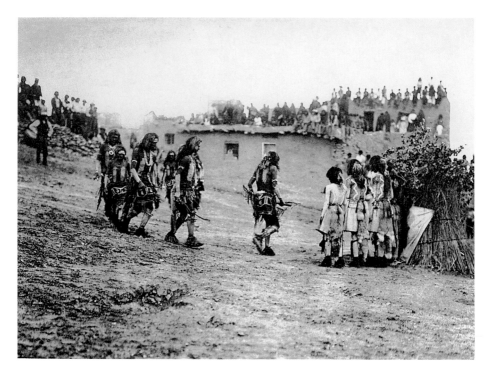

SNAKE DANCERS ENTERING THE PLAZA

At the right stand the Antelopes, in front of the booth
containing the snake-jars. The Snakes enter the plaza, encircle
it four times with military tread, and then after a series of songs
remarkable for their irresistible movement, they proceed to
dance with the reptiles.

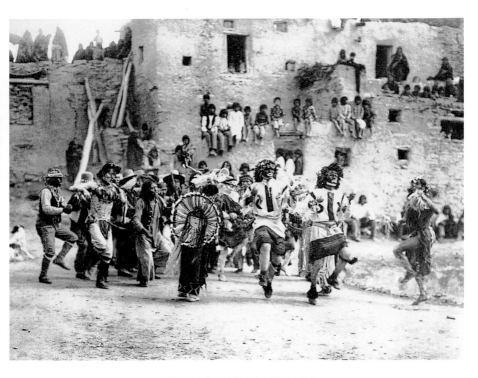

BUFFALO DANCE AT HANO

The Buffalo dance of the Upper Rio Grande pueblos was
lately introduced among the Hopi, who attach no religious
significance to it.

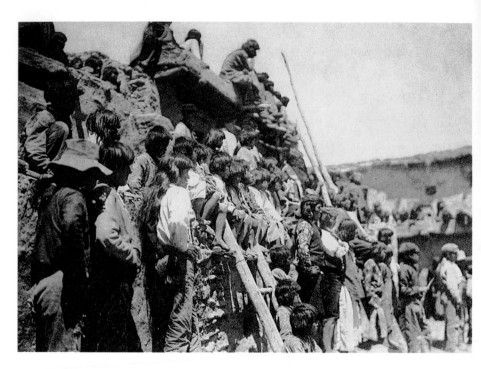

SPECTATORS AT THE SNAKE DANCE

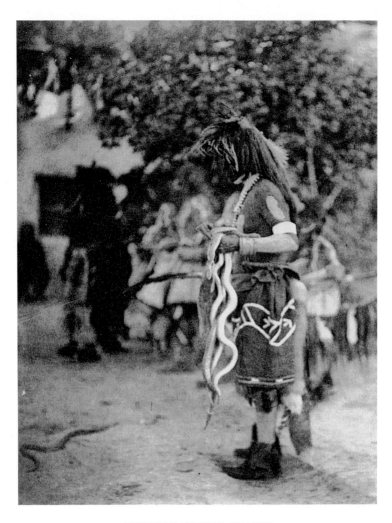

PICKING UP THE SNAKES

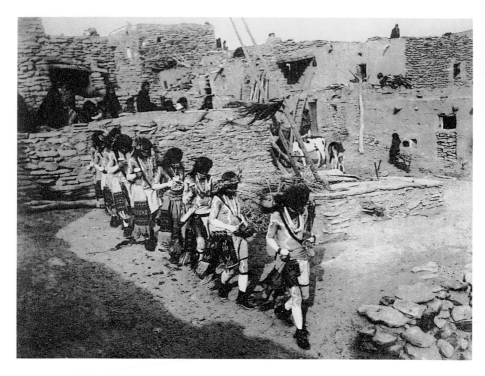

ANTELOPES STARTING FOR THE PLAZA –
SHIPAULOVI

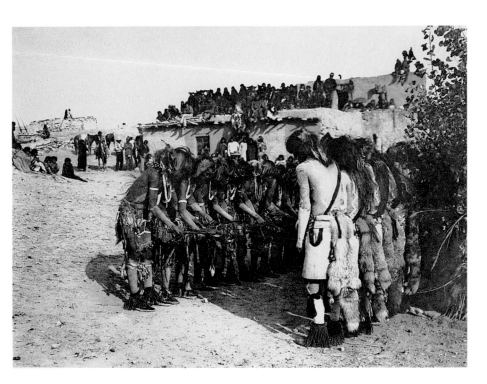

ANTELOPES AND SNAKES AT ORAIBI

The Antelope fraternity, at the right, and the Snake fraternity
facing them at the left, engage in singing prior to handling the
reptiles in the Snake dance. At the extreme right is the *kísi*, a
cottonwood booth in which sits the custodian of the snake-jars,
ready to hand out the reptiles one by one to the dancers.

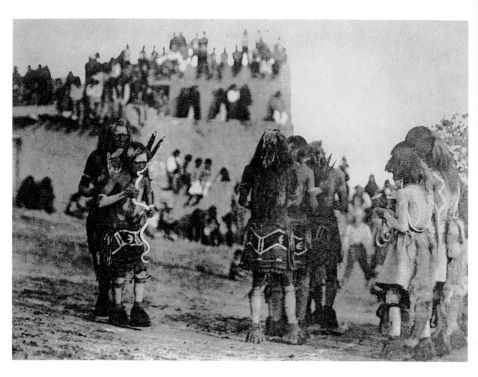

SNAKE DANCER AND HUGGER

KACHINA DOLLS

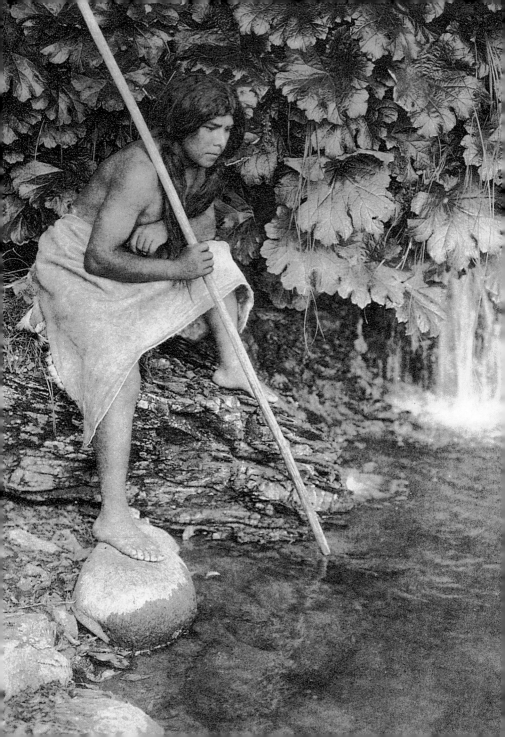

HUPA

YUROK

KAROK

WIYOT

TOLAWA

TUTUTNI

SHASTA

ACHOMAWI

KLAMATH

VOLUME XIII

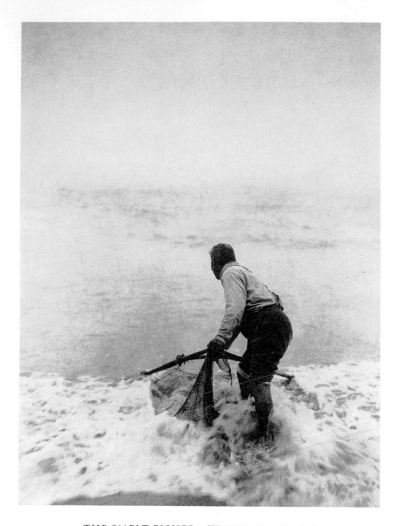

THE SMELT FISHER – TRINIDAD YUROK

The surf-net used in smelt-fishing is a bag suspended on two
diverging poles. At the bottom is a restricted opening into a long
net-bag, which is held in the fisherman's hand. Dipping and
raising his net, he allows the smelts to fall down into the bag.

PAGE 504
SPEARING SALMON

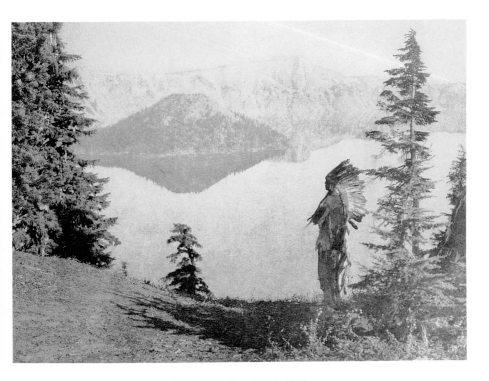

THE CHIEF – KLAMATH

The subject of this plate, in deerskin suit and feathered war-
bonnet of the Plains culture, is shown against a background
of Crater Lake and its precipitous rim towering a thousand
feet above the water.

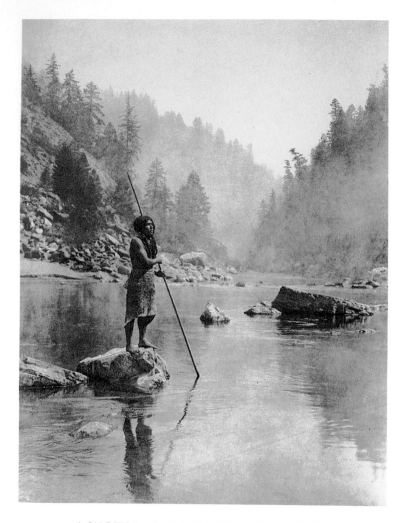

A SMOKY DAY AT THE SUGAR BOWL – HUPA

For the spring salmon-fishing season the southern division of
the Hupa assembled at Sugar Bowl rapids of Trinity River, near the
upper end of Hoopa Valley. Each fishing station was the hereditary
possession of some family. Men who owned no station begged the
use of one from those who were either weary of fishing
or had enough salmon for their immediate needs.

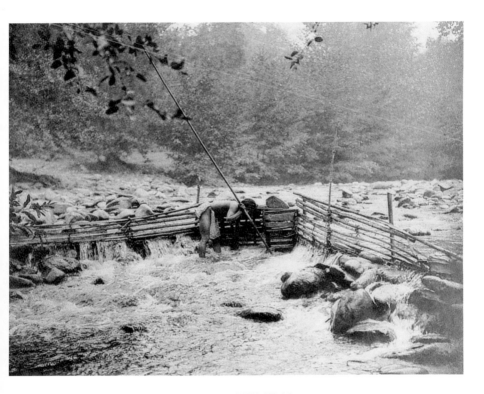

HUPA TROUT-TRAP

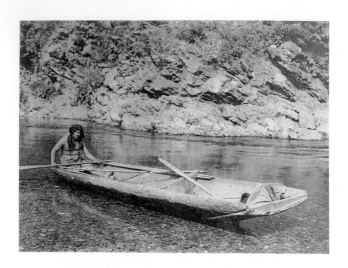

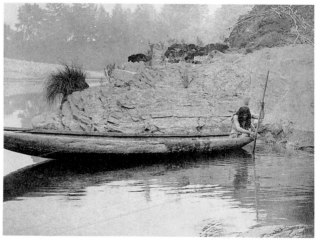

YUROK CANOE ON TRINITY RIVER

The Yurok canoe is simply a hollowed section of a redwood
log. The aboriginal implements for canoe-making were a stone
hammer and an elk-horn chisel for cutting the log and removing a
number of slabs in order to reduce it to the desired thickness.
The actual hollowing was accomplished by means of fire.

FISHING FROM CANOE – HUPA

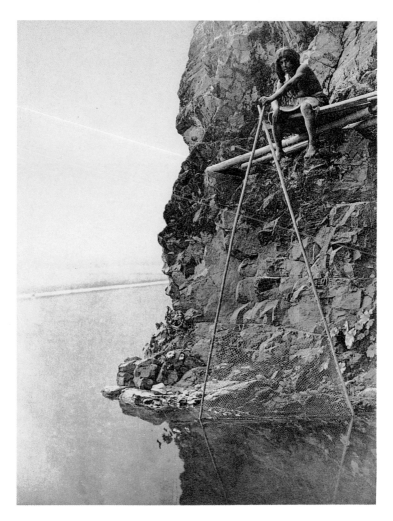

FISHING PLATFORM ON TRINITY
RIVER – HUPA

As the run of spring salmon occurs at a season when the river
is too high for the construction of a weir, they are taken in
dip-nets from platforms erected above favorable eddies.

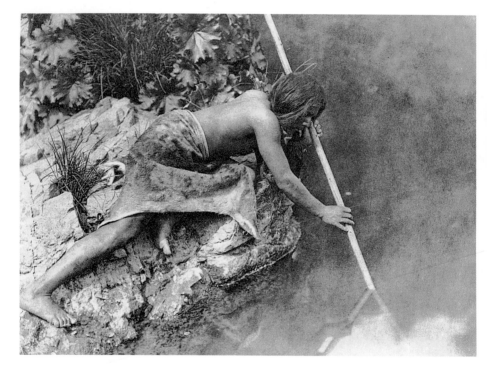

HUPA FISHERMAN

The fisherman has just made a thrust with
his double-pointed spear.

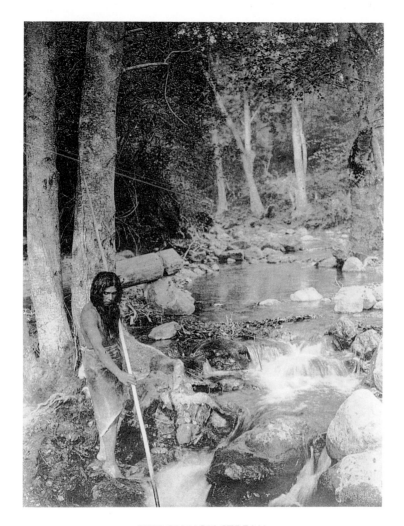

THE SALMON STREAM

A Hupa youth is waiting with poised spear for the shadowy
outline of a salmon lurking in a quiet pool and gathering its
strength for a dash through a tiny cascade.

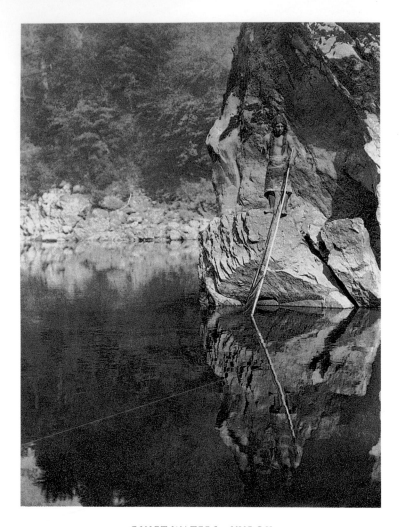

QUIET WATERS – YUROK

The plate shows the ruggedness characteristic of the shores
of Klamath River. Eddies caused by projecting masses of rock are
the spots chosen for taking salmon in dip-nets, both because the
upstream set of the current permits the net to be held with the
opening down-stream and because the salmon are attracted to
such pools of slack water after combatting the swift current.

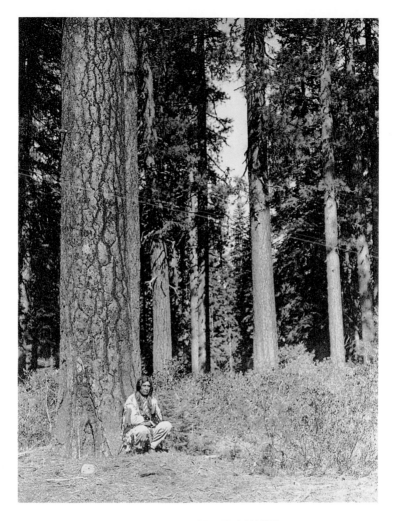

IN THE FOREST – KLAMATH

The Klamath live in a country of lakes and marshes, broad
meadows, and forested mountains. The reservation itself
includes an extensive area of splendid pines.

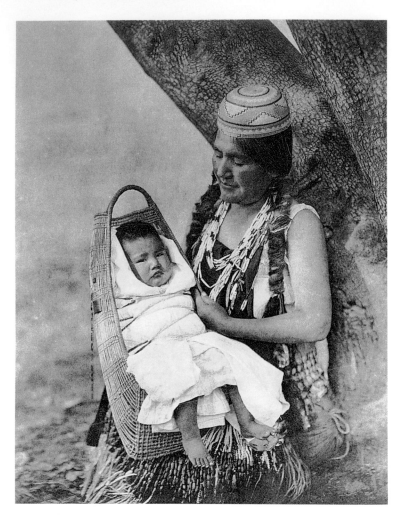

HUPA MOTHER AND CHILD

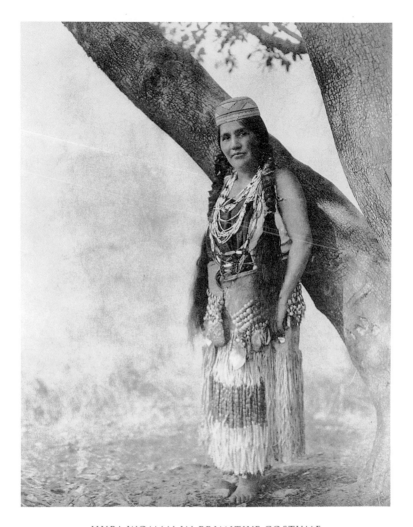

HUPA WOMAN IN PRIMITIVE COSTUME

This is an excellent example of the gala costume of Hupa women.
The deerskin skirt is worn about the hips and meets in front,
where the opening is covered by a similar garment. Both are
fringed and heavily beaded, and the strands of the apron are
ornamented with the shells of pine-nuts.

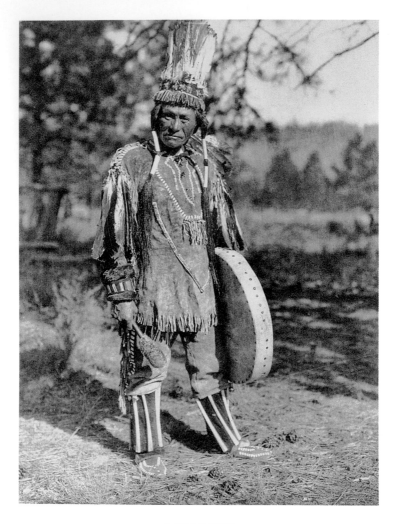

A KLAMATH

The entire costume here depicted is alien to the primitive
Klamath. The feather head-dress and fringed shirt and leggings
of deerskin were adopted by this tribe within the historical period,
along with other phases of the Plains culture, which extended
its influence to the Klamath country by way of Columbia River
and the plains of central Oregon.

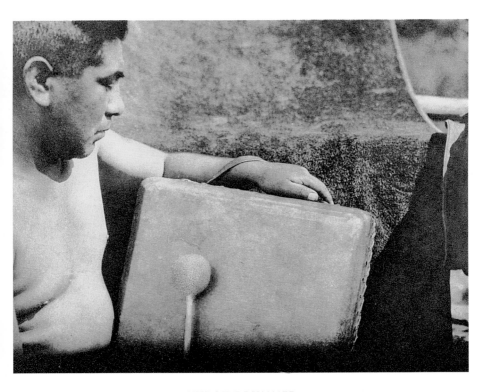

YUROK DRUMMER

The drum of deerskin stretched over a wooden frame was
not aboriginal with the Yurok, but was introduced in imitation
of drums seen in the possession of the garrison stationed
among the Hupa from 1855 to 1892.

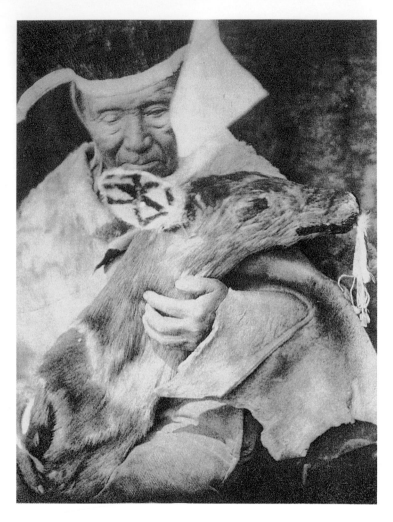

DANCER WITH BLACK DEER EFFIGY – HUPA

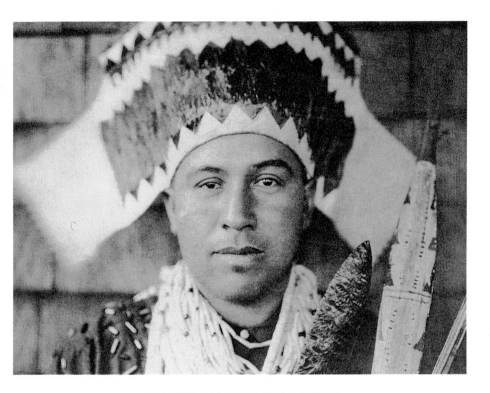

TOLOWA DANCING HEAD-DRESS

The head-dress is of the type common to the Klamath River
tribes – a broad band of deerskin partially covered with a row
of red scalps of the woodpecker. The massive necklace of clam-
shell beads indicates the wealth of the wearer, or of the friend
from whom he borrowed it. He carries a ceremonial celt of black
obsidian and a decorated bow.

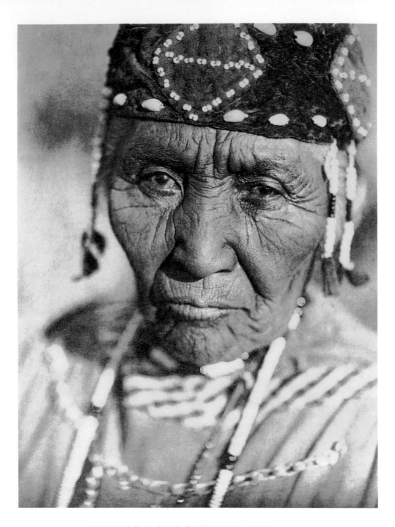

WIFE OF MODOC HENRY ‒ KLAMATH

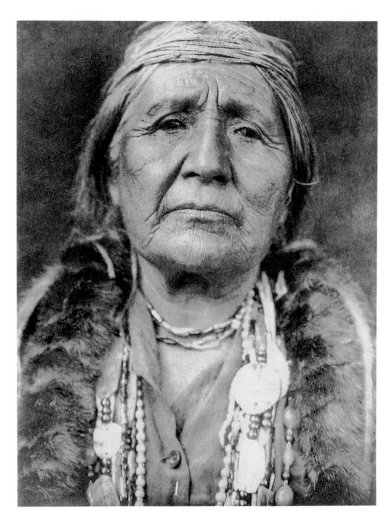

HUPA WOMAN

It would be difficult to find a better type of
Hupa female physiognomy.

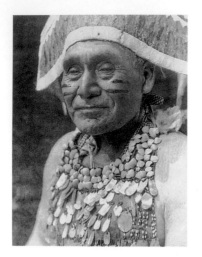

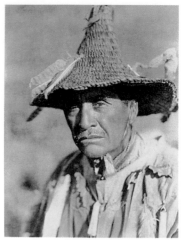

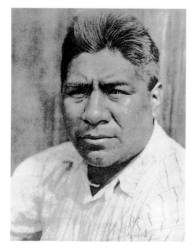

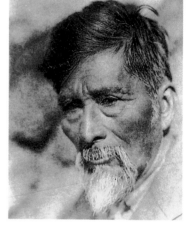

HUPA JUMPING DANCE COSTUME

The Jumping dance was an annual ceremony for averting pestilence. A deerskin robe was worn as a kilt, and each performer displayed all the shells and beads he possessed or could borrow.

SAM EWING - YUROK

KLAMATH WARRIOR'S HEAD-DRESS

The material used in this peaked hat is tule stems, and the weaving is done by the twined process.

ACHOMAWI MAN

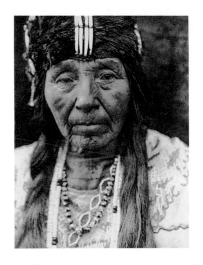

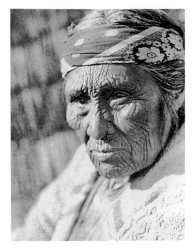

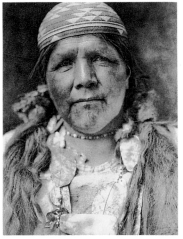

A KLAMATH TYPE

OLD KLAMATH WOMAN

PRINCIPAL FEMALE SHAMAN
OF THE HUPA

KLAMATH WOMAN

Many Hupa shamans were women. They
acquired the power to cure disease. They
were credited with the ability to inflict
mysterious sickness by sorcery, and only
they could relieve the victim of such magic.

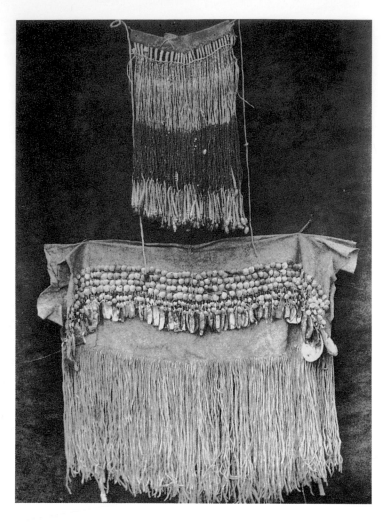

HUPA WOMAN'S DRESS

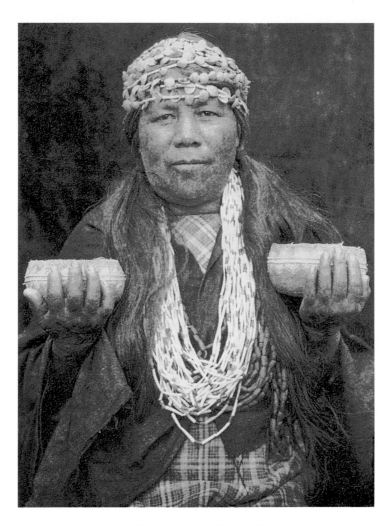

HUPA FEMALE SHAMAN

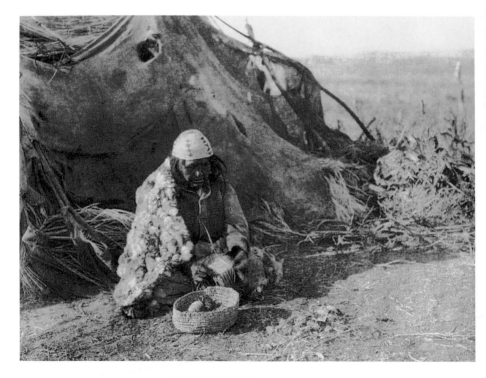

ACHOMAWI BASKET-MAKER

The Achomawi, or Pit River Indians, produce baskets only
by the process known as twining, which is true weaving, never
by coiling, which is actually a sewing process. Their baskets have
bottoms and sides slightly rounded, openings broad, and depth
rather shallow. The usual materials are willow rods for the warp, or
upright elements, and pine-root strands for the weft, or horizontal
elements. The structure in the background is a summer hut covered
with tule mats. The woman is wearing a rabbit-skin robe.

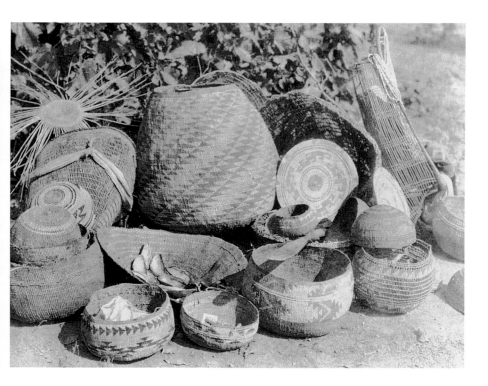

KAROK BASKETS

The Karok twine their baskets, and the usual materials are
hazel rod for the warp, roots of the digger or the yellow pine for
the weft, and Xerophyllum grass for white overlay, bark of the
maidenhair fern for black, and fibers from the stem of Wood-
wardia fern, dyed in alder-bark juice in the mouth of the work-
woman, for red. Represented in the plate are the receptacle for
storage, the burden-basket, the winnowing tray, various sizes
of mush-baskets and food containers, and the cradle-basket.

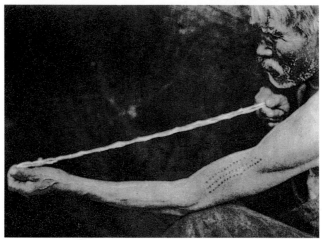

HUPA PURSES AND MONEY

MEASURING SHELL MONEY – TOLOWA

STICKS USED IN HUPA GUESSING GAME

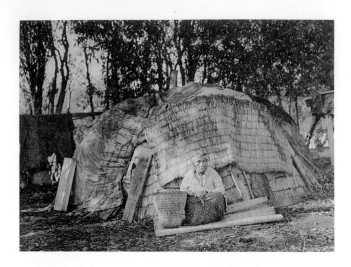

KLAMATH TULE HUT

MODERN HUPA HOUSE

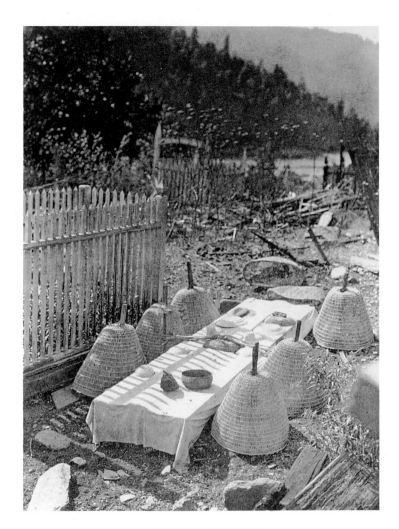

A YUROK CEMETERY

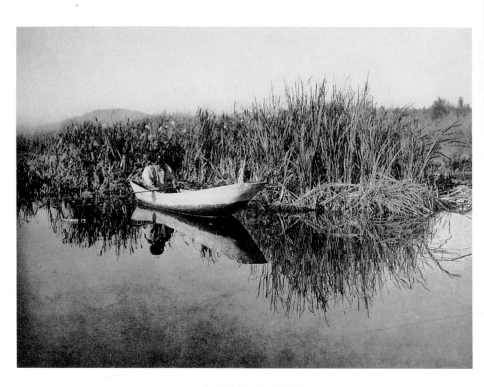

THE KLAMATH HUNTER

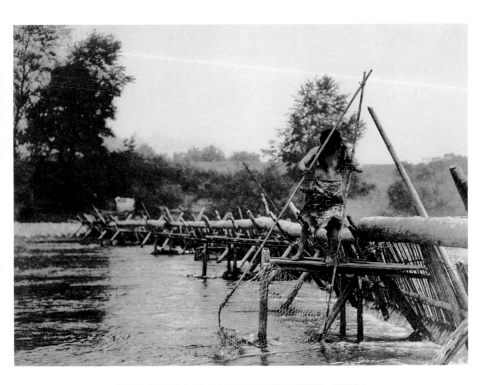

FISH-WEIR ACROSS TRINITY RIVER – HUPA

Each summer a substantial structure of this kind is thrown
across the river, the southern and the northern divisions of the
tribe alternating. The weir remains in place until the spring
freshets carry it away. A fisherman stands on each of several plat-
forms erected below an equal number of openings in the weir,
and lowers and draws his dip-net at random. As the construction
of a weir is a communal undertaking, the catch is divided each
evening according to the requirements of the various families.

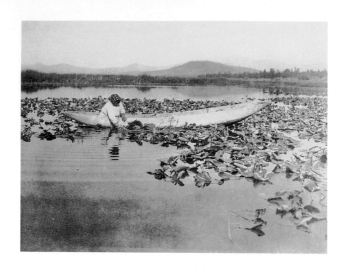

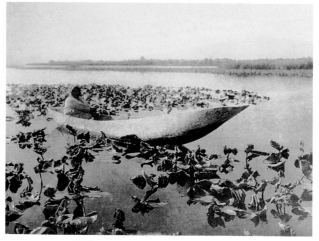

GATHERING WÓKAS – KLAMATH

Wókas, the seeds of the water-lily, *Nymphæa polysepala*, is harvested in August and September. The nearly ripe pods are plucked and deposited in the canoe. After the pods have fermented, the seeds are separated from the mass by stirring in water. They are then dried, parched, hulled, dried again, and stored in bags. *Wókas* was formerly a staple food, and is still much used as a luxury.

THE WÓKAS SEASON – KLAMATH

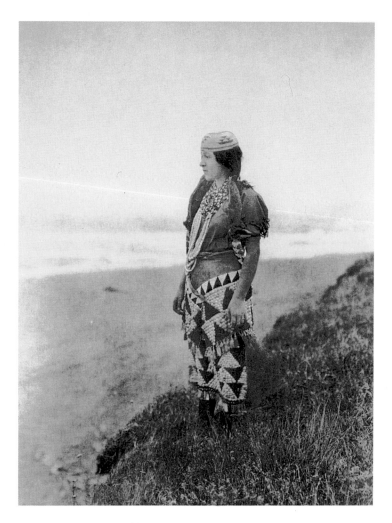

WOMAN'S PRIMITIVE DRESS – TOLOWA

This is the gala costume of Coast Athapascan women. The
ordinary dress was a deerskin kilt with the opening at the front
protected by a fringed apron of deerskin or of bark. Ordinarily
the feet and the upper part of the body were bare.

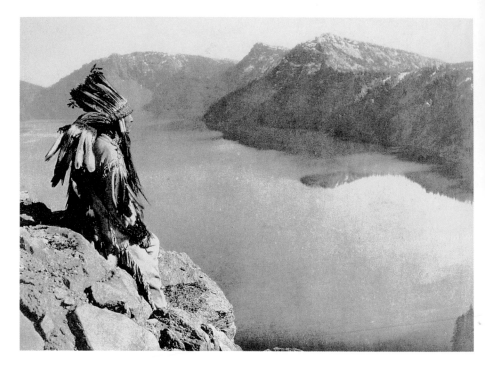

CRATER LAKE

Crater Lake, a body of water indescribably blue, occupies an extinct crater in the heart of the Cascade Mountains of southern Oregon. It is on the boundary of what was formerly the territory of the Klamath Indians, who held it to be especially potent in conferring shamanistic power upon men who there fasted and bathed. An important Klamath myth seeks to account for the former absence of fish from Crater Lake, a condition that was altered in 1888 by the introduction of trout.

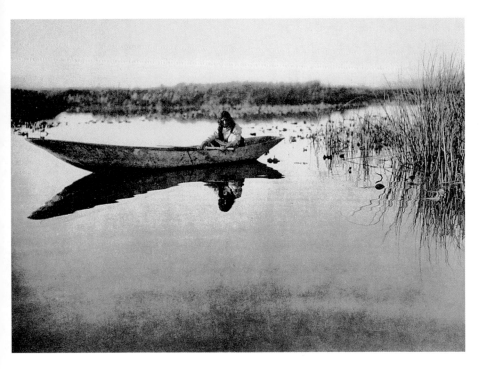

KLAMATH LAKE MARSHES

Fairly extensive marshes occur along the shores of Klamath
Lake, and Klamath marsh covers about a hundred square miles.
These areas are the resort of innumerable waterfowl, which were
of great importance to the aboriginal Klamath, and thousands
of acres were a mass of water-lilies, which yielded in abundance
an edible seed.

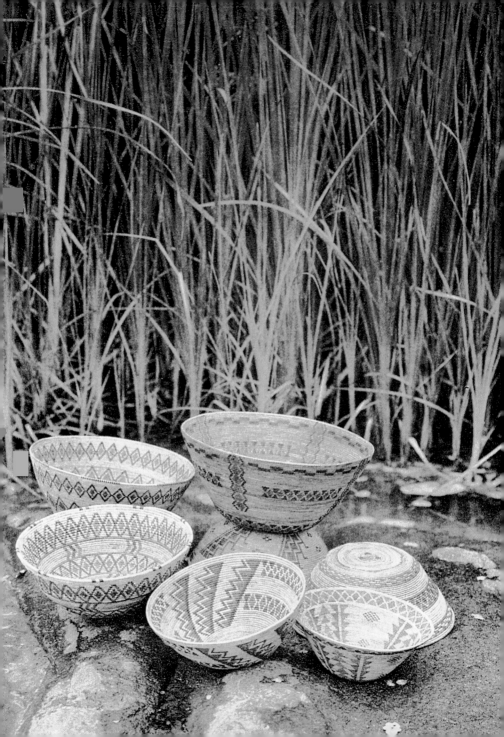

KATO

WAILAKI

YUKI

POMO

WINTUN

MAIDU

MIWOK

YOKUTS

VOLUME XIV

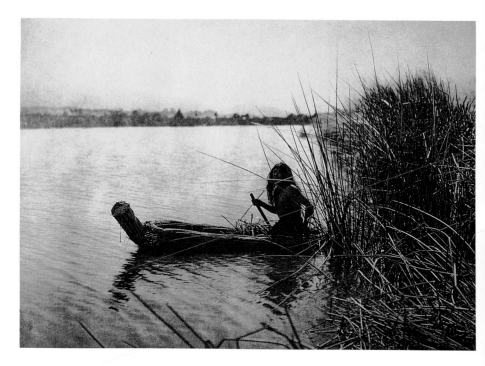

THE HUNTER – LAKE POMO

The scene is Clear Lake. The abundant tules along its shallows
formerly supplied the natives with material for house-coverings,
mats, garments, and balsas, and sheltered teeming flocks
of waterfowl.

PAGE 540
RATTLESNAKE DESIGN IN
YOKUTS BASKETRY

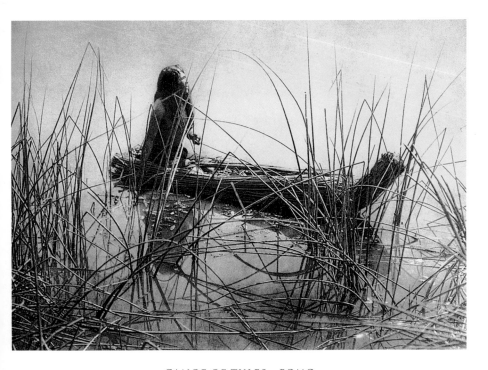

CANOE OF TULES – POMO

In an emergency a craft even more simple than this was made
by fashioning a long bundle of tules, which the boatman rode
astride with his legs in the water.

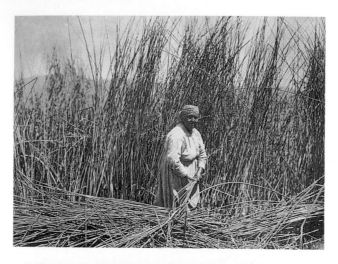

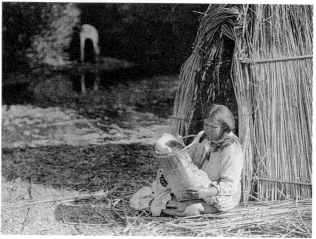

GATHERING TULES – LAKE POMO

The round-stem tule, *Scirpus lacustris*, was used principally for thatching houses, for making mats by stringing them laterally on parallel cords, and, securely lashed together in long bundles, in the construction of serviceable and quickly made canoes.

POMO MOTHER AND CHILD

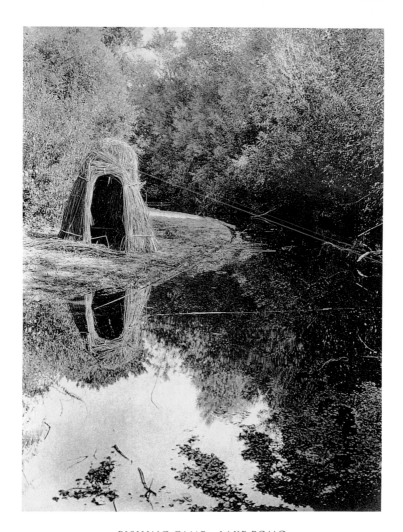

FISHING CAMP – LAKE POMO

Large quantities of a species locally called black-fish are still
taken annually by the Lake Pomo. The fish are split down the
back, and after the removal of backbone, head, and entrails, are
hung on pole racks to dry in the sun for about two weeks, after
which they are thoroughly cured in smoke-houses. Tule huts are
not now seen, the one here shown having been built especially
for the occasion.

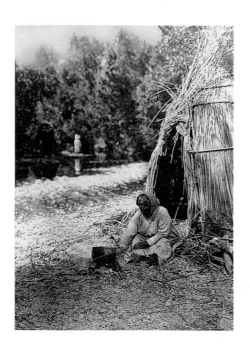

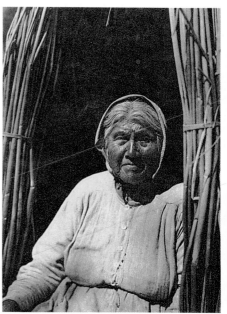

A SUMMER CAMP – LAKE POMO

Except that it was larger and rather more substantial,
the winter house of the Lake Pomo was identical with
this tule-covered framework of willow poles.

EASTERN POMO WOMAN

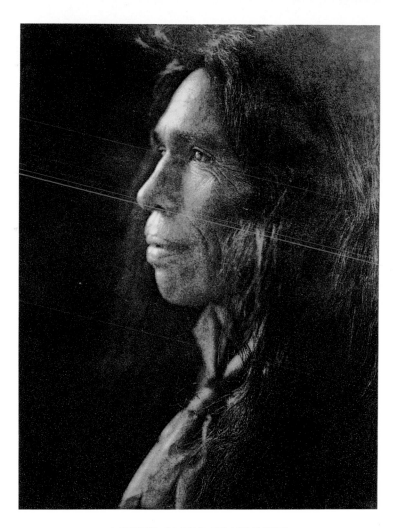

A MIXED-BLOOD COAST POMO

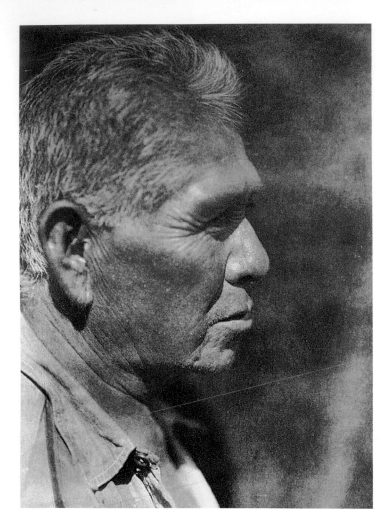

A SOUTHERN MIWOK

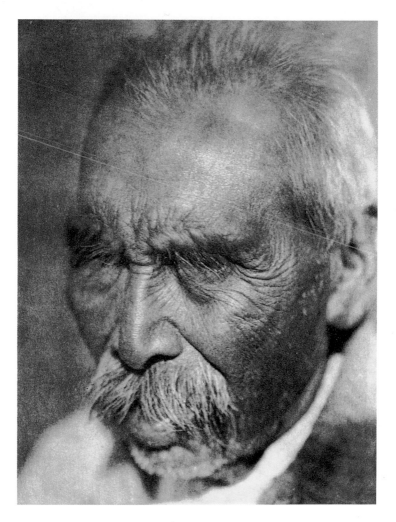

OTÍLA – MAIDU

Otíla, otherwise Jack Franco, was the principal source of
information regarding the Maidu. Born at the important village
Michopdo in the lowlands of Sacramento River about the year
1845, as a young boy he experienced the untainted native life before
the influx of miners and settlers proved the undoing of
the Indians. As a youth he rode the range for General John Bidwell,
and his old age he has spent in company with a small group of his
people on the Bidwell ranch at Chico.

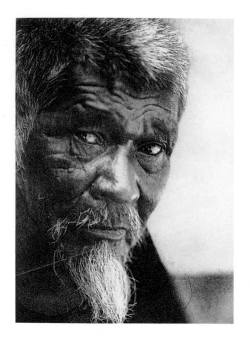

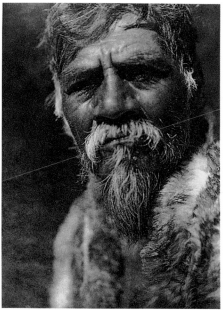

A WAPPO

The Wappo were a Yukian group occupying a detached area in the northeastern corner of Sonoma county. Only a small band survive in Alexander Valley near Healdsburg.

OLD UKIAH – POMO

The Pomo formerly occupied about half the area of Mendocino, Sonoma, and Lake counties, besides a small isolated territory in Glenn and Colusa. The survivors are found in greatest number in the vicinity of the town of Ukiah. This name, though it is applied to the original of the portrait as a nickname, is a word of Pomo origin, from *yo*, south, and *kaía*, valley.

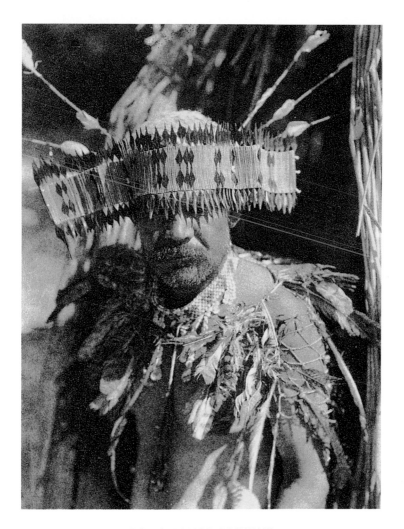

POMO DANCE COSTUME

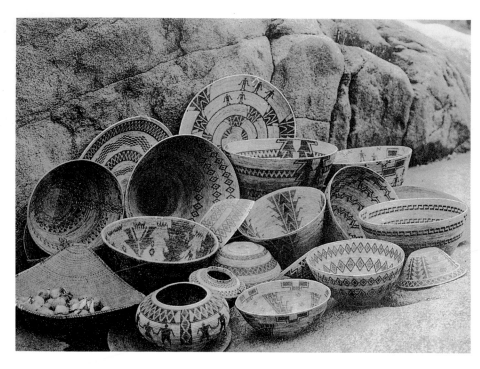

YOKUTS BASKETRY DESIGNS

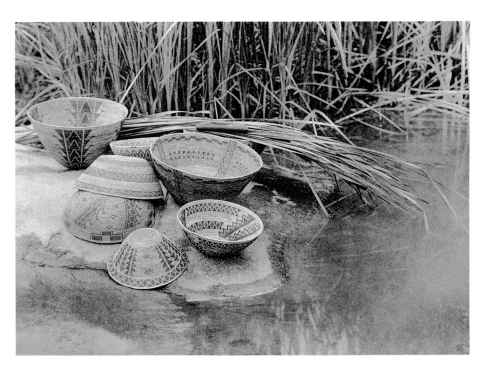

BY THE POOL – TULE RIVER RESERVATION

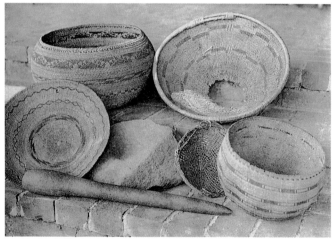

POMO SEED-GATHERING UTENSILS

The group includes a tight-mesh burden-basket for seeds,
an open-mesh burden-basket for acorns and other nuts, two
winnowing trays, and a seed-beater with which the seeds are
brushed from the plant into the burden-basket.

POMO BASKETS, MORTAR, AND PESTLE

ART AS OLD AS THE TREE –
SOUTHERN YOKUTS

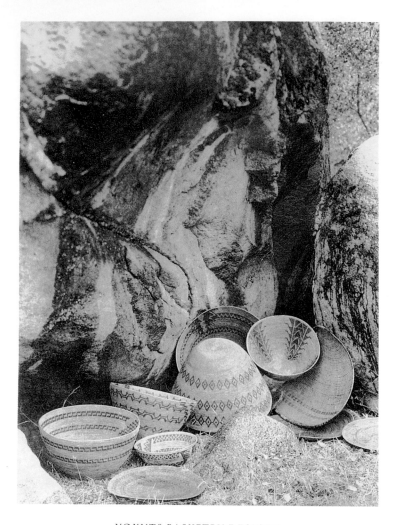

YOKUTS BASKETRY DESIGNS

LOOKING OUT OF THE PAINTED CAVE

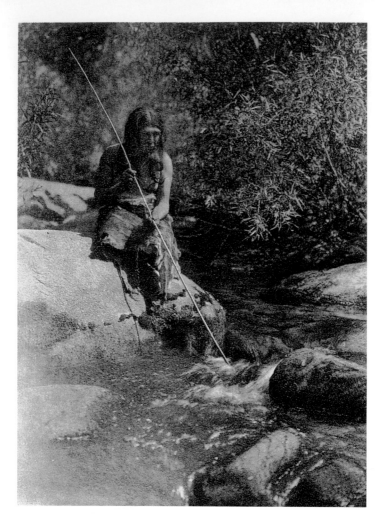

ON THE MERCED – SOUTHERN MIWOK

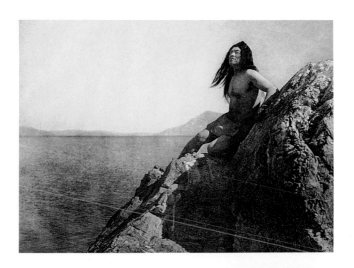

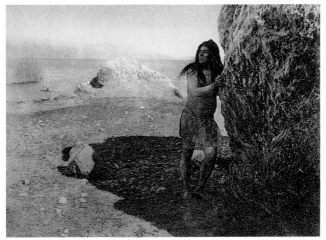

ON THE SHORES OF CLEAR LAKE

ON THE SHORES OF CLEAR LAKE

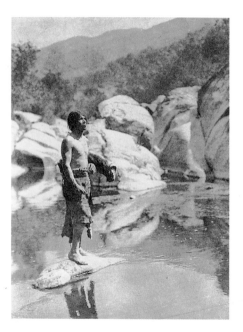

QUIET WATERS – TULE RIVER
RESERVATION

Tule River reservation, a tract of nearly fifty
thousand acres on the edge of the foothills of the
Sierra Nevada in Tulare county, is the home of about a
hundred and fifty Indians, practically all of whom are
members of the Yokuts family. Only a small portion of
the reservation is suited to agriculture.

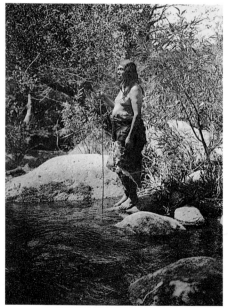

THE FISHERMAN –
SOUTHERN MIWOK

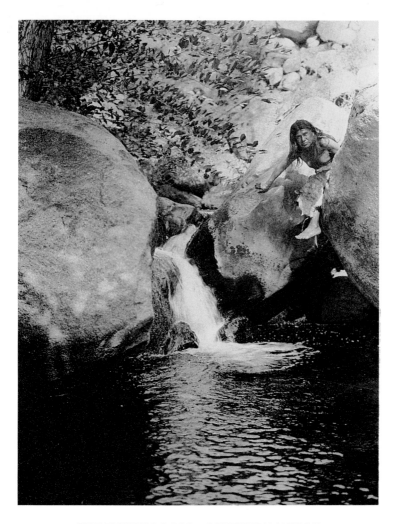

THE FISHING POOL – SOUTHERN MIWOK

Besides a small district at the southern end of Clear Lake, and
a larger territory that included all of Marin and a part of Sonoma
county, Miwok Indians occupied the western slope of the Sierra
Nevada. The higher regions are veined with brawling mountain
brooks, which converge into such larger streams as Merced,
Tuolumne, Stanislaus, Calaveras, and Mokelumne. Yosemite
and many of the sequoia groves lie in Miwok territory.

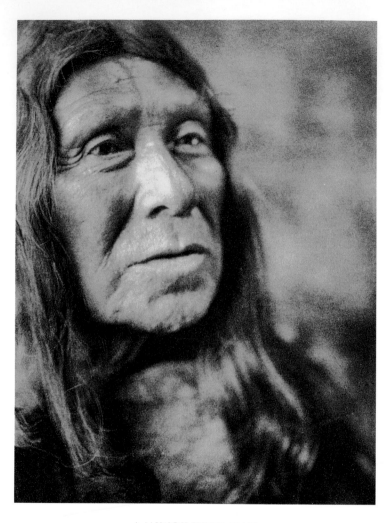

A MIWOK HEAD-MAN

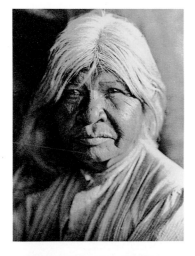

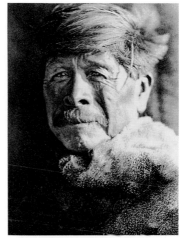

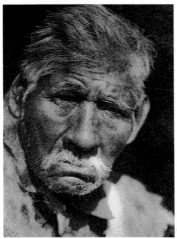

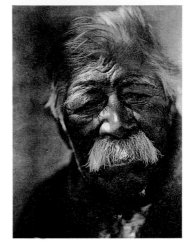

A CHUKCHANSI YOKUTS
TYPE

A YAUELMANI YOKUTS

The Yauelmani formerly lived in the plains
north of Kern Lake. The survivors are on
Tule River reservation in
Tulare county.

A CHUKCHANSI YOKUTS

The Chukchansi, one of the northern
divisions of the Yokuts, occupied the
headwaters of Fresno River and the north-
ern tributaries of the San Joaquin, in
Madera county, California.

S͡HATÍLA - POMO

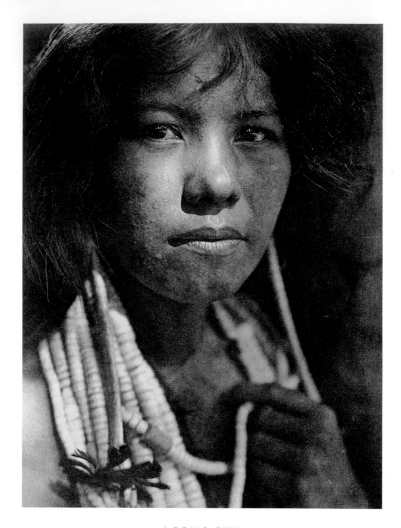

A POMO GIRL

Clam-shell beads are still made by some of the old men. Fragments
of shell are pierced and strung on a stem of the scouring-rush
(*Equisetum*), which is then drawn backward and forward on a
flat surface of sandstone until the fragments have become nearly
circular. The feathered ornament is an ear-pendant, which in this
case, because of its length and weight, is attached to a strand of the
hair. The large, dark-colored bead on one strand of the necklace is
a cylinder of magnesite, a highly valued object.

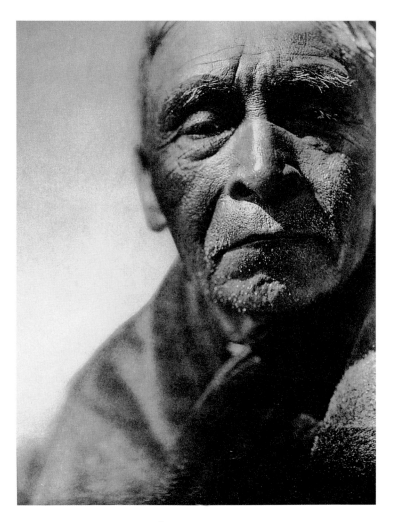

MÍTAT – WAILAKI

The Wailaki were a group of loosely connected Athapascan
bands occupying the watershed of the North fork of Eel River in
north-western California. About two hundred are now quartered
with the Yuki on Round Valley reservation.

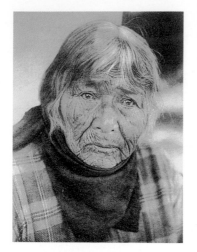

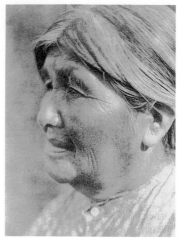

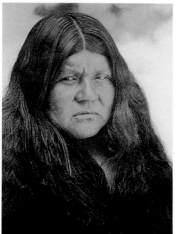

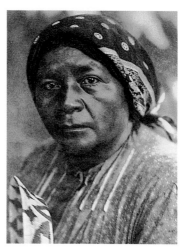

AGED POMO WOMAN

A WAPPO WOMAN

A YAUDANCHI
YOKUTS WOMAN

The Yaudanchi formerly controlled the
territory about the headwaters of Tule
River in Tulare county, including the
present Tule River reservation, where
the survivors are quartered.

A COAST POMO WOMAN

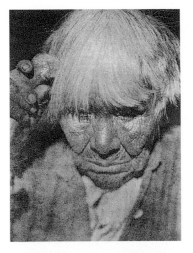

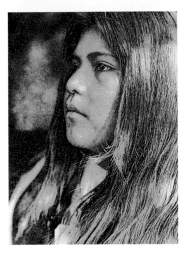

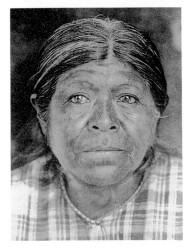

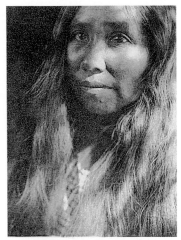

OLD WOMAN IN
MOURNING – YUKI

A KATO
WOMAN

A CHUKCHANSI MATRON

A COAST POMO GIRL

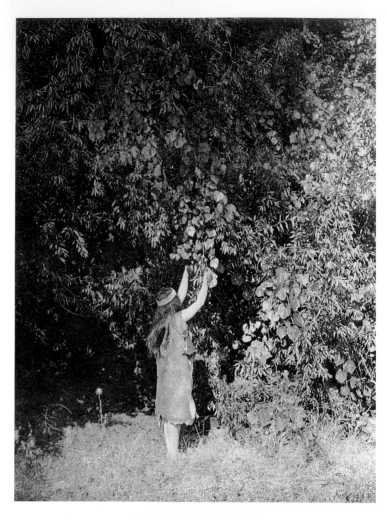

WILD GRAPES – POMO

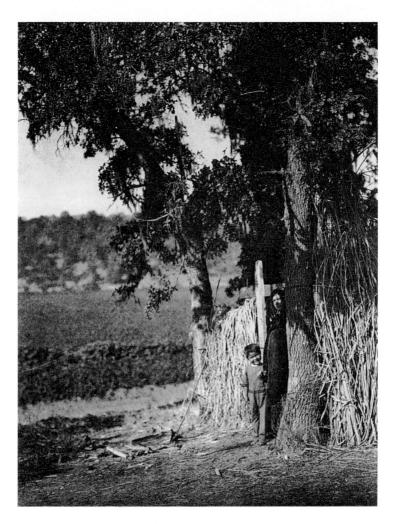

CAMP UNDER THE OAKS – LAKE POMO

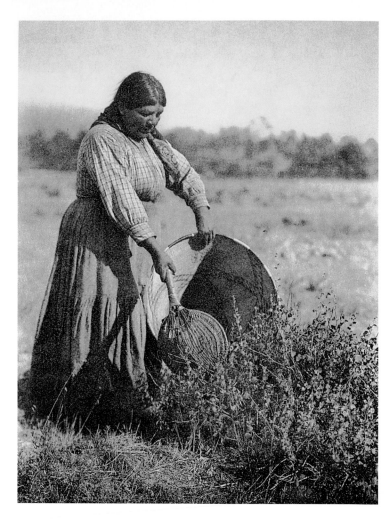

GATHERING SEEDS – COAST POMO

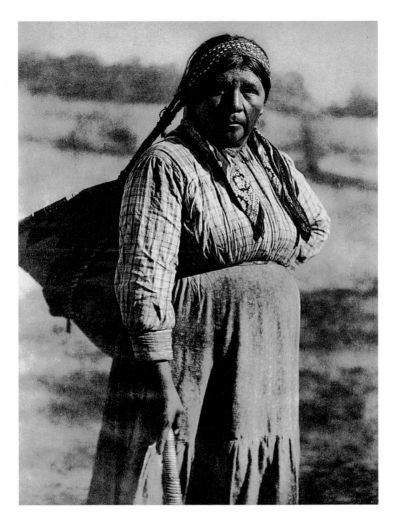

THE BURDEN-BASKET – COAST POMO

With her basket supported by a tump-line passing across her
head, and with seed-beater in hand, this capable matron is ready
for a day in the fields harvesting wild seeds, which she will parch
and crush into a nutritious and appetizing meal known by
the Mexican name *pinole.*

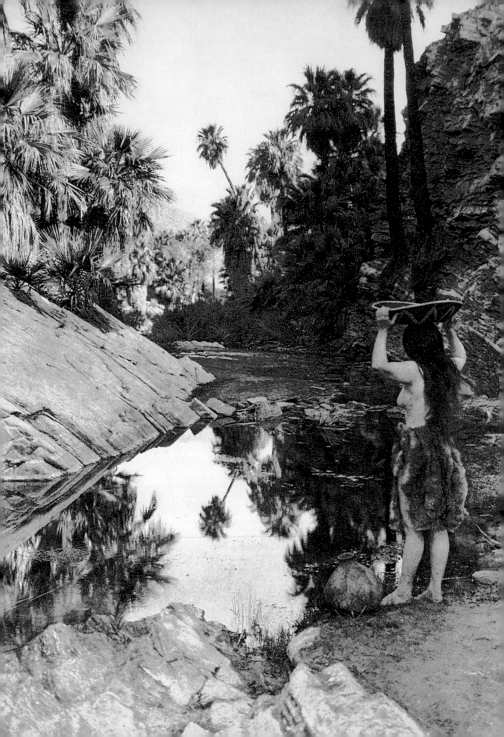

Southern California Shoshoneans

Diegueños

Plateau Shoshoneans (Paiute)

Washo

Volume XV

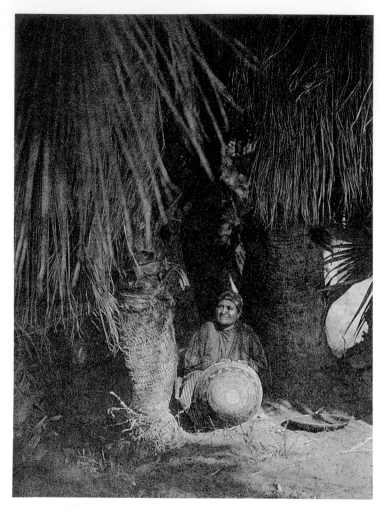

UNDER THE PALMS – CAHUILLA

PAGE 572
BEFORE THE WHITE MAN CAME –
PALM CAÑON

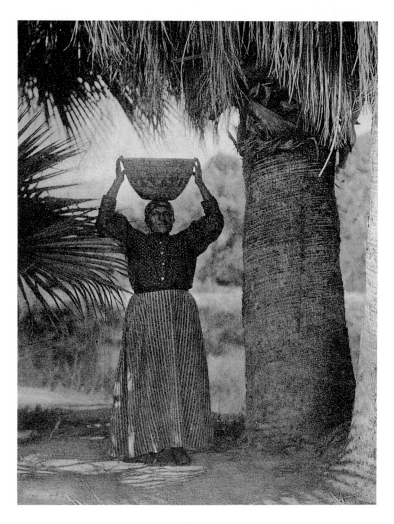

THE HARVESTER – CAHUILLA

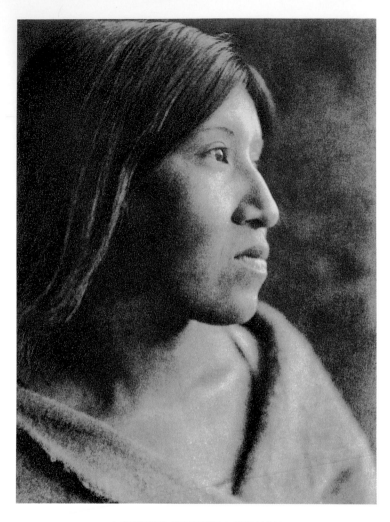

A DESERT CAHUILLA WOMAN

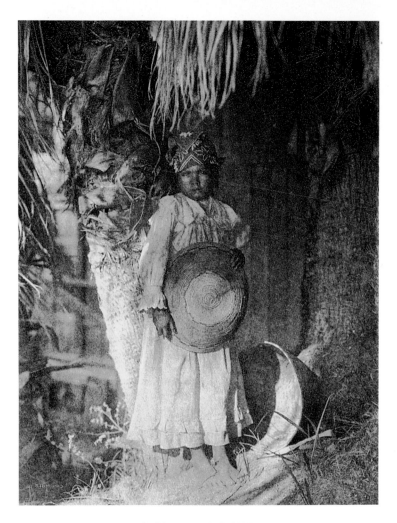

A CAHUILLA CHILD

UNDER THE PALMS – CAHUILLA

This view shows the immediate environment of the village
at Palm Springs on Agua Caliente reservation.

PALM CAÑON

Across the tops of a luxuriant growth of palms the view
sweeps away to the summit of San Jacinto, which attains
an elevation of 10,600 feet.

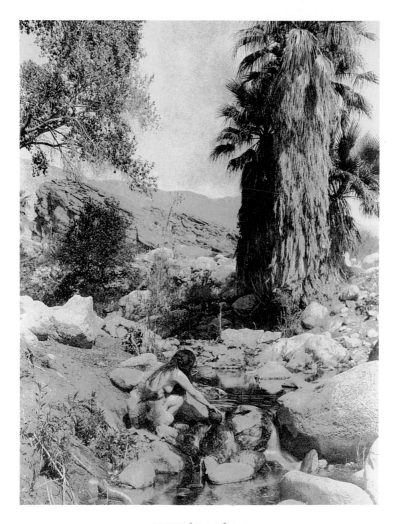

ANDRÉS CAÑON

Near Andrés Cañon, south of Palm Springs, was Paínik, the
winter residence of a branch of the Palm Cañon Cahuilla.

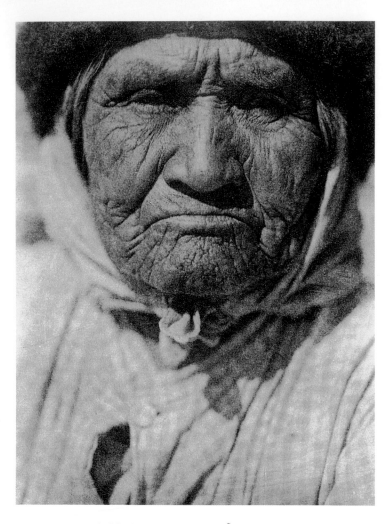

A SOUTHERN DIEGUEÑO WOMAN

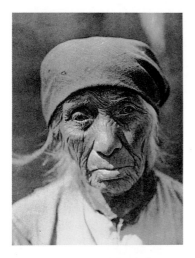

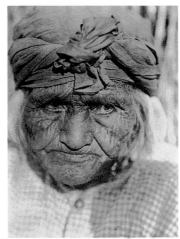

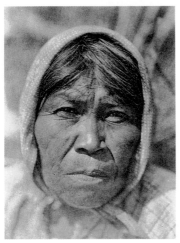

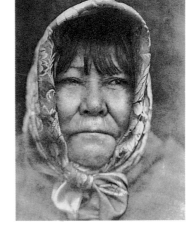

A SERRANO WOMAN
OF TEJON

A DIEGUEÑO WOMAN OF
SANTA YSABEL

A CUPEÑO
WOMAN

DATSOLALI, WASHO
BASKET-MAKER

The Cupeño are a small Shoshonean
group of mountaineers formerly residing
at the head of San Luis Rey River in
north-central San Diego county.

The coiled baskets produced by this
woman have not been equalled by any
Indian now living. About ninety years old,
Datsolali appears to be in the early sixties.

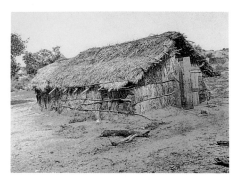

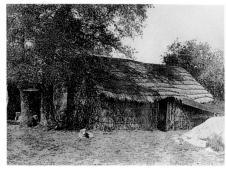

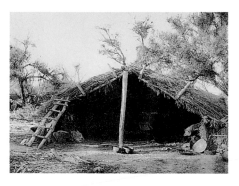

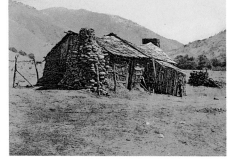

SOUTHERN DIEGUEÑO HOUSE

Linguistically the Diegueños fall into a northern
and a southern group. The variation, however, is not
so great as to prevent conversation between them.
The southern dialect is spoken at Campo, La Posta,
Manzanita, Cuyapipe, and Laguna reservations.

A HOME IN THE MESQUITE –
CHEMEHUEVI

A DIEGUEÑO HOME

The Diegueños are found on about a dozen small
reservations. Although they were not formerly agri-
culturists, many of them take excellent care of their
little ranches. Their houses are not of the primitive
type, though they are constructed of the
same materials.

MODERN HOUSE AT TEJON

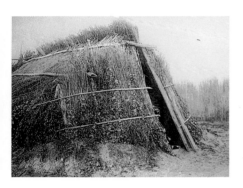

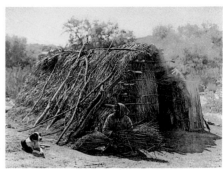

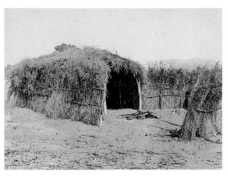

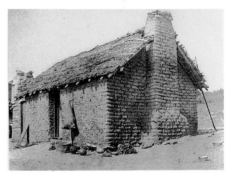

CHEMEHUEVI HOUSE

CAHUILLA HOUSE IN THE DESERT

The Desert Cahuilla are found on several small
reservations in their former habitat, the upper end
of Salton sink, the greater part of which is below
sea-level. They subsisted principally on rabbits
and other rodents, and mesquite-beans.

DIEGUEÑO HOUSE AT CAMPO

Campo reservation is only a few miles from the
Mexican boundary.

MODERN CUPEÑO HOUSE

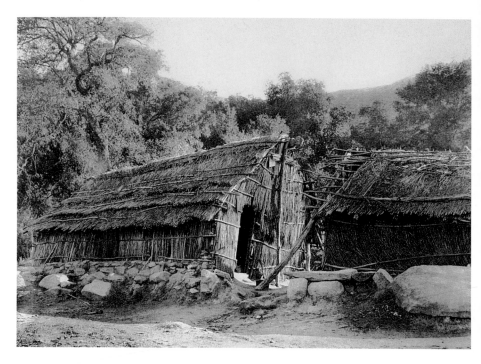

DIEGUEÑO HOUSE AT SANTA YSABEL

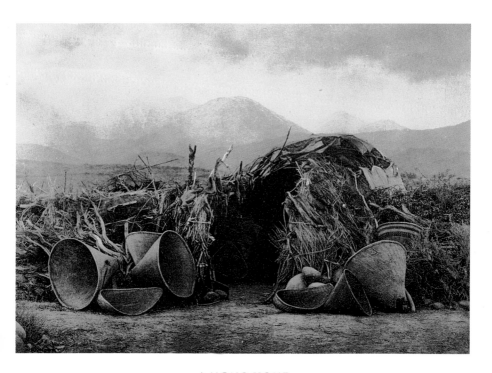

A MONO HOME

The Mono inhabit east-central California from Owens Lake
to the head of the southerly affluents of Walker River. The snow-
capped Sierra Nevada rises abruptly on the western border of this
inland basin. The wickiup shown in the plate is a typical winter
shelter, and the utensils are burden-baskets and sieves, or
winnowing-trays. All these baskets were appurtenances
of the one wickiup.

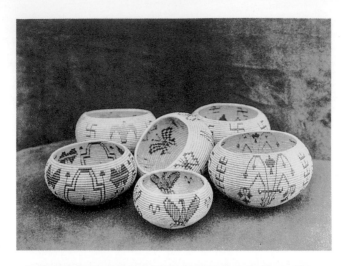

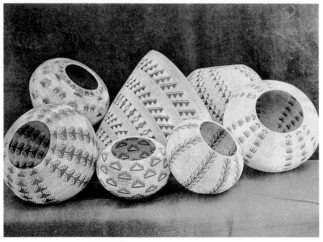

MODERN DESIGNS IN WASHO BASKETRY

WASHO BASKETS

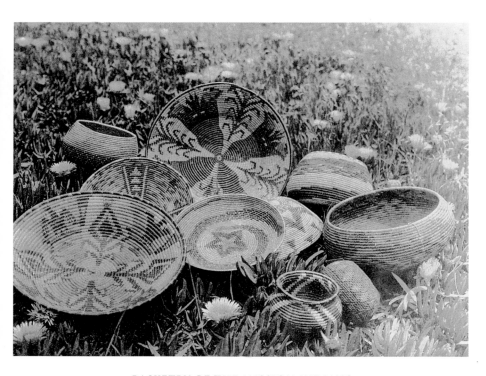

BASKETRY OF THE MISSION INDIANS

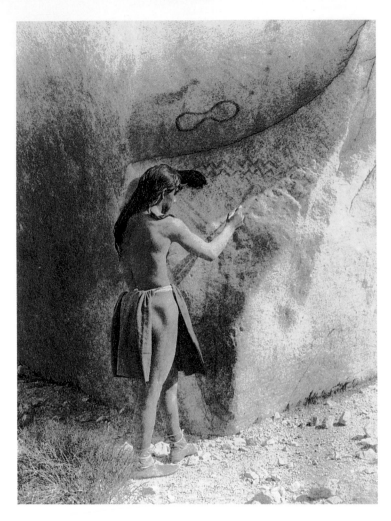

THE PRIMITIVE ARTIST – PAVIOTSO

A side of this glaciated bowlder near the southwest shore of
Walker Lake is covered with phallic symbols in faded red.

SANDSTONE VESSELS FROM SANTA
CATALINA ISLAND

CHEMEHUEVI GRANARY

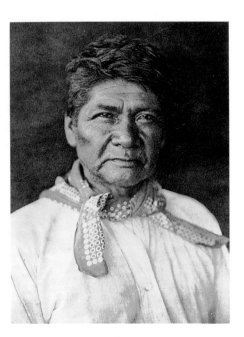

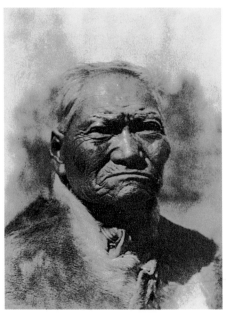

MARCOS – PALM CAÑON CAHUILLA A PYRAMID LAKE PAVIOTSO

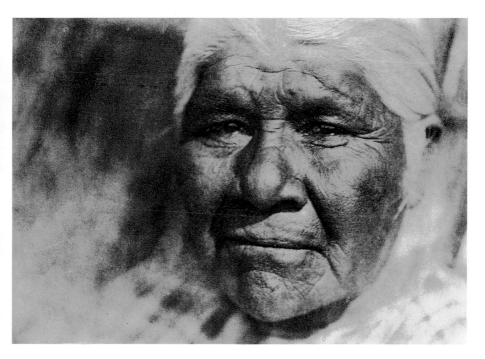

A DIEGUEÑO WOMAN OF CAMPO

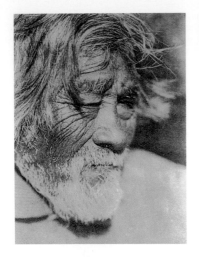

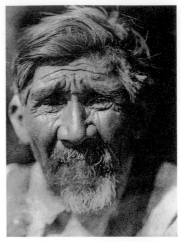

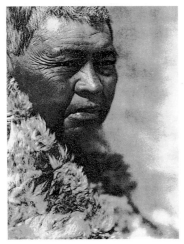

A DIEGUEÑO OF
SANTA YSABEL

NUMERO – DESERT
CAHUILLA

A WALKER LAKE PAVIOTSO

A DIEGUEÑO OF CAPITAN
GRANDE

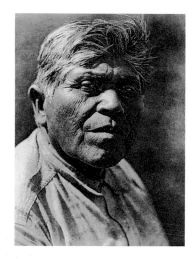
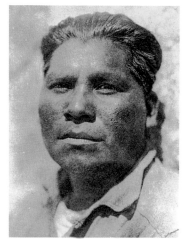
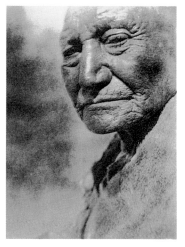
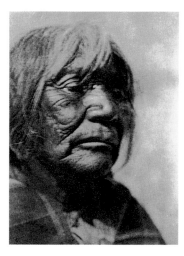

A TEJON SERRANO

A SOUTHERN DIEGUEÑO

AN AGED PAVIOTSO OF
PYRAMID LAKE

A WASHO WOMAN

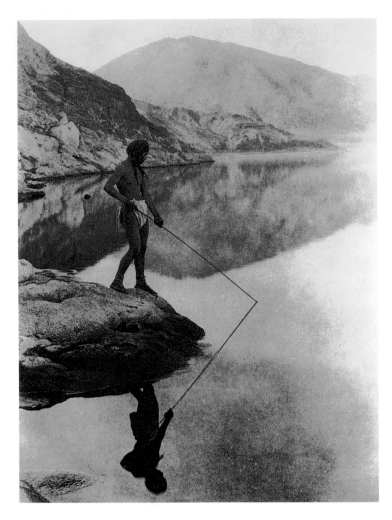

SHORES OF WALKER LAKE

Walker Lake, one of numerous saline lakes remaining from a great
inland sea that once covered western Nevada and northeastern
California, is the seat of a major division of the Paviotso. In the
western corner of Nevada it is fed by Walker River, the numerous
branches of which head on the eastern slope of the Sierra Nevada
in California. Although there is no outlet, the water is not too
saline for the thriving of trout and suckers, which were taken on
bone hooks, with double-pointed spears, and in gill-nets.

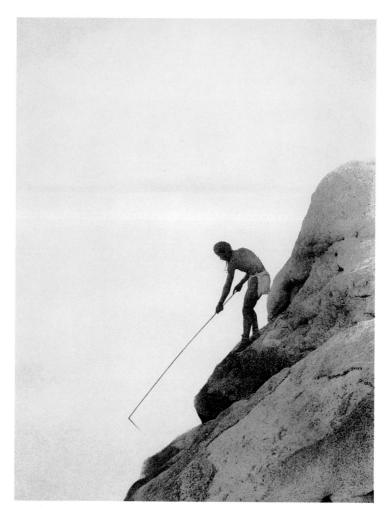

FISHING WITH A GAFF-HOOK – PAVIOTSO

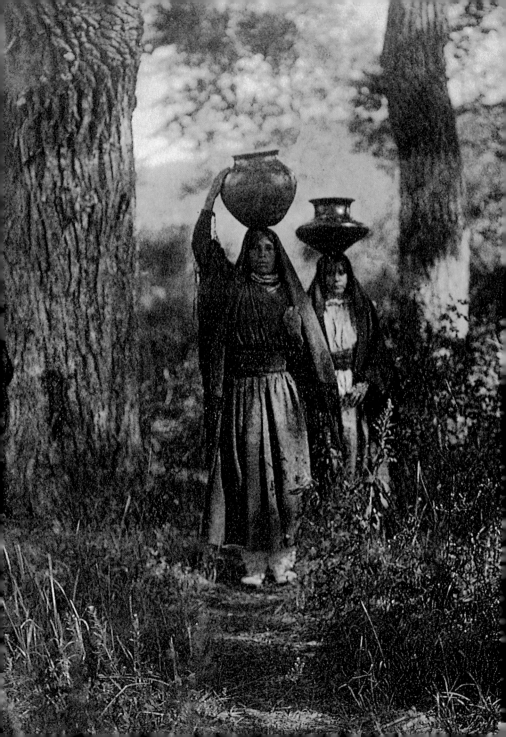

Tiwa

Tano

Keres

Volume XVI

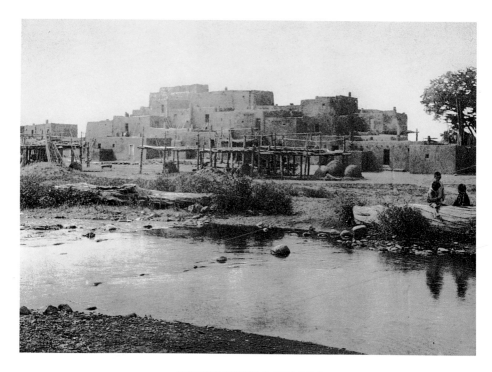

NORTH PUEBLO AT TAOS

Taos consists of two house-masses separated by Pueblo Creek.
The entire site was formerly surrounded by a protective wall. The
north structure is called Hlauóma ("cold elevated"), referring to
its situation (north being regarded as up, and south as down).
The other is Hlauqíma ("cold diminish").

PAGE 596
TAOS WATER GIRLS

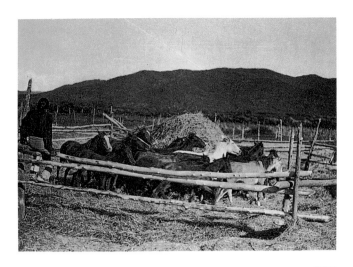

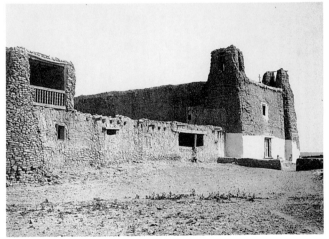

THRESHING WHEAT – TAOS

MISSION AND CHURCH AT ACOMA

JEMEZ ARCHITECTURE

On account of the comparative inaccessibility of its site on
Rio Jemez, a westerly affluent of the Rio Grande, Jemez is
annoyed by fewer white visitors than almost any other pueblo.
The reticence and the mental sluggishness of its inhabitants do
not encourage the ethnologist. The Jemez played a leading part
in the rebellion of 1680 and were so severely punished by Vargas
that their preference for isolation is comprehensible.

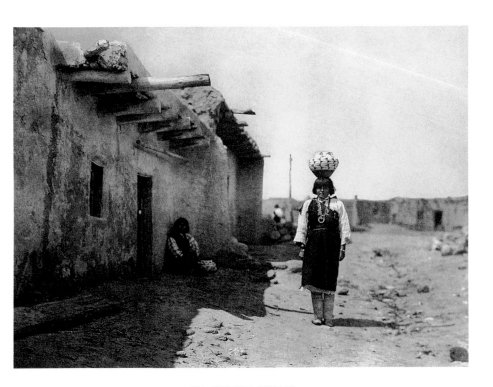

SIA STREET SCENE

Sia is situated on the north bank of Rio Jemez, a few miles
below Jemez pueblo. Ancient Sia, having participated in the revolt
of 1680, was completely destroyed and a large number of its in-
habitants were killed by Governor Domingo de Cruzate in 1689.
The pueblo was rebuilt, probably on nearly the same site, and
during the remaining years of this troubled period Sia remained
actively friendly with the Spaniards. Once a populous centre,
it housed only one hundred and fifty-four persons in 1924.

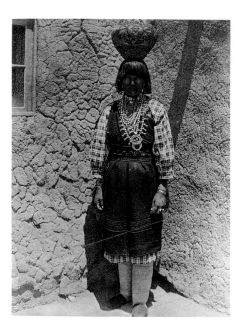

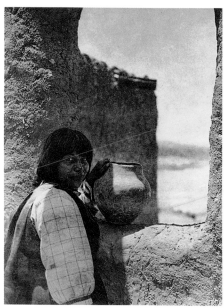

SHÚAṬI – SIA

TÍM'U – COCHITI

This Cochiti girl married a Sia man, and the
photograph was made at her adopted home.

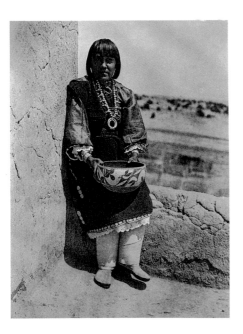

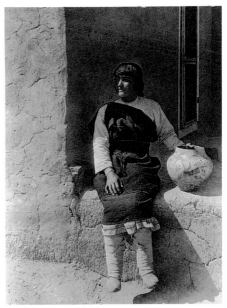

ON A SIA HOUSETOP

AÍYOWITS!A - COCHITI

Carolina Quintana, the most mentally alert
Indian woman met in more than twenty years of
field work in connection with this series, is a
shining example of what Pueblo women can become
with a little schooling and instruction in modern
housekeeping. She was mainly responsible for the
compilation of Cochiti relationship terms.

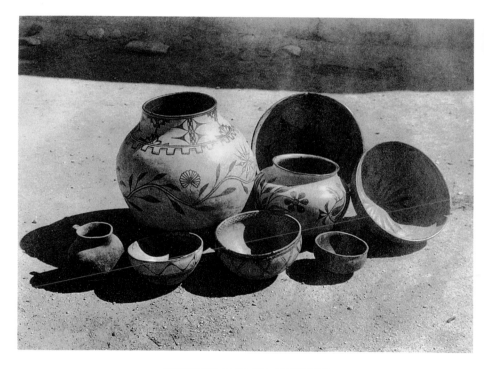

COCHITI AND SIA POTTERY

The vessel with the bird design was made at Sia, the others
are from Cochiti. Sia is noted for the excellence of its earthenware,
the best of which is the product of two women.

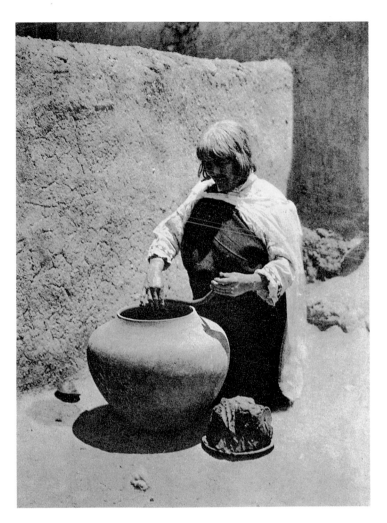

TSÍ'YONĔ (FLYING) – SIA

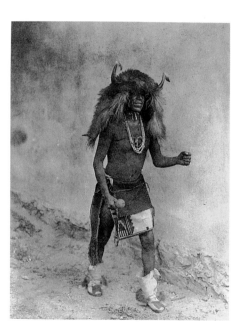

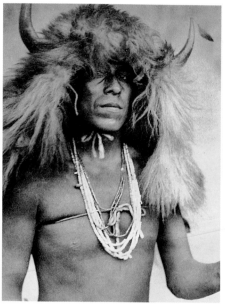

SIA BUFFALO DANCER

SIA BUFFALO MASK

The performers of the Buffalo Dance are two young
men with head-dresses of buffalo-hair and horns, and
a girl wearing the usual female costume and a pair of
small horns. The head of the hunters' society plays the
part of guard. The dance is very strenuous, and the
simulated actions of the buffalo are quite realistic and
readily comprehended by the spectator.

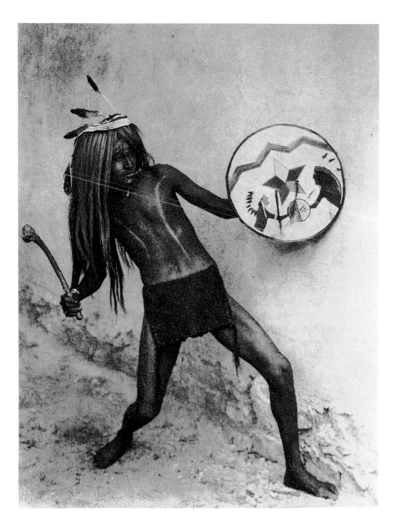

SIA WAR-DANCER

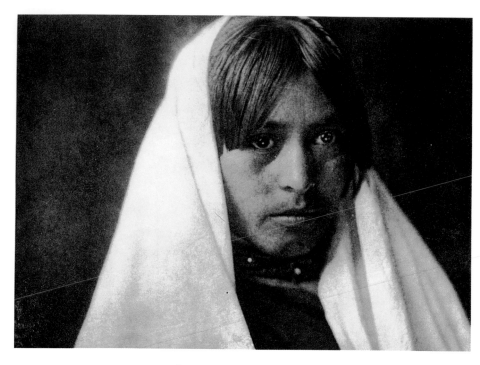

WALVÍA (MEDICINE ROOT) – TAOS

Walvía is a characteristic type of Taos womanhood.

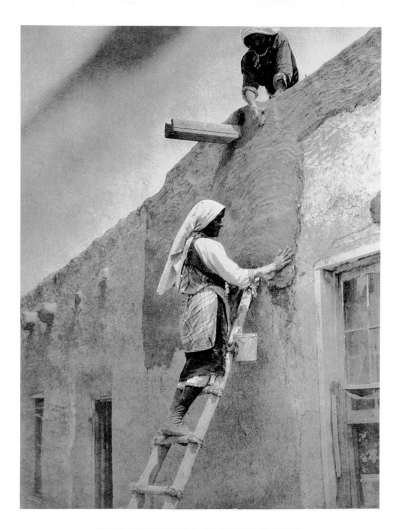

REPLASTERING A PAGUATE HOUSE

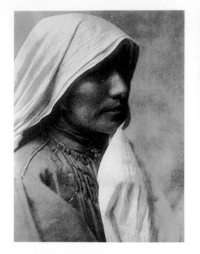

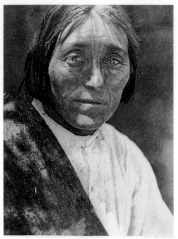

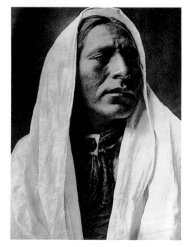

A TAOS WOMAN

IÁHLA (WILLOW) – TAOS

AN ISLETA MAN

LUCERO – SANTO DOMINGO

Photographing a native of Santo
Domingo is comparable to hunting
big game with a camera. This pueblo
measures its contentment inversely
to the extent of unavoidable contact
with the hated white race.

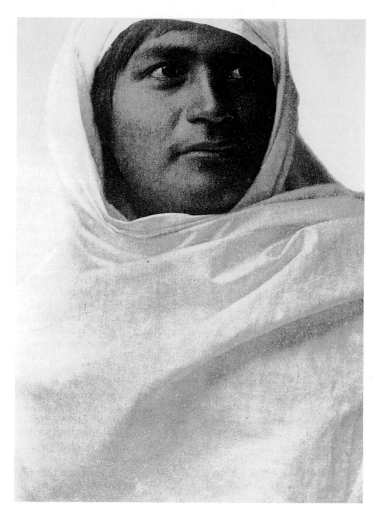

ṬÁ́PÂ (ANTELOPE WATER) ‒ TAOS

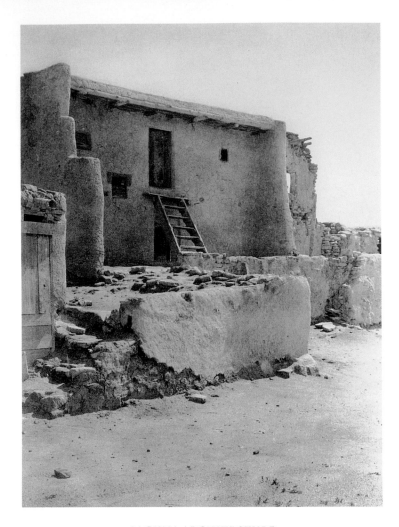

LAGUNA ARCHITECTURE

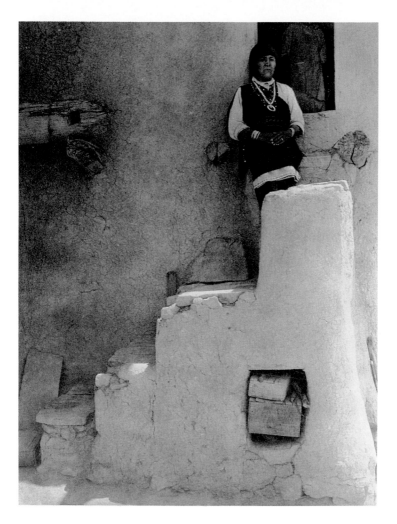

A PAGUATE ENTRANCE

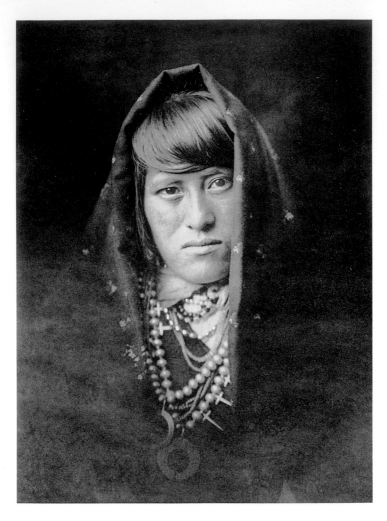

AN ACOMA WOMAN

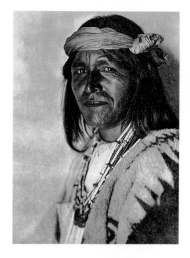

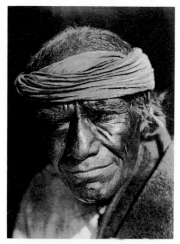

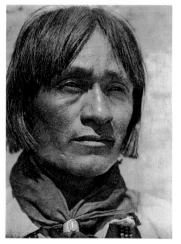

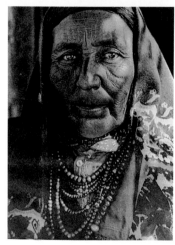

A JEMEZ FISCAL

The office of fiscal is of Spanish origin, and its incumbents are charged with the supervision of activities connected with the church, such as burial of the dead and physical care of the church building.

ĶYÉLLO – SANTO
DOMINGO

TÛVAHÉ – JEMEZ

FRANCISCA CHIWIWI –
ISLETA

In general, an Indian regards his name as a personal possession, and does not reveal it to strangers. But in a brief visit at Isleta at least Spanish names could be recorded.

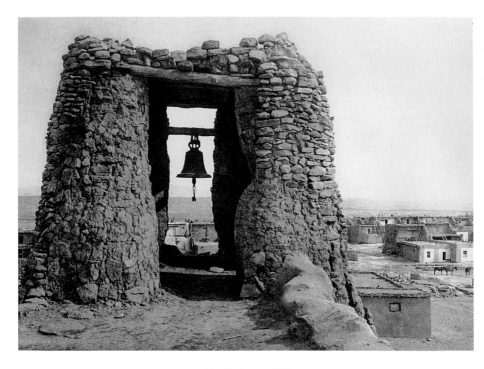

ACOMA BELFRY

With the possible exception of Sia, Acoma possesses the oldest
church among the pueblos. Its bell is dated 1710, but the massive
structure may have been erected as early as 1699.

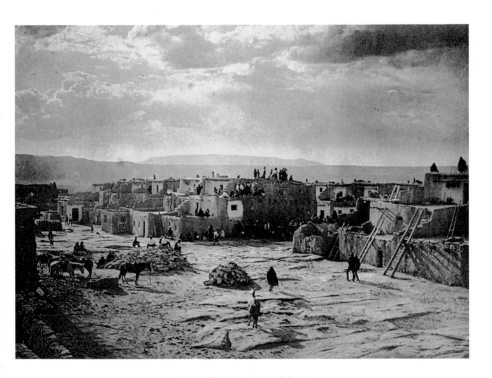

A FEAST DAY AT ACOMA

Franciscan missionaries early in the seventeenth century intro-
duced certain public Christian rites among the Pueblos, which
ever since have been performed, with an intermingling of native
ceremonial practices, especially on the days of the saints to whose
protection the villages were respectively assigned. The day of
San Estevan, patron saint of Acoma, is September second.

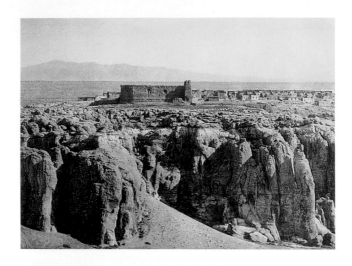

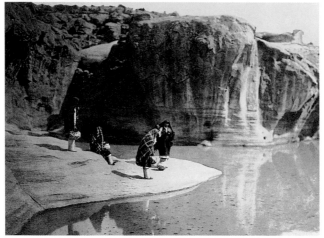

ACOMA FROM THE SOUTH

The large building in the centre is the church, and the walls
of the cemetery are visible at its right. In the distance is the
vague outline of Mount Taylor.

ACOMA WATER CARRIERS

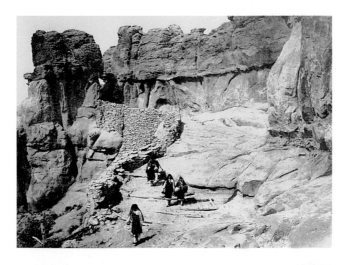

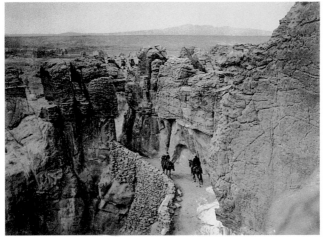

ACOMA ROADWAY

OLD TRAIL AT ACOMA

This is doubtless the trail built under the supervision of
Fray Juan Ramírez, who established himself at Acoma in 1629
and subsequently built a church and a trail which horses
could ascend.

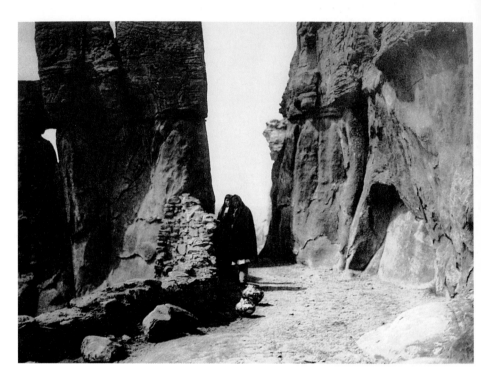

AT THE GATEWAY – ACOMA

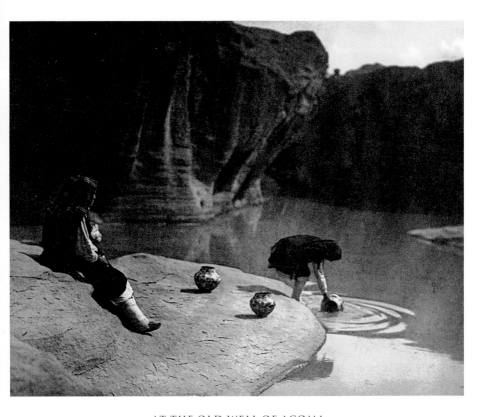

AT THE OLD WELL OF ACOMA

Members of Coronado's army of explorers in 1540 and
Espejo in 1583 noted the "cisterns to collect snow and water"
on the rock of Acoma.

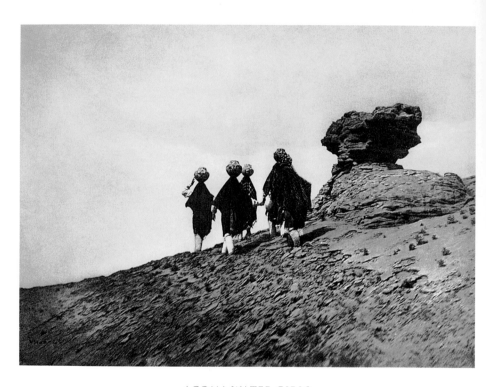

ACOMA WATER GIRLS

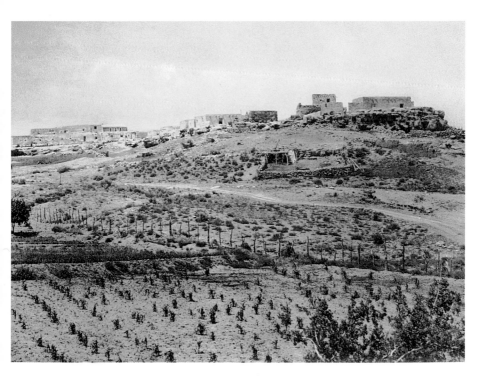

PAGUATE

Paguate is the oldest and largest of ten villages subsidiary to
Laguna, the parent pueblo of this group. It appears to have been
founded about the middle of the eighteenth century. Laguna itself
dates from 1699. The two-story structure at the right, one of the
two oldest buildings at Paguate, was a watchtower erected for the
defense of the farming population from the roving Navaho, who
disputed possession of this locality.

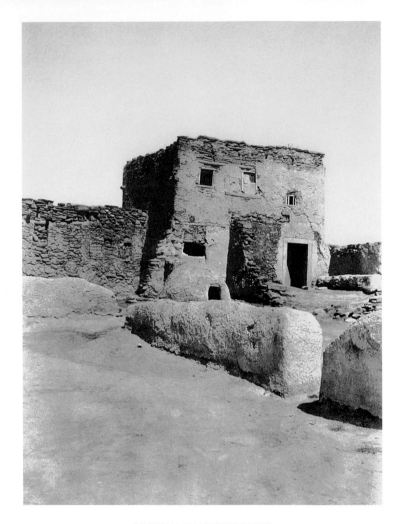

LAGUNA WATCHTOWER

The Navaho caused the people of Laguna considerable trouble
up to the middle of the nineteenth century. The latter probably
gave a good account of themselves, for they were sufficiently
warlike to furnish a band of volunteer scouts in the campaign
against the Apache band under Gerónimo, for which service they
or their surviving relatives were voted substantial pensions by
Congress in 1924.

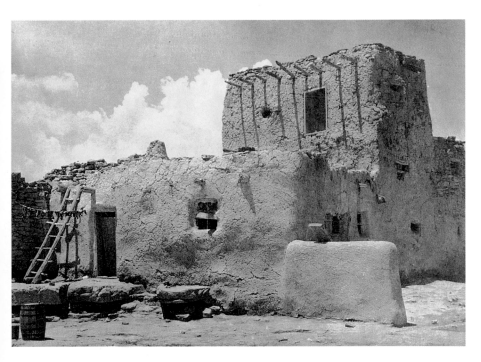

PAGUATE WATCHTOWER

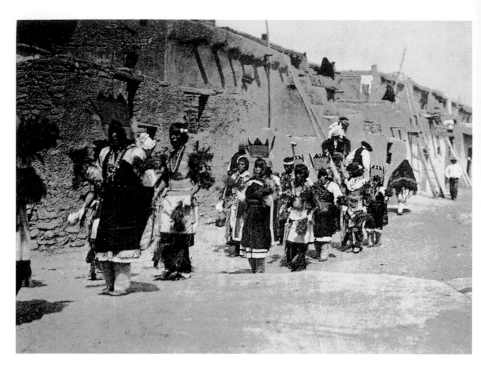

FIESTA OF SAN ESTEVAN – ACOMA

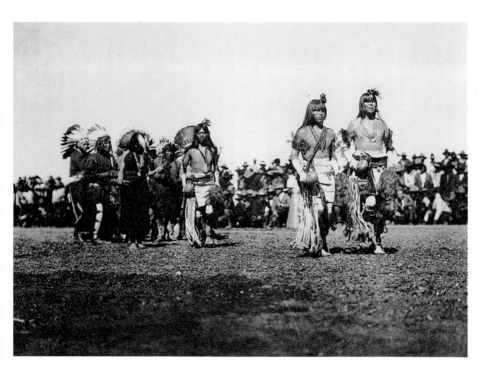

PICURIS HARVEST DANCE

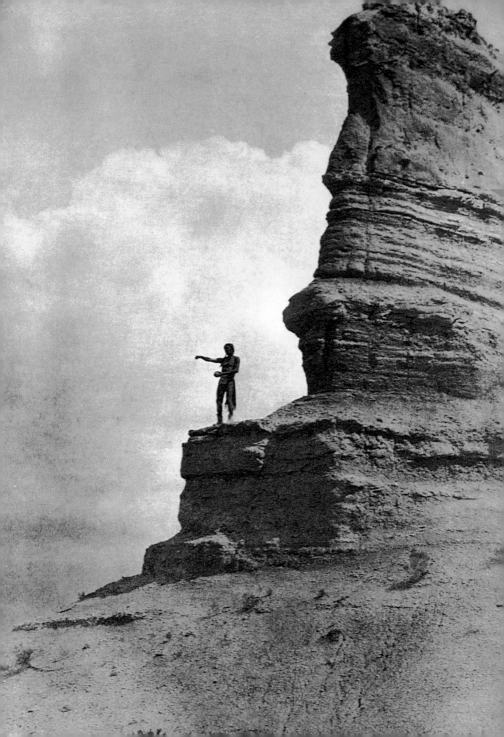

Tewa

Zuñi

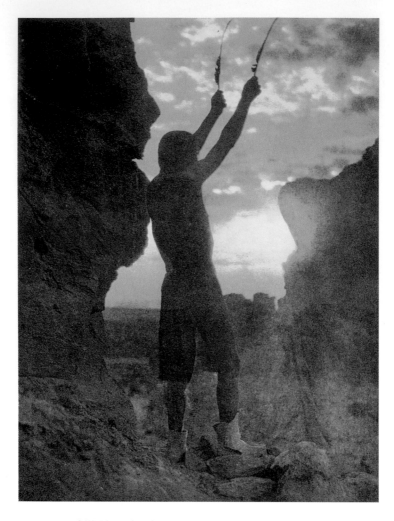

OFFERING TO THE SUN – SAN ILDEFONSO

PAGE 628
THE OFFERING – SAN ILDEFONSO

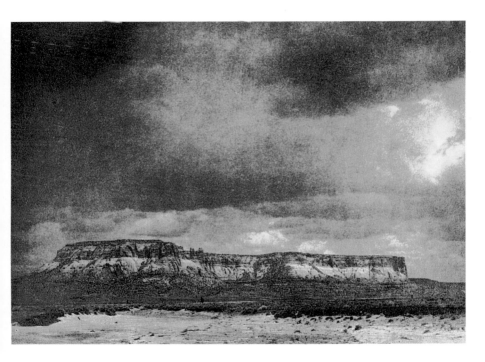

CORN MOUNTAIN

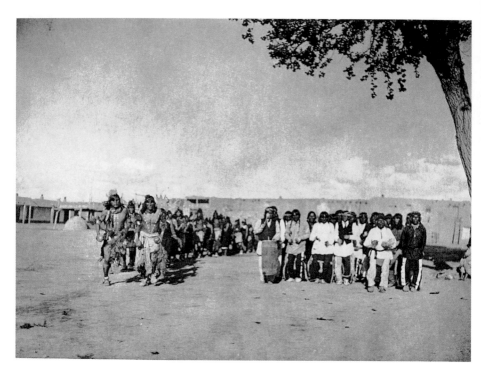

TABLITA DANCERS AND SINGERS –
SAN ILDEFONSO

The ceremony called *Kohéye-hyárě* ("tablita dance"), occurring
in June and again in September, is characterized by public dancing
and singing for the purpose of bringing rain-clouds. The name
refers to the wooden "tablets" worn by female dancers. In the
plate the performers are dancing into the plaza, men and women
alternating in pairs. At the right is the group of singers, their aged
leader slightly in advance and the drummer at one side.

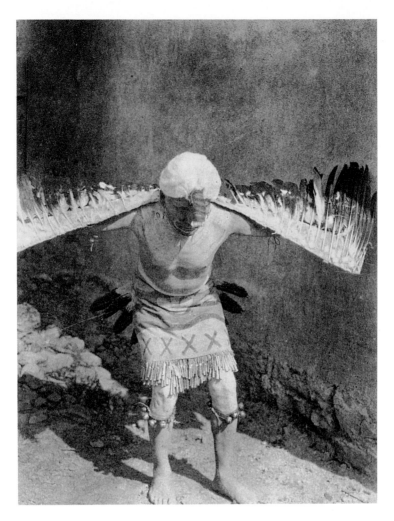

EAGLE DANCER – SAN ILDEFONSO

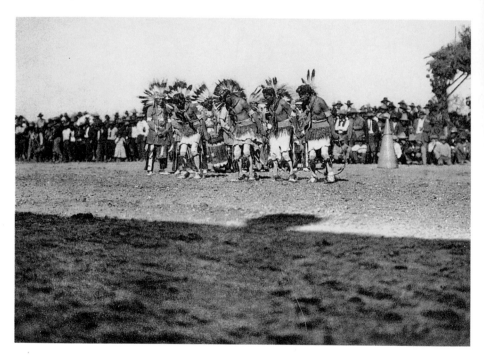

GOOD-LUCK DANCE BY SAN JUAN
HUNTERS

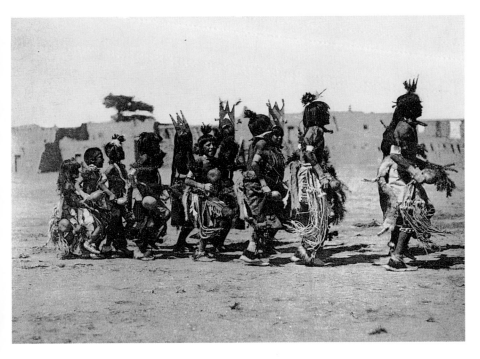

TABLITA DANCE – SAN ILDEFONSO

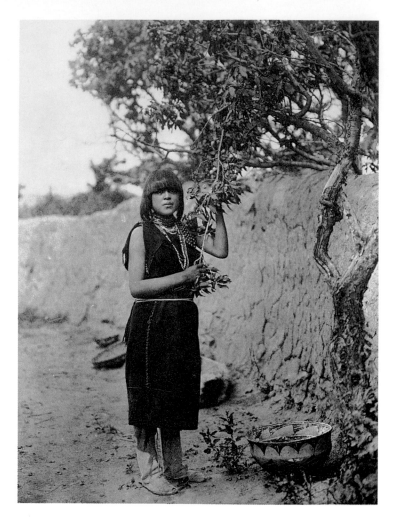

THE FRUIT GATHERER – SAN ILDEFONSO

Among the valued gifts of the early Spanish priests was the peach.
Every pueblo has its orchards of scrubby, twisted trees, which
without cultivation yield fruit of small size but agreeable flavor.

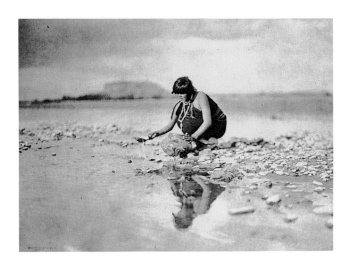

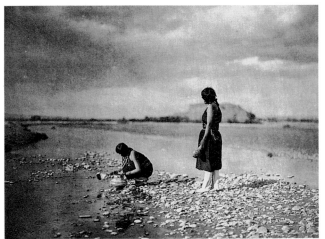

IN THE GRAY MORNING ‒ SAN ILDEFONSO

A housewife fills her jar with a gourd ladle at a shallow pool.
In the background is the Rio Grande at the season of high water,
and in the distance is a rugged mesa.

ON THE RIO GRANDE ‒ SAN ILDEFONSO

The plate illustrates the native garb of Tewa women, a sleeveless,
one piece, woollen dress, a woven belt, and white deerskin boots.

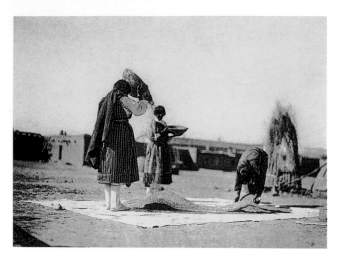

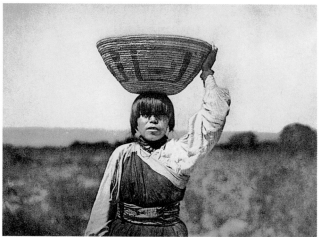

WINNOWING WHEAT – SAN JUAN

FROM THE THRESHING-FLOOR – SAN JUAN

Grain is threshed by the hoofs of horses or goats in the
fashion of Biblical times.

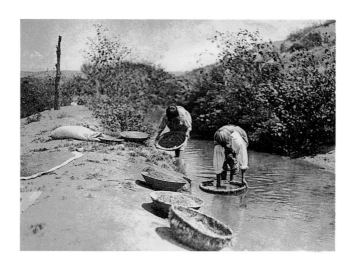

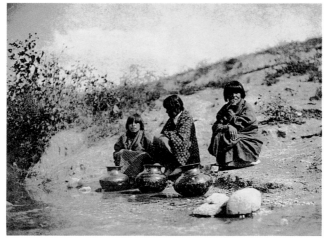

WASHING WHEAT – SAN JUAN

Threshed by the aid of animals and winnowed by tossing in
the breeze, wheat is placed in loose-mesh baskets and submerged
in the water of an acequia. Particles of earth are thus dissolved,
and floating bits of straw and chaff are scooped off. After thor-
oughly drying in the sun, the grain is stored in bags.

GOSSIPING – SAN JUAN

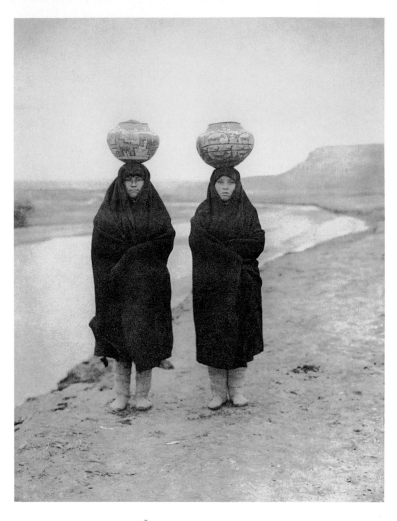

ZUÑI GIRLS AT THE RIVER

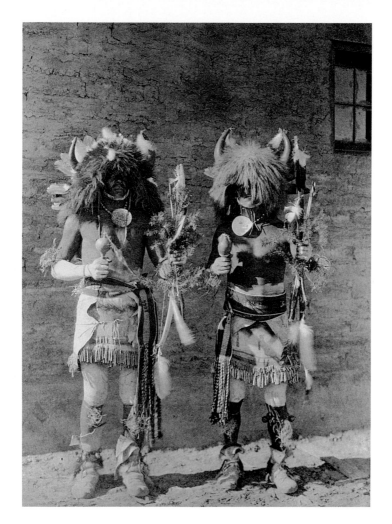

TESUQUE BUFFALO DANCERS

The Buffalo Dance is still performed, though the original
object of exerting preternatural influence on the abundance and
accessibility of the buffalo no longer prevails. The two male dan-
cers are accompanied by the Buffalo Girl, who is fully clothed in
native costume and has a pair of small horns on the head. These
three give a very striking and dramatic performance under the
watchful eye of the head of the hunters' society.

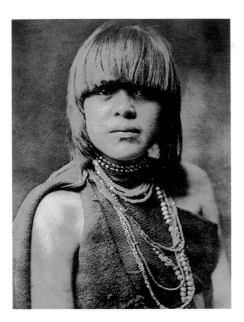

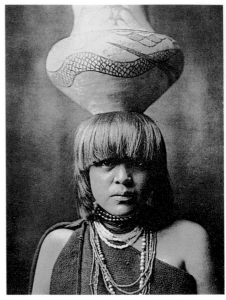

P̣ÓVI-TÁMUN (MORNING FLOWER) –
SAN ILDEFONSO

The flower concept is a favorite one in Tewa names,
both masculine and feminine. The regular features of
the comely Morning Flower are not exceptional, for
most Tewa girls, and indeed most Pueblo girls, are
not without attractiveness.

GIRL AND JAR –
SAN ILDEFONSO

Pueblo women are adept at balancing burdens on
the head. Usually a vessel rests on a fiber ring, which
serves to steady it and to protect the scalp. The design
on the jar here illustrated recalls the importance of
the serpent cult in Tewa life.

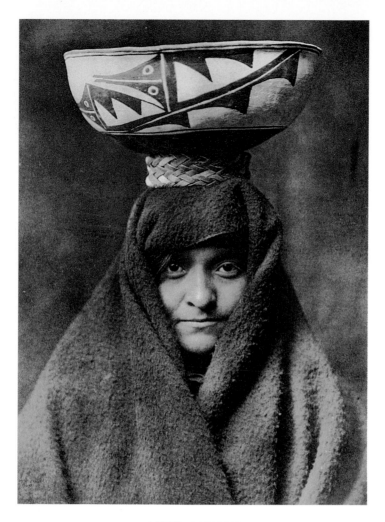

A ZUÑI WOMAN

Bowls of food are often thus carried on the head with a woven
yucca ring during an intermission in or following a ceremony,
when the participants feast.

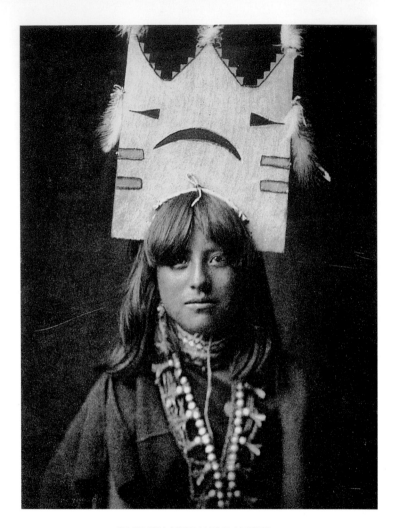

TABLITA WOMAN DANCER –
SAN ILDEFONSO

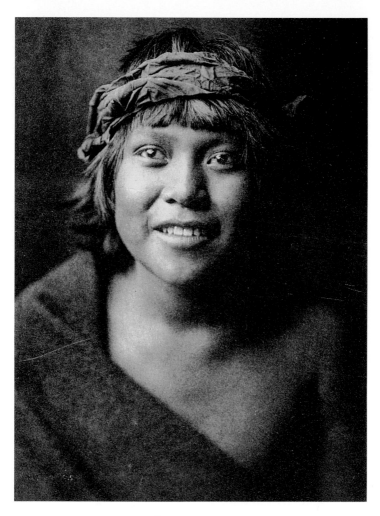

OKÚWA-TSIRĚ (CLOUD BIRD) –
SAN ILDEFONSO

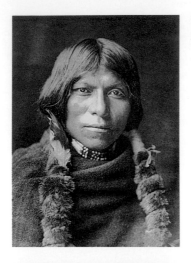

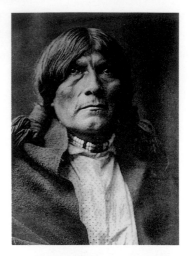

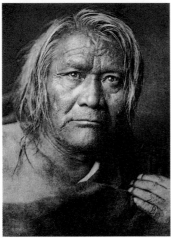

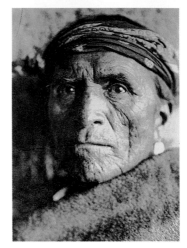

OKÚWA-TSE (CLOUD
YELLOW) – SAN ILDEFONSO

OYÍN-TS ĀN (DUCK WHITE),
SUMMER CACIQUE OF
SANTA CLARA

Each Tewa pueblo is dominated by two
native priests, the so-called caciques.

AMBROSIO MARTÍNEZ –
SAN JUAN

The influence of Plains blood is noticeable
at all Tewa pueblos, and especially at San
Juan. The typical Pueblo man is small-
featured and of short to medium stature.

LÚTAKAWI, ZUÑI GOVERNOR

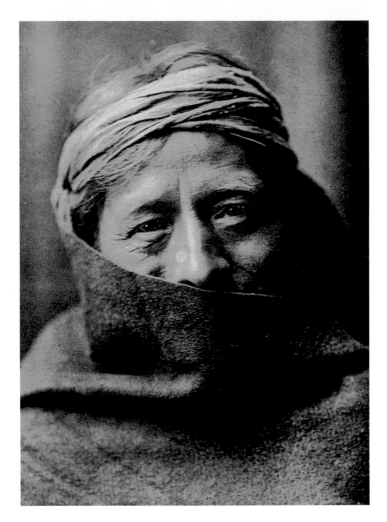

WAÍHUSIWA, A ZUÑI KYÁQĪMÂSSI

Kyáqī-mâssi ("house chief") is the title of the Shíwanni of
the north, the most important of all Zuñi priests. Waíhusiwa
in his youth spent the summer and fall of 1886 in the East with
Frank Hamilton Cushing, and was the narrator of much of the
lore published in Cushing's Zuñi Folk Tales. A highly spiritual
man, he is one of the most steadfast of the Zuñi priests in up-
holding the traditions of the native religion.

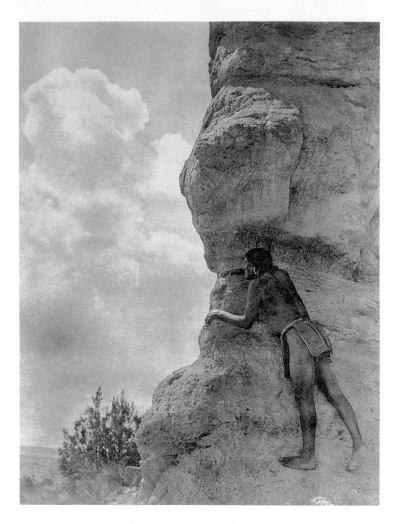

THE SENTINEL – SAN ILDEFONSO

In prehistoric times the Tewa were so beset by roving enemies
that not a few of them, for purposes of defense, became cliff-
dwellers. With a watchman posted in a niche of the cliff or on
a commanding elevation, there was little chance of an enemy
surprising laborers in the cornfields.

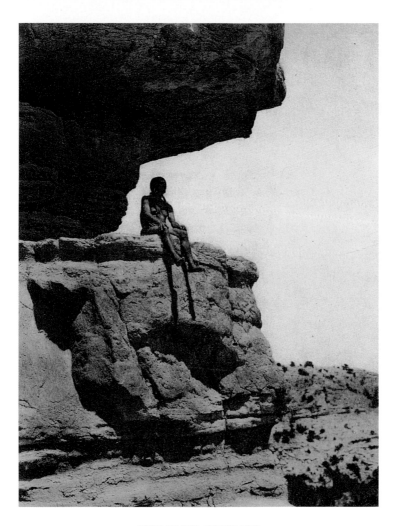

THE CLIFF-DWELLER

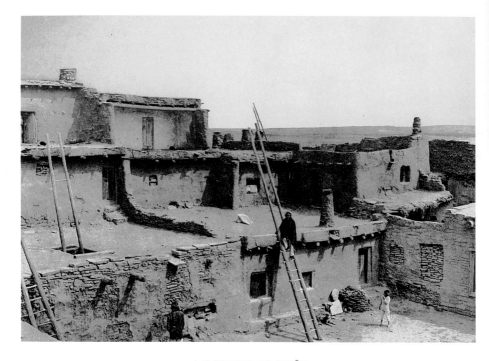

A CORNER OF ZUÑI

The chamber at the left, with ladder-poles projecting from the
hatchway, is the *kiva* of the north. Many dances are performed in
the small plaza here shown. The dark material piled against one
of the houses is sheep-dung for firing pottery.

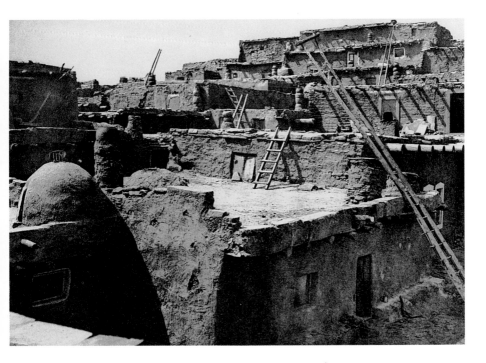

THE TERRACED HOUSES OF ZUÑI

In the early eighties one of the house-groups of Zuñi rose to a
height of six well-defined stories. In 1903, when the photograph
here reproduced was made, there were five stories. In 1910 a single
apartment was four stories from the ground, but in 1919 this room
was demolished. Note the bottomless pots forming chimneys,
the wooden drain piercing the coping, the hemispherical oven of
Spanish provenience on a roof.

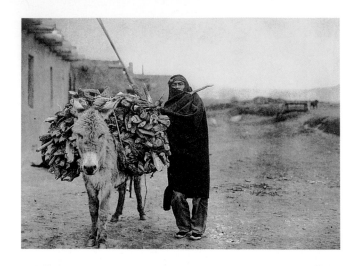

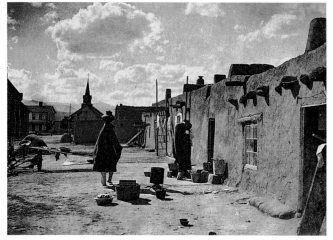

A LOAD OF FUEL – ZUÑI

The Zuñi tribe, now numbering twenty-two hundred, has
been concentrated in the present pueblo and its farming villages
for nearly two and a half centuries, and in the same valley for
hundreds of years before. Only a people as frugal as all the Pueblos
in the use of fuel could still have an available supply
in a region so poorly provided by nature.

STREET SCENE AT SAN JUAN

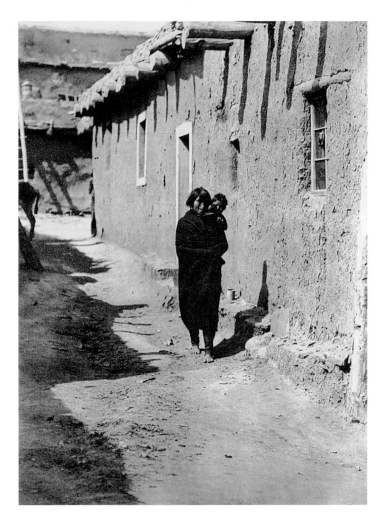

ZUÑI STREET SCENE

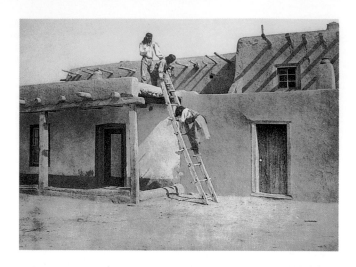

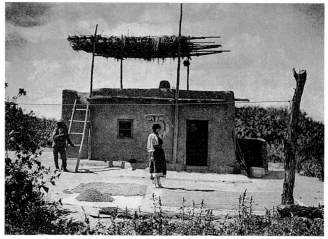

IN SAN ILDEFONSO

A SAN JUAN FARMHOUSE

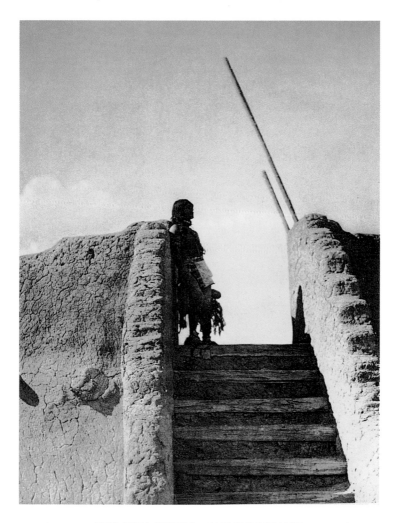

THE KIVA STAIRS – SAN ILDEFONSO

Pueblo ceremonial chambers are known as *kivas* (the Hopi name)
or *estufas* (the name applied to them by the Spaniards under the
misapprehension that they were sudatories). They are circular or
rectangular, wholly or partly subterranean, or simply cells in the
communal structure that forms a pueblo. The character of the
underlying soil or rock was probably the factor that determined
the degree to which a *kiva* was made subterranean. The one here
illustrated is mostly underground.

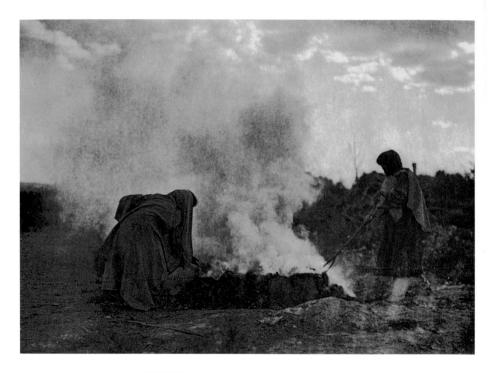

POTTERY BURNERS AT SANTA CLARA

Only with considerable practice can pottery be fired success-
fully. The vessels and the surrounding fuel of dry dung must be
so placed, and the fire must be so controlled that, while perfect
combustion takes place, high temperature shall not develop
too quickly. Cracked and blackened ware is the penalty of
inexperience and carelessness.

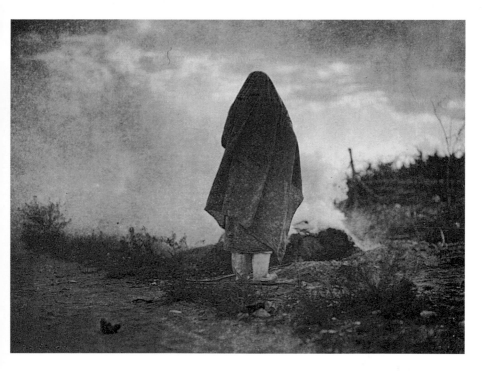

FIRING POTTERY - SANTA CLARA

THE POTTER – SANTA CLARA

The potter is polishing a vessel. The smooth pebbles used for
this purpose are found in small heaps among or near deposits
of fossil bones. They are the stomach pebbles of dinosaurs.
Tewa women prize them highly, refuse to part with them,
and foresee ill luck if one is lost.

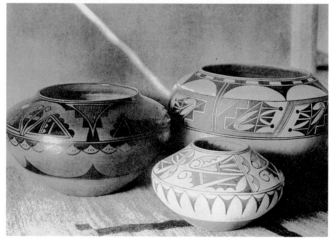

SAN JUAN POTTERY

SAN ILDEFONSO POTTERY

San Ildefonso possesses some very capable potters. The polished
black vessel at the left represents a recent revival, under the
stimulus of commercial encouragement, of an ancient phase of the
potter's art; for it answers the description of black ware observed
by Coronado's chroniclers.

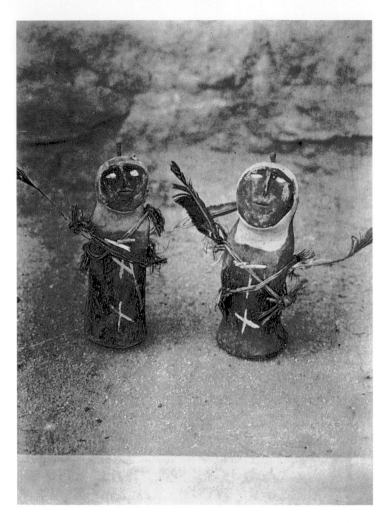

TEWA WAR-GOD EFFIGIES

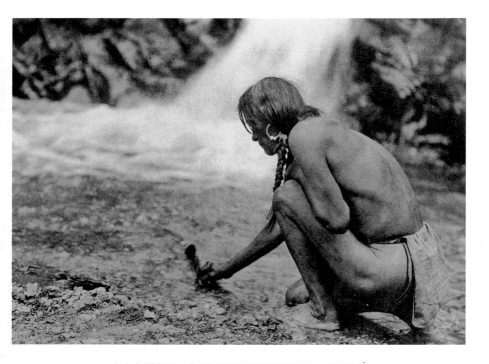

AN OFFERING AT THE WATERFALL – NAMBÉ

Feather offerings are deposited in numerous shrines, buried
in the earth near the pueblo, and placed in springs, streams, and
lakes, for the purpose of winning the favor of the cloud-gods.

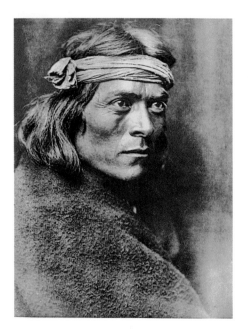

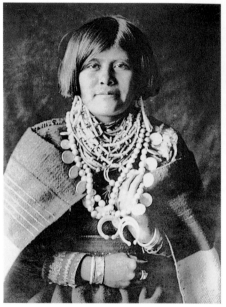

A ZUÑI GOVERNOR

A ZUÑI GIRL

This portrait may well be taken as representative
of the typical Pueblo physiognomy.

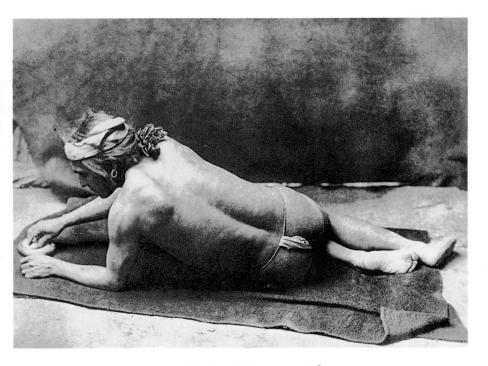

GRINDING MEDICINE – ZUÑI

Medicine and mineral pigments are ground in small stone
mortars by means of a water-worn pebble.

OÑATE'S INSCRIPTION

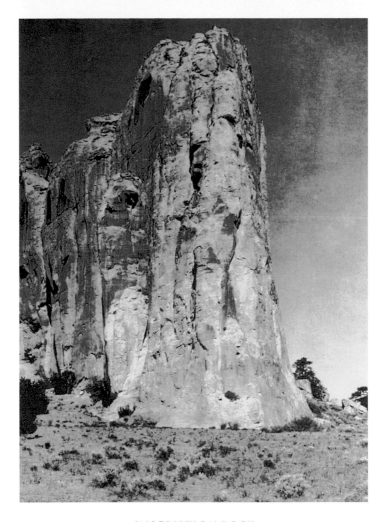

INSCRIPTION ROCK

Inscription Rock, or *El Morro* ("The Castle"), as the Spaniards
called it, is a striking landmark on the ancient trail between
Acoma and Zuñi. Beginning with Juan de Oñate, who passed
here in April, 1605, on his return to the Rio Grande from "the
south sea," Spanish explorers and administrators recorded their
names and dates on smooth surfaces of the cliff, which reveal also
numerous Indian petroglyphs. Two ancient ruined pueblos
are found on the top of the rock.

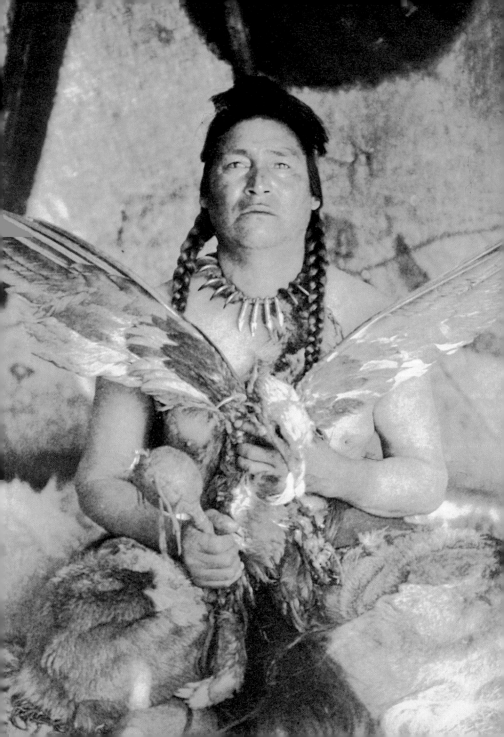

Chipewyan

Cree

Sarsi

Volume XVIII

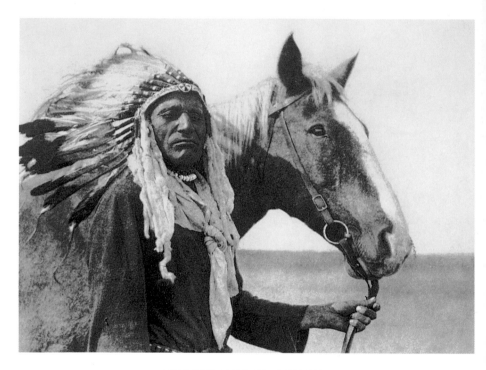

BLACKFOOT WAR-BONNET

PAGE 666
PLACATING THE SPIRIT OF A SLAIN
EAGLE – ASSINIBOIN

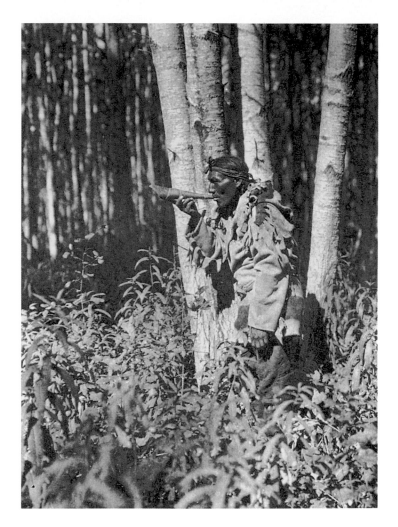

CALLING A MOOSE – CREE

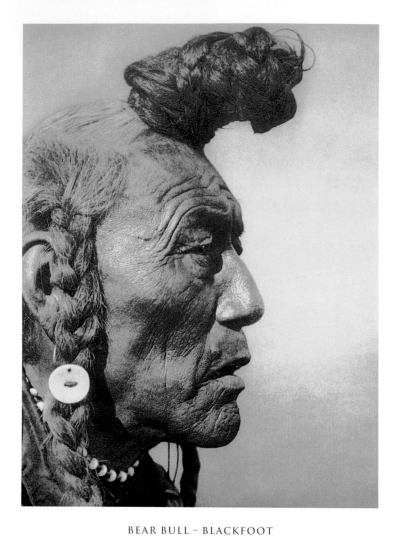

BEAR BULL – BLACKFOOT

The plate illustrates an ancient Blackfoot method
of arranging the hair.

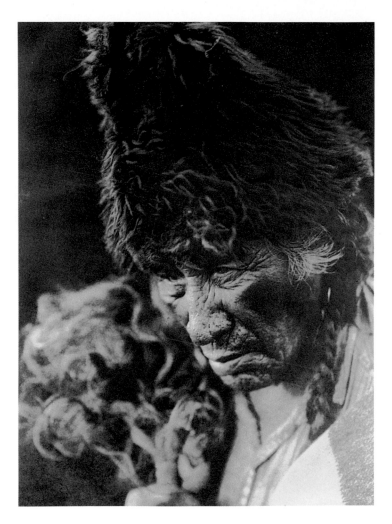

OKSÓYAPIW – BLACKFOOT

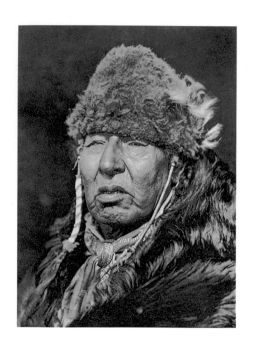

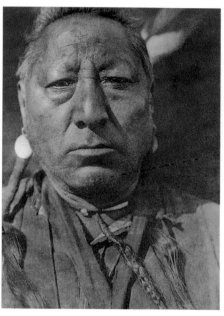

APIÓ-MITA (WHITE DOG) –
BLOOD

ÁSTANIĦKYI (COME-SINGING) –
BLOOD

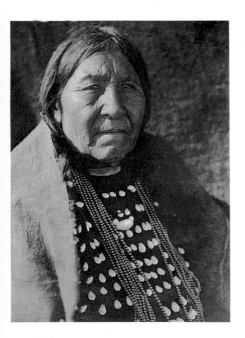

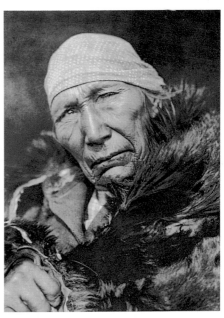

S͡TSÍMAKI (RELUCTANT-TO-BE-
WOMAN) – BLOOD

SOYÁKSĬN – BLOOD

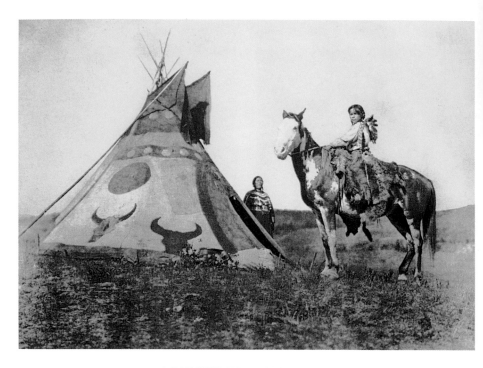

A PAINTED TIPI – ASSINIBOIN

A tipi painted with figures commemorative of a dream
experienced by its owner is a venerated object. Its occupants
enjoy good fortune, and there is no difficulty in finding a
purchaser when after a few years the owner, according to
custom, decides to dispose of it.

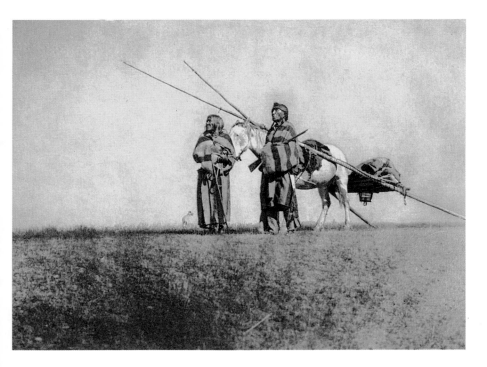

A BLACKFOOT TRAVOIS

The travois is still used for transporting bundles of ceremonial
objects. Before, and sometimes even long after, the acquisition
of horses, travoix were drawn by dogs.

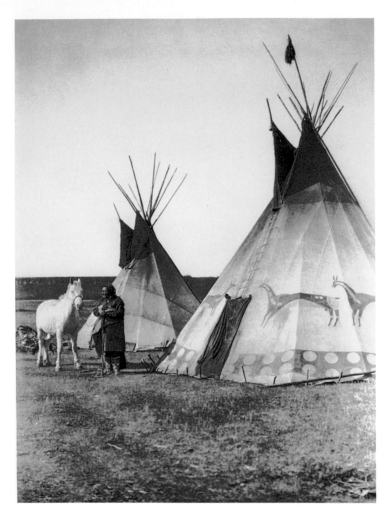

BLACKFOOT TIPIS

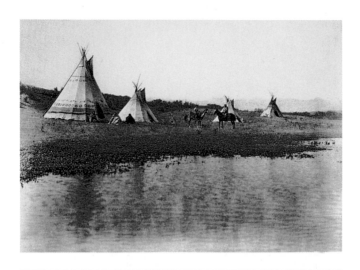

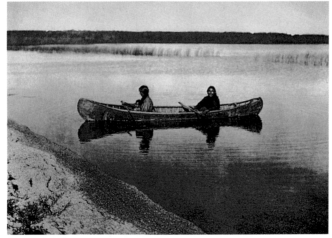

ASSINIBOIN CAMP NEAR THE
ROCKY MOUNTAINS

A CREE CANOE ON LAC LES ISLES

The Western Woods Cree are scattered in numerous bands
through the wooded country north of the prairies between
Hudson Bay and the Peace River drainage. Lac les Isles, locally
known as Big Island Lake, is in west-central Saskatchewan, near
the Alberta border. The canoe is a well-made craft of birch-bark.

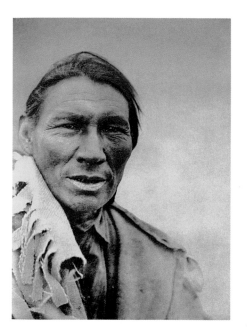

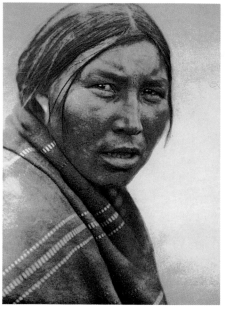

A CREE A CREE WOMAN

Of various widely differing types noted among the
Cree at Lac les Isles, the subject of this plate and that
of the following one were perhaps best representative
of Cree physiognomy.

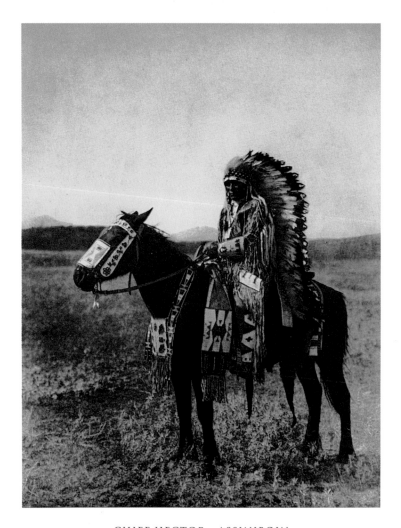

CHIEF HECTOR – ASSINIBOIN

The Assiniboin are an offshoot of the Yanktonai Sioux, from
whom they separated prior to 1640. The southern branch has
long been confined on a reservation in Montana, the northern is
resident in Alberta. The latter is divided into two bands, which
formerly ranged respectively north and south of Bow River,
from the Rocky Mountains out upon the prairies. Hector is
chief of the southern band of the Canadian branch known
locally as Bear's Paw band.

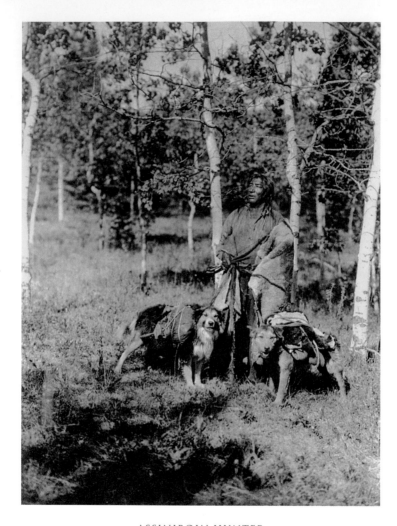

ASSINIBOIN HUNTER

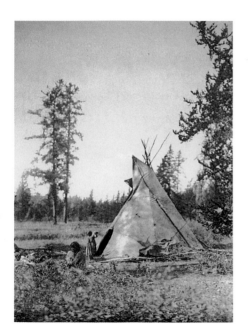

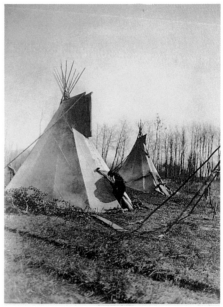

A CREE CAMP AT LAC LES ISLES

A family group consisting of two middle-aged
women, a young mother, and several children, camped
at the lake while the rest of the band were haying in a
swampy meadow some miles inland. They engaged in
fishing with a gill-net and in gathering blueberries. In
point of sanitation their tipi and
their cooking methods left much to be desired.

CREE TIPIS

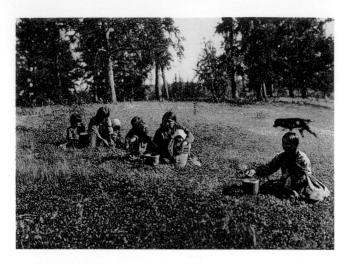

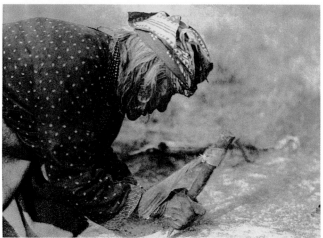

PICKING BLUEBERRIES – CREE

FLESHING A HIDE – BLACKFOOT

The implement for removing flesh and fat from hides is a
longbone with a beveled scraping edge. The thong attached to
the upper end and passing about the woman's wrist is for the
purpose of giving additional leverage.

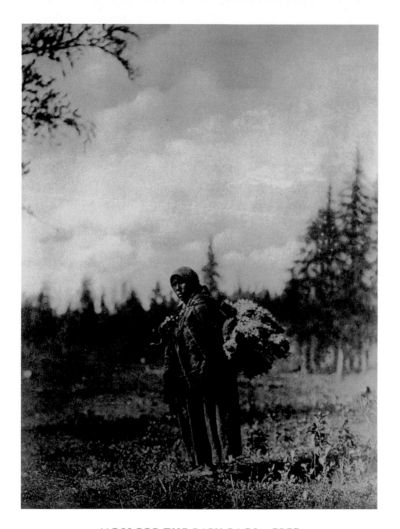

MOSS FOR THE BABY-BAGS – CREE

In moist localities of the northern bush country the ground is
thickly carpeted with *Sphagnum*. The moss is dried on racks, and
is used as an absorbent in the tightly laced bags of infants.

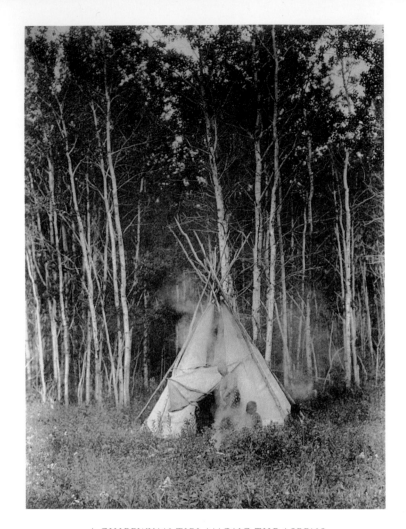

A CHIPEWYAN TIPI AMONG THE ASPENS

The Chipewyan are one of several Athapascan groups occupying
the territory between Hudson Bay and the Rocky Mountains. The
Chipewyan dwelling was formerly made of the skins of caribou,
on which animal these people principally depended for food,
clothing, and shelter. Their distinctive garment was a leather or
fur coat with skirts cut to a point before and behind, a feature
to which the appellation Wichipwayániwŭk ("the pointed fur
people"), the Cree original of Chipewyan, alluded.

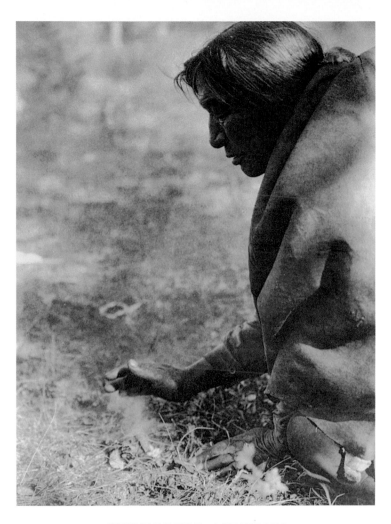

KINDLING FIRE – ASSINIBOIN

The fire-drill is unknown to the oldest Assiniboin traditionists,
but striking fire from flint was apparently an aboriginal method.

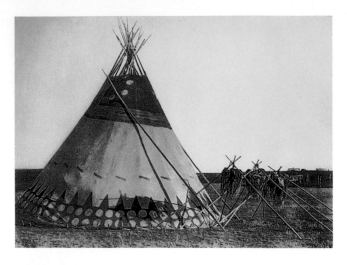

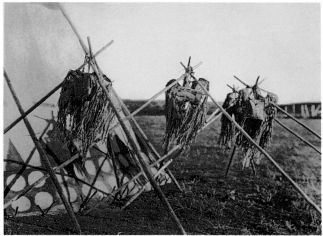

LODGE OF THE HORN SOCIETY – BLOOD

The Horn society is the custodian of a cult about which the
natives are loath to give details. It stands apart from the system
of age societies, which though partly religious in character
were more concerned with warfare and the preservation
of order in camp.

SACRED BAGS OF THE HORN SOCIETY –
BLOOD

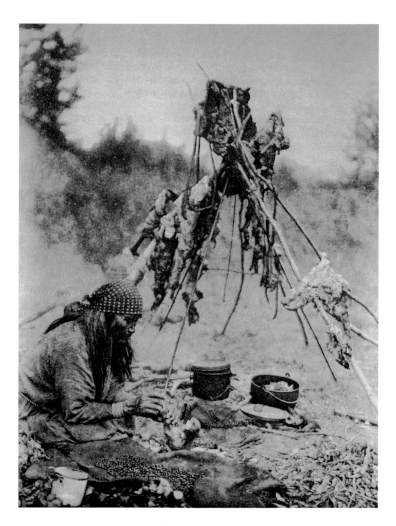

A SARSI KITCHEN

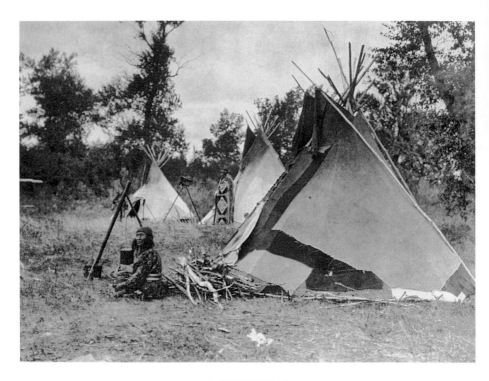

A SARSI CAMP

The scene is a riverside grove near Okotoks, Alberta, where a
band of Sarsi were awaiting clement weather to begin the prosaic
labor of shocking wheat for one of their Caucasian neighbors.

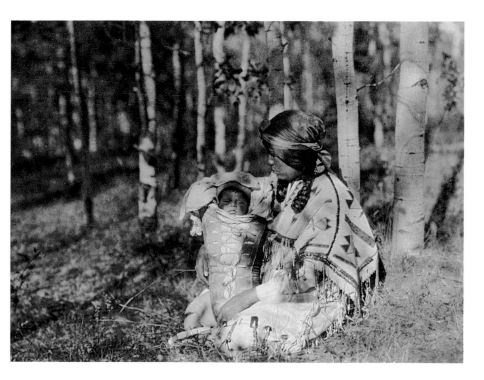

ASSINIBOIN MOTHER AND CHILD

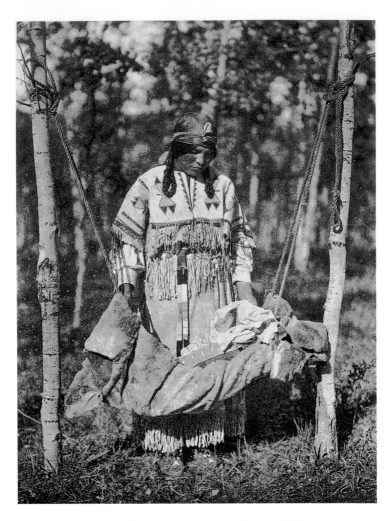

WOMAN'S COSTUME AND BABY SWING –
ASSINIBOIN

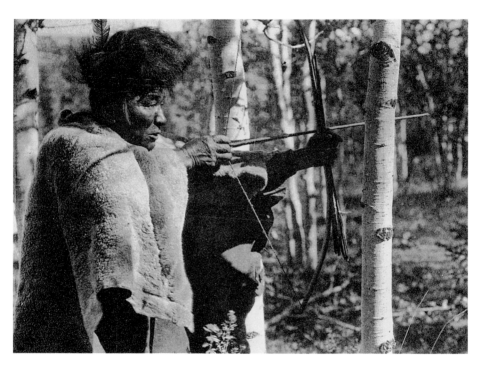

ASSINIBOIN BOWMAN

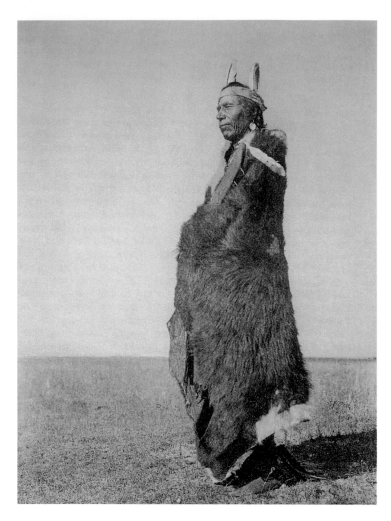

A BLACKFOOT SOLDIER

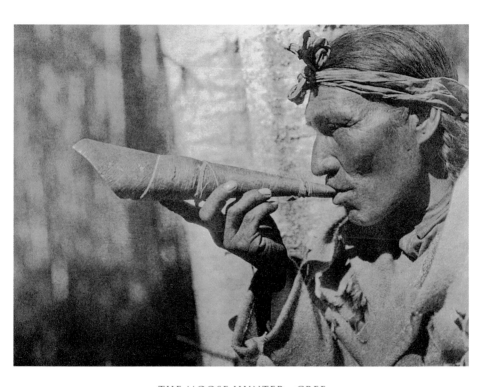

THE MOOSE HUNTER – CREE

Cree hunters are masters of the art of imitating, by means
of a birch-bark trumpet, the call of a moose of either sex, and
thus luring within gunshot an animal seeking a mate during
the rutting season.

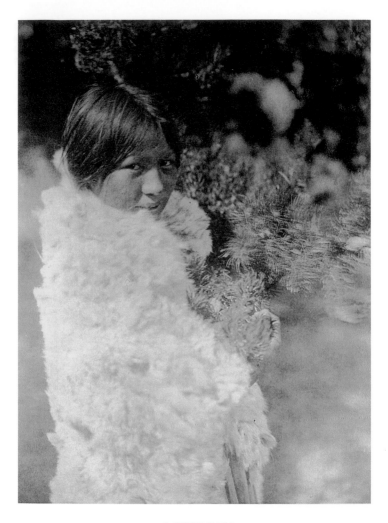

A CREE GIRL

The garment here illustrated is a robe of twined strips of rabbit-fur.

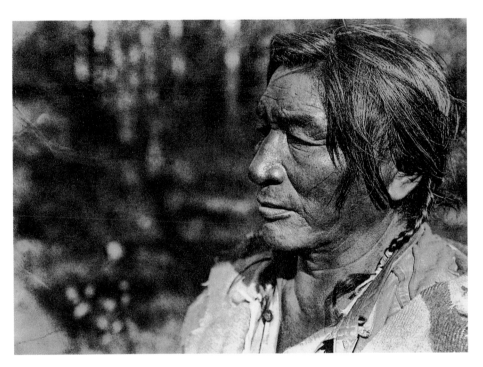

AGÍCHÍDĔ – ASSINIBOIN

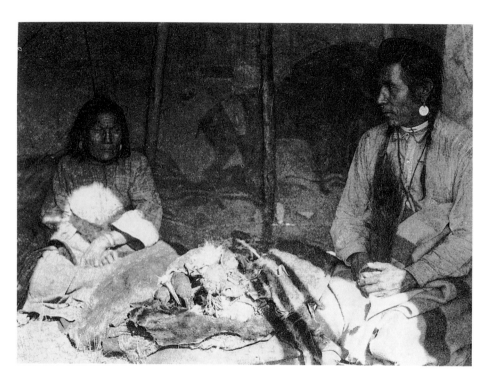

A BEAVER BUNDLE – BLACKFOOT

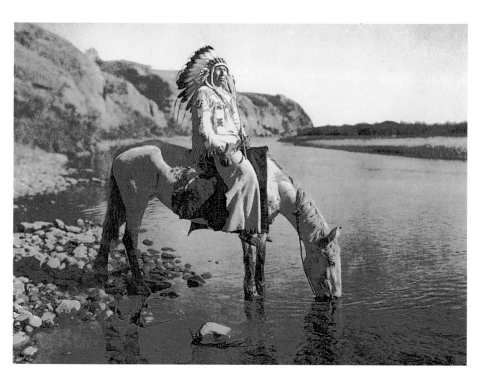

BOW RIVER – BLACKFOOT

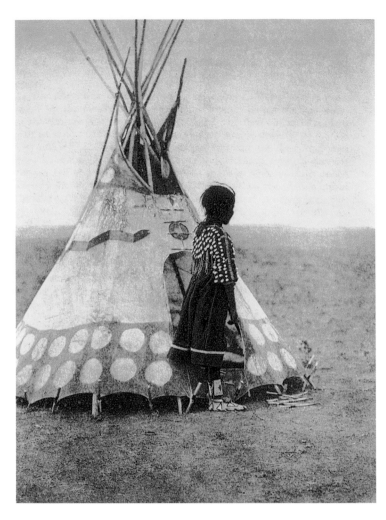

A PIEGAN PLAY TIPI

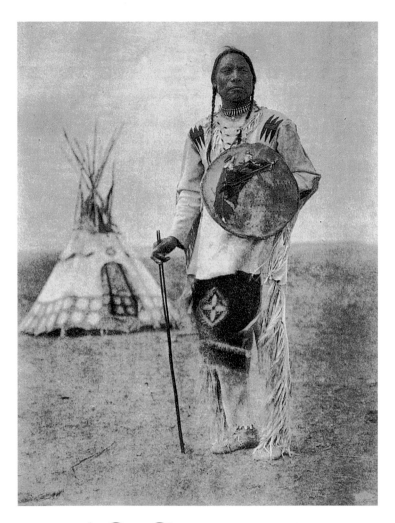

ÁKATSIM-ATSÍSSI (WHISTLE SMOKE) –
PIEGAN

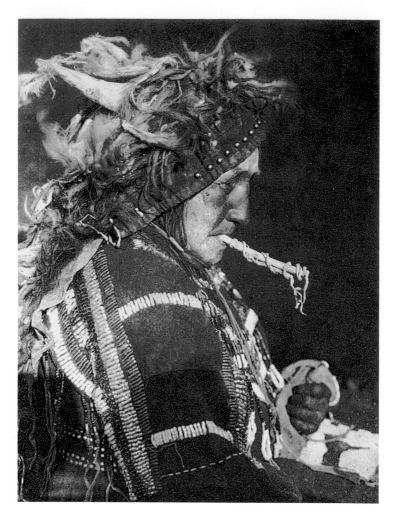

HEAD-DRESS OF MATÓKI SOCIETY – BLOOD

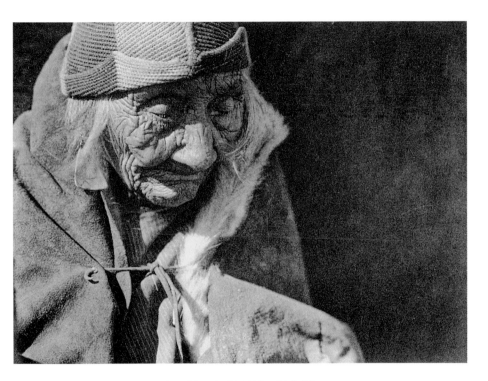

AN OLD WOMAN – BLOOD

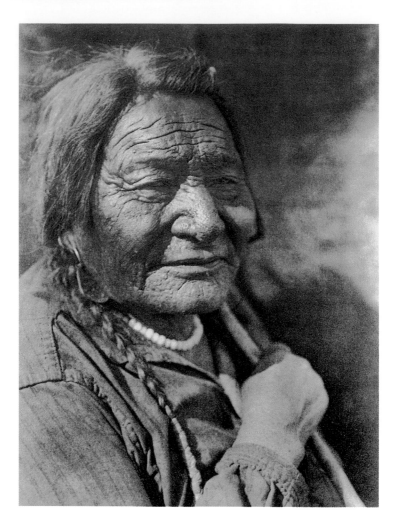

CALF CHILD – BLACKFOOT

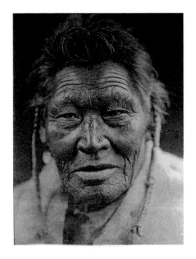

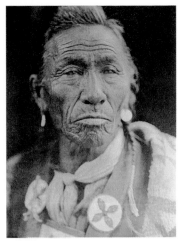

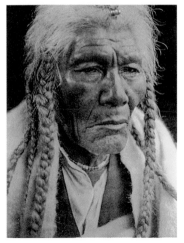

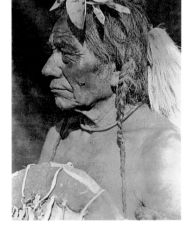

TSÁASSI-MĬS-SALLÁ (CROW
WITH NECKLACE) – SARSI

The name refers to a neck-ornament
of crow-feathers.

TIȚISHÚ-G̑HITL!ŬHL
(DEER RUNNING) – SARSI

MÚWŬ (HIS-TOOTH) –
SARSI

The childhood nickname, "His Tooth,"
completely supplanted the formally
bestowed "Star Child."

MAKÓYĔPUK (WOLF-
CHILD) – BLOOD

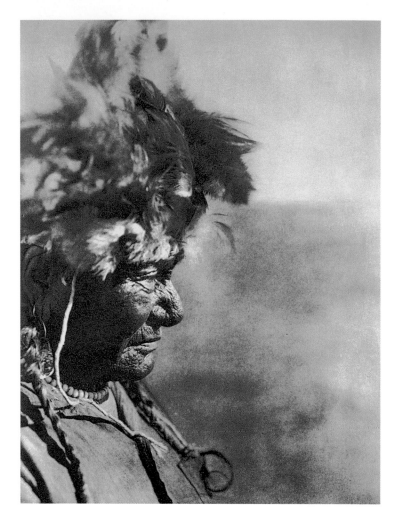

A MEDICINE HEAD-DRESS – BLACKFOOT

By long usage the term "medicine" in the sense of supernatural
has become firmly fixed in the literature of American Indians, and
especially the plains tribes. A head-dress of the sort here depicted
consists of some part of the body, sometimes the entire skin, of
the creature that appeared as a spirit in a dream of the wearer and
instructed him how to have its help, especially in war.

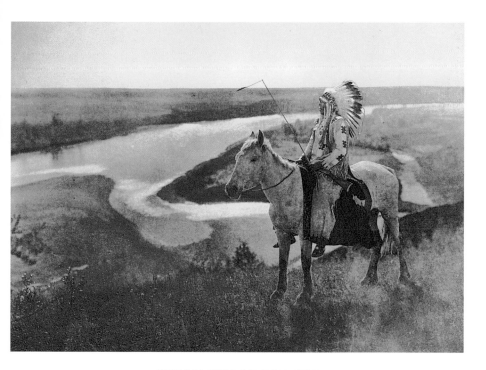

THE BLACKFOOT COUNTRY

Since the beginning of the historical period the Blackfeet
have ranged the prairies along Bow River, while their allies,
the Bloods and Piegan, were respectively on Belly and Old
Man rivers. In the earliest time of which their traditionists
have knowledge the three tribes were respectively on Sas-
katchewan, Red Deer, and Bow rivers.

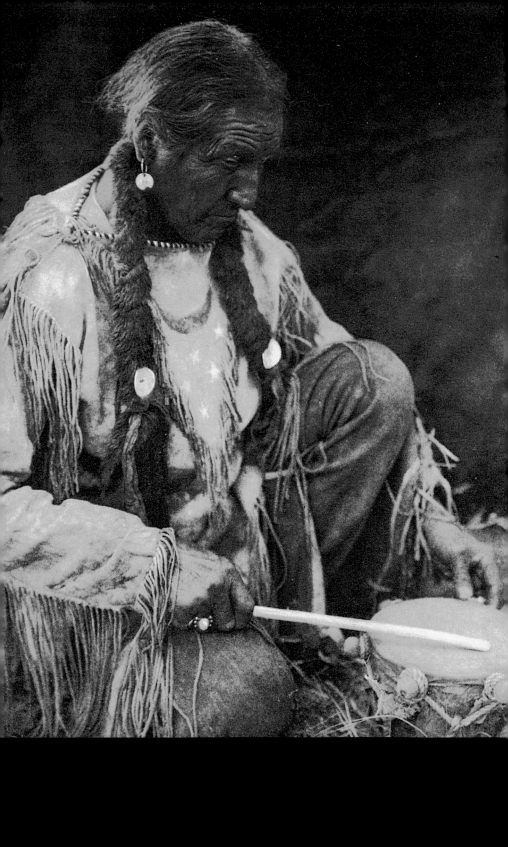

Wichita

Southern Cheyenne

Oto

Comanche

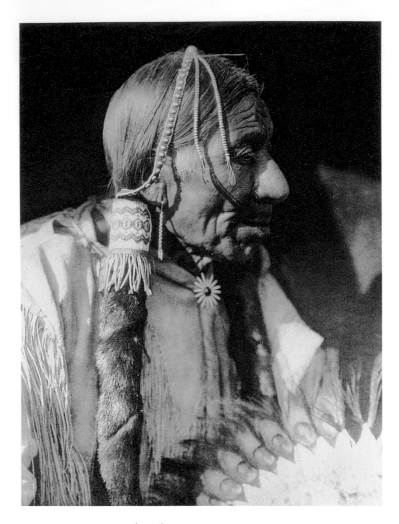

ÉSIPÉRMI – COMANCHE

There were no more vigorous people among the Indians of the
Plains than the Comanche. They were noted warriors and raiders,
being the enemies of many tribes and extending their depredations
far into Mexico. One need look no farther than the accompanying
portraits to discern the warrior character of these old braves.

PAGE 706
PEYOTE DRUMMER

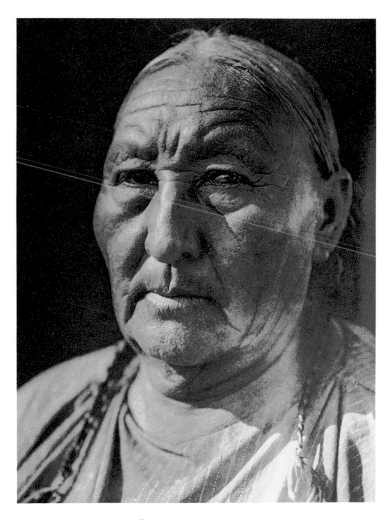

WOÍSTA – CHEYENNE WOMAN

Remarkable strength of character is depicted in the features of
this woman, and indeed in those of all the Cheyenne. Their
former life was such that only the fittest could survive.

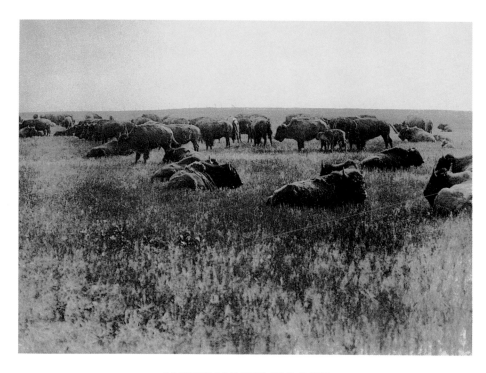

AS IT WAS IN THE OLD DAYS

In early days, before white men ruthlessly slaughtered them by
hundreds of thousands, bison were of prime importance to the
hunting tribes. The bison was the chief source of food, its skin
was made into clothing, shields, packs, bags, snowshoes, and
tent and boat covers; the horns were fashioned into spoons and
drinking vessels; the sinew supplied thread for sewing, bow-
strings, and fiber for ropes. So dependent on the buffalo were
these Indians that it became sacred to them.

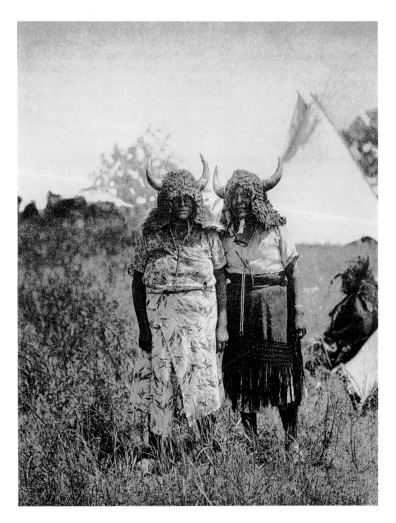

BUFFALO DANCERS, ANIMAL DANCE –
CHEYENNE

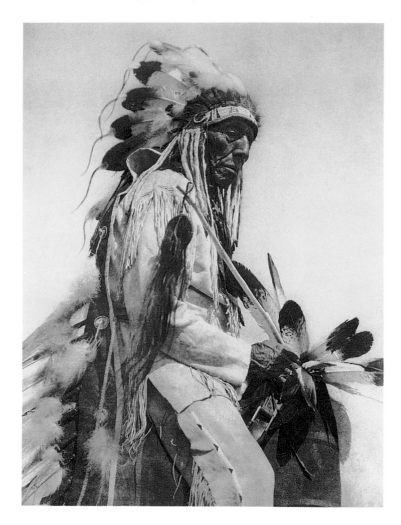

THE OLD CHEYENNE

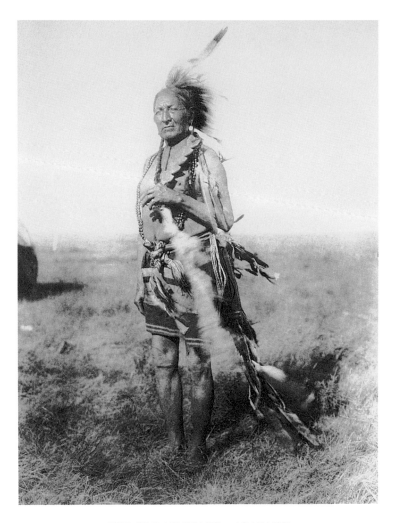

THE OLD WARRIOR – ARAPAHO

The Arapaho, of Algonquian stock like the Cheyenne, are
divided into a Northern and a Southern tribe, the former
living on the Wind River reservation in Wyoming and the
latter on the reservation assigned to them and the Cheyenne
in the present Oklahoma in 1867.

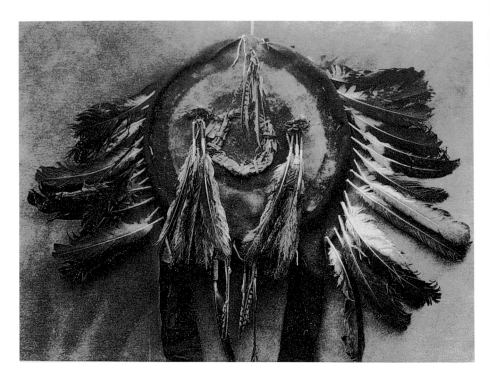

ARAPAHO SHIELD

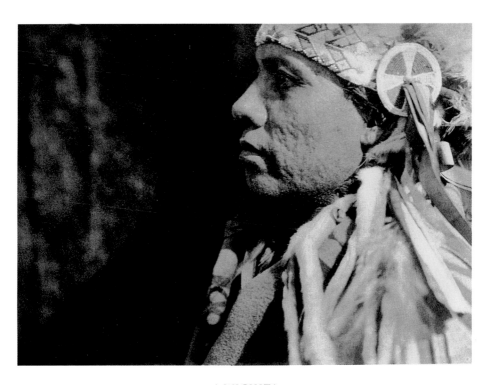

A WICHITA

The Wichita belong to the Caddoan linguistic family and in
the earliest historical times lived in the Arkansas valley in the
present Kansas. Here they were visited by Coronado and his force
of Spaniards in 1541, in a region known to them, through Indian
informants, as the Province of Quivira. Then, as in later times, after
moving southward, the Wichita lived in grass-houses.

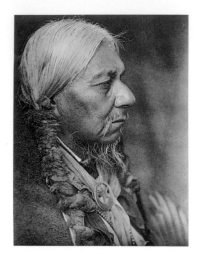

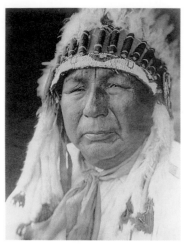

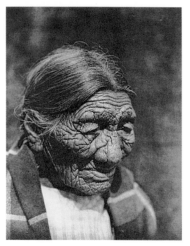

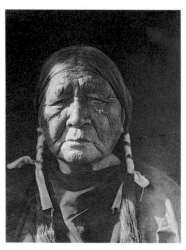

JOHN QUAPAW – HÚNTA
WAKÚNTA

The Quapaw are another Siouan tribe,
otherwise known as Akansa, from which
Arkansas river and state derive their name.

BLACK BELLY – CHEYENNE

PIPE-STEM – OTO

ÚWAT – COMANCHE

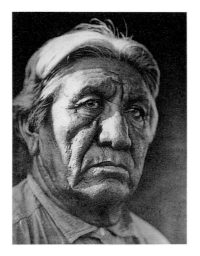

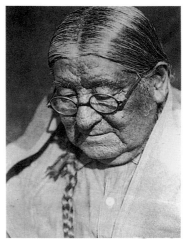

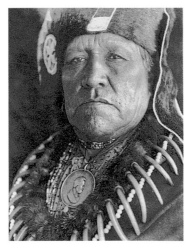

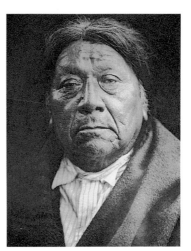

REUBEN TAYLOR
(ISTÓFHUŤS) – CHEYENNE

HENRY – WICHITA

The native names of Indians are often un-
pronounceable by untrained white people,
who therefore apply such incongruous
English names as this and the following.

OLD EAGLE – OTO

The medal worn by Old Eagle, in this case
bearing the portrait of Lincoln, is like other
medals given by the Government to noted
chiefs from Washington's time.

A COMANCHE

GRASS-HOUSE CEREMONY – WICHITA

THE DANCE – WICHITA

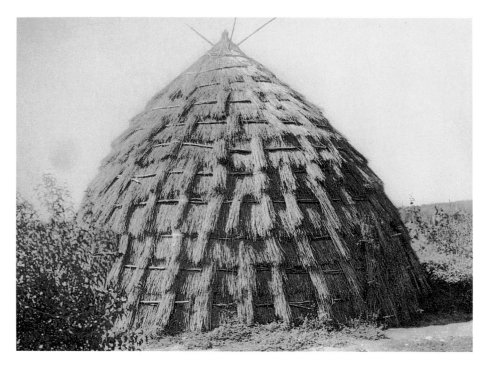

WICHITA GRASS-HOUSE

The relatively permanent character of the typical dwelling of
the Wichita indicates the sedentary life of this tribe. They were
farmers in the main, but hunted the buffalo and other
game in season.

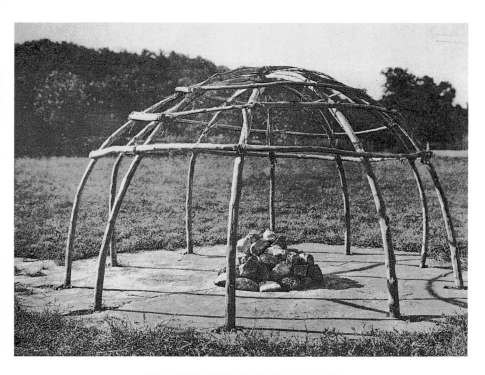

FRAME OF PEYOTE SWEAT-LODGE

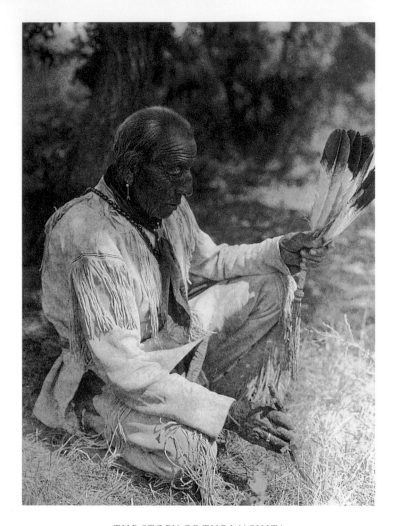

THE STORY OF THE WASHITA

An old Cheyenne warrior recounts the famous battle of
the Washita in 1868, when the tribe was severely defeated
by General Custer.

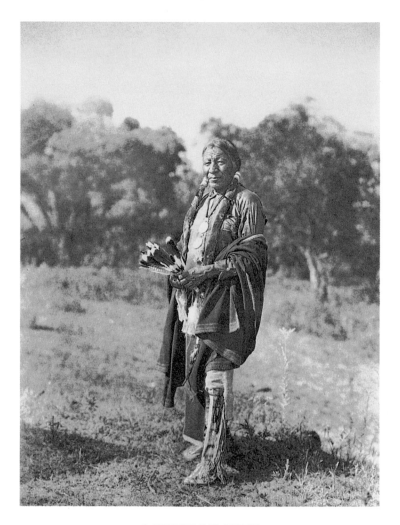

A CHEYENNE CHIEF

The Cheyenne belong to the Algonquian linguistic family
and therefore are related to the tribes of the Blackfoot
Confederacy and to the Arapaho of the north, and, much more
remotely, to many of the tribes that once lived along the Atlantic
seaboard and in the Midwest. They are now divided into the
Northern Cheyenne, living in Montana, and the Southern
Cheyenne who were assigned a reservation in the present
Oklahoma in 1867.

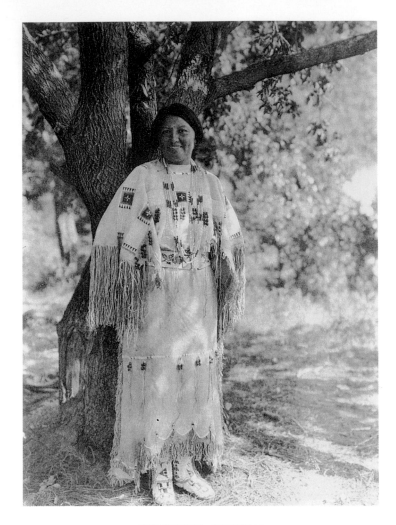

CHEYENNE COSTUME

This woman's deerskin costume, ornamented with porcupine-
quill embroidery and with beads and fringe, is characteristic of
that of the Cheyenne; but such is now worn only on gala occasions
and probably before very long will be a thing of the past.

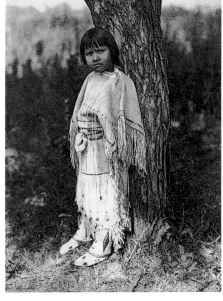

CHEYENNE FOOTWEAR

CHEYENNE CHILD

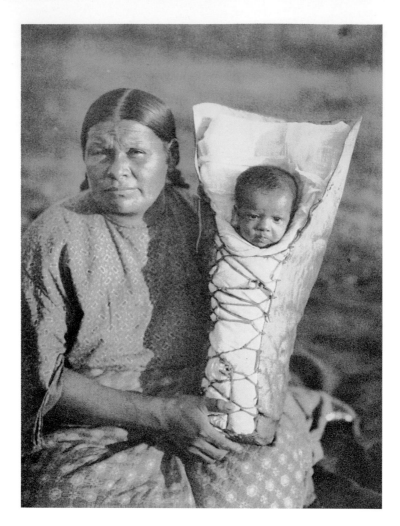

A COMANCHE MOTHER

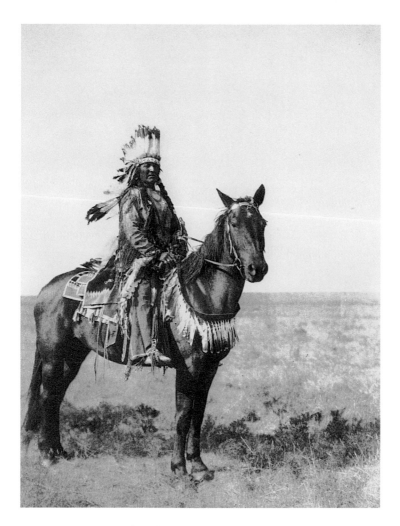

BLACK MAN – ARAPAHO

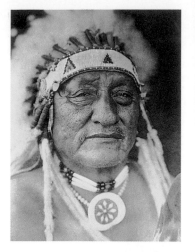

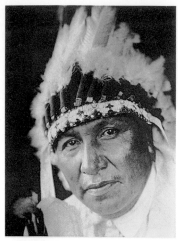

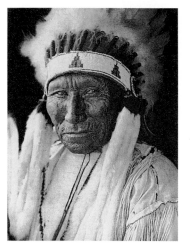

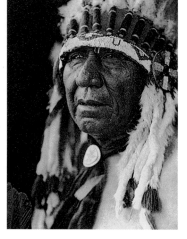

STANDING TWO – OTO

The Oto belong to the great Siouan lin-
guistic family and originally formed, with
other tribes, a part of the Winnebago. The
typical ceremonial head-dress of the Oto
of the present time is shown here.

MAGPIE – CHEYENNE

LONE CHIEF – OTO

WAKÓNDA – OTO

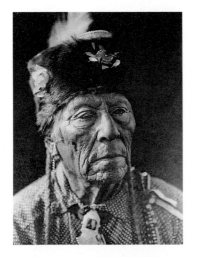

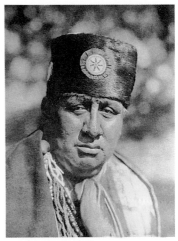

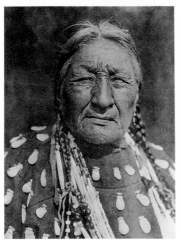

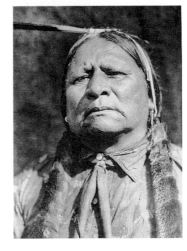

LEFTHAND – COMANCHE

DOG WOMAN – CHEYENNE

The woman's dress is embellished
with elk-teeth.

JOHN ABBOTT – OSAGE

The Osage (corrupted from Wáźhaźhe,
their own name) is a Siouan tribe – the
wealthiest of all Indians, and probably the
richest people in the world, population
considered. They are most closely related to
the Omaha, Quapaw, Ponca, and Kansa.

WALTER ROSS – WICHITA

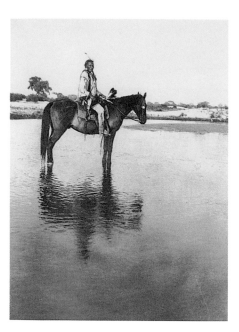

THE LONE CHIEF – CHEYENNE

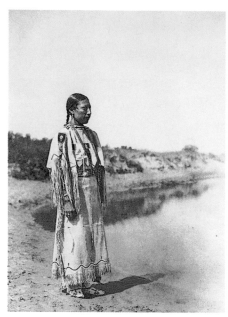

CHEYENNE MAIDEN

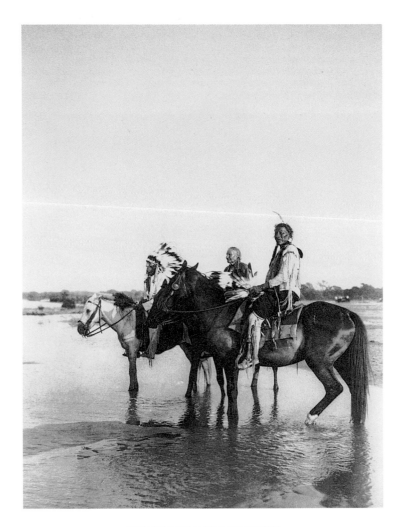

ON THE CANADIAN RIVER

The name of the Canadian River was not derived from any
association with Canada or the Canadians, but from the Spanish
cañada, on account of the high, cut banks of the stream. The Ca-
nadian originally divided the lands claimed by the Quapaw on the
south and those of the Great and Little Osage on the north. The
Indians in the picture are Cheyenne.

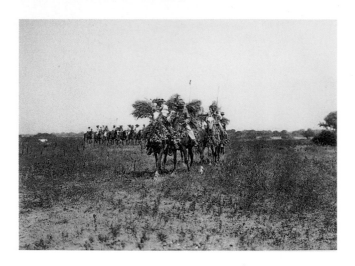

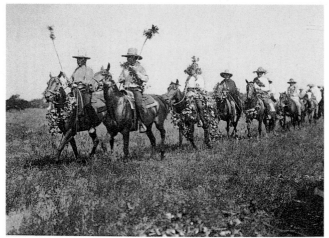

HÓTAMĬTÁᴺYĔ SOCIETY, CHEYENNE
SUN DANCE

The members of this band go to the forest for the poles
with which to build the lodge. They decorate themselves and
their horses with willow branches, leaving the rearmost
horsemen to drag the poles to camp.

HÉFATÁᴺYŬ SOCIETY, CHEYENNE
SUN DANCE

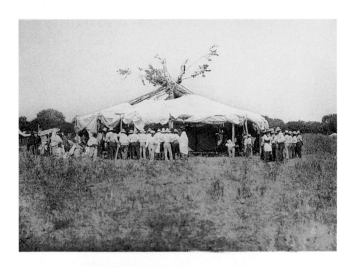

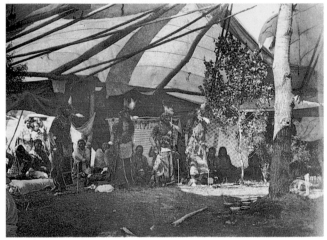

CHEYENNE SUN DANCE LODGE

SUN DANCERS – CHEYENNE

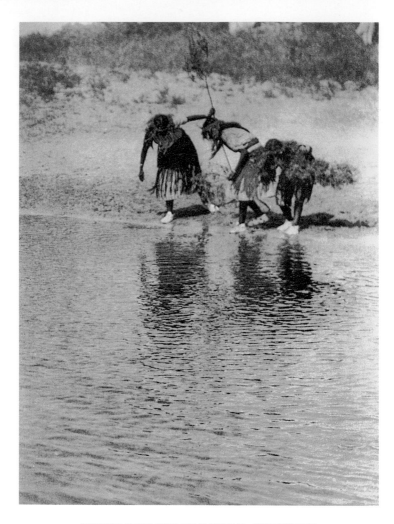

WATER RITE PURIFICATION, CHEYENNE
ANIMAL DANCE

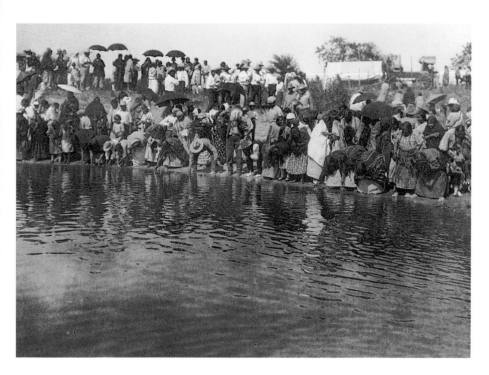

AT THE POOL; ANIMAL DANCE –
CHEYENNE

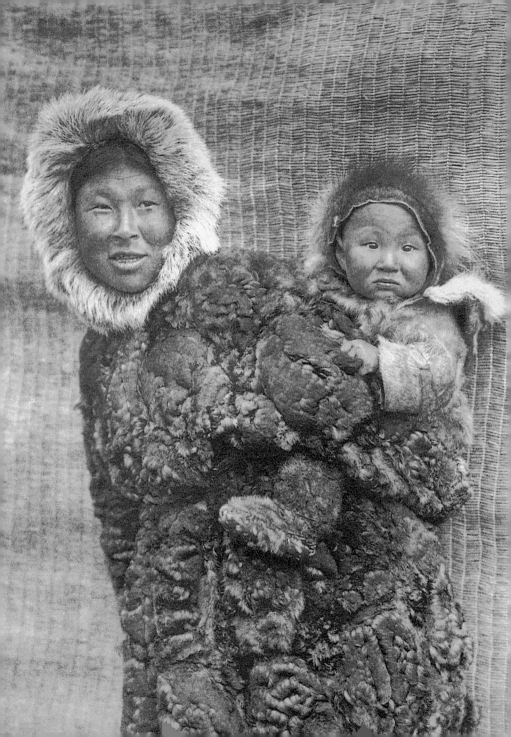

Nunivak

King Island

Little Diomede Island

Cape Prince of Wales

Kotzebue

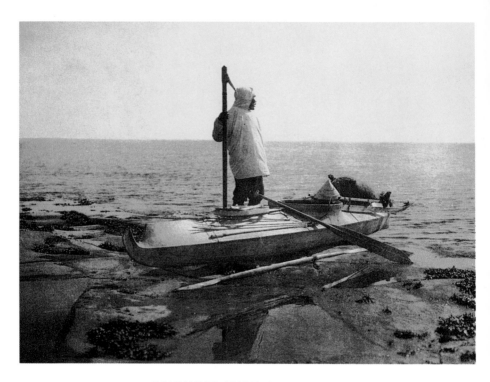

READY FOR SEALING – NUNIVAK

The kaiak of this Nunivak sealer is fully equipped with the
apparatus required for augmenting the family larder. Sealing is
of prime importance to the people of Nunivak Island, the seal
being sought in spring and in fall during their northward and
southward migrations respectively.

PAGE 736
WOMAN AND CHILD – NUNIVAK

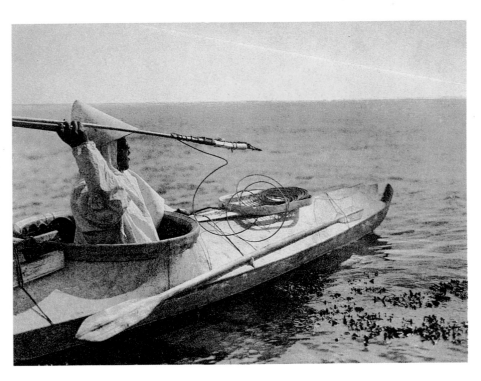

READY FOR THE THROW - NUNIVAK

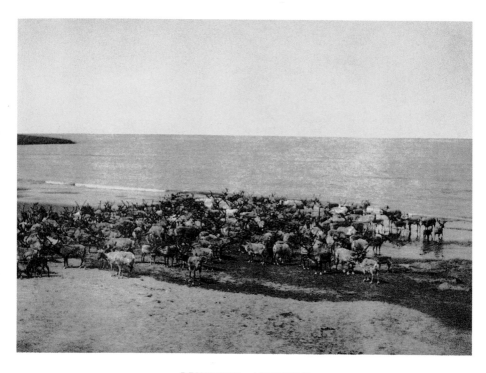

REINDEER - NUNIVAK

Formerly caribou were of great importance to the Nunivak
Eskimo, both for food and for many utilitarian purposes; but
they have been entirely superseded by the reindeer intro-
duced to the island.

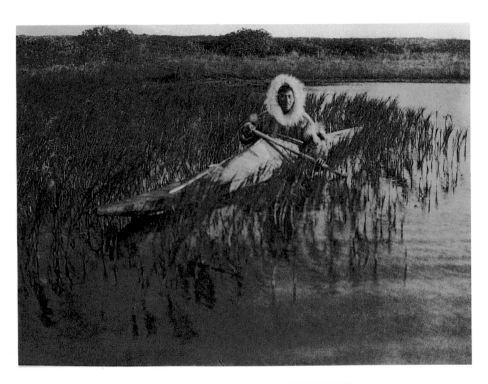

THE MUSKRAT-HUNTER – KOTZEBUE

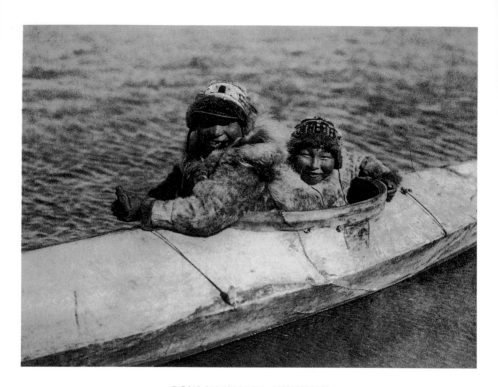

BOYS IN KAIAK – NUNIVAK

Eskimo boys are trained in manly pursuits from their earliest
years and are honored with feasts on taking their first game.

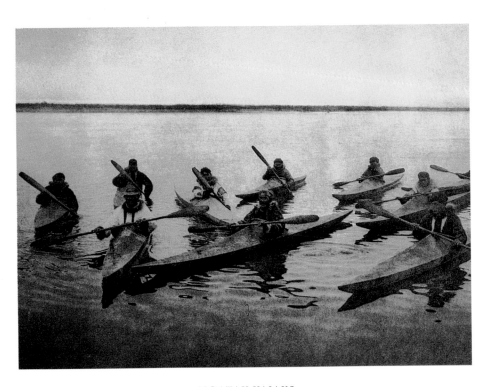

NOATAK KAIAKS

These skin-covered craft, of marvellous lightness and efficiency,
are of outstanding importance to the Eskimo. Remarkable too is
the manner in which they are handled by their owners, who are
exceedingly expert even in rough water.

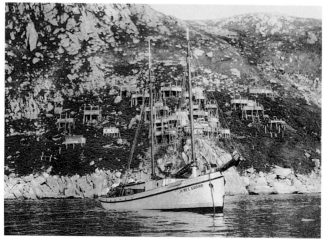

THE VILLAGE – HOOPER BAY

This settlement consists of dwellings dug and built into a hill
with such little regard for order that the entrance to one may
open on the roof of a house below.

KING ISLAND VILLAGE FROM THE SEA

The King islanders occupy dwellings erected on stilts
on the cliff side.

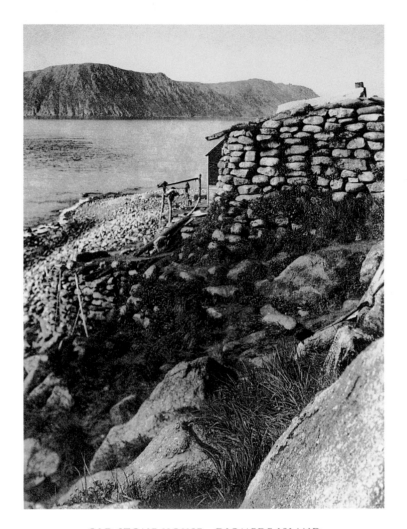

OLD STONE HOUSE – DIOMEDE ISLAND

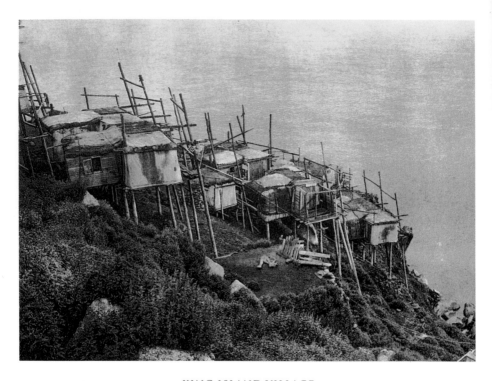

KING ISLAND VILLAGE

The settlement consists of only twenty-nine houses, built
irregularly on seven terraces, the lowest about eighty or a
hundred feet above sea-level.

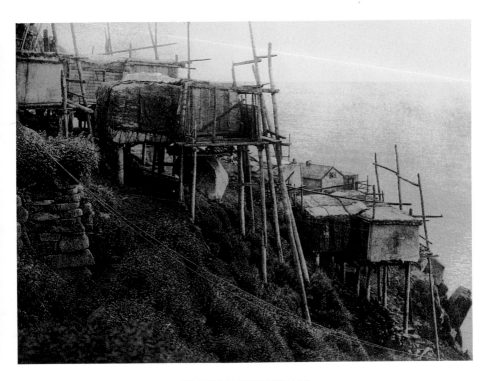

KING ISLAND HOMES

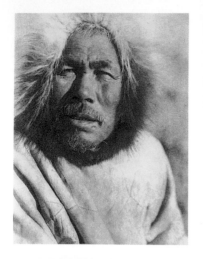

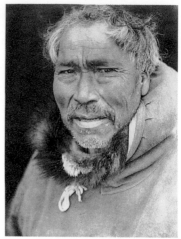

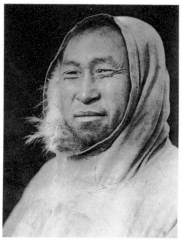

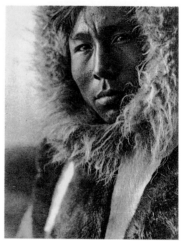

QUNANÍNRU – KING ISLAND

A KOTZEBUE MAN

Although commercial cloth has displaced
the native skin garments to some extent,
the old-style tailoring is adhered to.

CAPE PRINCE OF WALES
MAN

JACKSON, INTERPRETER
AT KOTZEBUE

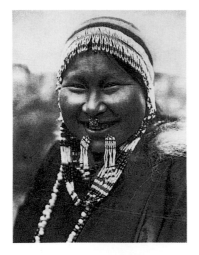

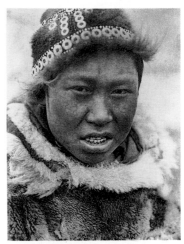

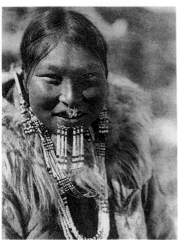

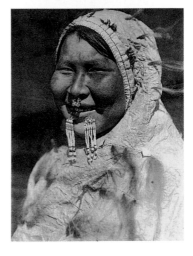

ÚGIYAKŬ – NUNIVAK

HOOPER BAY YOUTH

KENÓWŬN – NUNIVAK

ÚGIYAKŬ – NUNIVAK

The nose-ring and labret of beads
are typical.

This contented young woman wears
a nose-ring and a labret. Her waterproof
hooded parka is made of intestinal
parchment.

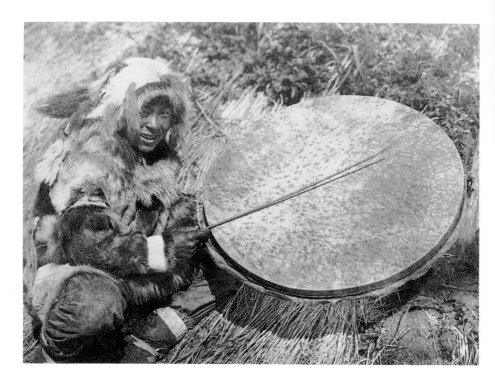

THE DRUMMER - NUNIVAK

This tambourine-like instrument, its head made of walrus
stomach or bladder, is used chiefly in the winter ceremonies. Such
drums vary in diameter from a foot to five feet; the one illustrated
measured three feet six inches. When beaten, the drum is held in
a position varying from horizontal to vertical. The drum-stick
is a slender wand.

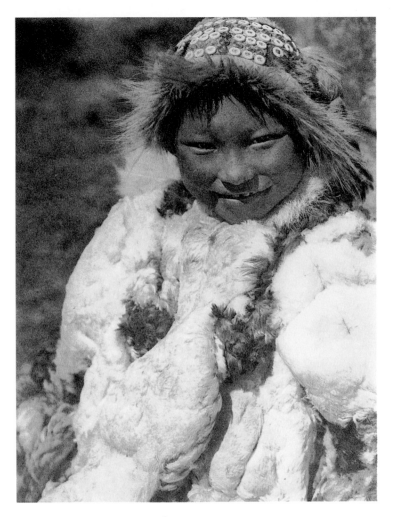

UYOWŬTCHĄ – NUNIVAK

The effect of trade is shown in this and in other portraits by the
buttons with which this child's cap is ornamented; otherwise the
costume is quite aboriginal.

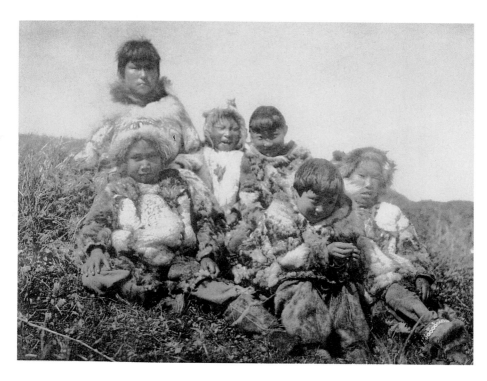

NUNIVAK CHILDREN

Children and adults alike of the Nunivak group are healthy,
as a rule, and exceptionally happy because they have been little
affected by contact with civilization.

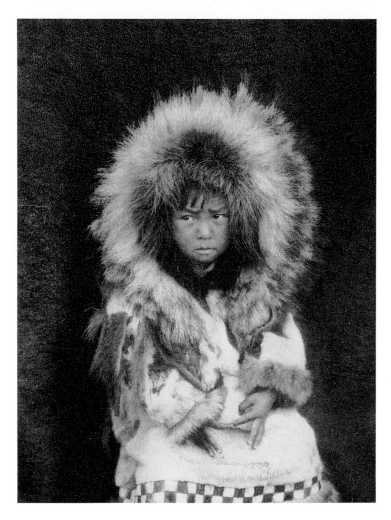

NOATAK CHILD

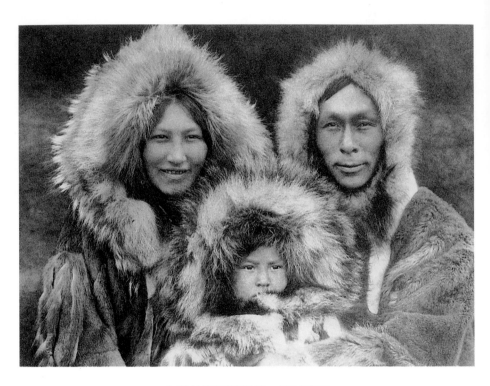

A FAMILY GROUP – NOATAK

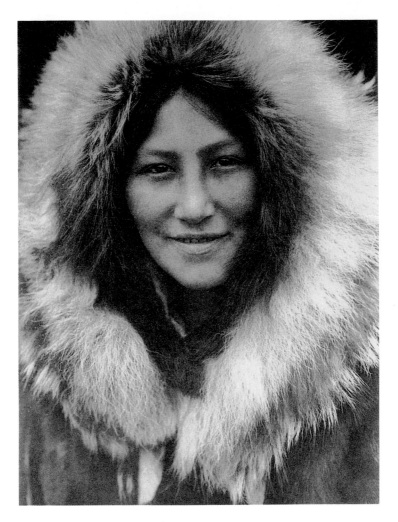

ÓLA – NOATAK

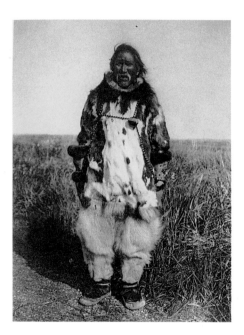

KOBUK COSTUME

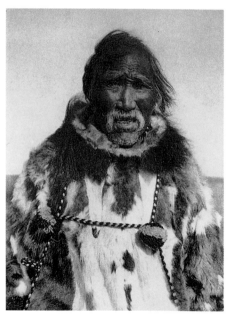

CHARLIE WOOD – KOBUK

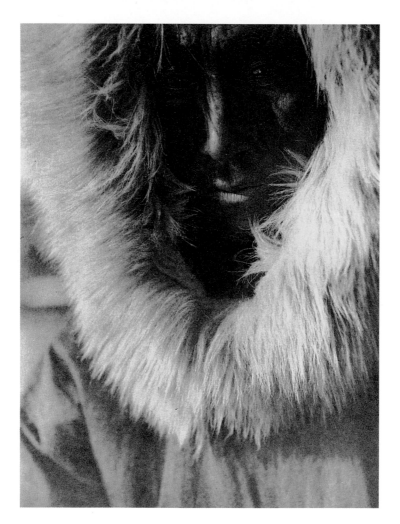

JÁJÜK – SELAWIK

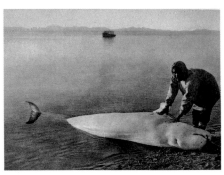

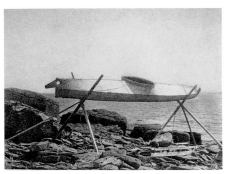

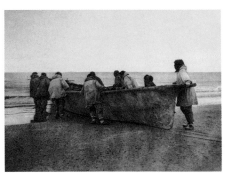

KAIAK FRAME – NUNIVAK

KAIAK ON RACK – NUNIVAK

THE BELUGA – KOTZEBUE

LAUNCHING THE WHALE BOAT –
CAPE PRINCE OF WALES

The Eskimo of the Alaskan coast are
expert whale-hunters, even with such
seemingly flimsy skin craft.

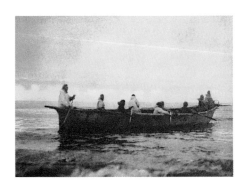

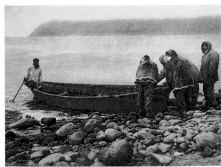

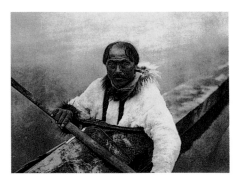

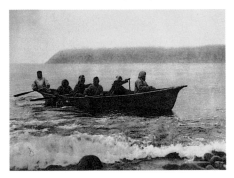

WHALING CREW - CAPE PRINCE
OF WALES

LAUNCHING THE BOAT - LITTLE
DIOMEDE ISLAND

NUNGÓTŎK - NOATAK

DIOMEDE BOAT CREW

The crew are putting out from their island home
from which the Asiatic coast is readily visible.

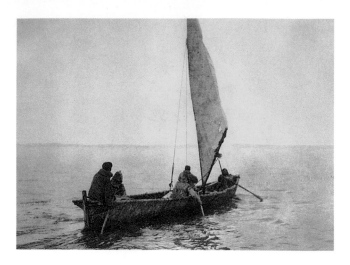

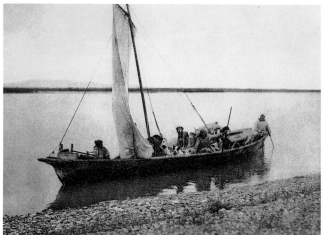

A FOGGY DAY – KOTZEBUE

STARTING UP THE NOATAK RIVER –
KOTZEBUE

Although it has become reduced in recent times, the Kotzebue
people still carry on a brisk trade with the Eskimo of the mainland
and islands, as well as with those of the Siberian coast.

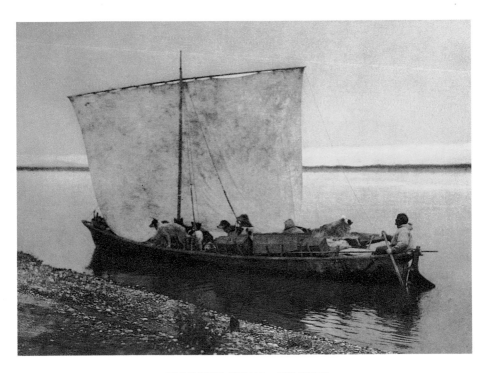

ARRIVING HOME – NOATAK

Sails were an invention of great importance to the Alaskan
Eskimo, whose material culture indeed reached a highly
advanced stage.

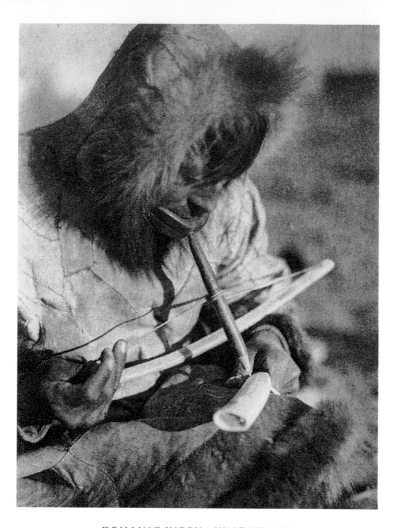

DRILLING IVORY – KING ISLAND

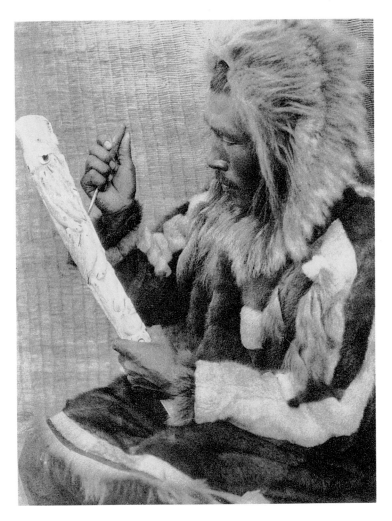

THE IVORY CARVER – NUNIVAK

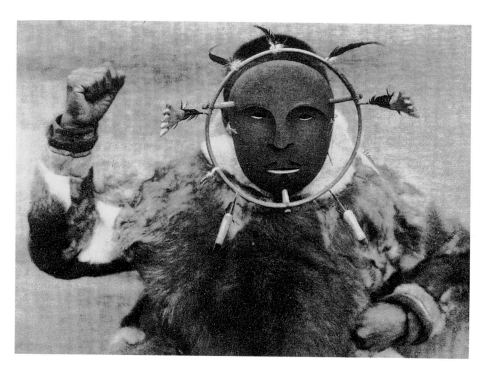

CEREMONIAL MASK – NUNIVAK

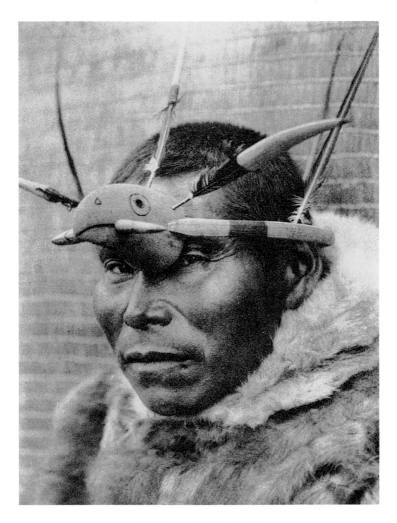

MASKETTE – NUNIVAK

1000 Chairs

1000 Lights

Decorative Art 50s

Decorative Art 60s

Decorative Art 70s

Design of the
20th Century

domus 1950s

Logo Design

Scandinavian Design

100 All-Time
Favorite Movies

The Stanley Kubrick
Archives

Bookworm's delight:
never bore, always excite!

TASCHEN
Bibliotheca Universalis

20th Century
Photography

A History of
Photography

Stieglitz.
Camera Work

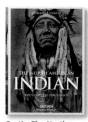
Curtis. The North
American Indian

Eadweard Muybridge

Karl Blossfeldt

Norman Mailer.
MoonFire

Photographers A–Z

Dalí. The Paintings

Hiroshige

Leonardo.
The Graphic Work

Modern Art

Monet

Alchemy & Mysticism

Braun/Hogenberg.
Cities of the World

Bourgery. Atlas of
Anatomy & Surgery

D'Hancarville.
Antiquities

Encyclopaedia
Anatomica

Martius.
The Book of Palms

Seba. Cabinet of
Natural Curiosities

The World
of Ornament

Fashion. A History from
18th–20th Century

100 Contemporary
Fashion Designers

Architectural Theory

The Grand Tour

20th Century
Classic Cars

1000 Record Covers

1000 Tattoos

Funk & Soul Covers

Jazz Covers

Mid-Century Ads

Mailer/Stern.
Marilyn Monroe

Erotica Universalis

Tom of Finland.
Complete Kake Comics

1000 Nudes

Stanton.
Dominant Wives

BOESEN, Victor & GRAYBILL, Florence Curtis:
Edward S. Curtis: Photographer of the North American Indian. New York:
Dodd, Mead & Co., 1977

CARDOZO, Christopher:
Native Nations: First Americans as Seen by Edward S. Curtis. Boston:
Bullfinch Press, 1993

COLEMAN, A. D. & MCLUHAN, T. C.:
Curtis: His Work. Introduction to Portraits from the North American Indian
by Edward S. Curtis. New York: Dutton, 1972

CURTIS, Edward Sheriff:
The North American Indian. 20 vols., 1907-1930: vols. 1-5, Cambridge, MA:
The University Press; vols. 6-20, Norwood, MA: The Plimpton Press

CURTIS, Edward Sheriff:
Indian Days of Long Ago. Yonkers-on-Hudson, NY: World Book Co. 1914;
reprint Berkeley, CA: Ten Speed/Tamerack Press, 1975

CURTIS, Edward Sheriff:
In a Sacred Manner We Live: Photographs of the North American Indian by
Edward Sheriff Curtis. Barre, MA: Weathervane Books, 1972

CURTIS, Edward Sheriff:
The North American Indians. Photographs by Edward S. Curtis. Text compiled
with an introduction by Joseph Epes Brown. Millerton, New York: Aperture, 1972

DAVIS, Barbara A.:
Edward S. Curtis: The Life and Times of a Shadow Catcher. San Francisco:
Chronicle Books, 1985

FLEMING, Paula Richardson & LUSKEY, Judith:
The North American Indians in Early Photographs. New York: Dorset Press, 1986

GIDLEY, Mick:
The Vanishing Race: Selections from Edward S. Curtis's The North American Indian.
New York: Taplinger Publishing, 1977

GOETZMANN, William N.:
The Arcadian Landscapes of Edward S. Curtis. In: Castleberry, May: Perpetual Mirage.
Photographic Narratives of the Desert West. New York: Whitney Museum/Harry N.
Abrams, 1996, pp. 83-91

HARTMANN, Sadakichi:
E. S. Curtis, Photo-Historian. In: The Valiant Knights of Daguerre. Berkeley, CA:
University of California Press, 1978, pp. 262-272

HAUSMAN, Gerald & KAPOUN, Bob:
Prayer to the Great Mystery. The Uncollected Writings and Photography of
Edward S. Curtis. New York: St. Martin's Press, 1995

LYMAN, Christopher M.:
The Vanishing Race and Other Illusions: Photographs by Edward S. Curtis.
New York: Pantheon Books, in association with the Smithsonian Press, 1982

PRITZKER, Barry:
Edward S. Curtis. New York: Crescent Books, 1993

SCHWARZ, Angelo:
Cronica fotografica del genocidio delle nazioni indiane d'America. Ivrea:
Priuli & Verlucca, 1980